Gifts in Honor of the 125th Anniversary
of the Philadelphia Museum of Art

Made possible by Wilmington Trust and The Women's Committee
of the Philadelphia Museum of Art.

Additional support was provided by Montgomery, McCracken, Walker &
Rhoads, LLP, the Robert Montgomery Scott Endowment for Exhibitions,
and The Pew Charitable Trusts, with a donation from Sotheby's. Generous
contributions were given by Gisela and Dennis Alter, Marguerite and
Gerry Lenfest, Maxine and Howard H. Lewis, Harvey S. Shipley Miller,
and Martha J. McGeary Snider.

Gifts in Honor of the 125th Anniversary of the Philadelphia Museum of Art

Organized by Alice Beamesderfer

Published on the occasion of the exhibition

Gifts in Honor of the 125th Anniversary of the Philadelphia Museum of Art

September 29–December 8, 2002, at the Philadelphia Museum of Art

Produced by the Department of Publishing
Philadelphia Museum of Art
2525 Pennsylvania Avenue
Philadelphia, Pennsylvania 19130
www.philamuseum.org

Edited by Nicole Amoroso
Production managed by Richard Bonk
Designed by Phillip Unetic, Willow Grove,
Pennsylvania
Color separations by Professional Graphics, Inc.,
Rockford, Illinois
Printed and bound by Butler and Tanner Ltd., Frome,
England

Library of Congress Cataloging-in-Publication Data

Gifts in honor of the 125th anniversary of the
Philadelphia Museum of Art / organized by Alice
Beamesderfer.
 p.cm.
 Published on the occasion of an exhibition held at
 the Philadelphia Museum of Art, Sept. 29-Dec. 8,
 2002.
 Includes bibliographical references and index.
 ISBN 0-87633-159-2 (cloth)–ISBN 0-87633-160-6
 (pbk.)
 1. Philadelphia Museum of Art—Exhibitions.
2. Art—Private collections—Exhibitions. 3. Art—
Pennsylvania—Philadelphia—Exhibitions.
I. Beamesderfer, Alice O. II. Philadelphia Museum of Art.

 N685 .A554 2002
 708.148'11—dc21

 2002029276

Contents

Committee for Collections 2001

Harvey S. Shipley Miller
Chairman

Anne d'Harnoncourt
The George D. Widener Director and
Chief Executive Officer

Dennis Alter
Dr. Alvin O. Bellak
Dilys E. Blum
George M. Cheston
Dr. Constance E. Clayton
H. Richard Dietrich, Jr.
Felice Fischer
Hannah L. Henderson
J. Welles Henderson
Kathryn Bloom Hiesinger
John Ittmann
Joan M. Johnson
Maxine Lewis
Jack L. Lindsey
Darielle Mason
John J. Medveckis
Ann Percy
Joseph J. Rishel
Barbara B. Rubenstein*
Keith L. Sachs
Darrel L. Sewell
Innis Howe Shoemaker
Martha J. McGeary Snider
Marion Stroud Swingle
Ann Temkin
Bruce E. Toll
Dean Walker
Katherine Ware

Ex-Officio
Berton E. Korman
H. F. (Gerry) Lenfest
Raymond G. Perelman
Kathleen C. Sherrerd

*deceased

Harvey S. Shipley Miller

Chairman, Committee for Collections 2001

On Transformation and Appreciation

The Philadelphia Museum of Art as we know it today is unimaginable without the gifts and bequests of masterworks donated by public-spirited benefactors over the past 125 years. More than 90 percent of the works of art in the Museum's world-renowned collections were acquired as gifts, an extraordinary testament to the generosity of distinguished collectors over the past twelve decades. In celebration of its 125th Anniversary in the year 2001, the Museum launched a major "collection-transforming" initiative to gather works of art of extraordinary quality and importance and thereby to enrich the holdings of each of its curatorial departments as a legacy for future generations.

Collections are the lifeblood of the Museum with its mission to forge deep connections between great works of art and the public for whom it holds them in trust. Indeed, the very identity and special character of the Museum are defined by the works of art it owns, conserves, exhibits, and interprets for a broad audience. Enriching and expanding the collections are essential to the continued vitality of the Philadelphia Museum of Art and its ability to attract new audiences. Each major acquisition also evokes resonances with the existing collections, giving familiar works fresh meaning and extending new opportunities for knowledge and pleasure in the visual arts to all visitors.

The "Gifts That Transform" initiative was conceived as one of three parts of a comprehensive anniversary campaign based on the Museum's long-range plan—"Our Future Together"—which I believe is the first such coordinated effort to combine raising funds for current operations, endowment growth, and building expansion; encouraging planned or deferred giving through bequest and charitable annuities; and acquiring collection-transforming works of art by gift or purchase.

As the Trustee charged with stewardship of the 125th Anniversary project to grow the collections significantly, I worked almost daily with our visionary Director, Anne d'Harnoncourt, without whose brilliant leadership, indefatigable efforts, passion for art, and personal magic this campaign would not have been possible. To her, above all, we owe an enormous debt of gratitude. To accomplish our goal, Anne and I formed the Committee for Collections 2001, representing all parts of the Museum's family and community of interests. All senior Museum curators—recognized experts in their particular fields—joined a distinguished group of Trustees who both loved and had profound knowledge of different aspects of the collections and were willing to assume responsibility for actively attracting new gifts of the greatest importance to the Museum collections. Their energy, insights, connoisseurship, and enthusiasm, together with their gift of time, led to the unprecedented success of the campaign. The members of the Committee, who performed such exemplary service, are listed in this catalogue.

Our first order of business was to define what we meant by works that are "collection-transforming," even before we identified the objects the Museum most coveted. We arrived at a two-part definition: First, the works had to be of the highest quality. Second, and even more importantly, they had to serve the particular needs of the Philadelphia Museum of Art—that is, they had to contribute significantly to its present holdings and its future growth.

Concerning quality, we followed the dictum of the legendary art historian and founding Director of The Museum of Modern Art, Alfred H. Barr, Jr., who stated in 1944 that "[t]o acquire and exhibit works of the finest possible quality is imperative. This should be the chief objective of the Museum . . . of its collection, because the excellence of the works of art contributes not only to the public's enjoyment but also to the educational effectiveness of the Museum." Further, our course paralleled the philosophy of Barr and others that "[q]uality, for practical purposes, is a problem of finding the best of its kind. It is quality, too, that is the primary factor in making a work of art historically important or educationally valuable." As one of our Museum's former Presidents, R. Sturgis Ingersoll, said on the occasion of the Museum's Diamond Jubilee in 1950–51, "We have set our sights high, but no higher than did our predecessors who fanned the flame first lit in 1875 into that blazing glory of architecture, painting and sculpture that now burns on the acropolis of Fairmount."

The Committee decided that, once the standard of quality had been met, the critical dimension of being "collection-transforming" was the most important criterion for selection. This meant that all of the outstanding works of art to be drawn into the magnetic field of the "Gifts That Transform"

initiative had to affect the shape of the Museum's present holdings in a particular area by adding a significant, new aspect to the collections. This could be accomplished in either or both of two ways: by *extension*, that is, by adding works in areas not yet well represented in the Museum's collections; or by *enrichment*, that is, by adding works that deepen our understanding of a particular artist, period, or school already represented in the Museum's collections.

At the outset, all Committee members realized that this was a diacritical, unique moment in the life of the institution, providing an opportunity for the Museum to enlarge its holdings with world-class acquisitions, supported by the entire Board of Trustees, while expanding and securing the financial foundation of the institution and increasing the amount of additional space required to exhibit these new treasures properly. The institution-wide support of this campaign was reflected by the active participation of the Committee's ex-officio members: Raymond G. Perelman, the Museum's Chairman Emeritus, and the three co-chairs of the overall capital campaign itself—H. F. (Gerry) Lenfest, our current Board Chairman; Kathleen C. Sherrerd; and Berton E. Korman. Their efforts were further supported by our Chief Operating Officer, Gail Harrity, and many members of the Development Department.

The Committee for Collections 2001 has worked tirelessly over the past two years, as myriad meetings, telephone conferences, cultivation dinners, and related events, letters, and strategy sessions were all carried out by Committee members working closely with the Museum's professional staff. Plans were implemented with the care and precision of a military action. No one who possessed an object the Committee had identified as desirable was safe from our crusade, including even Committee members themselves; after all, we were serving a collective and higher purpose—to gather extraordinary works of art that crystallize the greatest aspirations and aesthetic achievements of humankind, and that translate spiritual values into the material for all to share. This effort culminated in an enormous success that went beyond anything we had dared to hope—more than four thousand works of art, individually or collectively as part of interrelated thematic collections, met the collection-transforming standard and were either given out-

right, purchased with specifically raised funds, or irrevocably promised to the Museum as future gifts.

Our success was heady indeed. In an unexpected number of instances, we acquired entire collections, which by their very numbers as well as their overall quality redefined the range of ideas represented in departmental holdings. Additionally, a number of icons—works of transcendent and recognized historical importance in various areas—were generously given on this anniversary occasion. The campaign had an impact on the holdings of every department in the Museum, and significant progress was made in a number of newer areas of collecting, such as African art and "outsider" art. Noteworthy too was the broad range of donors of these magnificent objects—many historic patrons of the Museum, joined by a gratifying number of newer members of the Museum family.

A particularly rewarding and direct result of this initiative was a renewed and ongoing commitment by the Museum to expand its distinguished holdings of works of art by African American artists. I salute my fellow Trustee, Dr. Constance E. Clayton, who, with Anne d'Harnoncourt, co-chairs the African American Collections Committee that continues to work on this important effort, the first fruits of which are evident in the pages that follow.

Supporting the efforts of the Committee for Collections 2001 was the most marvelous professional staff. First and foremost was Alice Beamesderfer, the Museum's Associate Director for Collections and Project Support. Alice was extraordinary as she brilliantly worked out legal questions with donors and their advisers, and skillfully planned the exhibition and oversaw the production of this anniversary catalogue. She became my left and right hands—the perfect muse in this effort. She supported me with sage advice and firm encouragement when needed, and was the master of diplomacy in tirelessly dealing with issues large and small. Also assisting the effort were members of our Development Department, and I am grateful indeed to Alexandra Q. Aldridge and Betty J. Marmon, who viewed the acquisition of works of art as synergistic to the vitality of the overall success of the capital campaign. In particular, Eileen Matchett of their staff did a superb job keeping track of donors and coordinating our cultivation efforts with lapidary precision, while maintaining her calm, reassuring composure throughout.

Finally, my thanks go to Mary-Jean Huntley, assistant to our Director, who was invaluable—always upbeat, even-keeled, ready for any mission—and who managed to keep Anne and me in constant communication during the two-plus years of this process.

To each member of the Committee goes my profound gratitude—we are all indebted to them for their deep commitment and sustained work in reaching this shining pinnacle of achievement, unequaled in our institutional history.

Finally, and most importantly, my greatest thanks are extended to the individuals who donated works of art and the funds to help us acquire such important works. They and their heirs have relinquished family treasures and prized possessions to our beloved Museum and thereby made all of our lives unimaginably richer. Their great generosity and perceptive taste are reflected in the works of art contained in this catalogue and in the accompanying exhibition, a monument that records the greatness of these gifts and honors not only their donors but also those donors who have preceded them in the past 125 years. We look forward expectantly to celebrating the continued flow of major gifts into the collections as our expanding Museum moves into the twenty-first century—a most important legacy of the momentum generated by the work of the members of the Committee for Collections 2001.

Anne d'Harnoncourt

The George D. Widener Director
and Chief Executive Officer

Foreword

Five months before the new building of the Philadelphia Museum of Art opened on the city's grand boulevard in February 1928, after ten years of construction, its new Director Fiske Kimball wrote with delight, "Soon it will . . . be placed in the service of everyone." And he added, "In providing the building the City of Philadelphia is doing its share in the handsomest manner on the assumption that public-spirited citizens will provide the works of art needed to fill it." That assumption was gloriously affirmed, over the ensuing decades, as celebrated collectors gave great objects and donors responded to the call to purchase period architectural settings from three continents or banded together to buy the celebrated Edmond Foulc Collection of Renaissance decorative arts and sculpture. Upon the occasion of the Museum's Diamond Jubilee in 1951, Museum President R. Sturgis Ingersoll declared: "We will make memorable the pivot years of the Twentieth Century, our own Seventy-fifth Anniversary Years." He went on to write, "Our endeavor will be a failure unless we expand the recognition of the spiritual sustenance which may be drawn from art. Beauty created by the hand of man makes the whole world kin. It knows no geographical boundaries, nor limitations of race, color or creed A high purpose of our Museum should be . . . the re-establishment of a close relationship between art and society." The Museum, in the year 2002, aspires to no less, in a mission rephrased for contemporary ears.

In 1951, and again in 1976, this time led by legendary collector-curator-trustee Henry P. McIlhenny, the Museum celebrated milestones in its history with an appeal for gifts of works of art to fill the vast temple of art on Fairmount. No appeal has ever received a more splendid or far-ranging response from both collectors and donors of funds for collection-transforming purchases than this 125th Anniversary celebration, which carries the Museum exuberantly into the twenty-first century.

What distinguishes this anniversary appeal is not only the quality of the works of art it has garnered but their breathtaking range and spirit of adventure. Many gifts are on such a scale that their magnitude can only be hinted at in this book. The collections of Dr. Alvin O. Bellak and Howard I. and Janet H. Stein, lovingly assembled over decades, have already been celebrated in separate volumes, as has the brilliant group of Jacques

Villon prints that The Judith Rothschild Foundation pursued, purchased, and gave—all within an amazingly brief span of time. Several astounding collections literally transform the departments receiving them—Diane Wolf's couture and John Cale's spectacular men's clothing give a brilliant contemporary aspect to one of the earliest mediums collected by the Museum. No collection strength is unchanged, and many gaps are filled: The Department of American Art found its deep concentration in Philadelphiana crowned by the magnificent Cadwalader chair given by H. Richard Dietrich, Jr., and balanced by Anne H. and Frederick Vogel III's great objects from New England. Extraordinary among more recent gifts is the Julien Levy Collection of almost 2,500 photographs, which the spectacular, combined generosity of the collector's widow, Jean Farley Levy, and Lynne and Harold Honickman has brought to Philadelphia, where it joins deep holdings of the work of Levy's mentors Alfred Stieglitz and Marcel Duchamp, also now augmented by wonderful new acquisitions.

The profoundly moving, strikingly varied art of self-taught painters, sculptors, draftsmen, and artisans has been especially appreciated and collected privately in Philadelphia for over fifty years, but now assumes a major role in the Museum thanks to outstanding gifts from a number of private collections. John Ollman, of the Fleisher/Ollman Gallery, deserves special mention for bringing this work to the public's attention and for encouraging collectors to embrace this fascinating, nontraditional field.

To each and every one of the donors whose generosity is reflected in this book and the exhibition it accompanies goes the inexpressible gratitude not only of the Museum's Trustees and staff but most importantly of millions of future visitors. The *primum mobile* of this most far-reaching of anniversary celebrations, Harvey S. Shipley Miller, together with the Committee for Collections 2001, which he so elegantly chaired, have wrought wonders in their quest. Harvey Miller's inimitable mix of exuberance, diplomacy, and determination, and above all his thirst for great art of every era, ensured the astonishing success of the Committee's work. His own generosity has been exemplary and extraordinary, reaching into every field in which the Museum collects.

H. F. (Gerry) Lenfest, the Museum's dynamic Chairman of the Board, as keen about building its great collections as he is about growing its financial base, gave the Committee his heartfelt endorsement with generous contributions toward a number of important purchases as well as the gift of two wonderful works of art by William H. Johnson and William Trost Richards.

Dr. Constance E. Clayton, a dedicated member of the 2001 Committee and generous donor to that effort, graciously consented to co-chair with me a second committee with the crucial, ongoing mission to expand the Museum's distinguished but hitherto limited holdings of important work in all mediums by African American artists. Identifying exciting opportunities for purchase, six of which have already been secured and their funding launched, the Committee on African American Collections has also gratefully applauded remarkable gifts, the most recent of which is Jacob Lawrence's iconic painting *Taboo* from the family of Zelda and Josef Jaffe.

This anniversary effort also owes warm thanks to the Museum's Korean Heritage Group and its dynamic Chairman, Dr. Bong Sik Lee. The group's devotion to building the Museum's collection and programs in the field of Korean art has both inspired large gifts of works of art recorded here and supported the purchase of the fine *ch'aekkori* screen, whose charmingly rendered scholar's accoutrements resonate with objects on view in the Hollis Chinese Scholar's Study, which the Museum has owned since 1928.

The lion's share of works of art in this book and exhibition are either gifts of prized treasures from collectors or the families in which the objects have descended, or purchases with moneys raised for the purpose in honor of the Museum's anniversary, but it should be most gratefully remembered that invaluable gifts of endowed purchase funds over the past 110 years, inaugurated by the handsome bequest from Anna P. Wilstach in 1893, have made possible the acquisition of several splendid objects included here. Mrs. Wilstach's fund (used with such lasting impact in 1899 to buy Henry Ossawa Tanner's *Annunciation,* in 1937 for Paul Cézanne's *Large Bathers,* and in 1950 for Peter Paul Rubens's *Prometheus Bound*) was joined by the George W. Elkins Fund and terrific contributions from Mr. and Mrs. Fitz Eugene Dixon, Jr., and other

benefactors, to secure John Singleton Copley's masterful portrait of the Mifflins. Without the Museum's recent endowment for East Asian art given by Trustee William M. Hollis, Jr., to the anniversary campaign, the striking Jōmon jar, which is the first work of art discussed in this catalogue, would not have found its place as the oldest object in a museum celebrated for its ceramics.

This exhibition, overseen with such intelligent flair by our Associate Director for Collections and Project Support, Alice Beamesderfer, and its accompanying book, brought to life by the Museum's indefatigable Director of Publishing, Sherry Babbitt, skillfully and carefully edited by Nicole Amoroso, and seen through the press by Production Manager *extraordinaire* Richard Bonk, were a collective project in which all of the Museum's superb curatorial talent was enlisted. Danielle Rice, Associate Director for Program, brings her erudition to bear on the happy human impulse of gift-giving. Graydon Wood and Lynn Rosenthal took the fine photographs that illustrate this catalogue, and Jason Wierzbicki negotiated the complexities of scheduling. Jessica Murphy ably assisted with many details of both the exhibition and the catalogue. Phillip Unetic's thoughtful design distinguishes this book, as it has so many Museum publications, and Jack Schlechter has deftly risen to the challenge of designing the exhibition.

The Museum owes a special debt of thanks to the funders of this anniversary project: Wilmington Trust, our lead corporate sponsor, joins forces with The Women's Committee, which helped bring the Museum itself into being in 1876 and continues to support a broad range of institutional needs, including landmark acquisitions in the field of American crafts. We have also received a very meaningful mix of public and private support from Montgomery, McCracken, Walker & Rhoads, LLP, the Robert Montgomery Scott Endowment for Exhibitions, The Pew Charitable Trusts, Sotheby's, and five Museum Trustees. The handsome contributions from Gisela and Dennis Alter, Marguerite and Gerry Lenfest, Maxine and Howard H. Lewis, Harvey S. Shipley Miller, and Martha J. McGeary Snider come on top of their splendid gifts of works of art.

It is to the artists above all—past, present, and future—that our most vivid appreciation is due. Without Jean-Antoine Houdon's breathtaking

ability to render marble into flesh and intellect, we would know less about Benjamin Franklin; through Hon'ami Kōetsu's incomparable calligraphy, twelfth-century Japanese love poems float into our hearts; the apprehensive yet steady gaze of Alice Neel's weary mother in her plaid bathrobe could be that of any of us looking death in the face; while the observant eye, wry humor, and brilliant pencil taken up by former slave William Traylor at the age of eighty-three remind us of our shared humanity. Many of the artists represented in these pages (including some whose work we may never be able to identify by name) are distinctive new voices in the timeless conversation that is the Museum's collection. Others, such as Jasper Johns, whose magisterial painting *Catenary (I Call to the Grave)* has now entered into colloquy with works by Paul Cézanne, Marcel Duchamp, and Pablo Picasso in neighboring galleries, are old and valued friends. The youngest work of art in this anniversary cornucopia, Sol LeWitt's sculpture *Splotch (Philadelphia)* of 2002, which comes as the gift of Henry S. McNeil, Jr., was not even in physical existence as of this writing. Its outburst of brightly colored fiberglass form will bring us full circle to the curling coils of clay used with such freedom by the unknown Japanese potter who created the Jōmon vessel over three thousand years ago.

Donors of Works of Art

as of August 1, 2002

Anonymous (2)
Josephine Albarelli
Elizabeth Albert
Gisela and Dennis Alter
Kate and Ken Anderson
Susanne Strassburger Anderson, Valerie
 Anderson Readman, and Veronica
 Anderson Macdonald
Alvin O. Bellak
Mrs. Edwin A. Bergman
William C. Bertolet
Daniel Blain, Jr.
Jill and Sheldon Bonovitz
Dr. Luther W. Brady, Jr.
Margaret McKee Breyer
John Cale
George M. Cheston
Collab: The Group for Modern and
 Contemporary Design at the
 Philadelphia Museum of Art
Mr. and Mrs. M. Todd Cooke
Dedalus Foundation, Inc.
Emilie deHellebranth
Derrel DePasse
Maude de Schauensee and Maxine de S. Lewis
Anne d'Harnoncourt and Joseph Rishel
Cordelia Biddle Dietrich, H. Richard
 Dietrich III, and Christian Braun Dietrich
H. Richard Dietrich, Jr.
Margaret Chew Dolan and Peter Maxwell
Adele Donati
Alexina Duchamp
Eckenhoff Family
Frank A. Elliott, Josiah Marvel, and
 Jonathan H. Marvel
Helen Williams Drutt English
Kathleen P. Field
John and Berthe Ford
Mr. and Mrs. Jack M. Friedland
The Friends of the Philadelphia Museum
 of Art
Beatrice B. Garvan
Melanie Gill
Harold S. Goldman and John A. Bonavita
Rachel Bok Goldman and
 Allen S. Goldman, M.D.
Gerald and Virginia Gordon
Carole Haas Gravagno
Agnes Gund and Daniel Shapiro
John C. and Chara C. Haas

Audrey and William H. Helfand
Hannah L. and J. Welles Henderson
Judith Hollander
Walter Hopps and Caroline Huber
Pemberton Hutchinson
Zelda and Josef Jaffe Family
Mr. and Mrs. Victor L. Johnson
Estate of Alice M. Kaplan
Mr. and Mrs. Sidney Kimmel
Mr. and Mrs. Leonard I. Korman
Werner H. Kramarsky
Mary Louise Elliott Krumrine
Lannan Foundation, Santa Fe, New Mexico
Mr. and Mrs. Edward B. Leisenring, Jr.
Marguerite and Gerry Lenfest
Levitties Family
Mrs. Julien Levy
Jacques and Yulla Lipchitz Foundation, Inc.
Susan P. MacGill
Charles E. Mather III and
 Mary MacGregor Mather
Colonel Stephen McCormick
Joseph F. McCrindle
Henry S. McNeil, Jr.
Mrs. Robert L. McNeil, Jr.
Ann and Donald W. McPhail
John J. Medveckis
Harvey S. Shipley Miller and
 J. Randall Plummer
The Miller-Plummer Foundation
Jacqueline Matisse Monnier
Heirs of Charlotte Hope Binney Tyler
 Montgomery
Keith and Lauren Morgan
Martha Hamilton and I. Wistar Morris III
Family of Samuel Wheeler Morris
Dr. David R. Nalin
Richard Neel and Hartley S. Neel
Charles W. Nichols
Isamu Noguchi Foundation, Inc.
Dorothy Norman
The Georgia O'Keeffe Foundation
Enid Curtis Bok Okun
Ann and John Ollman
Franklin Parrasch
Mr. and Mrs. David N. Pincus
Martha Stokes Price
Mr. and Mrs. Stewart A. Resnick
Allen B. and Heidrun Engler Roberts
Eileen Rosenau

Suzanne A. Rosenborg
The Judith Rothschild Foundation
Keith L. and Katherine Sachs
Alice Saligman
David and Naomi Savage
Robert Montgomery Scott
Mr. and Mrs. Joseph Shanis and
 Mr. and Mrs. Harris Stern
Mrs. Samuel R. Shipley III
Martha J. McGeary Snider
Mr. and Mrs. Harold P. Starr
Family of Dorothy and Irvin Stein
Howard I. and Janet H. Stein
Ann R. Stokes
Marion Boulton Stroud
Charlene Sussel
Nancy F. Karlins Thoman and Mark Thoman
Brenda and Evan H. Turner
Edna and Stanley C. Tuttleman
Anne H. and Frederick Vogel III
Wade Family
Mildred L. and Morris L. Weisberg
John Whitenight and Frederick LaValley
C. K. Williams, II
Diane Wolf
Irene and Walter Wolf
The Women's Committee of the Philadelphia
 Museum of Art

Donors of Funds for the Purchase of Works of Art

as of August 1, 2002

Anonymous (3)
The Acorn Club
Alexandra Q. and Fred C. Aldridge, Jr.
Gisela and Dennis Alter
Mr. and Mrs. Ronald C. Anderson
The Annenberg Foundation
Arcadia Foundation
Theodore R. and Barbara B. Aronson
Mr. and Mrs. Edward K. Asplundh
The Barra Foundation, Inc.
Peter A. Benoliel
Dr. Luther W. Brady, Jr.
Robert W. Brano and Craig W. Conover
Mrs. Philip A. Bregy
The Honorable Ida Chen
Mr. and Mrs. George M. Cheston
Dr. Constance E. Clayton
The Committee on East Asian Art
The Committee on Indian and Himalayan Art
The Committee on Prints, Drawings, and
 Photographs
Mr. and Mrs. M. Todd Cooke
Donna Corbin and Samuel Kalter
Helen Cunningham and Theodore T.
 Newbold
Maude de Schauensee
Daniel W. Dietrich
The Dietrich Foundation
Mr. and Mrs. Fitz Eugene Dixon, Jr.
Dr. and Mrs. Paul G. Ecker
Stephanie S. Eglin
Jaimie and David Field
John G. Ford
Mr. and Mrs. Robert A. Fox
Mr. and Mrs. Jack M. Friedland
Donors to the Fund for Franklin
Betty Gottlieb
Priscilla Grace
Mr. and Mrs. Gary Graffman
Mary Livingston Griggs and Mary Griggs
 Burke Foundation
Otto Haas Charitable Trust
The Hamilton Family Foundation
Dr. Benjamin F. Hammond
Mrs. Robert A. Hauslohner
Audrey and William H. Helfand
Hannah L. and J. Welles Henderson
The Henfield Foundation
Regina and Ragan A. Henry
Lynne and Harold Honickman

Mrs. Eugene W. Jackson
Thomas Jayne Studio, Inc.
Mr. and Mrs. James Nelson Kise
Korean Heritage Group
Mr. and Mrs. Berton E. Korman
Mr. and Mrs. Leonard I. Korman
Mr. and Mrs. Edward B. Leisenring, Jr.
Mr. and Mrs. Brook Lenfest
Marguerite and Gerry Lenfest
Maxine and Howard H. Lewis
Betty J. Marmon
Eileen and Stephen Matchett
Colonel Stephen McCormick
John H. McFadden
Amanda D. McLennan
Henry S. McNeil, Jr.
Ann and Donald W. McPhail
John J. Medveckis
Barbara Rothschild Michaels
Harvey S. Shipley Miller and
 J. Randall Plummer
Leslie A. Miller and Richard B. Worley
Keith and Lauren Morgan
Toru Noshiro
Mr. and Mrs. John A. Nyheim
Kelly O'Brien
Joseph A. O'Connor, Jr.
June and Perry Ottenberg
Marsha and Jeffrey Perelman
Philadelphia Fountain Society
Mr. and Mrs. John S. Price
Dr. and Mrs. Paul Richardson
Christopher Riopelle
Mr. and Mrs. Julius Rosenwald II
Mr. and Mrs. George M. Ross
The Herbert and Nannette Rothschild
 Memorial Fund
The Judith Rothschild Foundation
Mr. and Mrs. Mark E. Rubenstein
Caryn J. Rubinstein
Keith L. and Katherine Sachs
Robert Saligman Charitable Foundation
Ella B. Schaap
Mr. and Mrs. John J. F. Sherrerd
Mr. and Mrs. E. Newbold Smith
Marilyn L. Steinbright
Frances and Bayard Storey
Mr. and Mrs. James B. Straw
Marion Boulton Stroud
Mr. and Mrs. W. B. Dixon Stroud

Carl and Joan Tandberg
The Tiffany & Co. Foundation
Robert Tooey and Vicente Lim
Edna and Stanley C. Tuttleman
Mr. and Mrs. William T. Vogt
Warren H. Watanabe
Judie and Bennett Weinstock
Mildred L. and Morris L. Weisberg
Mr. and Mrs. Henry Wendt III
Geraldine B. Wexelblat
C. K. Williams, II
Ann and David Winkowski
The Women's Committee of the Philadelphia
 Museum of Art
Elizabeth G. Woodward
Young Friends of the Philadelphia Museum
 of Art

Endowed Funds

as of August 1, 2002

Edith H. Bell Fund
Edward and Althea Budd Fund
James D. Crawford and Judith N. Dean
 Fund
George W. Elkins Fund
Hollis Family Foundation Fund
Lynne and Harold Honickman Fund for
 Photography
Henry B. Keep Fund
Fiske Kimball Fund
Stella Kramrisch Fund
Henry P. McIlhenny Fund in memory of
 Frances P. McIlhenny
John D. McIlhenny Fund
Alice Newton Osborn Fund
Lola Downin Peck Fund
Walter E. Stait Fund
J. Stogdell Stokes Fund
George W. B. Taylor Fund
W. P. Wilstach Fund

The Gift of Art

Danielle Rice

When he was a young boy, the poet Pablo Neruda received an anonymous gift in the form of a small toy sheep, thrust through a hole in a fence. The giver of the toy disappeared without making himself known to his surprised recipient. Later in life Neruda reflected on this significant moment and commented on this unanticipated and unsolicited gift: "That exchange brought home to me for the first time a precious idea: that all humanity is somehow together."[1] As sociologists and anthropologists have pointed out, Neruda was not far off: indeed, the act of gift-giving functions to define and cement social ties.

The French scholar Marcel Mauss made this revolutionary discovery in the first half of the twentieth century. Mauss's seminal essay, *The Gift*, focused on gift exchange as a total social phenomenon, one that involves religious, legal, moral, economic as well as aesthetic institutions simultaneously. Examining the exchange of gifts through both historical texts and living practice, Mauss understood a fundamental truth of gift-giving: while common sense may tell us that charity is a virtue and that gifts should be given for no motive other than the sheer pleasure of giving, this is contrary to actual practice.[2] Throughout the world and from earliest recorded history gifts have never been "free," even when they were unsolicited and unexpected. Each gift is part of a system of reciprocity in which the honor of the giver and the recipient is engaged. In other words, when we receive a gift, we feel obligated to the giver and that obligation creates a bond until it is fulfilled, generally when we give something in return. In response to a gift, the receiver can offer gratitude, delight, or a return gift of some kind.

When one person gives a gift to another, the bond that is created between the two individuals is a reciprocal one; one is indebted to the other. However, when an individual gives a gift to someone or to something, an institution such as a museum, for example, without the hope of obvious and immediate return, that gift creates a broader bond. Mauss's theory of gifts is actually a theory of human solidarity. In preindustrial economies, where money either did not exist as such or was insignificant for the acquisition of goods when compared to bartering or other forms of exchange, gift-giving followed prescribed and usually cyclical paths that served to solidify ties between the members of a group.

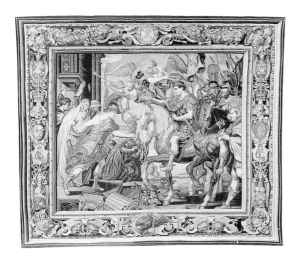

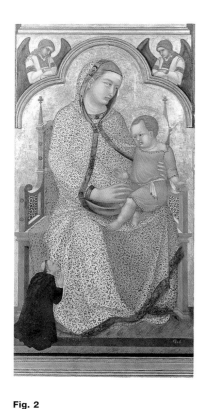

Subsequent anthropologists and sociologists have continued Mauss's initial work, expanding and refining his findings. But most concur, that when rare and valuable objects are given as gifts, their circulation engages people in permanent commitments that keep the social framework strong and stable.

In modern cultures, the flow of gifts functions alongside the flow of money for usable objects, but is distinct and different from it. While art objects can be bought and sold like any other commodity, art, by its very nature, falls outside of the traditional boundaries established for objects that we need for our day-to-day functions. Unlike the toothpaste or food or clothing that we consume and discard, art has a certain assumption of permanence built into it. Although art objects are made or defined as art for a variety of reasons, in contemporary practice they are most often defined by how they differ from everyday, consumable objects. Art objects occupy a special status in most cultures, and because of this status, they are often singled out as ideal gifts.

Royal or aristocratic patrons have often traditionally bestowed art gifts on people with whom they wanted a social or political connection. In India, as well as throughout Europe, painted and sculpted portraits were frequently exchanged among ruling classes to underscore political and matrimonial alliances.[3] Elaborate gifts of porcelain, silver, or tapestries were often intended to cement allegiance to the giver. Seven of the thirteen tapestries adorning the Philadelphia Museum's Great Stair Hall, designed by the Flemish artist Peter Paul Rubens, were given in 1625 by King Louis XIII of France to the papal envoy Cardinal Francesco Barberini (fig. 1). The tapestries, representing scenes from the life of Constantine, then believed to have been the first Christian Roman emperor, were clearly meant to be a sumptuous reminder of the monarch's largesse and lineage.

While this particular use of art to reinforce status and strengthen connections between ruling classes may not be surprising, it is interesting that an equally old tradition exists of giving art to "public" institutions. In fact, this tradition even predates the very concept of museums. For example, private individuals commissioned much of the art adorning the great cathedrals of Europe as an overt expression of piety and charity, virtues that were much celebrated. An ancient Vedic principle, that a sacrifice to a deity compels the deity to make a return gift, may well have been in effect with Christian donors as well.[4] The earliest donor portraits in European art, such as the one in the painting of the *Virgin and Child Enthroned* by Pietro Lorenzetti (fig. 2), often show donors as much smaller than the holy figures they accompany. But as the practice continued, giving rise in its wake to the new category of portraiture, donors eventually came to occupy more and more of the pictorial or sculptural space, as is clearly evident from the *Holy Family* by Dosso Dossi (fig. 3). Here, the man and woman who are the patrons of the work occupy the same space as the Virgin Mary, the baby Jesus, and the child Saint John the Baptist, and they are certainly more prominent than the shadowy figure of Saint Joseph in the background.

In fact, the act of giving away art may well predate and in most respects be a much more universal practice than the actual accumulation of art for personal gratification that we identify as art collecting. Historian Joseph Alsop identified a few cultures that had what he designated as "rare art" traditions, in other words, cultures in which certain classes of

objects have been designated as art and become ends in themselves, without regard to their function or use. He maintains that only when art is defined as an end in itself does art collecting per se come into being. Those cultures that manufacture beautiful objects for adornment or worship or status may trade or give those objects as gifts, but seldom accumulate them into "collections."[5] Alsop further distinguishes between art patronage and art collecting. Patrons of art commission art for a variety of reasons, but in such cases the art generally serves a clear function beyond its role as art. Collectors, on the other hand, "gather objects belonging to a particular category the collector happens to fancy; and art collecting is a form of collecting in which the category is, broadly speaking, works of art."[6] Alsop argues that while many cultures make beautiful objects that are both aesthetic and functional, the cultures that have rare art traditions—in other words, those in which art is collected and admired for its sole function as art—are the exception rather than the rule. When art is defined as such, as an end in itself, then several institutions follow as a natural by-product of this manner of thinking about art. These institutions include the art market, collecting, art history, and museums.

Collecting of objects of all kinds seems almost instinctive to human beings. Children begin with stones and shells and all kinds of found things, progress to stamps and trading cards and Beanie Babies. The essence of collecting in its many forms has always been the gathering of superfluous numbers of objects belonging to chosen categories, without the least need for so many objects or for the particular category, and often at great expense or even physical risk.[7] The literature on the phenomenon of object acquisition or collecting is vast. Modern theorists identify and explore a range of themes that characterize collecting as an intentional, but partly subconscious, activity. These themes include desire and nostalgia, saving and loss, and the urge to erect a permanent and complete system against the destructiveness of time.[8] Discussed by sociologists and anthropologists, collecting becomes a metaphor for the rampant individualism that characterizes Western, capitalist culture. Analyzed by psychologists, collecting is seen as a kind of fetishism, a displacement of affection from people to things. But despite the fact that collecting as a human impulse lends itself well to a broad range of study, or perhaps because of it, collecting as a basic human activity, and the collecting of art as a specialized activity under that broader umbrella, persist with gusto.

Collectors themselves often discuss their collecting habits in more prosaic terms than scholars. Art collectors frequently begin by citing a surprise encounter with a particular object or set of objects, which is in turn followed by deepening awareness coupled with intensified desire. While collectors talk about their collecting passions in ways that touch upon some of the themes in the critical literature—great attachment to and interest in a certain type of object, considerations for posterity, a wish to share the fruits of one's passions—they often do so in unselfconscious terms. Thus when Dr. Alvin O. Bellak, an avid collector of Indian painting, first became aware of himself as a "collector," he questioned the role that collectors play in the world of art. An art historian, Pramod Chandra, informed him that collectors are the preservers of the art. To this, Dr. Bellak responded with characteristic tongue-in-cheek irony: "Sounded good to me. Now I could look in the

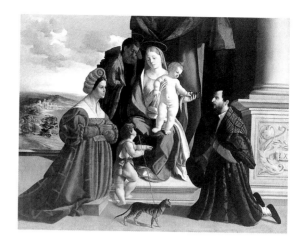

Fig. 3
Dosso Dossi
Italian, first recorded 1512, died 1542
The Holy Family, with the Young Saint John the Baptist and Two Donors
c. 1512–13
Oil on canvas
38 ⁷⁄₁₆ x 45¾ inches (96.7 x 116.2 cm)
John G. Johnson Collection. Cat. 197

mirror and say, 'There stands a preserver of the art.' That was a lot better than saying, as Freud would have it, 'There stands an anal retentive personality!'"[9]

Much less scholarship exists on the motivating factors that lead to the transfer of art from private hands to public collections. In general, the bequeathing of a collection insures that the collector's name as well as the record of his or her taste is inscribed in the history of the institution to which it is given. And, while many collectors acknowledge the attraction of having their name associated with that of a great institution, that in itself seems too abstract a concept to be fully credible. Compared to the very palpable attraction of buying and having art, the idea of giving art away for recognition alone does not seem like enough of a motivator to explain the prevalence, in modern society, for private art collections to go public. How then can we explain this phenomenon that is so essential to museums in the United States today: the generosity of private collectors that is the bedrock of the institution itself?

A partial explanation may found in the very essence of a collection of art. When an individual puts together a collection, that collection is greater than the sum total of its parts. It reflects that individual's taste. Each collection has a character or personality of its own that is based on the intentions and accidents of its formation. As such, it has both historical and biographical merit. The donation of an entire or a partial collection to a public institution safeguards its character.

All great museums are private collections made public, whether we think of the princely palaces of Europe transformed into palaces for the people, or the more prosaic American museums intentionally developed for purposes of civic pride and public enlightenment. From their inception, museums in America functioned on the assumption that private art purchases would, on the whole, eventually end up in public collections, thus celebrating communal prosperity.[10] In fact, much of the rhetoric that accompanies the foundation of art museums in the United States underlies the assumption that art has the power to instruct, inspire, and elevate—that these qualities are in a sense gifts that art can give to museumgoers.

Some have argued that art is a gift in a broader sense of the word. Common to the understanding of the meaning of gift is the notion that a gift is a thing we do not get by our own efforts. It cannot be bought or taken. Instead, it is bestowed upon us. Talent and inspiration, qualities that are often essential to the act of creating a work of art, are therefore not surprisingly often referred to as gifts. But more importantly, just as we often refer to the talents of the artist as gifts, the spirit of the artist's gifts can awaken the creative energies of the viewer. When a work of art moves us out of the humdrum of daily existence, we feel fortunate, even grateful, as if we had received a special gift.[11] Perhaps for this reason the necessity to share art, to make it broadly accessible, seems to go hand in hand with the making and collecting of art. By presenting art as a gift to the public, collectors complete the cycle of obligation that art itself begins.

Some collectors acknowledge this sense of necessity involved in giving their prized possessions away to public institutions like museums. Collector Alvin Bellak sees certain

inevitability in having private collections become public.[12] There is something about art that makes it want to be public. And, as noted, in cultures where the idea of art for art's sake exists, institutions such as museums are a natural by-product. As many modern philosophers and artists have pointed out, art is not art because of any intrinsic characteristics. Instead, art is a value assigned by people to certain categories of objects. At the Philadelphia Museum of Art, visitors are always reminded of this especially when viewing the work of Marcel Duchamp, an artist who capitalized on the mutability of the definition of art.

When art goes from private hands to public ones it undergoes a subtle but powerful transformation. As the object of private admiration it can be displayed, but it can also be bought and sold. It is still primarily property. But if art is in a museum, it goes from being property to being idea; in other words, its status as art is reinforced. Museums exist for the primary purpose of physically and symbolically representing art's "artness," that conceptual value that transforms mere things into art. The only function that art can serve in a museum is a visual one: we can admire, be inspired by, discuss, and consider the art in the museum setting. We cannot own, decorate with, and exchange the art in the museum. Furthermore, museums often create elaborate aesthetically powerful settings in which art objects resonate with one another and with the hearts and minds of visitors.

However, if in fact it is inevitable for art to go from private hands to public museums, this still does not explain the act of individual generosity that is required for a private collector to decide to give his or her valuable and cherished object to a museum. Such generosity, in a culture such as ours that emphasizes individuality and self-expression, can only be interpreted as an acknowledgment of social responsibility and of the connectedness between people. The gifts of art given to the Philadelphia Museum of Art are sacrifices of cherished personal possessions made in the interest of museum visitors time present and time future.

And what about these visitors? How are we as museumgoers and art lovers to reciprocate? Receiving a gift is not, as we have seen, entirely without its obligations. The formal display of gratitude to the giver is an institutional responsibility. The museum acknowledges the generosity of its donors in a variety of ways, but in particular by associating their names with their collections in some fashion. However, this does not seem like enough to fulfill the obligation. There is an implied obligation as well on the part of the museumgoer, the ultimate recipient of the gift of art. What then is expected of them? To answer this question, we return to the poet Pablo Neruda, whose receipt of an unexpected and unrequitable gift played a significant role in his decision to become a poet. Neruda writes: "To feel the love of people whom we love is a fire that feeds our life. But to feel the affection that comes from those whom we do not know, from those unknown to us, who are watching over our sleep and solitude, over our dangers and our weaknesses—that is something still greater and more beautiful because it widens out the boundaries of our being, and unites all living things."[13] In looking at and admiring the art objects that now grace public collections through the generosity of individual donors, we as viewers complete the cycle of exchange that is so natural a part of both gift-giving and art.

1. Quoted in Lewis Hyde, *The Gift: Imagination and the Erotic Life of Property* (New York: Vintage Books, 1983), p. 281.

2. Marcel Mauss, *The Gift: The Form and Reason for Exchange in Archaic Societies,* trans. W. D. Halls, foreword by Mary Douglas (London: W. W. Norton, 1990; reissued 2000).

3. In India these gifts were governed by elaborate codes developed to ensure the maintenance of proper distinctions in social status. See Darielle Mason et al., *Intimate Worlds: Indian Paintings from the Alvin O. Bellak Collection* (Philadelphia: Philadelphia Museum of Art, 2001), p. 14.

4. The Vedas are a body of sacred writings that came into being in the Indus Valley between 1500 B.C.E. and 400 B.C.E.

5. Joseph Alsop, *The Rare Art Traditions: The History of Art Collecting and Its Linked Phenomena, Wherever These Have Appeared,* Princeton University Press, Bollingen Series XXXV, 27 (New York: Harper & Row, 1982).

6. Ibid., p. 76.

7. Ibid., p. 71.

8. John Elsner and Roger Cardinal, eds., *The Cultures of Collecting* (Cambridge: Harvard University Press, 1994), p. 1.

9. Alvin O. Bellak, "Reflections of a Collector," in Mason et al., *Intimate Worlds,* p. xiii.

10. As historian Neil Harris points out, "museums legitimated the pursuit of private pleasure, suggesting that collecting goals and object accumulation were public benefactions" (Harris, *Cultural Excursions: Marketing Appetites and Cultural Tastes in Modern America* [Chicago: The University of Chicago Press, 1990], p. 136).

11. Hyde, *The Gift,* p. xii.

12. In conversation with the author, February 25, 2002.

13. Quoted in Hyde, *The Gift,* p. 281.

Catalogue

Authors

Dilys Blum	DB
Christa Clarke	CC
Donna Corbin	DC
Felice Fischer	FF
Beatrice B. Garvan	BBG
Martha C. Halpern	MCH
H. Kristina Haugland	HKH
Kathryn Bloom Hiesinger	KBH
John Ittmann	JI
Melissa Kerin	MK
Alexandra Alevizatos Kirtley	AAK
Shelley R. Langdale	SRL
Audrey Lewis	AL
Jack L. Lindsey	JLL
Darielle Mason	DM
Diane L. Minnite	DLM
Richard Ormond	RO
Ann Percy	AP
Adriana G. Proser	AGP
Suzanne Ramljak	SuR
Joseph J. Rishel	JJR
Susan Rosenberg	SR
Darrel Sewell	DS
Innis Howe Shoemaker	IHS
Michael Taylor	MT
Ann Temkin	AT
Jennifer Thompson	JT
Dean Walker	DW
Katherine Ware	KW
John Zarobell	JZ

Jar

Japan, Middle Jōmon period (2500–1500 B.C.)
Earthenware, height 14⅛ inches (35.9 cm)

Purchased with the Hollis Family Foundation Fund, the Henry B. Keep Fund, and the East Asian Art Revolving Fund. 1999-130-1

The Japanese ceramic tradition began more than ten thousand years ago during the Neolithic Jōmon period (10,500–300 B.C.). During this time Japanese potters created a variety of wares, often with distinct regional differences. This magnificent jar exemplifies the style that predominated in the central area of Japan's main island, Honshu, during the Middle Jōmon period (2500–1500 B.C.). Its type is called *Katsusaka*, after the archeological site in Kanagawa prefecture where pieces in this style were first unearthed.

The term *Jōmon* (cord-marked) is taken from the decorative technique found on the pottery of the time. Potters applied clay, which was rolled into long cord shapes, to the surface of their hand-built wares as a form of embellishment. On this jar the artist worked the clay cords up from the base along the cylindrical body in vertical lines that are capped by swirling loops. Along the upper part of the body, the potter applied a wide horizontal band of the spiraling cords, which look like waves rolling around the circumference of the jar. The wave motif continues at the top of the vessel, where the potter finished the rim with a thick, incised triple band that swoops up into open curls at the four corners, two of which have small, open-looped handles. The cord appliqué technique gives the piece an exuberant and lively quality that emphasizes its sculptural features.

This dynamic, three-dimensional form is a hallmark of the Middle Jōmon pieces found at the Katsusaka site, and the present piece is one of the finest extant examples of the style, making it an ideal addition to the Museum's collection. FF

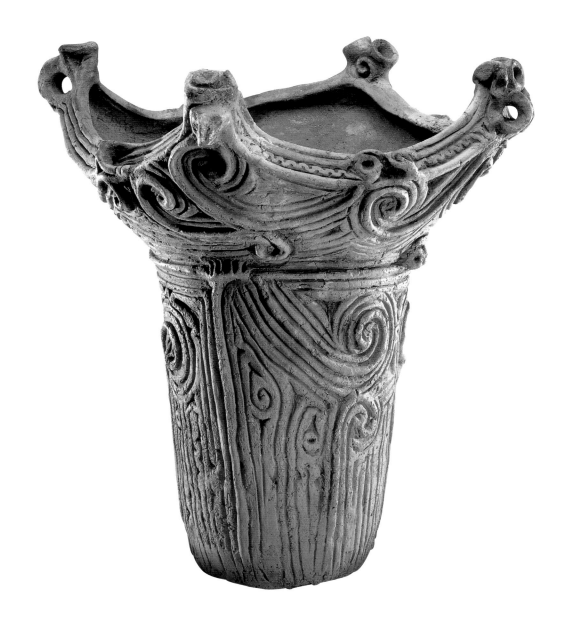

Cocoon Jar

China; Western Han dynasty (206 B.C.–A.D. 9), second century B.C.–early first century A.D. Earthenware with painted decoration, height 14 ¼ inches (36.2 cm)

Tomb Figures: *Mounted Lute Player* (left) and *Mounted Cymbal Player* (right)

China; Tang dynasty (618–907), late seventh–early eighth century. Earthenware with painted decoration, height 17 ⅝ inches (45.4 cm) each

Promised gift of Ann and Donald W. McPhail

Low-fired ceramic replicas of all kinds of creatures from the natural world and material goods from daily life, called *mingqi* in Chinese, were often interred with the dead in ancient China. Descendants of the deceased placed the wares in tombs for the gratification of and use by the relative's soul. The finest of the unglazed earthenware *mingqi* were delicately painted in a varied palette of bold colors. Three large, painted burial ceramics given to the Museum by Ann and Donald McPhail are strong complements to our excellent collection of glazed funerary figures from China.

The earliest of these pieces is a cocoon jar, named for the similarity of its form to a silkworm cocoon. The body of the vessel, shaped like an oval lying on its side, is supported by a small flaring base. It is decorated with seven sets of three incised lines that encircle the form at evenly spaced intervals. The surface is painted in red, orange, white, and black with a symmetrical cloud pattern *(yunwen)* derived from stylized dragon and bird motifs.

The other two *mingqi*, probably once part of a larger set, represent female equestrian musicians. They have beautifully made-up faces and wear black "basket hats" *(longguan)*, a kind of horsehair hat that extends down below the ears. The Tang-dynasty Chinese were fascinated by the concept of dressing up in the guise of others. These women don men's clothing, as one plays a lute and the other cymbals—instruments used to make the foreign-sounding music that was extremely popular at the Tang court. AGP

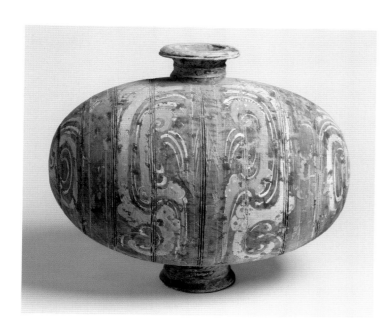

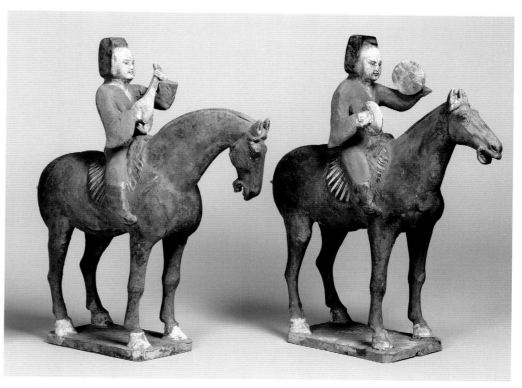

Two Musicians
From the sanctum door of the Chaturbhuj Temple
India, Rajasthan, Isawal; c. 990. Wood, height 14½ inches
(36.8 cm) each

Gift of Dr. David R. Nalin. 2001-212-1, 2

These small but exquisite musicians are of enormous importance for the history of Indian art as they antedate, by at least three centuries, all known woodcarving from either western or central India. Originally the sculptures formed part of an elaborate wooden double door that protected the sanctum of the Chaturbhuj Temple, a shrine to the god Vishnu, which still stands near the small town of Isawal, north of the city of Udaipur in the Rajasthan state. Although an old photograph shows these musicians in place, they were missing long before the doors themselves disappeared in 1987. Stylistic attributes combined with the evidence of nearby temples (datable by inscriptions) show that the Chaturbhuj Temple was erected around 990 A.D., probably under the auspices of the ruling Guhila dynasty. A comparison of the carving of these figures with the stone images on the temple proves that the same sculptors carved both.

The musicians, one playing the flute and the other a cylindrical drum, stand on lotus flowers that rise from foliage-filled pots. Holes remain in the top and bottom of each piece where they were once nailed to the lower third of the door, separated by recessed images of celestial women. The upper two-thirds of the door bore pierced geometric screens (*jalis*) held in place by an ornamental wooden framework. The lower portion, although within the same framework, mimicked the exterior walls of the stone temple with its alternating rhythm of projections and recesses. The figures themselves—with plump, soft bodies and square, full-cheeked faces—as well as the wide, fleshy leaved lotus pedestals, epitomize the stone-carving tradition of the southern Rajasthan region. Indeed, these pieces not only demonstrate the early sophistication of woodcarving in the area but also give crucial clues to ancient craft practice. DM

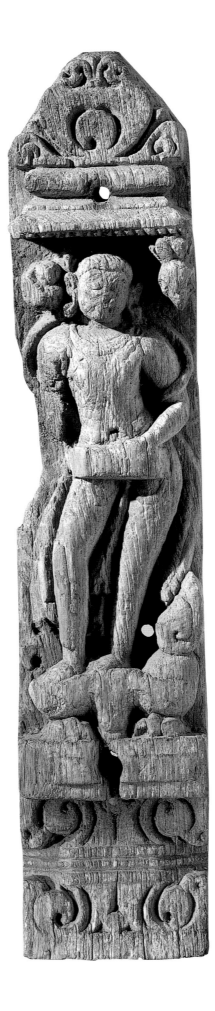
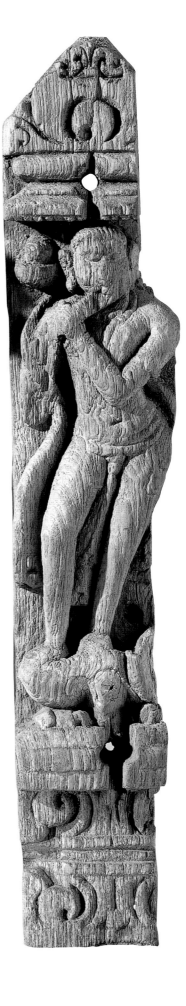

Harinegameshin Transfers Mahavira's Embryo

Page from a dispersed manuscript of the *Kalpasutra*
India, Gujarat or Rajasthan; c. 1300–1350. Opaque watercolor, ink, and gold on palm leaf; 2½ x 12 inches (6.4 x 30.5 cm)

Purchased with the Stella Kramrisch Fund and with funds contributed by the Committee on Indian and Himalayan Art in honor of Alvin O. Bellak on the occasion of the 125th Anniversary of the Museum. 2001-184-1

King Vajrasimha and Queen Surasundari in Conversation

Page from a dispersed manuscript of the *Kalakacharyakatha*
India, Gujarat; c. 1375–1400. Opaque watercolor, ink, and gold on paper; 2⁹⁄₁₆ x 9⁷⁄₁₆ inches (6.5 x 24 cm)

Alvin O. Bellak Collection (promised gift)

Before Muslims entering India from western Asia brought with them papermaking technology, ancient Indians often wrote out their religious texts on long, dried palm leaves. Thus these two pages, each bearing illustrations of exceptional delicacy and vigor, demonstrate a crucial juncture in the history of manuscript painting in India; one is actually painted on palm leaf, the other on paper.

Both pages were created for Jains, followers of one of India's most ancient religious traditions. The palm-leaf page is from the *Kalpasutra*, a canonical text that narrates the life of Mahavira, the most recent Jain savior-saint who lived during the sixth century B.C. The page itself depicts Harinegameshin, the goat-headed divine helper, placing the embryo of Mahavira into the womb of a woman from the ruling caste so that Mahavira might fulfill his destiny as temporal or spiritual sovereign. The paper page, which follows the horizontal palm-leaf format, is the first page of a manuscript of the *Kalakacharyakatha* (Legend of the Teacher-Monk Kalaka), and depicts Kalaka's royal parents engrossed in conversation.

Both pages are pierced by a hole located in the central red dot where string once bound together the stacked pages and their wooden covers. By the fifteenth century such bindings were becoming obsolete, although the colored dots long remained as reminders of the earlier form. Both pages also share stylistic similarities: the body parts of the wiry figures are rendered in a way that makes them most readable to the viewer; for example, the faces are drawn in profile but with both eyes in frontal view. The elaborately patterned textiles in both highlight the sophisticated block printing that made western India a renowned textile center even before the fourteenth century. Costly pigments, such as pure gold and ground lapis lazuli, were favored in these illustrations to increase the spiritual merit earned by the pious donors who contributed such sacred manuscripts to monastic libraries. DM

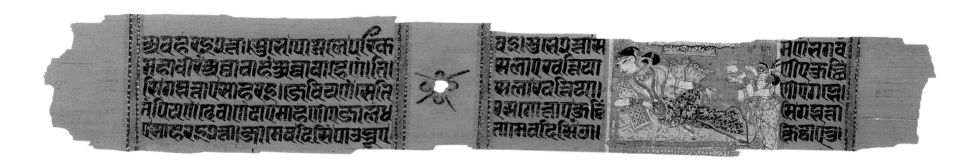

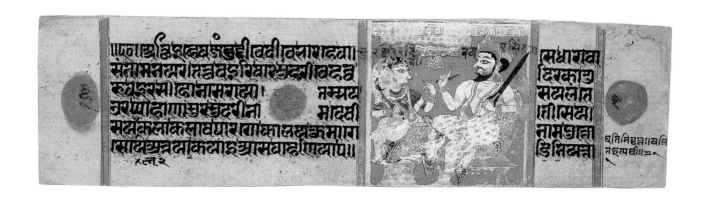

Eleven-Headed Avalokiteshvara, Lord of Compassion

Tibet, c. early fourteenth century. Copper alloy, silver-colored inlay, copper-colored inlay, coral, turquoise, lapis lazuli, and cold gold; height 20¾ inches (52.7 cm)

Purchased with the Stella Kramrisch Fund. 2001-90-1

Avalokiteshvara, the Bodhisattva of Compassion, appears here in his cosmic form with eleven heads and "one thousand" arms. The deity was introduced into Tibet from India in the seventh century and quickly became the most popular of all Buddhist beings. He even came to be considered the tutelary deity of Tibet, where he protects the world in the time between the departure of Shakyamuni Buddha, the historical founder of Buddhism, and the advent of Maitreya, Buddha of the Future.

The eleven heads rise upward in progressive manifestations of Avalokiteshvara, culminating with the fearsome face of a protector deity and, finally, the beatific head of the Eternal Buddha, Amitabha. The eight arms that are cast with the body once each held standardized attributes, although now only the jewel of enlightenment remains, concealed within the folded front hands. The fanlike halo of another thirty-four arms is separately cast and attaches to the body. Originally the entire composition would have also had an additional halolike back-piece depicting even more arms and an elaborate lotus-shaped base. Although ritual accretions, including a layer of gold pigment, now cover the sculpture, ornamental details abound. Not only are the crowns and jewelry inset with semi-precious stones, but silver- and copper-colored metal inlays embellish the garments and enliven the lower faces, while graceful foliate swirls decorate the garment folds.

This impressive sculpture is extremely rare in the preservation of two parts of its original four-part composition, which together with its large stature and exquisite modeling would be enough to make it a significant acquisition for the Museum. However, its identity as a complex form of the Bodhisattva Avalokiteshvara also enriches the collections by complementing the Museum's superb and important images of this primary Buddhist deity from other Asian regions, including India, Cambodia, and China. DM

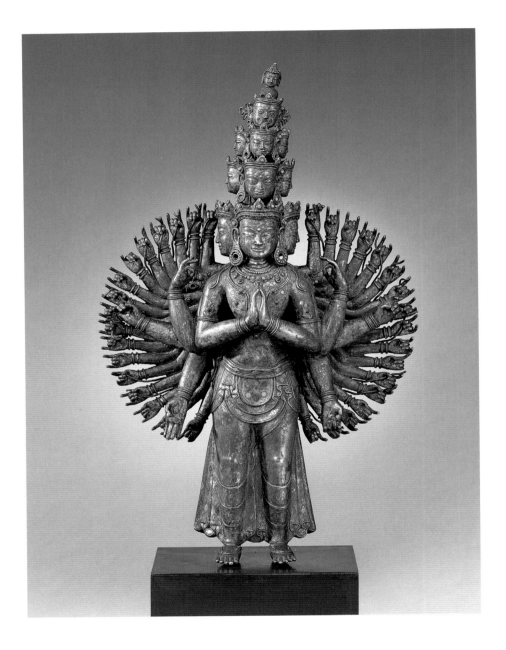

Left to right:

Wine Ewer
Korea; Koryo dynasty (918–1392), twelfth century. Glazed porcelain (celadon) with underglaze iron decoration, height with lid 7¾ inches (19.7 cm)

Square Mirror
Korea, Koryo dynasty (918–1392). Bronze, 4⅝ x 4⅝ inches (11.7 x 11.7 cm)

Jar
Korea; Chosŏn dynasty (1392–1910), early twentieth century. Glazed porcelain (white ware), height 10 inches (25.4 cm)

Water Dropper
Korea; Chosŏn dynasty (1392–1910), eighteenth century. Glazed porcelain (white ware), height 4 inches (10.2 cm)

Flask
Korea; Chosŏn dynasty (1392–1910), sixteenth–seventeenth century. Porcelain with underglaze iron decoration, height 7½ inches (19.1 cm)

Lidded Pedestal Dish
Korea, Silla period (57 B.C.– A.D. 935). Stoneware, diameter 5¾ inches (14.6 cm)

Gift of Colonel Stephen McCormick in honor of the Korean Heritage Group. 2000-80-5; 2001-134-12, 2; 2000-80-11; 2001-134-3, 8a, b

Among the highlights of an impressive group of Korean art, primarily ceramics, given in honor of the Museum's 125th Anniversary by Colonel Stephen McCormick are a number of Koryo dynasty celadon wares, including this melon-shaped wine ewer with underglaze iron motifs. The jade-colored glaze of the celadon ceramics was admired by contemporary Chinese and Japanese aficionados, and the wares themselves were among the prized possessions of early Western collectors of Korean art.

The ceramics of the Chosŏn dynasty made in kilns located in the same southwestern part of the Korean peninsula, are quite different in character from the celadons. A large jar with an irregular splash of blue glaze is an unusual example of Chosŏn-dynasty white ware made in the early twentieth century. In other examples such as this flask or a dragon vase (see checklist no. 11), the underglaze iron or cobalt blue decorations on white clay are covered with a clear glaze and reveal continental Chinese influence in their forms. The peach shapes and landscape decoration on a group of small water droppers for a scholar's desk similarly reflect the taste of the Chinese literati.

This gift is remarkable for its variety and depth as a survey of Korean ceramic production, effectively doubling the Museum's holdings. Also in the donation are paintings, including an important eight-panel screen of the famous subject *General Guo Ziyi's Banquet,* and the first two bronze mirrors from Korea to enter the collection, one of which is illustrated here. FF

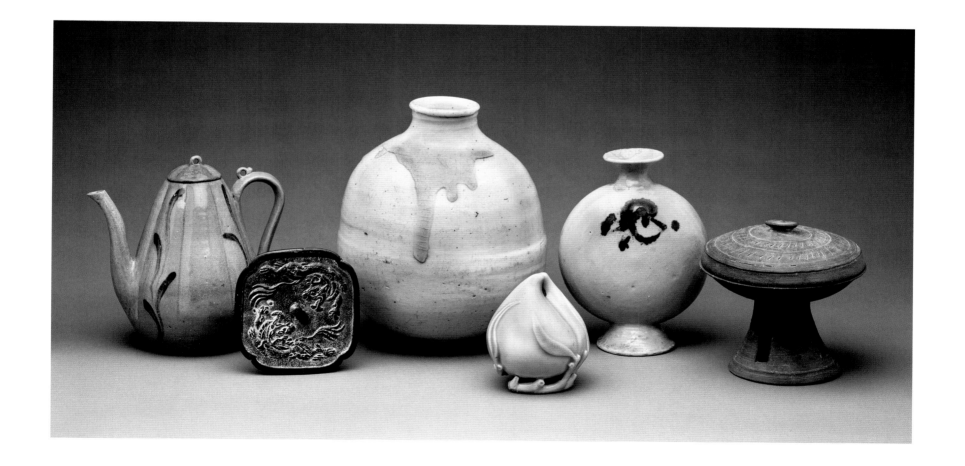

Israhel van Meckenem
German, 1440/45–1503
Self-Portrait with His Wife, Ida
c. 1490. Engraving, sheet 5¼ x 7 ⅟₁₆ inches (13.3 x 17.9 cm)

Gift of Suzanne A. Rosenborg. 2002-59-1

In the late 1400s, when the faceless artisan was beginning to shed the anonymity of the medieval guild system, a Latin caption beneath this double portrait proudly proclaimed the identities of the sitters as "Israhel and his wife, Ida." Not only are these the earliest engraved portraits of known persons, but Van Meckenem's own likeness is the first self-portrait by a printmaker.

Engraving emerged as a new method for making pictures in towns along the Upper Rhine in the 1430s as goldsmiths began to ink and print their incised designs as workshop patterns. Around 1490, when he made this print, Van Meckenem was the most successful engraver in German-speaking lands and was producing a wide variety of printed wares, ranging from playing cards and scenes of wooing to sacred images and religious indulgences.

In addition to disseminating distinctive regional styles of painting, architecture, and design, engravings also efficiently conveyed the latest fashions. For his portrait Van Meckenem has donned a soft felt cap and simple tunic, while his wife has chosen an elegant fur-trimmed dress and crisp linen headdress, which she has fastened neatly with a pin below her dimpled chin. The rich brocade backdrop is of the sort often encountered in the finest paintings during this period. As moderately priced luxury goods, such engravings must have been printed by the dozens and quickly purchased by all who could afford them, but few survive today. Of the ten known impressions of Van Meckenem's masterful portrait print, a landmark in the history of Western art, this pristine example is one of the very best. JI

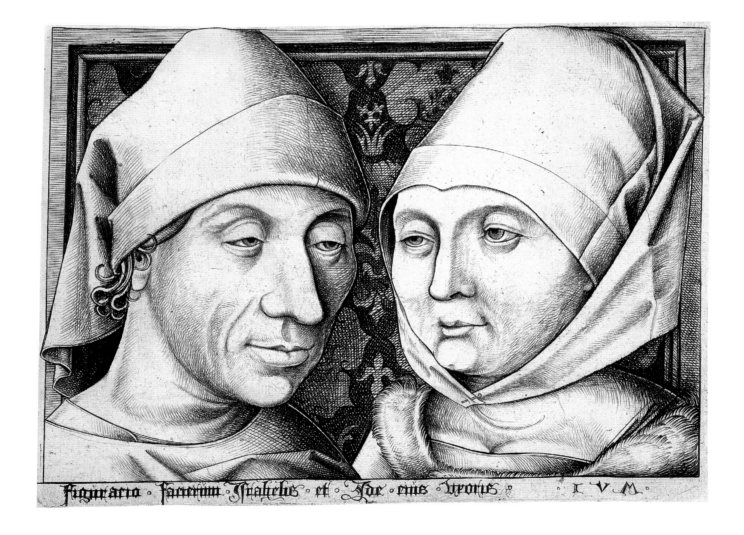

Apostle, probably *Saint Judas Thaddeus*
Southern Netherlands or northeastern France, c. 1450–60
Alabaster, height 13 9/16 inches (34.5 cm)

*Purchased with the John D. McIlhenny Fund and with
funds bequeathed by Carl and Joan Tandberg
1999-131-1*

This figure belongs to a series of statuettes representing Jesus and the twelve apostles, most of them now preserved in the Metropolitan Museum of Art in New York. The alabasters were certainly conceived as components of a structure in a church interior. Their shallow depth and flat backs could point to an original placement in individual niches, possibly in an altar decoration. For works of art created in the fifteenth century, the precise identification of some apostles can be complicated since the attributes they hold have been assigned to more than one figure. This saint with a club is most likely Saint Judas Thaddeus, also known as Jude the Apostle or Saint Thaddeus. Although all the figures in the series seem to commune with their respective attributes, this is the only one to embrace the instrument of his death with complete absorption, a compelling image of the intensity of religious devotion from the late Middle Ages.

The sculpture contrasts with the roughly contemporary large-scale painted wood Crucifixion group from the Museum's George Grey Barnard Collection. Even as an isolated figure, this diminutive apostle is a work of greater refinement and emotional expressiveness. In the fifteenth century, famous painters like Jan van Eyck are known to have designed sculpture, and they frequently imitated sculpture in grisaille paintings. Examples of simulated statues of Mary and the angel of the Annunciation appear on the wings from a triptych by Jan Provost in the Museum's John G. Johnson Collection. Such paintings have long been studied by scholars and loved by the public. The statuette of Saint Judas Thaddeus is an eloquent reminder of the still-obscure achievements of Netherlandish sculpture from the same period. DW

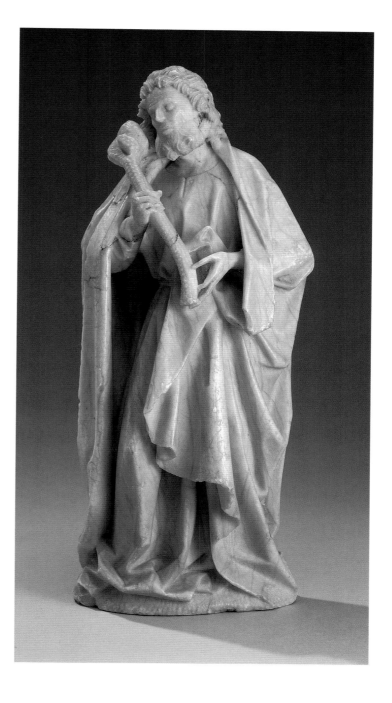

Left to right:

Francesco Durantino
Italian, active Urbino and elsewhere, documented 1543–47
Bowl and Lid, from a Childbirth Set
Mid-1540s. Tin-glazed earthenware; bowl diameter
6 15/16 inches (17.6 cm), lid diameter 8 3/4 inches (22.3 cm)

The Howard I. and Janet H. Stein Collection. 2000-154-4, 5

Cradle
Italy, Tuscany, perhaps Florence; c. 1570. Walnut with
remains of gilded and painted decoration, height 35 inches
(88.9 cm)

Purchased with the John D. McIlhenny Fund. 2000-117-1

Workshop of Orazio Pompei
Italy, Castelli; c. 1510/20–after 1590
Spouted Pharmacy Jar
c. 1540–50. Tin-glazed earthenware, height 10 5/16 inches
(27 cm)

Workshop of Guido Durantino
Italy, documented 1516–76
Plate with Apollo and Daphne
1535. Tin-glazed earthenware, diameter 10 5/16 inches
(26.2 cm)

The Howard I. and Janet H. Stein Collection (promised gift)

At the time of its acquisition by the Museum, the Stein Collection was distinguished as the finest private holding of Italian Renaissance maiolica in the United States. The seventy-one pieces, dating primarily from the 1500s, represent a number of the principal centers of ceramic production in Italy, including Deruta, Montelupo, Urbino, Castel Durante, Pesaro, and Venice. While the Museum has acquired maiolica over the years—including a few outstanding master-pieces—its holdings were markedly incomplete. The gift of the Stein Collection enables the Museum to present an important selection of maiolica worthy of international attention (see checklist no. 39).

Among the strengths of the Stein pieces are the *isto-riato*, or "narrative," wares. These are the first European ceramics since antiquity to treat complicated figurative

compositions that mostly illustrate dramatic moments from ancient history or mythology. One notable plate is this example depicting the tale of Apollo and Daphne; it was created in the Urbino workshop of Guido Durantino, the founder of an important dynasty of ceramic artists.

Another specialty of the Stein Collection is the large group of ingeniously decorated drug jars ordered for pharmacies. One of the most striking examples of these wares is this dragon-spouted jar from Castelli, which held a syrupy tonic intended to strengthen the immune system and ward off the plague.

Early on, the Steins were attracted to the range of ceramics created for daily use, including the stacking table services presented to women recovering from childbirth. Shown here are two of the very finest of these rare pieces, made by the peripatetic artist Francesco Durantino, who painted them with domestic interiors rich in engaging detail.

Increasing affluence in Italy and the refinement of manners encouraged the development of many kinds of decorative household objects aside from ceramics. Related to the childbirth pieces is this cradle, which was intended for everyday use by a family of some importance, as indicated by the presence of three coats of arms. Although the basic form is traditional, it is transformed by a variety of ornamental designs that embellish its surface. While a few such pieces survive, a very good comparison for the Museum's example appears in a fresco from around 1565 of the birth of the Virgin by Siciolante da Sermoneta in the chapel of San Tommaso ai Cenci in Rome. DW

Purnabhadra, King of Vaishravana's Attendants

Tibet or China, c. late fifteenth or early sixteenth century
Gilded copper alloy with turquoise, height 8¼ inches
(21 cm)

Partial and promised gift of Hannah L. and J. Welles Henderson. 2001-44-1

Purnabhadra (Abundant Good) is a king of the *yakshas*, who, in Buddhism, are the eight attendants of Vaishravana, the lord of wealth and guardian of the Buddhist teachings. Purnabhadra carries in his right hand a water pot brimming with foliage, an ancient symbol of abundance and prosperity. In his left hand he clutches Vaishravana's common attribute, the mongoose vomiting precious jewels. He is outfitted as a Chinese warlord with mustache, pointed-toe boots, and a helmet in the form of a *makara*, a crocodilian sea creature. Purnabhadra rides a proud horse on whose long nose rests a giant gem. The horse prances upon golden swirls of clouds, seemingly unsupported above the lotus-flower base.

This sculpture, which is fully gilded and inset with cabochon-cut turquoises, may have been made in Tibet proper or in more northerly parts of China. It is of a type often called Sino-Tibetan, since during this period artistic forms and Buddhist beliefs were shared across the region. The elegance of the modeling together with the imaginative and finely cast details makes this work a masterpiece of Sino-Tibetan metalwork. The image and base reinforce a dating to the late fifteenth or early sixteenth century, making it the earliest Sino-Tibetan piece in the Museum's collection. The superb workmanship enhances appreciation of this significant convergence of artistic form in Tibet and China. DM

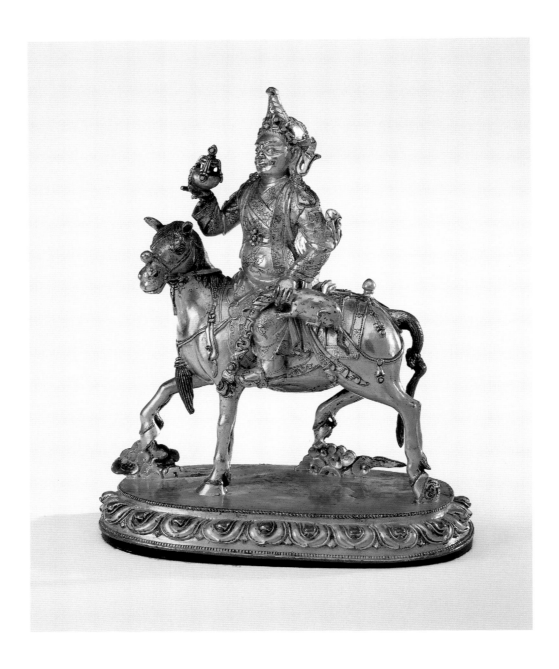

Vaishravana, Lord of Wealth

Tibet, late sixteenth–seventeenth century. Gold ground with opaque watercolor on cotton, 44½ x 28⅞ inches (113 x 73.3 cm)

Promised gift of John and Berthe Ford

The symbolic function of the Buddhist deity Vaishravana, protector of wealth and the Buddhist teachings, is appropriately combined with the literal expression of wealth in this magisterial gold *thangka*, or Tibetan scroll painting. Gold *thangkas* are uncommon since they are very expensive to make, especially in such a large size. The background of this painting is covered with paint made of pure ground gold mixed with rabbit-skin glue, which was then burnished to give the effect of solid gilding. Over the gold ground the figures are painted with flowing red outlines, their facial features and hair further defined with green, yellow, black, white, and red natural pigments.

The subtle use of color is evident on the deity's corpulent body as he sits astride a ferocious lion with green mane and tail. Vaishravana holds a victory banner in his right hand—symbolizing his conquest over defilement—and carries a jewel-producing mongoose in his left. The colorful, round jewels emanating from the mongoose's mouth collect on the base of the lotus pedestal that supports these central figures. Vaishravana's fierce, stern countenance and his armor-clad body make him a formidable character, appropriate for a worldly guardian who has taken an oath to protect the Buddhist teachings. Framing the regal and voluminous Vaishravana is a nimbus containing traditional offerings such as jewels and jewelry, rhinoceros and elephant tusks, and coral.

Immediately surrounding the central figure are his eight mounted attendants, known as *yakshas*. Like him, each is dressed in full armor and holds a jewel-producing mongoose in his left hand. Purnabhadra rides at the lower left and can be identified by the water vase he holds. Around these eight attendants are several fierce images of Vaishravana both standing and sitting on lotus pedestals. At the bottom appears an animated pair of dancing skeletons known as *chitipati*, which serve to protect riches from theft.

This painting's preoccupation with wealth may seem uncharacteristic of Buddhism, but worldly goods are vital to Buddhist practice, for without them patrons could not appropriately provide their monastic community with the financial support and materials necessary to carry out the ritual practices that are essential to maintaining the order of the cosmos. This deity, therefore, is not propitiated for material abundance alone but also for spiritual prosperity and well-being.

This large-scale *thangka*, with its unique gold-ground style, is the first of its type to join the Museum's Himalayan collection, and enhances our holdings of paintings and sculptures dedicated to Vaishravana and his entourage. MK

Mahasamvara Kalachakra Mandala

Central Tibet, c. first half of the sixteenth century
Opaque watercolor on cotton with silk framing; painting
with mount 33 x 22 ½ inches (83.8 x 57.2 cm)

Purchased with the Stella Kramrisch Fund. 2000-7-1

This intimately sized *thangka* (Tibetan scroll painting) displays the rarely painted Mahasamvara Kalachakra mandala, which represents a divine cosmos in which particular Tibetan Buddhist deities reside. By meditating on this colorful and minutely detailed *thangka*, devotees can accurately visualize the process of entering the sacred space in order to move inward toward the deity couple at its center. The worshiper's ultimate goal is to merge with these deities and thereby assume their enlightened qualities.

At the top and bottom of the painting a row of pillared arches encloses the seated figures, who represent the teachers and monks who introduced and passed on this form of Buddhist teaching. The mandala's outermost rings feature multicolored fire and cremation grounds, complete with bones and vultures. They represent the states of ignorance that a devotee must transcend before gaining access to the more powerful, inner reaches of the divine cosmos. The circle of eight elaborately decorated gates lead to the subsidiary deities, protector figures, and ritual offerings, all of which serve to protect and sustain the deities residing at the center. The central couple is in wrathful form, their formidable expressions warding off obstacles on the spiritual path. The three-headed, multicolored male deity carries numerous ritual implements in his twenty-four arms. While standing in a broad, strong posture he holds his consort against him in sexual and spiritual union. Yellow in color, she tilts her head back to look up into his face as she wraps her right leg around his torso.

This *thangka*, with its vivid colors, symmetrical composition, and sharply observed details, represents the Ngor style that developed in central Tibet in the fifteenth century. Such a masterfully painted and well-preserved example is a wonderful addition to the other *thangkas* in the Museum's Stella Kramrisch Collection. Indeed, it was on Kramrisch's advice that the former owner, John Hafenrichter, purchased the piece in 1961. MK

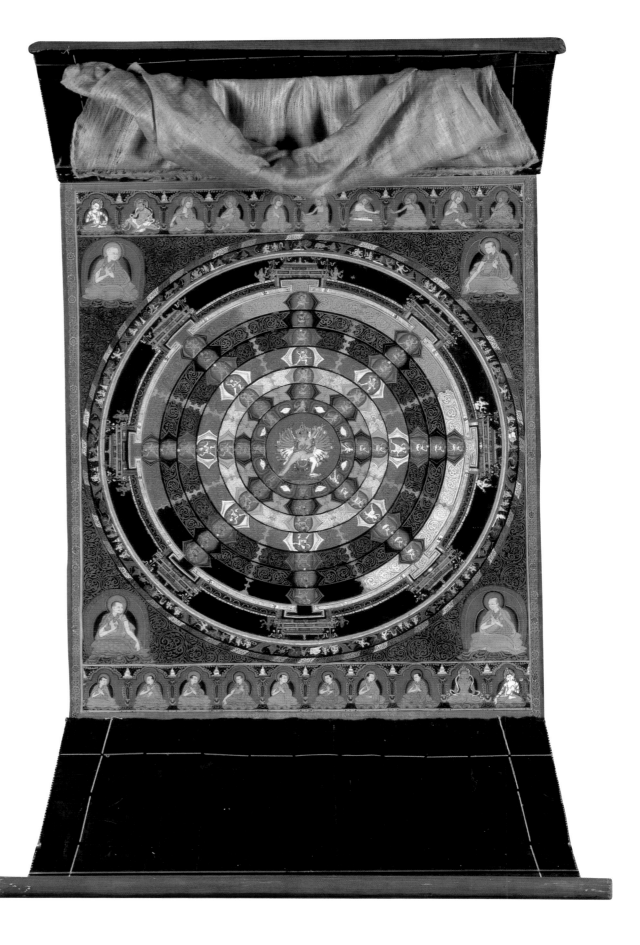

Dish

Vietnam, fifteenth–sixteenth century. Stoneware with underglaze cobalt decoration, diameter 13½ inches (34.3 cm)

Purchased with funds contributed by Warren H. Watanabe and the George W. B. Taylor Fund. 1998-148-1

Vietnamese potters are believed to have been introduced to Chinese ceramic wares with cobalt blue underglaze during the fourteenth century. Like the Chinese, the Vietnamese had two distinct levels of ceramic production. The great mass of wares had simple designs and were manufactured for everyday use. A second group, comprised of large, impressive vases and dishes with elaborate, finely painted decoration, was created for wealthy consumers both at home and abroad.

This beautifully potted dish, with its complex foliate rim and deep cavetto, is an excellent example of the rare, large-scale wares made for the upper class. It is the finest piece of Vietnamese ceramics that the Museum has acquired to date. The delicate landscapes of the four seasons are encircled by three bands of cloud and lotus-petal motifs, all painted in a deep purplish-blue. The glaze is unusually thick and lustrous, emphasizing the rich color of the decoration. The underside is treated with the chocolate brown wash that is characteristic of many Vietnamese ceramics. These high-quality wares were much admired and became popular items of trade with Japan, the Middle East, and Europe from the sixteenth through the eighteenth centuries. The bits of barnacle that adhere to the underside of the dish are evidence of its presence on a shipwrecked boat that once carried the wares for trade overseas. AGP

Attributed to **Kanō Motonobu**
Japanese, 1476–1559
Tiger (left) and ***Dragon*** (right)
Muromachi period (1392–1573), late fifteenth–early sixteenth century. Ink on paper, mounted as hanging scrolls; 33¼ x 21¾ inches (84.5 x 55.2 cm), 33¼ x 17¼ inches (84.5 x 43.8 cm)

Purchased with the Edith H. Bell Fund, the Edward and Althea Budd Fund, the Hollis Family Foundation Fund, the J. Stogdell Stokes Fund, and the East Asian Art Revolving Fund. 2000-114-2,1

This pair of scrolls bears the seal of Kanō Motonobu, Japan's leading master of ink painting, who enjoyed a long and successful career. He was the son of Masanobu, the founder of the Kanō school, whose successors carried on the traditions of the Kanō painting style for over five centuries. Motonobu succeeded his father as head of the Kanō family and brought the atelier to prominence.

The tradition of pairing the dragon and tiger dates to at least the Chou dynasty (c. 1050–256 B.C.) in China. The creatures represent two of the cardinal directions, east (dragon) and west (tiger), and were also associated with the yin and yang, darkness and light, water and earth principles of Taoism. In Buddhist terms, the tiger came to symbolize solitary enlightenment, and the dragon the spreading of the doctrine.

In these paintings Motonobu showcased his virtuoso brushwork. The tiger, hunched over and looking back warily at something beyond the bamboo beside him, is masterfully depicted. Every strand of fur is brushed with a sharp, thin stroke, and one senses the sinuous muscles beneath his coat. Early Japanese portrayals of tigers such as this one, with all their strength and ferocity, are closely modeled on Chinese ink paintings. Despite the slight red wash employed for the tongue, Motonobu's tiger does not have the soft, kittenlike features of later Japanese examples.

The painting of the dragon is a tour de force. Motonobu uses the dark background of night associated with the mythical creature to best advantage. The dragon flies down from the upper edge of the scroll, half-hidden by the rain clouds dripping into the waves below. The dark ink wash under and over the dragon gives the surface a vivid, wet look, as if the ink were still drying.

The contrast between the tiger and dragon is dramatic and memorable. The depictions reflect the skills of a master who was justly revered in his own lifetime and through the centuries to the present day. FF

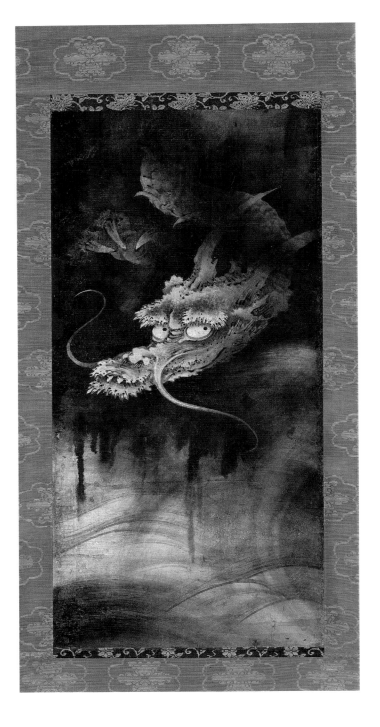

Vase

Japan; Muromachi period (1392–1573), sixteenth century
Negoro lacquer, height 10 inches (25.4 cm)

*Purchased with the Hollis Family Foundation Fund
2001-181-1*

Hand Drum

Japan; Momoyama period (1568–1615), seventeenth
century. Kōdai-ji *makie-e* lacquer, height 10 inches (25.4 cm)

*Purchased with funds contributed by the Mary Livingston
Griggs and Mary Griggs Burke Foundation, The Annenberg
Foundation, Priscilla Grace, Colonel Stephen McCormick,
the Honorable Ida Chen, Mr. and Mrs. Gary Graffman,
Hannah L. and J. Welles Henderson, and other donors
in honor of the 125th Anniversary of the Museum*

These two spectacular objects, acquired in honor of the 125th Anniversary of the Museum, showcase the two major types of Japanese lacquerware made in the sixteenth and seventeenth centuries, *negoro* and Kōdai-ji *makie-e*.

The Japanese term *negoro* is taken from the Negoro-ji Temple in Wakayama Prefecture, where priests made the distinctive wares for their own daily use from the thirteenth century onward. The lacquers were originally intended to be simple monochrome red, but with repeated handling the surface layer was gradually worn away, revealing the black lacquer beneath. The effect of the irregular patches of black contrasting with the red gained popularity outside temple circles, and later the wares were deliberately buffed down to give the "worn" effect. The form of this elegant vase is derived from a metal or ceramic prototype. Its totally unadorned surface accentuates the beautiful shape and the subtle effects of the red and black lacquer. While this vase may have been made for a temple, its unusual shape and excellent condition suggest that it was owned by a tea aficionado, who would have used it to serve wine to his guests at the *kaiseki* meal during tea ceremonies.

Kōdai-ji *makie-e* lacquer also takes its name from a temple, the Kōdai-ji in Kyoto, where the decorative technique known as *makie-e* (sprinkled picture) was featured prominently. On this small hourglass-shaped hand drum *(kozutsumi)*, the lacquer artist has created a bold design of pear leaves and fruit in varying shades of gold against a deep black background. The outlines of the fruit appear in thin gold lacquer lines, and the motifs are filled in with a light dusting of gold powder *(makie-e)*. The simplicity and clarity of the design make this small hand drum seem much larger than it actually is. FF

Celestial Dancer

Nepal, probably Bhaktapur; c. mid-fifteenth century
Wood with polychrome, height 43½ inches (110.5 cm)

Purchased with the Stella Kramrisch Fund. 2000-7-4

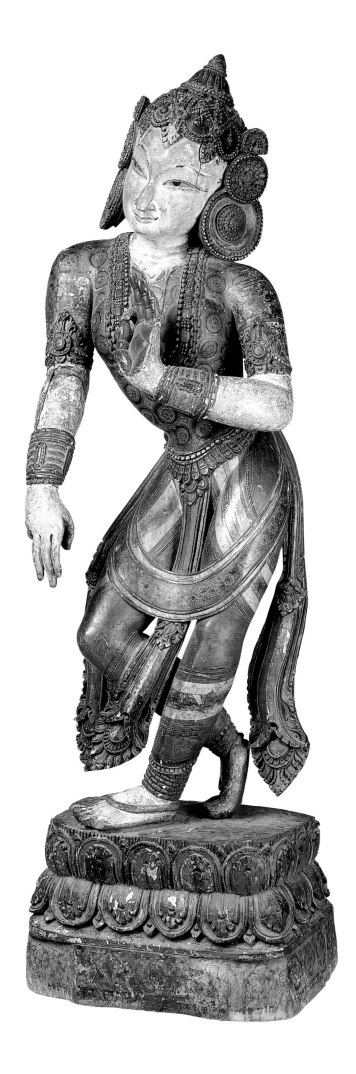

Wood is a significant medium in Nepalese sculpture and architecture. This graceful image of a standing female dancer not only is a superb example of the woodcarver's art but also retains an extraordinary amount of the polychrome decoration. The sculpture probably once formed a pair with another, and the mirror-image figures most likely would have flanked a larger, central deity.

The dancer sways in *tribhanga*, or triple-bend position. She crosses her right leg behind her left, both slightly bent, with right foot raised. Her left hand is held up, palm outward, with thumb and forefinger meeting in a dance posture indicating benediction, while her right hand hangs downward, palm toward her knee, in *gajahasta* (the elephant-hand position). The skin of her face, arms, and feet is white, creating a stark contrast with the bright red henna on the palms of her hands and soles of her feet. She wears a closely fitting, short-sleeved red upper garment marked with green and white roundels, which differs from the striped pattern of her lower garment and floral sash looped from hip to hip. Three pieces of fabric fall from her pearl and petal belt, each ending in a pointed half-flower motif common in the sculpture and painting of fifteenth-century Nepal. Around her neck she wears a series of chains; wide bangles and upperarm bands adorn her wrists and arms; and large doublecircle earrings topped by leonine *kirtimukhas* (faces of glory) in half-beaded circles frame her face. Her hair is covered with a beaded net and topped by a lotiform headpiece. She has the wide eyes that were typical of the period, especially for subsidiary sculptural figures, a delicate mouth, and a generous but elegant highbridged nose.

With its sharp features yet flowing form and its rich colors, this exceptional sculpture embodies the characteristics of contemporaneous scroll painting from Nepal and central Tibet, one of the strengths of the Museum's Himalayan collection. DM

Votive Plaques

From a set of the Thirty-six Immortal Poets
Japan; Edo period (1615–1868), 1698. Ink and colors on
wood, height 19½ inches (49.5 cm) each

Promised gift of Dr. Luther W. Brady, Jr.

Ema, the Japanese term for such votive plaques, literally means "horse picture," because they were used from the eleventh century onward as gifts meant to substitute for the actual horses traditionally offered to Shinto shrines. The practice of giving *ema* to shrines and then temples became popular throughout Japan, and eventually artists introduced subjects other than horses. The plaques were usually hung under the eaves of the shrine or temple buildings, so that few *ema* from the early periods have survived the wear of time and the elements. These three examples are from a complete set of thirty-six votive plaques of poets, most likely commissioned for a shrine or temple by a wealthy donor, that is a rare example of its type.

Poetry and poets have been highly revered in Japan for over a thousand years. The works of famous poets were collected in imperially commissioned anthologies as early as the tenth century. By the twelfth century, imaginary portraits of the poets, made by and for the aristocracy, were painted on paper or silk. The most popular of these paintings depicted a group known as the Thirty-six Immortal Poets (*Sanjūrokkasen*), who were selected from among favorite poets of the past. The practice of portraying these illustrious individuals on *ema* dates to the thirteenth century. The best-known example still surviving in Japan is installed in a small building called *Shisendō* (Hall of Poets) in Kyoto and dates to the 1640s.

The Museum's set is painted on cryptomeria wood, and the reverses of the plaques are inscribed with the date Genroku 11 (1698). Each poet's portrait is accompanied by one of his (or her) verses brushed in calligraphy, which is sometimes quite faded, with only traces of the original thirty-one-syllable poems remaining. FF

Ogata Kenzan
Japanese, 1663–1743
Set of Five Dishes
Edo period (1615–1868), late seventeenth–early eighteenth century. Glazed stoneware, diameter approximately 5½ inches (14 cm) each

Purchased with funds contributed by Marguerite and Gerry Lenfest, Maxine and Howard H. Lewis, Maude de Schauensee, Alexandra Q. and Fred C. Aldridge, Jr., and other donors in honor of the 125th Anniversary of the Museum. 2002-75-1–5

While Ogata Kenzan was also active as a painter of fans and scrolls, he is primarily known for his ceramic wares. He usually did not make the pottery itself, but instead used blank pieces to paint his designs. The ceramic surfaces served as Kenzan's canvas, on which he brushed motifs in cobalt blue, iron brown, and white slip. He then applied a transparent glaze and fired the pieces at a high temperature, giving his stonewares a smooth, rich luster.

The small dishes called *mukōzuke* were used for serving food, often fish, during the meal accompanying a tea ceremony. They were made in sets of five and occasionally ten. One of the charms of these dishes is "uncovering" the design as the food is eaten, and this feature is especially evident in Kenzan's wares. The design of pampas grasses *(susuki)* is a popular theme among Japanese artists and is often the subject of poetry associated with autumn and the transitory nature of this world. It has been suggested that the popularity of the pampas-grass motif after the seventeenth century was inspired by the cover designs of the *Saga-bon* (*Saga*-text libretti) by Hon'ami Kōetsu.

Kenzan exploits the rounded edges of the dishes to the fullest, extending the blades of grass over the edges of the pieces and around to the outside, spilling over in wind-swept profusion. The "Kenzan" signature appears on the underside of each dish in brown iron oxide. From the style of the signature, this set can be dated to Kenzan's work of the early eighteenth century. According to an inscription on the fitted storage box, the dishes were handed down in the Kōnoike family, who were merchants in the city of Osaka.

Surviving complete sets of *mukōzuke* dishes by Kenzan are rare, and this group of five is an extremely significant addition to the Museum's collection of Edo period ceramics. FF

Hon'ami Kōetsu

Japanese, 1558–1637

Poems from the *Shinkokin wakashū*

Edo period (1615–1868), early seventeenth century
Ink, gold, and silver on paper; 1 foot, 1⁵⁄₁₆ inches x 27 feet,
3 inches (3.4 x 8.3 m)

*Purchased with funds contributed by the members of the
Committee on East Asian Art in honor of the 125th
Anniversary of the Museum. 1999-39-1*

Hon'ami Kōetsu, a central figure in Japanese art at
the turn of the seventeenth century, brushed the
elegant calligraphy on this over twenty-seven-foot-long
scroll. Throughout his lifetime, Kōetsu collaborated
with other outstanding artists to breathe new life into
traditional art forms. He revolutionized the visual
effects of classical poetry scrolls, working with artists
such as Tawaraya Sōtatsu to produce striking designs
that complemented his distinctively bold calligraphy.

This scroll features twelve poems—all on the sub-
ject of love and written in the traditional thirty-one-
syllable format—from the early thirteenth-century
imperial poetry anthology *Shinkokin wakashū* (New
Collection of Japanese Poems from Ancient and
Modern Times). The designs beneath the calligraphy
depict gold- and silver-printed motifs of ivy, *mehishiba*
grasses, and wisteria on nine sheets of paper dyed
blue, pale pink, yellow, and cream. The papermaker
Kamishi Sōji has stamped his rectangular seal at every
other join of the paper on the reverse of the scroll,
which also shows a random pattern of butterflies
stamped in silver and gold. Kōetsu's transcription of
the twelve verses shows his characteristic variations
of dark and light ink, and broad and fine brush-
strokes, along with a scattering of the words among the
grasses, which provide lovely, irregular visual patterns.
His brushwork is particularly effective in such sections
as the wisteria and grasses that span the blue and pink
sheets of paper.

Originally the scroll may have been longer, but it
suffered fire damage at an unknown date. The careful
restoration, undertaken in Japan in the 1980s, deliber-
ately retained some signs of damage, emphasizing the
beauty of age and wear, rather than denying or dis-
guising the work's history. Only a few handscrolls with
Kōetsu's calligraphy can be found in collections out-
side Japan, making this acquisition a major addition
to the Museum's holdings. FF

Bhadrakali within the Rising Sun
Page from a dispersed "Tantric Devi" series
India, Himachal Pradesh, Nurpur or Basohli;
c. 1660–70. Opaque watercolor, gold, silver-colored paint,
and beetle-wing cases on paper; 8 ¾ x 8 ⁵⁄₁₆ inches
(22.2 x 21.1 cm)

Ascribed to **Khushala**
The Gods Sing and Dance for Shiva and Parvati
Page from an unidentified dispersed series
India, Himachal Pradesh, probably Guler or Kangra;
c. 1780–90. Opaque watercolor and gold on paper,
9 x 12¹⁵⁄₁₆ inches (22.9 x 32.9 cm)

Alvin O. Bellak Collection (promised gift)

Alvin O. Bellak's preeminent collection of Indian paintings is one of the finest in the world. Eighty-eight pieces from the collection are a partial and promised gift from Dr. Bellak to the Museum in honor of its 125th Anniversary (see checklist no. 19). These lush, delicate, and intimately scaled paintings and drawings span five hundred years of India's artistic history. Dating from the 1400s, before the rise of the Mughal empire, to the heyday of the British Raj in the late 1800s, most of the pictures were created for India's royal courts and patronized by Hindus, Muslims, and Jains. Themes range from the epic adventures of heroes and gods, to poetic explorations of divine and human love, to solemn and satirical portraits, to sumptuous visions of palace life. The focus and glory of the Bellak Collection are the quirky, live-

ly, and colorful products of the ateliers active from the seventeenth to the nineteenth century in the Hindu kingdoms of northern India, ruled by the interlinked clans known as the Rajputs (Sons of Kings).

These pages are just two of the Rajput masterworks from the gift, but together they demonstrate the extraordinary range and quality of the Bellak Collection. Both come from the state of Himachal Pradesh in the Himalayan foothill region of northern India, sometimes called the Panjab Hills. In the first painting, dating from the seventeenth century, a great golden sun beams forth from a pure black ground that is enclosed by an elaborate architectural frame. At the sun's core stands the dark goddess, here called Bhadrakali. She is opulently dressed, her gold jewelry enhanced by small pieces of iridescent green beetle

shell. Her eyes widen hypnotically, and her red lips stretch in a faint, fang-baring smile. She stands with her jeweled and hennaed feet solidly planted on a corpse, whose huge, twisted body hovers within the sun's sphere. His arms frame his haggard face, with mouth agape and pupils rolled back in his eye sockets. Perhaps better than any other painting in the entire history of Indian art, this work illustrates the concept of divine power at the very moment of embodiment.

As opposed to this stark vision of divinity, with its saturated, enamel-like colors and flat, bold composition, is the late eighteenth-century pastel panorama *The Gods Sing and Dance for Shiva and Parvati,* which shows the gods at their most bucolically regal. Gentle rolling hills, grazing deer, flowering trees, and a lotus-filled lake create an ideal landscape for the divine out-ing of the god Shiva and his wife Parvati, who sit together on a tiger skin. Parvati wears a queen's regalia; her skirt of gold cloth worked with pink flowers exemplifies India's sumptuous textile tradition. Shiva is her perfect companion, a sweet-faced young man whose alternate persona as a fierce ascetic is only implied by his ash-whitened skin and the live snake that wriggles around his neck. In front of the couple, two women dance in rhythmic symmetry, and at the right musicians assist a third woman to don a scarf intricately textured with thin lines incised into the metallic gold surface.

Each work in the Bellak Collection is a masterpiece of its type, and together they vault the Museum into a pre-eminent position in the realm of Indian painting. DM

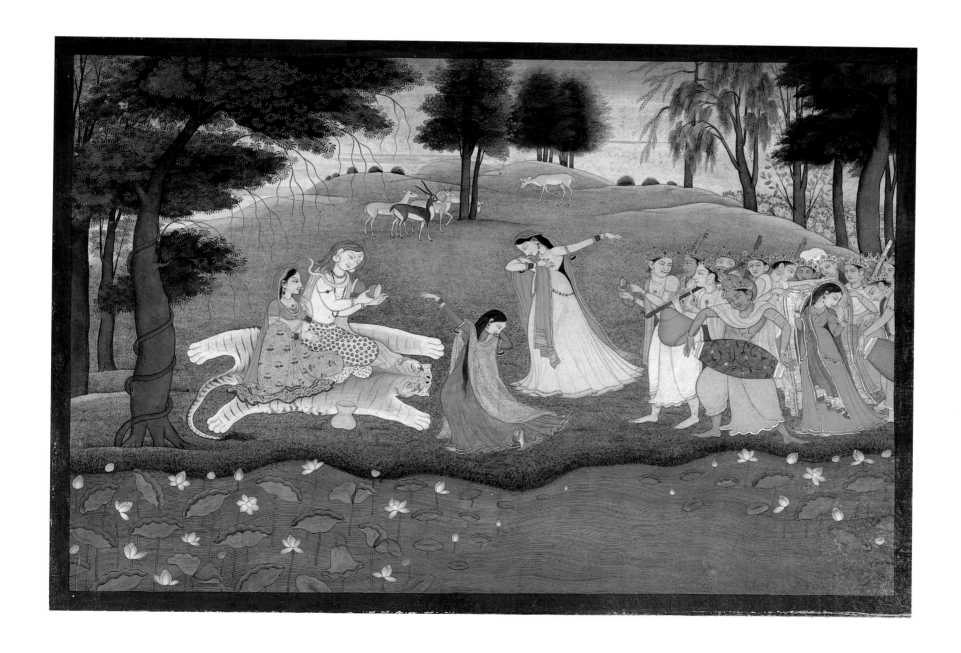

Hadley Chest
America, made in Hartford, Connecticut; c. 1695–1715
Oak and white pine, height 45¾ inches (116.2 cm)

Promised gift of The Anne H. and Frederick Vogel III Collection for the Philadelphia Museum of Art

Easy Chair
America, made in Boston; c. 1700–1710. Maple and pine, eighteenth-century flamestitch needlework upholstery; height 51 inches (129.5 cm)

Gift of Anne H. and Frederick Vogel III. 1999-62-1

The generous gift of early New England and Delaware Valley furniture from the collection of Anne H. and Frederick Vogel III greatly enhances the Museum's remarkable holdings of late seventeenth- and early eighteenth-century furniture forms. This important Hadley chest from Hartford, Connecticut, and this rare arm chair from Boston are two examples of the significance of the Vogels' collection.

The study and identification of the Hadley chest, long considered one of the basic forms of furniture made in early New England, fascinated the pioneering collectors of American material culture. More than 125 examples made for households in or near the Connecticut Valley towns of Hadley or Hartford are currently known, and they all bear similarly incised, relief-carved decoration. While few of the specific craftsmen involved in making these chests have been identified, the sources for their design, structure, and decoration are rooted in earlier seventeenth-century English joinery practices and in the carving traditions of late Elizabethan and Renaissance Britain. Until this point, the Museum's holdings have lacked a carved Hadley chest of this type. This example is remarkable for its profusely carved abstract patterning, intact structure, original painted decorative surfaces, and overall state of preservation.

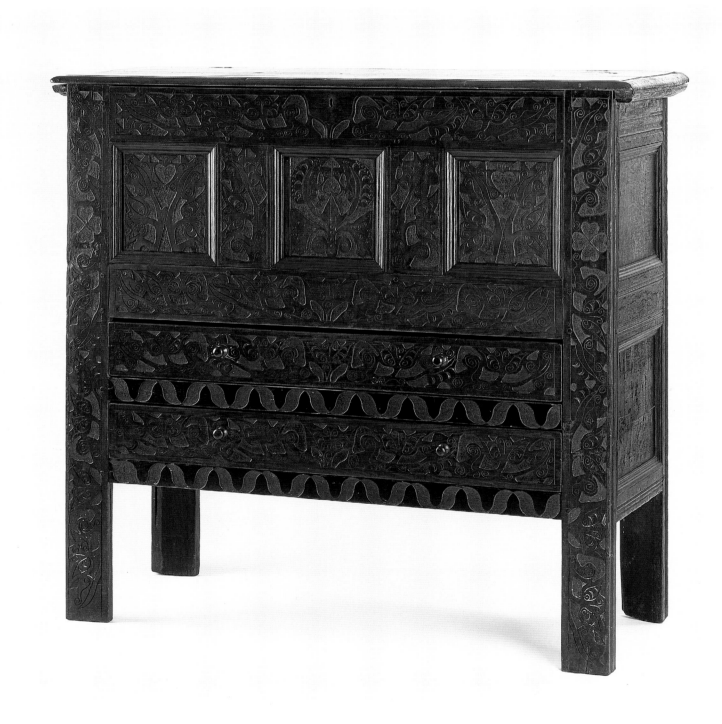

The rarity of this easy chair from Boston stems in part from the high cost of fine textiles in early colonial America. The resulting expense of padded and stitched foundations and finely finished textile coverings thus placed most fully upholstered furniture out of the reach of all but the wealthiest colonial households. The eighteenth-century flamestitch needlework on this chair is not the original, but it follows the pattern and form of luxurious upholstery of the highest style early eighteenth-century seating furniture. While no Philadelphia upholstered easy chairs of comparable early date are known to survive, over twenty from Boston, dating from 1695 to 1725, have been identi-

fied and are highly regarded for their historical significance, refined proportions, and rarity. This chair is thought to be among the earliest of only three surviving examples with turned feet. The angular, boldly raked stance of the chair's back, together with its arched back crest, distinctive scroll-form arms, deep and accommodating seat, and elaborately sawn-shaped seat-rail combine to make it one of the most splendid and ambitious examples from this important and stylistically influential group of early American chairs. JLL

Apothecary Tiles

England, London; eighteenth century. Tin-glazed earthenware, height 10½–12½ inches (26.7–31.8 cm)

Gift of Audrey and William H. Helfand. 2000-153-1–3

Ceramics of this type, commonly known as pill tiles, were made exclusively in England in the seventeenth and eighteenth centuries for apothecaries belonging to the Worshipful Society of Apothecaries of London, founded in 1617. With some variations, all of the tiles are decorated with the Society's coat of arms: surrounded by mantling, Apollo, the god of healing, vanquishes the dragon of disease while holding a bow and arrow; two unicorns act as supporters; and an often unidentifiable rhinoceros serves as the crest. The Latin motto, *OPIFERQUE PER ORBEM DICOR* (I am spoken of all over the world as one who brings help), is taken from Ovid's *Metamorphoses*. On one of these tiles the rhinoceros crest is surmounted by a cedar tree, a reference to those planted in the Society's Chelsea Physic Garden in 1673. The other two tiles display the arms of the City of London.

Generally the tiles have two pierced holes for hanging; they were intended to be displayed by the apothecaries as a means of publicly proclaiming their professional association. They are known to exist in four shapes: octagonal (the most common), shield-shaped, heart-shaped, and oval (the most rare). The tiles were painted with both polychrome and cobalt blue decoration, and were probably made in a number of the same English centers that produced delftwares, including these from Lambeth/London (where the earliest examples are also thought to have been made), Bristol, Liverpool, and possibly Wincanton in Somerset. The name "pill tile" has come to be associated with these ceramics because it was suggested, although without much evidence, that in addition to display they may have been used for rolling out pills. Later in the eighteenth century, tiles made expressly for this purpose were painted with a scale for measuring out uniform sections of pill material. DC

Chest on Stand

America, made in Philadelphia or southeastern
Pennsylvania; c. 1710–25. Walnut, cedar, white pine, and
tulip poplar; height 56 inches (142.2 cm)

Promised gift of Martha Stokes Price

This rare Pennsylvania chest on stand, one of only two known examples of its type, is part of the important collection of regional eighteenth-century American furniture and decorative arts assembled by the late Museum President J. Stogdell Stokes. His extensive gifts to the Museum between 1927 and 1953 established an unrivaled holding of eighteenth- and early nineteenth-century Pennsylvania furniture that became the foundation from which the American collections have grown. This remarkable chest, from a group of important furniture and objects belonging to his daughter, Martha Stokes Price, now takes its place as one of the earliest examples of colonial Pennsylvania furniture in the Museum and further enriches our important collections.

The chest on stand as produced in colonial America most likely evolved from earlier Italian, French, or Dutch Renaissance–inspired "specimen" cabinets on stands, many of which were ornately decorated with the stone mosaics, lacquer work, gilding, or wood marquetry highly regarded in wealthier households throughout the seventeenth century. This furniture form enjoyed continued popularity and was further adapted during the reign of William and Mary in Holland and England in the 1680s and 1690s. The cabinetmaking skills and familiarity with stylistic traditions necessary to design and construct such case pieces were present in colonial Pennsylvania by the early 1690s, brought to the region by the first Welsh, English, Dutch, and Germanic turners, joiners, and carpenters, who followed William Penn's promises of religious tolerance and economic prosperity.

Early domestic inventories document the presence of the chest on stand in the households of prosperous Philadelphians. For example, in 1700, the "great chamber" of Margaret Beardsley's townhouse contained "a stand chest of drawers." A handwritten inscription, left by a later cabinetmaker in two locations on the interior of the present example, helps to confirm its early date: "Repaired May 1811 then soposed [*sic*] them Made 100 years. Bethernath Hodgkinson." JLL

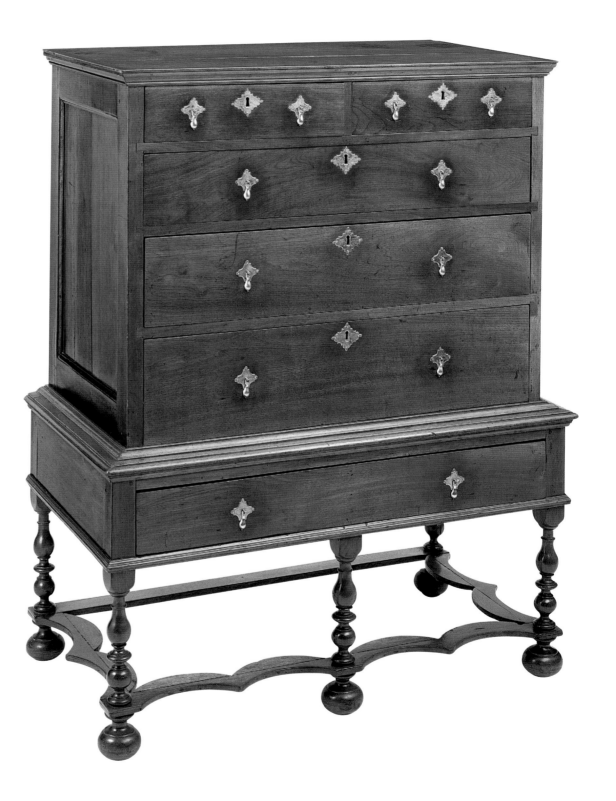

China Table

America, probably made in Virginia; c. 1765–75
Mahogany, tulip poplar, and pine; height 29 ¼ inches
(74.3 cm)

Promised gift of Charlene Sussel

Inscribed by **John Townsend**
American, 1733–1809
Pembroke Table

Made in Newport, Rhode Island; c. 1790–1800
Mahogany, maple, and tulip poplar; height 27 ¾ inches
(70.5 cm)

*Gift of the Family in memory of Dorothy and Irvin Stein
2000-136-1*

By the middle of the eighteenth century, tea drinking in Europe and America had become a performance art, replete with its own elaborately defined rules of etiquette. The ability to host and partake in this tasteful activity defined one's gentility and sophistication. Parallel with this cultural progression, distinct forms of furniture, silver, and porcelain evolved to complement the art of tea drinking.

While tea tables during this period were essentially simple constructions of a wooden board placed on pedestals or on four legs, china tables, as described by furniture-maker Thomas Chippendale in 1762, were more formal, as seen in the intricately carved legs and fretwork galleries that embellish the top of this example. In England and especially in America, the china table was considered a step above a tea table, and examples survive from centers where the ties to England were the strongest, such as Maryland, New Hampshire, and Virginia. This china table relates most closely to several made in Virginia and represents the

Museum's first acquisition of a major piece of Southern furniture.

The Pembroke, or breakfast, table was used not only for tea but also for small meals and table games, making it an extremely popular piece of furniture by the end of the eighteenth century. The form was named after a countess of Pembroke, who is said to have invented the design around the mid-eighteenth century in England. Meticulously constructed and delicately embellished with inlay, this table illustrates the superior craftsmanship of John Townsend, one of the most important Quaker cabinetmakers of Newport, Rhode Island, during the late eighteenth century. It bears the inscription *IT* and the partial date of 179[] on its interior rail, and is one of at least twelve known examples of Federal furniture signed or labeled by Townsend. While the Museum owns a number of Philadelphia-made Pembroke tables, this is the first New England piece to enter the collection. AAK/MCH

Joseph Wright of Derby
English, 1734–1797
Portrait of William Rastall
c. 1763. Oil on canvas, 30⅛ x 25 inches (76.5 x 63.5 cm)

Purchased with funds contributed by John H. McFadden
1997-1-1

Poised in a moment of reflection, William Rastall leans on a table with his art materials before him. Dressed in a green coat underneath which an ocher-striped waistcoat and a frilled shirt peek out, the boy of about nine years of age prepares to color in a book of prints. Mussel shells, brushes, and a bottle of red ink await his attention. The painting marks a critical turning point in Joseph Wright's portrayal of children as he abandons the traditional portrait of a child posed stiffly as an adult and instead captures a restless young boy engaged in a familiar activity.

Wright's account book for the 1760s lists his sitters in the city of Newark, England, among whom are Mr. and Mrs. Rastall and the "Masters Rastall." In addition to the painting of William, Wright painted portraits of the elder Rastalls and their older son, Joseph. All four works remain in their original carved and gilded Rococo frames. Wright's receipt book from the 1760s records payments to a Huguenot frame-maker in London named John Dubourg, suggesting that Wright carefully considered and commissioned the frames for these portraits.

Although he studied with Thomas Hudson in London in the 1750s and exhibited regularly there at the Royal Academy of Arts, Wright spent much of his career working in his native Derby in the Midlands. He was known as "Wright of Derby" in order to distinguish him from two contemporary painters, Richard Wright of Liverpool and Joseph Wright, an American working in London. A skilled portraitist capable of capturing the sensibility of his sitters in informal portraits, Wright of Derby was also a talented land-scape and genre painter. Though maligned as provincial, he was one of the most gifted and imaginative artists of eighteenth-century England, making this portrait a superb addition to the Museum's British painting collection. JT

Left to right:

Jug (with applied monogram of Johann Mennicken)
Germany, Raeren or Westerwald region; probably 1590s
Stoneware, height 9½ inches (24.1 cm)

***Bartmann* Jug**
Germany, Cologne or Frechen; c. 1525–50. Stoneware,
height 6 inches (15.2 cm)

Jug
Germany, Westerwald region; 1661. Stoneware, height
14 inches (35.6 cm)

Jug
Germany, Westerwald region; c. 1650–1700. Stoneware,
height 9 inches (22.9 cm)

Promised gift of Charles W. Nichols

The most important sixteenth-century German contribution to European ceramics was the development of stoneware. These wares, which ranged from simple storage jars to stylish, decorated vessels for the table, were distributed internationally, and the demand for them encouraged the production of numerous designs well into the 1700s. The ceramics are depicted in object-rich Dutch genre and still-life paintings, and shards have been excavated as far away as sites in colonial North America.

The four objects illustrated here represent characteristic forms of the medium and styles. The earliest work is a small jug decorated with the face of a bearded man—a very popular motif perhaps descended from the Wild Men (the legendary inhabitants of German forests). Supplanting this type of object were more costly wares like the jug marked with the initials associated with Johann Mennicken, an artisan who belonged to one of the principal potting dynasties at Raeren, which relocated to the Westerwald region during the 1590s. This jug is embellished with an elegant strapwork frieze and an unexpected she-devil who waves at the viewer. Examples of other styles developed in the Westerwald are apparent in two more jugs: one with circles, and another with stylized figures of a crowned woman alternating with scenes of an unnamed city.

At the 1876 Centennial Exhibition, Philadelphians were drawn to the German ceramics on display, and the early organizers of this Museum assembled the nucleus of a small collection. The appeal of these wares, perhaps only now experiencing a revival in the United States, is amply displayed in the promised gift of Charles W. Nichols (see checklist no. 40). Eventually seventeen exceptional pieces from this collection will broaden the scope and significantly elevate the quality of the early German ceramics presented in our galleries. DW

Francis Richardson, Sr.
American, 1681–1729
Tankard
c. 1715–20. Silver, height 7 inches (17.8 cm)

Gift of Mr. and Mrs. Harold P. Starr. 1999-142-1

Jacobus Van der Spiegel
American, 1666–1716
Tankard
c. 1690–1708. Silver, height 7 ½ inches (19.1 cm)

Gift of Robert Montgomery Scott. 1996-176-1

These two important early tankards exhibit the cultural differences and influences in the work of the earliest American craftsmen as well as the style preferences of their patrons. The example by Francis Richardson, Sr., is a pivotal piece by the progenitor of three generations of distinguished Philadelphia Quaker silversmiths. The other, by Jacobus Van der Spiegel, one of New York's earliest silversmiths, clearly illustrates the stylistic attributes of silver design in that city. Both tankards descended in their original owners' families.

Although Francis Richardson was born in New York, he and his family moved to Philadelphia before 1690 and settled on land that his father had purchased from William Penn. Richardson's Quaker family connections in New England helped him to secure an apprenticeship in Newport, Rhode Island, or Boston. By 1705 he had returned to Philadelphia to practice his trade. This tankard, made for William and Mary Branson of Chester County, Pennsylvania, reveals Richardson's training in an English style, as seen in the raised domed lid, tapering sides with midband, and a tall thumbpiece with a gadroon edge. In typical early Quaker practice, initials, not coats of arms, were engraved on their silver. Here the Branson initials are surrounded by a foliate wreath.

Jacobus Van der Spiegel was also born in New York and apprenticed there in the shop of a Dutch master. On this tankard the decorative cutwork on the flaring edge of the flat lid, the tightly scrolled thumbpiece, and the grand, raised fleur-de-lis cut-edge banding applied just above the molded base exhibit the style and design vocabulary practiced by silversmiths in New York who worked within the Dutch and Huguenot traditions. The front of the piece is engraved with the arms and crest of the Morin family (probably added in the early nineteenth century). Pierre Morin was a French Huguenot from La Rochelle, France, who settled in New York in 1691. His daughter married John Scott in 1728, and the tankard descended in the Scott family. BBG

31

Desk and Bookcase

America, made in Philadelphia; c. 1740–50. Mahogany, white cedar, pine, and tulip poplar; height 8 feet, 9 inches (2.7 m)

Gift of Daniel Blain, Jr. 1997-67-3

During the mid-1720s, desks with hinged and slanted lids surmounted by bookcase sections with elaborately fitted interiors gained popularity among Philadelphia's elite merchant class. Often referred to as an "escritoire" in period household inventories, the joinery techniques, design, and carved decoration of these early domestic desk forms evolved throughout the eighteenth century in response to developing Baroque, classical, and Rococo influences. Some of the more complex examples offered an owner the opportunity for a rich and varied presentation of prized objects. The elaborately shaped upper and lower interior compartments were intricately divided into drawers, ledger racks, and pigeonholes. These could be used to display the finely bound daybooks and atlases of the worldly and successful merchant, or the exotic curiosities, imported porcelains, or natural specimens of the gentleman collector.

This desk, which descended in the Logan and Dickinson families of Philadelphia, is thought to have been commissioned by William Logan, eldest son of James Logan, William Penn's personal secretary. The desk's broad, broken-scroll pediment with floral terminals, its central richly carved double-shell tympanum ornamentation, the scroll-shaped, deeply beveled panels of the doors, and the richly grained imported mahogany of its case are all design characteristics drawn from later European and English Baroque influences popular among Philadelphia's leading cabinetmakers during the mid- to late 1740s.

The desk has survived with remarkably few restorations and retains its original brasses as well as an early accumulated surface finish. It relates in form and decoration to a small group of desks, several of which include similar carved ornamentation. Despite extensive research, none have been firmly documented to any known Philadelphia cabinetmaking shop or carver. However, aspects of the carving on several of these desks, as well as on this example, show marked similarities to the work of Samuel Harding, a specialized craftsman who supplied the carved architectural ornamentation for the stair tower and first-floor reception room of Independence Hall. JLL

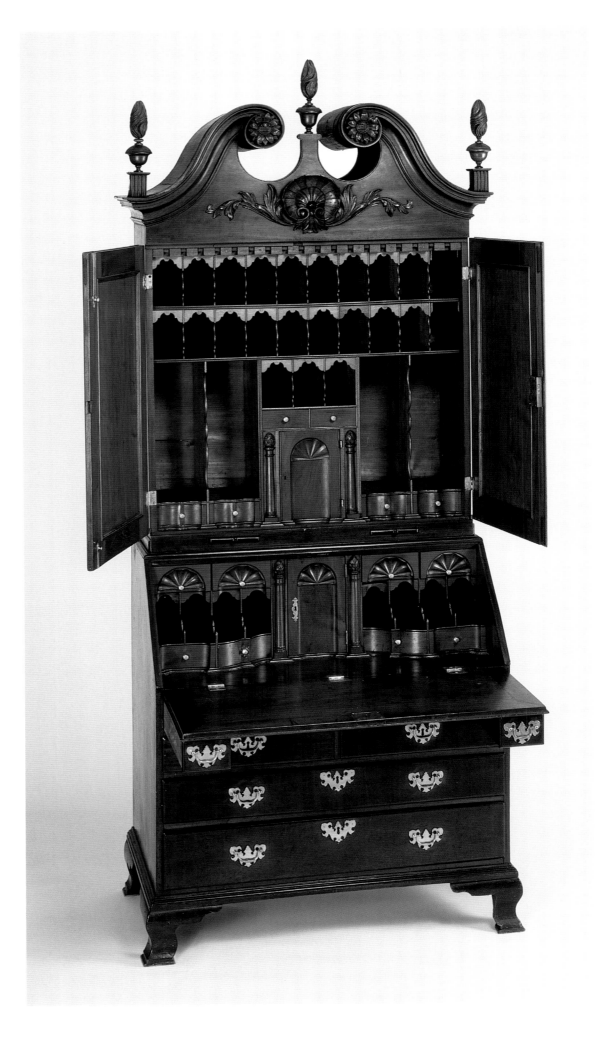

Jean-Antoine Houdon
French, 1741–1828
Bust of Benjamin Franklin
1779. Marble, height with socle 20½ inches (52.1 cm)

Purchased with a generous grant from The Barra Foundation, Inc., matched by contributions from the Henry P. McIlhenny Fund in memory of Frances P. McIlhenny, the Walter E. Stait Fund, the Fiske Kimball Fund, and with funds contributed by Mr. and Mrs. Jack M. Friedland, Hannah L. and J. Welles Henderson, Mr. and Mrs. E. Newbold Smith, Mr. and Mrs. Mark E. Rubenstein, Mr. and Mrs. John J. F. Sherrerd, The Women's Committee of the Philadelphia Museum of Art, Marguerite and Gerry Lenfest, Leslie A. Miller and Richard B. Worley, Mr. and Mrs. John A. Nyheim, Mr. and Mrs. Robert A. Fox, Stephanie S. Eglin, Maude de Schauensee, Mr. and Mrs. William T. Vogt, and with funds contributed by individual donors to the Fund for Franklin. 1996-162-1

While minister from the new American republic to France from 1776 to 1785, Benjamin Franklin was a celebrity who embodied the emerging nation, and many artists hastened to attempt his likeness. This masterpiece is a great artist's portrait of a great man. Jean-Antoine Houdon, who portrayed a series of eminent intellectuals, doubtlessly counted on Franklin's fame to guarantee many sales of plaster versions and to attract attention to himself.

Houdon's Franklin is posed frontally, head slightly lowered, his asymmetrical face rendered in great detail. The treatment of the eyes is a superb example of the sculptor's sensational technique, one admired at the time as more accurate than any painter's. The gaze is directed to one side and the mouth slightly open. Normally, Franklin was taciturn, and Houdon rendered his deliberate manner so that it appears to capture the outward manifestation of Franklin's mind at work. The result is fascinating and powerful.

Houdon's vision of Franklin is all the more impressive because it was realized without the benefit of studio sittings. We know that the sculptor could only have observed Franklin at public gatherings. The superiority of the bust must also owe something to the circumstances of the commission. The exceptional attention and skills lavished on this marble point to a very important, but unfortunately still-unknown, patron.

This Museum has a continuing interest in acquiring historic portraits of Franklin in many forms. Most have come as gifts, including a collection of prints donated by Mrs. John D. Rockefeller, Jr., in 1946. The Houdon bust crowns the collection as a powerful presence in the European and American galleries. It is fitting that such an extraordinary portrait of the most famous Philadelphian belongs to the Museum at the end of the boulevard that bears Franklin's name. DW

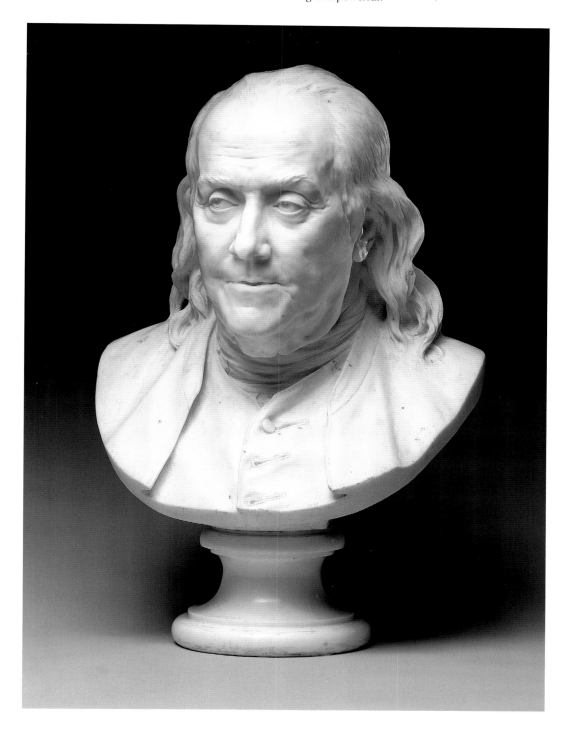

American and European eighteenth-century objects, including (clockwise) *Portrait of Samuel Morris* (n.d.), by Charles Balthazar Julien Fevret de Saint-Memin; porringer (c. 1755–70), by Edward Milne; tankard (c. 1718–22), by Johannis Nys; pocketbook or wallet (1765), by Mary Flower or Ann Flower; child's whistle and bells (1765–75); pocket watch (c. 1761–73), by Jason Ribouleau; ladle (c. 1801), by Joseph Richardson, Jr.; cream pot (1760–75); and Bible cover (c. 1750), by Mary Flower or Ann Flower (for full captions, see checklist nos. 73, 106)

Promised gift of the Family of Samuel Wheeler Morris

Patronage of the arts, historic preservation, and research into Philadelphia's illustrious past has long benefited from the consistent and sustained interest of a number of the city's earliest, most prominent families. Portraits and family heirlooms, hereditary namesakes, traditional occupations, and, in many cases, the ancestral homes of the city's political, intellectual, mercantile, and military leaders have been preserved through familial lines of descent and the importance placed on genealogical identity and history.

This important group of eighteenth-century silver, needlework, and other family objects is a promised anniversary gift to the Museum from the family of Samuel Wheeler Morris. They have descended through various lines of intermarriage and inheritance from earlier generations of the Morris, Dury, Wistar, and Wheeler families of Philadelphia. These rare and important objects add immeasurable depth to the Museum's already significant collections of early Morris family materials given in 1928 by Lydia Thompson Morris, which has been augmented by other family members.

Although the family's patriarch in colonial Pennsylvania was Anthony Morris, who arrived with William Penn and was among the "first purchasers" of the colony, perhaps the most widely revered and best-known early member of the family was his grandson Samuel Morris (1734–1812). Many of the objects in this group either were directly commissioned by Samuel or were inherited by him through earlier ancestral lines of descent.

Samuel Morris became a prominent and successful brewer and merchant in Philadelphia, and his patronage aided numerous local artisans and craftsmen. Known as "Captain Sam" or "Christian Sam," he was widely respected as a civic leader, fraternal club member, and brave military commander during the American Revolution. A Quaker, Morris was disowned by the Society of Friends for his military activities, but he continued to command authority and respect from Quaker leaders throughout his life. JLL

Attributed to **Peter Van Dyck**
English, born Holland, 1729

Portrait of Lady Juliana Penn

Portrait of the Right Honorable Thomas Penn

c. 1751–52. Oil on canvas, 36⅛ x 31⅛ inches
(92 x 78.2 cm) each

Promised gift of Susanne Strassburger Anderson, Valerie Anderson Readman, and Veronica Anderson Macdonald from the estate of Mae Bourne and Ralph Beaver Strassburger

This evocative pair of marriage portraits provide an important and rare glimpse into the seldom documented British aspects of the lives of the Penn family. Painted in London around 1751–52, the paintings portray William Penn's son Thomas and his new wife, Lady Juliana Pomfret. Following the popular traditions of this portrait genre, the bride and groom are depicted in the interiors of their respective family homes: Lady Juliana in the London townhouse of her father, the first earl of Pomfret, and Thomas in the ancestral house of his father, William, in Warminghurst, Sussex. The contrast between the ornate decorations in the interior of the bride's portrait and the spare furnishings of the groom's suggests some of the philosophical differences between the Anglican Pomfrets and Quaker Penns relative to the ownership of luxury goods.

Upon William Penn's death in 1718, Thomas inherited one-quarter of his father's proprietary interest in the colony of Pennsylvania. His ownership increased to a full three-quarters in 1746 when his older brother, John, died. Thomas resided in Philadelphia from 1732 until 1741, when he returned to England, leaving his proprietary and financial interest in control of the family's personal secretary, James Logan, who had also served his father. Although he never returned to Pennsylvania, Thomas Penn's influence and authority continued to define the economic and governmental character of the colony for over forty years. Lady Juliana Penn never visited the region, but was a much-admired and dedicated supporter of many of Pennsylvania's early cultural institutions. Her benefactions included a 1763 gift of numerous valuable books, globes, and other scientific curiosities to the Library Company in Lancaster, Pennsylvania, which later honored her by changing its name to the Juliana Library Company. JLL

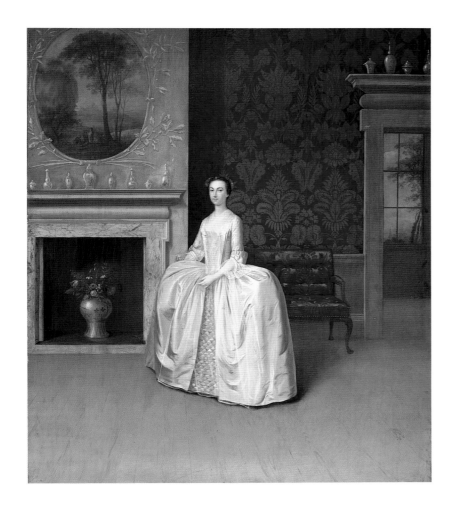

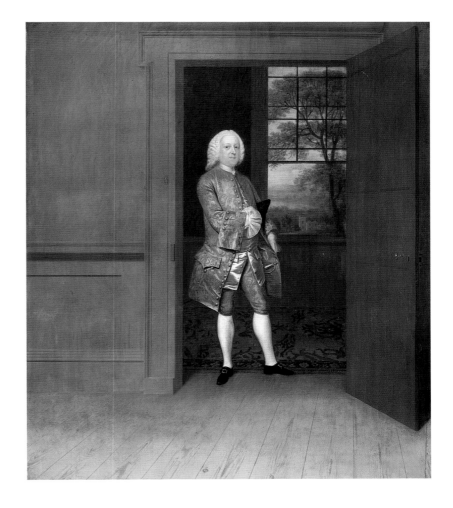

35

Reliefs of Cherubim in Clouds

France, Paris region; c. 1710–20. Gilded bronze, height 30 ⅞ inches (78.5 cm) each

Purchased with the gift (by exchange) of Mr. and Mrs. Orville H. Bullitt and with funds contributed by Maude de Schauensee. 1998-5-1, 2

Among the last great projects of Louis XIV were church decorations, including the chapels of the Hôtel des Invalides in Paris and the château of Versailles. The ensembles produced during this period have long been celebrated as examples of a distinctive phase of the late Baroque in France in which the first stirrings of the Rococo style appear. During the French Revolution, the animosity toward the Catholic Church and the demand for valuable metals guaranteed the destruction of most large-scale ecclesiastical structures like altars and tombs that incorporated gilded metal ornaments. These two precious reliefs, almost certainly created as components in an early eighteenth-century church decoration, have fortunately survived.

The angels' animated faces, tousled curls, delicate feathers, and even the form of the clouds are very close in style and quality to the gilded wood organ case designed by Pierre Lepautre and revised and completed under François-Antoine Vassé in 1710 for the chapel of Versailles. Collaboration between artists was standard for such objects. It is probable that for these reliefs an architect or sculptor provided an initial drawing. A sculptor then created a model from that drawing, or several sculptors modeled the elements independently. Afterward, specialists cast and gilded the pieces, although the sculptor might have finished the surface of the bronze himself.

Thanks to the gifts of Eleanore Elkins Rice, the Museum's holdings include important gilded eighteenth-century French domestic objects like wall lights, firedogs, and furniture with gilded-bronze mounts, mostly dating after 1750. Our collections contain few such works of art from Louis XIV's long reign. These two architectural reliefs are charming yet imposing survivors of that era when the artists working for the French crown established the standards of craftsmanship for the rest of the century. DW

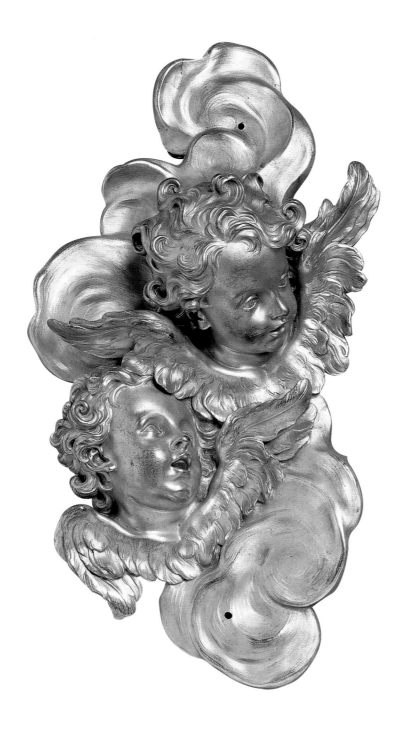
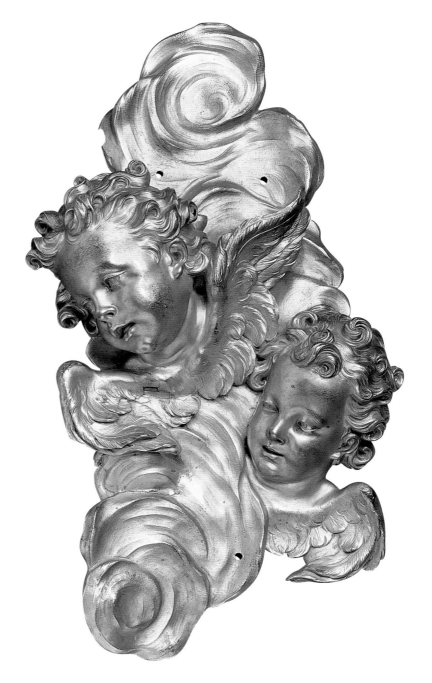

Jean-Honoré Fragonard
French, 1732–1806
Useless Resistance

c. 1770–73. Brush and washes over chalk underdrawing, watercolor, and opaque watercolor on paper; 9⅛ x 13⅝ inches (23 x 34.7 cm)

Promised gift of George M. Cheston

In contrast to the Museum's extensive holdings of eighteenth-century Italian drawings, our representation of the French school from that period is suprisingly modest. The gift of this superb drawing by Jean-Honoré Fragonard adds not only a telling example of French Rococo éclat but also a tour de force by a supreme draftsman of European art.

Unlike most other French artists who launched their careers after attending the Royal Academy in Paris, Fragonard began his after brief stays in the studios of Jean-Baptiste-Siméon Chardin and François Boucher. In 1752 he won the Prix de Rome, and the years he spent in that city (1756–61) transformed his style and marked his emergence as one of the great draftsmen of his time. As a student in Italy, working under the influences of French Academy director Charles Natoire and his friend and fellow artist Hubert Robert, Fragonard created some of the most beautiful landscapes ever drawn, using red chalk to portray subjects in which vast spaces, effects of light and shade, luxuriant trees and foliage, figures and architecture—both ancient and modern—are swept together in a coherent unity.

Upon returning to Paris, Fragonard did not choose to become an official history painter, as was customary, but rather became known for private decorative commissions, intimate easel paintings, exquisite small oil sketches, genre scenes with charming domestic details, and virtuoso chalk or ink and wash drawings produced as ends in themselves rather than as preparatory works. His paintings and works on paper embody youth, radiant good health, exuberance, tender domesticity, and a sensuous love of life in all its intensity. *Useless Resistance*, which probably dates to the early 1770s, relates closely to a small number of wash drawings of boudoir subjects that are notable in Fragonard's oeuvre for their lightness, wit, and effortless ease of execution. AP

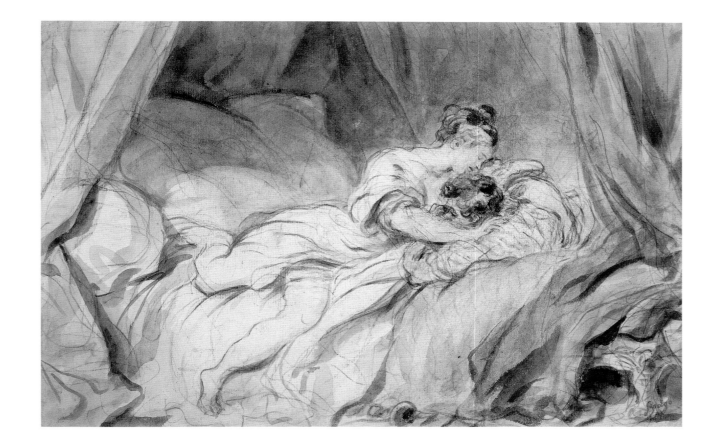

John Singleton Copley
American, 1738–1815
Portrait of Mr. and Mrs. Thomas Mifflin
(Sarah Morris)
1773. Oil on ticking, 60½ x 48 inches (153.7 x 121.9 cm)

Bequest of Mrs. Esther F. Wistar to The Historical Society
of Pennsylvania in 1900, and acquired by the Philadelphia
Museum of Art by mutual agreement with the Society
through the generosity of Mr. and Mrs. Fitz Eugene Dixon,
Jr., and significant contributions from Stephanie S. Eglin,
Maude de Schauensee, and other donors to the
Philadelphia Museum of Art, as well as the George W.
Elkins Fund and the W. P. Wilstach Fund, and through the
generosity of Maxine and Howard H. Lewis to the
Historical Society of Pennsylvania. EW1999-45-1

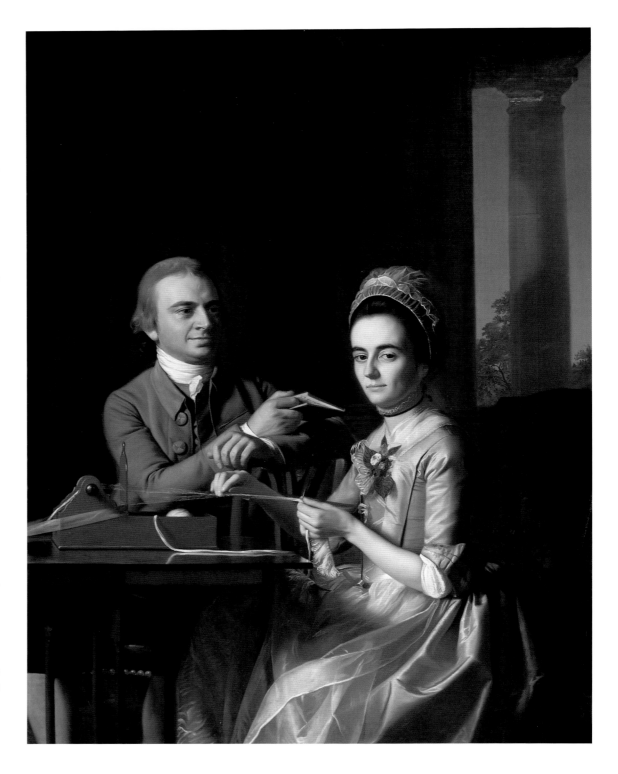

Famous as one of John Singleton Copley's finest works immediately after it was painted, the portrait of Thomas and Sarah Mifflin—the first painting by Copley to enter the Museum's collection—shows the artist at the height of his powers. Copley was a self-taught artist who developed a highly finished style that rendered the features, costumes, and surroundings of his subjects with remarkable accuracy.

He was so popular in his native Boston that, unlike most colonial portraitists, Copley did not travel far seeking commissions. Thomas Mifflin and his wife, Sarah Morris Mifflin, the only Philadelphians to be painted by the artist, sat for their portrait in Boston in the summer of 1773. An ardent patriot and active participant in the Revolutionary movement, Mifflin rose to the rank of major general in the Continental Army and was elected the first governor of Pennsylvania after the colonies achieved independence. Sarah Morris, who married Mifflin in 1767, was an accomplished, witty, and supportive partner. In the portrait, Sarah's handwork may symbolize the couple's patriotic endorsement of the nonimportation agreements signed by American colonists resolved to boycott English goods.

Portraits with more than one figure are rare in Copley's work. However, he always kept a keen eye on his competition. He may have been inspired to paint the Mifflins together by his contemporary Charles Willson Peale, who recently had returned from art study in London with the newly fashionable idea of placing two or more figures together in informal poses.

By showing both Sarah and Thomas Mifflin on a single canvas, Copley not only depicts the features and costumes of his sitters with his famed, painstaking skill (Sarah recalled that he required twenty sittings for the hands alone) but also creates an image of marriage as an affectionate, equal partnership—an innovative concept in American portraiture at the time. As a penetrating study of an undoubtedly happy union, it has few peers among paintings of any era. DS

Attributed to the **Workshop of Thomas Affleck**
American, born Scotland, 1740–1795
Easy Chair
Made in Philadelphia, 1770–71. Mahogany, yellow pine,
white oak, white cedar, black walnut, and tulip poplar,
modern upholstery; height 45 inches (114.3 cm)

*Partial and promised gift of H. Richard Dietrich, Jr.
2001-12-1*

This extremely rare carved-mahogany upholstered easy chair is widely considered one of the masterpieces of eighteenth-century American furniture in the Rococo style. It was part of an extensive and ornate suite of household furniture commissioned in 1770–71 by General John Cadwalader of Philadelphia from the local cabinetmaker Thomas Affleck. In 1768

Cadwalader married Elizabeth Lloyd, the daughter of the wealthy planter Edward Lloyd III of Maryland. Cadwalader's growing reputation and authority as a business and military leader were enhanced by Elizabeth's inherited wealth, placing the new couple at the top of Philadelphia's elite society. To demonstrate the dynastic importance of their union, the couple purchased a large Georgian townhouse on Second Street the following year, and began its extensive remodeling and expansion.

A remarkable group of surviving bills and receipts document the Cadwaladers' commissions for the house. This easy chair is recorded on a bill of sale from Affleck, dated December 20, 1770. The carved rocaille embellishments of its frame were created by highly trained, specialized carvers working in Affleck's shop. These artisans, documented by the noted surcharges due to them, are identified as James Reynolds,

Nicholas Bernard, and Martin Jugiez—three of the city's leading carvers who produced such ornament.

Affleck's bill also refers to other pieces in the large suite of furniture, all of which were united by their rich foliate relief carving, serpentine "commode" forms, and hairy-paw feet. This chair will join other pieces from the group currently exhibited in the Museum, including a pair of hairy-paw-foot card tables, one of the serpentine-form side chairs, a "pole screen," and the celebrated group of Cadwalader family portraits painted by Charles Willson Peale.

The surviving elements of Cadwalader's grand interior, preserved within the Museum, are now further enriched by this magnificent easy chair. Together the pieces provide a unique and memorable glimpse of Philadelphia's artistic brilliance as achieved just before the War for Independence. JLL

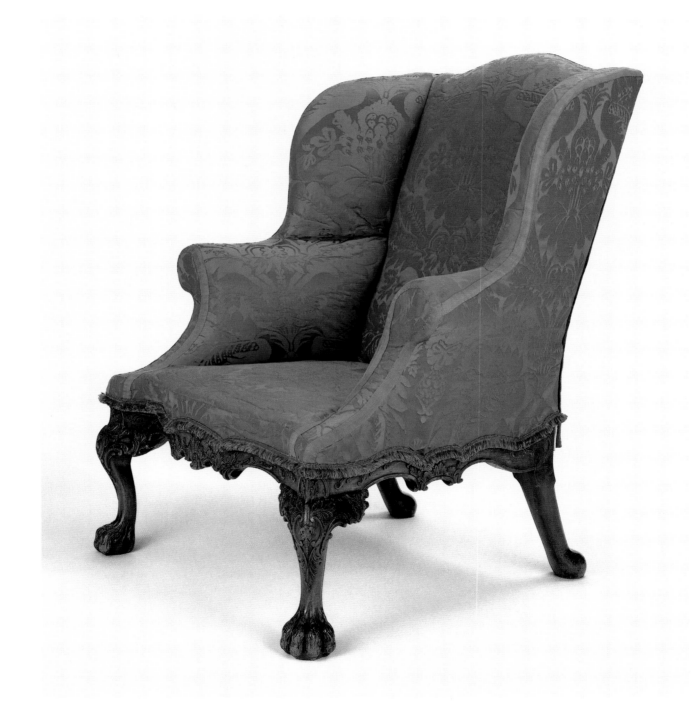

Philipp Otto Runge
German, 1777–1810

The Four Times of Day (Morning, Day, Evening, Night)
1805. Etchings (edition 25), sheet 28¾ x 19¼ inches (73 x 48.9 cm) each

Purchased with the Lola Downin Peck Fund and the Carl and Laura Zigrosser Collection (by exchange), and The James D. Crawford and Judith N. Dean Fund, and with funds contributed by The Judith Rothschild Foundation, Marilyn L. Steinbright, The Henfield Foundation, Mildred L. and Morris L. Weisberg, Mr. and Mrs. John J. F. Sherrerd, Audrey and William H. Helfand, Harvey S. Shipley Miller and J. Randall Plummer, Marion Boulton Stroud, George M. Cheston, Peter Benoliel, Joseph A. O'Connor, Jr., Mr. and Mrs. M. Todd Cooke, and Helen Cunningham and Theodore T. Newbold in honor of the 125th Anniversary of the Museum. 2001-94-1–4

As appreciation for German Romantic art has grown in recent years, a number of exhibitions in Europe and the United States have made evident the importance of this previously neglected field. Thanks to the Muriel and Philip Berman gift of European prints of 1985, the Museum is fortunate to possess the largest collection of German prints from this period outside of Europe. Since the depth and range of these holdings were first revealed to the public in the 1992 exhibition *Art and Nature: German Printmaking from 1750 to 1850*, the collection has been enriched by the addition of four great masterpieces, which are among the most sought-after prints of any era. First to be acquired was Caspar David Friedrich's haunting woodcut *The Woman Seated below a Spider's Web*, which was made in Dresden in 1803. The most recent acquisition, *The Four Times of Day* by Philipp Otto Runge, has been made possible by donations given to celebrate the 125th Anniversary by members of the Committee on Prints, Drawings, and Photographs, along with funds provided by other patrons of the department.

Runge and Friedrich each played a pivotal role in forging the new Romantic style that emerged in Germany after 1800 to overturn long-established artistic conventions. By advocating direct observation of nature over the study of revered classical models, their example helped elevate landscape painting to an unprecedented position of prestige. Runge's most important legacy involves his designs for a projected series of monumental paintings symbolizing the four times of day, a project that found its most complete expression in this suite of four etchings, first issued in an edition of only twenty-five sets in Dresden in 1805.

Intended as distillations of the divine that is present in all facets of the natural world, Runge's hieroglyphic arrangements of figures and flowers express an exuberant joy and delight in life. The modernity of his etched outlines was unmistakable: when the great German writer Johann Wolfgang von Goethe introduced his own set of Runge's prints to a friend, he commented on their madness and beauty, while his visitor promptly compared them to the music of Beethoven and other startlingly contemporary composers. JI

Robert Gaw
American, active c. 1793–1833
Suite of Windsor Armchairs (24)
Made in Philadelphia, c. 1808. Painted tulip poplar and
hickory, height 33¼ inches (84.5 cm) each

Promised gift of Keith and Lauren Morgan

The techniques of Windsor chairmaking in colo-
nial America are most directly rooted in late
seventeenth-century British vernacular furniture
traditions. Both foreign- and native-trained craftsmen
working throughout the colonies freely adapted and
applied these techniques with imaginative innovation.
By the second quarter of the eighteenth century,
Windsor chairmaking had evolved to a high degree
of sophistication and refinement in southeastern
Pennsylvania. The stylistic variety and widespread
popularity of simply constructed, durable, and afford-
able furniture continued to expand and develop
throughout the eighteenth and nineteenth centuries
in Philadelphia. The anniversary gift of this large suite
of armchairs, remarkable for its documentation,
immeasurably enriches the Museum's significant yet
small collection of Windsor chairs.

The twenty-four "birdcage" armchairs, which are
accompanied by their original bill of sale from the
Philadelphia chairmaker Robert Gaw, are one of the
largest suites of Windsor chairs to have survived undi-
vided and intact. In 1808 Gaw was commissioned by
the Board of Managers of Saint John's Evangelical
Lutheran Church to supply the chairs for a newly con-
structed, elegant sanctuary at Race and Sixth streets.
The surviving church manuscripts that accompany the
chairs record their varied uses within the building: in
the second-floor choir gallery, periodically in the
Board of Managers' meeting room, and regularly out-
side in the church's adjacent burial grounds during
funeral services.

Typical of late eighteenth- and early nineteenth-
century Neoclassical adaptations of the Windsor style,
Gaw's design incorporates slender, lightly turned
structural elements with lathe-scored, faux bamboo
decorative rings. He created the birdcagelike form of
the back, arm supports, and legs by repetitively posi-
tioning and anchoring the rings into the thick, saddle-
shaped board seat. The painted surface visually unites
the mixed woods that were chosen and positioned for
their innate structural properties and strengths. JLL

Carl Edward Munch
American, born Germany, 1769–1833
Birth Certificate for Georg Negely
Made in Dauphin County, Pennsylvania; 1805. Watercolor, ink, and gum arabic on paper; 12½ x 15½ inches (31.8 x 39.4 cm)

Promised gift of Mary Louise Elliott Krumrine in memory of Jack Milton Krumrine

This ornate birth certificate, or *taufschein*, includes both text rendered in fractured, or broken, script and ornate decorative patterns characteristic of the wider body of traditional fractur documents produced by the early Pennsylvania German community. It was made to record the birth of Georg Negely to Joseph and Anna Maria Negely of Dauphin County, Pennsylvania, on September 8, 1805. Unusual in its inclusion of neoclassically derived elements such as garlands, festoons, urns, and ovals, the work was produced by Carl Edward Munch, one of the few traditional Pennsylvania German fractur artists whose preferred style demonstrates a direct familiarity with these design influences and inspirations.

Born in the Palatinate, near Mettenheim, Germany, Munch immigrated to Pennsylvania in 1798. Initially he taught school in Schaefferstown before settling in 1804 in the Lykens Valley in Dauphin County as schoolmaster for Saint Peter's Reformed Church. He remained there until his death in 1833. For almost thirty years he supplied decorated certificates to the local community and developed the ornately flowing, graceful compositions seen in this important *taufschein*. Munch's accomplished incorporation of the popular allegory of the four seasons, here depicted with interesting detail that charts the changing activities of seasonal agrarian labor shared between father and son, is known on one other version from the artist, now in the National Gallery of Art in Washington, D.C.

This *taufschein* and the reward of merit (see page 48) help to establish a fuller, more accurate representation of the fractur tradition within the Museum's collection. Both works highlight the differences between the individual artists and the various motivating factors that inspired and maintained this important local genre.
JLL

Cupboard

Switzerland, Appenzell region; 1811. Painted wood, height
5 feet, 2 inches (1.6 m)

Promised gift of Irene and Walter Wolf

From its early years, the Museum has embraced the various traditions that distinguish artistic production in its surrounding region. The eighteenth-century collections are rich in both the elegant decorative arts created in Philadelphia's Rococo style and the lively wares produced by the Pennsylvania Germans. However, although the galleries also display many English objects that were prized by Philadelphians and influential for American artisans, they do not currently represent the European folk art that settlers brought with them or that continued to evolve abroad. This deficiency will be partially remedied by a generous donation from the collection of Irene and Walter L. Wolf, who, as newlyweds over sixty-five years ago, began to furnish their house with these joyous objects.

Over time in certain continental countries, prosperous farmers developed distinctive local styles that interacted with fashionable taste. This artistic process is especially clear in the Wolfs' Swiss furniture, which absorbed aspects of late Renaissance, Rococo, and Biedermeier styles. Originally this cupboard was part of a woman's dowry when she married in 1811. (The date and owners' names and images appear on the door.) The painted surface includes simulated burl and ebony woods and designs popular in the elegant bourgeois furniture of the day. These stylistic features were adapted to a traditional furniture form that was enlivened by bright colors in the folk taste.

The Wolfs' collection includes objects large and small, from a canopied bed to hat boxes, from a tall case clock to cake molds depicting Orpheus playing his lyre (see checklist no. 43). Various Scandinavian countries are also represented with characteristic pieces, such as a Norwegian ship's cabinet and two rare Swedish painted wall hangings, which were created by itinerant artists and only displayed for such special occasions as the Christmas holidays. DW

John Lewis Krimmel
American, born Germany, 1786–1821
Pepper-Pot: A Scene in the Philadelphia Market
1811. Oil on canvas, 19½ x 15½ inches (49.5 x 39.4 cm)

Gift of Mr. and Mrs. Edward B. Leisenring, Jr. 2001-196-1

"Pepper-pot, smoking hot," was a familiar cry heard on the streets of Philadelphia in the early nineteenth century. Residents and visitors alike described the numerous African American women who sat in the famous market stalls that ran along High Street (now Market Street), enticing passersby to purchase the spicy soup. Unique to the city and invented by African Americans, pepper-pot combined African, Caribbean, and local flavors; it was an inexpensive meal that appealed to a diverse population. In his treatment of the subject, John Lewis Krimmel captures the vitality of Philadelphia's marketplace, displaying the sharp eye for observation that earned him recognition as the first significant genre painter working in America.

Krimmel painted this scene two years after moving to Philadelphia from Ebingen, Germany. As an immigrant, he was fascinated by the contrasts in race, social and economic class, religion, and attitude that he encountered on the streets of the city. The assortment of character types that appear in this work would become common in Krimmel's other well-known paintings. Here the barefoot African American woman in the center grounds the composition. Her warm presence brings together a disheveled old soldier (still wearing his Revolutionary War uniform), a watchful elderly woman, and a gawky young country fellow, all of whom sharply contrast with two elegantly dressed girls who observe the scene with apparent apprehension.

Exhibited in 1811 at the Pennsylvania Academy of the Fine Arts, Krimmel's *Pepper-Pot* was one of the earliest narrative scenes to depict a freed person of color at work in the city. Unfortunately, the painting was out of the public eye for many years before being rediscovered in the 1990s. As the earliest surviving oil from an artist whose work influenced the next generation of American genre painters—including William Sidney Mount and George Caleb Bingham—the painting is a fascinating view of early nineteenth-century Philadelphia, making it an exceptionally important addition to the Museum's collection. AL

William Langenheim (American, born Germany, 1807–1874) and **Frederick Langenheim** (American, born Germany, 1809–1879)

Merchants Exchange, Philadelphia

1849. Salt print from a paper negative, sheet 10 ¹³⁄₁₆ x 9 ⁷⁄₁₆ inches (27.4 x 23.9 cm)

Gift of The Miller-Plummer Foundation. 2000-164-1

This historic and extremely rare photograph by two of Philadelphia's earliest distinguished photographers is one of only two prints of this size known to exist, making it the centerpiece of the Museum's select group of early photography in the city.

After many years of experimentation, the discovery of photography was announced in Paris in January of 1839, with Louis Jacques Mandé Daguerre's eponymous invention, the daugerreotype. The details of this amazing new process did not become available in the United States until the fall of that year. By 1840, the enterprising Langenheim brothers had opened a daguerreotype studio in the Merchants Exchange building in Philadelphia. A distinctive Neoclassical edifice completed in 1834, the Exchange was a highly visible symbol of Philadelphia's predominance and economic vitality, and therefore an ideal location for the Langenheims, who were soon among the first successful commercial photographers in the country.

Stimulated to action by Daguerre's announcement, William Henry Fox Talbot, a gentleman scientist from London, introduced a different approach to capturing a sitter's likeness. Unlike the daguerreotype, the "Talbotype" or calotype was made by projecting light through a negative, allowing more than one print to be made of the same image. The business-savvy Langenheims pioneered the use of this process in America and in 1849 acquired the U.S. patent rights. This large view of the Merchants Exchange was made three months later, on August 16. It was probably intended as a showpiece to demonstrate the art of the calotype, with the idea of attracting other photographers to license the patent. Though the Langenheims correctly recognized the importance of Talbot's invention—a version is still in use today—the public did not quickly abandon its affection for the daguerreotype, and the brothers' investment led to bankruptcy. KW

Talbotype from Nature. Aug. 16. 1849. by W. & F. Langenheim. Philad⁴ Exchange.

The Exchange, Philadelphia.

Attributed to **Martin Gottschall**
American, born Germany, 1785–1857
The Temptation of Eve
Made in Bucks County, Pennsylvania; c. 1830–35
Watercolor, ink, and gum arabic on paper; 9¾ x 13¾
inches (24.8 x 34.9 cm)

Promised gift of Mr. and Mrs. Victor L. Johnson

In 1891 Edwin AtLee Barber, curator and later direc-
tor of the Museum, began a concentrated effort to
collect and preserve the various artistic craft traditions
of the region's diverse Pennsylvania German popula-
tions. In 1897 he enthusiastically acquired the
Museum's first examples of fractur work—colorfully
illuminated and illustrated *vorschriften* (writing samples),
taufschein (birth certificates), decorated bookplates,
pictorial rewards of merit, and other records created
by the Pennsylvania Germans—that established the
institution's enduring dedication to this important
regional artistic tradition.

While the Museum's holdings of Pennsylvania
German fractur have grown to well over one hundred
significant examples, the acquisition of the master-
piece *The Temptation of Eve* greatly enhances the quality
and depth of the collection. Devoid of any text, the
spirited drawing of a popular biblical image may have
originally been a reward of merit or a religious or
moral lesson for a honored student or other deserving
recipient. Its intricate patterning, bold color, and direct
but loose rendering of the figures relate it to the work
of Martin Gottschall, who, together with his brother
Samuel, taught school and operated a successful mill
on the Perkiomen Creek in Bucks County, Pennsylvania,
in the first half of the nineteenth century.

The surviving works attributed to both Gottschalls
employ thickly applied, vibrant, water-based pigments
that have developed a pronounced mottled coloration
and crystalline surface texture as they oxidized and
dehydrated over time. Such thick color applications
and the resulting craquelure are quite fragile and
rarely survive intact, making this work's fine condition
exceptional. This remarkable and lively drawing, widely
considered a masterwork of Martin Gottschall, was
included in the pioneering exhibition *The Flowering of
American Folk Art* held in 1976 at the Whitney
Museum of American Art in New York. JLL

Joshua Johnson

American, active c. 1795–1825

Portrait of Edward Aisquith

c. 1810. Oil on canvas, 22½ x 18⅜ inches (57.2 x 46.7 cm)

Purchased with funds contributed by Dr. Benjamin F. Hammond, and with other funds being raised in honor of the 125th Anniversary of the Museum and in celebration of African American art. 2001-11-1

Joshua Johnson, the earliest documented professional African American artist, worked as a portrait painter in Baltimore from about 1795 to 1825, producing more than eighty known portraits. The facts about Johnson's biography are scant; he may have begun life as a slave, but was a free man by the time he described himself as a self-taught "genius" in an advertisement in the *Baltimore Intelligencer* in 1795. In fact, the style and technique of Johnson's paintings suggest that he received training from members of the Peale family—Charles Willson Peale, his sons Raphaelle and Rembrandt, or his nephew Charles Peale Polk—all of whom visited or were resident in Baltimore in the late 1780s and 1790s.

Johnson's most famous, and most charming, portraits are full-length portrayals of young children in detailed settings. Of the remainder, the majority are single figures at half- or bust-length, portraying working- and middle-class Baltimoreans. His rendering of Edward Aisquith, a Baltimore merchant who lived from 1780 to 1815, is an outstanding example of these simpler portraits, and the first of Johnson's paintings to enter the Museum's collection.

This work has a liveliness of characterization and feel of connectedness between the sitter and the artist/viewer that are much more vivid than in most of Johnson's portraits, whatever their size and complexity. Aisquith's little smile, the fanatically precise arrangement of his hair, and the delicacy and refinement conveyed by the positions of his hands are all rendered in exquisite detail. Johnson painted in very thin layers of color, and many of his works have suffered from abrasion and harsh cleaning that have removed their original detail, giving them a spectral appearance. Fortunately, the portrait of Aisquith retains its original coloration and detail to a remarkable degree. Furthermore, Johnson has portrayed his sitter at half-length in the small format that he usually employed for less ambitious bust-size portraits. As a result, Aisquith completely fills the canvas, enhancing the impression of a vital, energetic personality. DS

Thomas Cole
American, born England, 1801–1848
View of Fort Putnam
1825. Oil on canvas, 27 x 34 inches (68.6 x 86.4 cm)

Promised gift of Charlene Sussel

A key work in the history of American art, this recently rediscovered landscape by Thomas Cole has been identified as *View of Fort Putnam*, and is the first painting by the artist to enter the Museum's collection. After his first sketching trip up the Hudson River in 1825, the young Cole returned to his studio in New York City and created works that would revolutionize American landscape painting. When he showed them at a Manhattan gallery, three were purchased by influential figures in the New York art world—John Trumbull, the venerable history painter and president of the National Academy of Design; William Dunlap, the artist and writer who wrote a glowing letter about the "discovery" of these works in the *New York Post* on November 22, 1825; and Cole's slightly older contemporary the painter Asher B. Durand, who acquired this painting. The publicity that these men gave to the works secured Cole's reputation and won him several commissions from wealthy patrons, launching his career as the first artist of what would become known as the Hudson River School.

In *View of Fort Putnam*, the river itself is out of sight, beyond the range of hills on top of which the fort stands. Cole devotes the painting to the dramatic play of light and shade across the landscape, which is caused by the dark storm clouds broken by patches of blue sky. Although the canvas lacks the allegorical overtones of some of Cole's later subjects, the aged man in old-fashioned knee britches and tailcoat—perhaps a veteran who served at the fort during the American Revolution—may represent humankind standing in awe before the beauty and grandeur of the American landscape. DS

Ferdinand Olivier
German, 1785–1841

Tuesday: Salzburg Castle Seen from the South

From *Seven Places in Salzburg and Berchtesgaden,
Arranged According to the Seven Days of the Week,
United by Two Allegorical Plates* (Vienna, 1823)
1823. Lithograph with tint stone, image 7 ¹¹⁄₁₆ x 10⅝ inches
(19.5 x 27 cm)

*Purchased with the Lola Downin Peck Fund and the Carl
and Laura Zigrosser Collection (by exchange). 1997-170-4*

Barely two decades after the invention of lithography in Munich, Ferdinand Olivier was using the new medium in Vienna to create an extraordinary album of nine prints (see checklist no. 65). At the heart of the album are seven landscapes representing the days of the week, each a simple scene of daily life set against one of the majestic monuments in the Salzburg region. A poet as well as an artist, Olivier designed the series as a humble paean to man's harmonious relationship with God and nature, intertwining the commonplace with the complex. In each print, recognizable religious allusions are combined with natural cycles of life—times of the day, days of the week, seasons, ages of man. *Tuesday* (seen here) is a midday scene of a young hunter and herdswoman by a pond below Salzburg castle. It captures a chance encounter intended to recall the Old Testament episode when Jacob falls in love with Rachel after catching sight of her bringing her father's flock of sheep to a well.

All nine lithographs in the album are careful constructions of light and shadow using only three colors. In each case, one stone is printed in black over a second stone inked in honey brown, with the paper providing the white accents. Olivier drew the interlocking stones for each print with painstaking precision so that when they are combined, the entire image is magically suffused with glowing light. Conceived and executed over a period of seven years between 1816 and 1823, Olivier's album of lithographs is one of the nascent medium's most enduring masterpieces and a magnificent addition to the Museum's outstanding collection of German Romantic prints. JI

Johann Anton Ramboux
German, 1790–1866
The Brothers Eberhard
1822. Lithograph with tint stone, image 12⅜ x 13¹¹⁄₁₆ inches (31.9 x 34.7 cm)

Purchased with the Lola Downin Peck Fund and the Carl and Laura Zigrosser Collection (by exchange). 2000-119-1

Born in the Rhineland to a French father and a German mother, Johann Anton Ramboux studied for several years in Paris under Jacques-Louis David before completing his artistic education in Rome. On his way home from Italy in 1822, he was able to take advantage of Munich's new lithography workshops and translated a double portrait he had painted in Italy into one of the most splendid examples of print-making of the Romantic era. Ramboux's striking lithograph of the German artists Franz and Konrad Eberhard shares its forthright realism with the penetrating likenesses of German and Italian humanists created three hundred years before, while introducing

a note of tender affection more typical of artists' friendship portraits of his own century.

As a member of the Romantic generation, Ramboux repudiated the prevailing Neoclassical taste, which bore the stamp of Napoleon's fallen empire, and instead drew inspiration from medieval and Renaissance models, blending the simple pieties of earlier times with his own deeply felt reverence for the earlier masters, especially Albrecht Dürer and Raphael. The antiquarian air of this remarkable portrait is heightened by the distinctive type of clothing worn by the Eberhard brothers, who adopted the early Renaissance style of dress favored by so many German artists at this time. JI

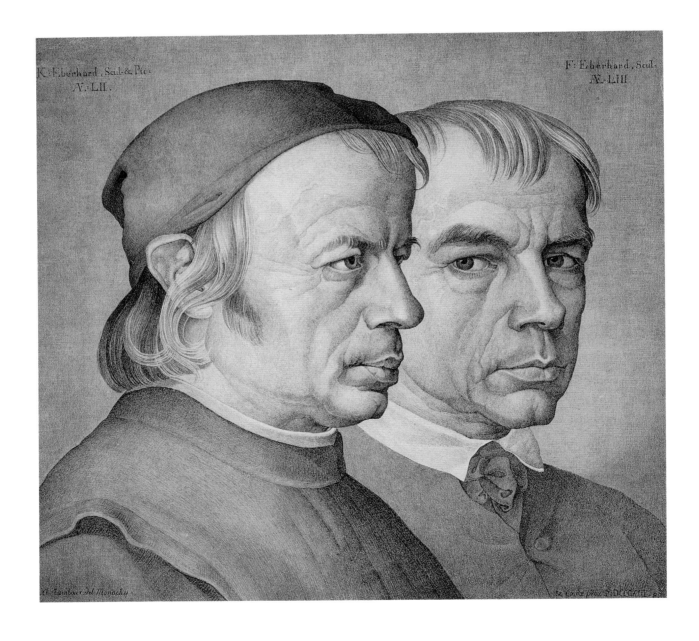

Sir Francis Chantrey
English, 1781–1841
Bust of Sir Walter Scott
1828. Marble, height with socle 26 ¼ inches (66.7 cm)

Promised gift of Martha J. McGeary Snider

Busts by Sir Francis Chantrey are among the greatest achievements of English sculpture. Chantrey portrayed many of the leading figures of his time, fashioning public likenesses for his contemporaries who were enthralled with character, accomplishment, and national prestige.

Chantrey was perhaps best known for his portraits of Sir Walter Scott, then the most famous living author in Europe. This bust is derived from an earlier model made in 1820. As an inscription on the back testifies, it was finished after new sittings with Scott in 1828. Here Chantrey revised his portrait with a number of changes that are subtle but not negligible. Most importantly, Chantrey enhanced and improved the expression of Scott's mouth by showing a hint of a smile. Scott was a challenging sitter for artists, and Chantrey succeeded in capturing his warm and charming presence in this speaking likeness. To set off the head, Chantrey devised a cloaklike tartan garment suitable for a writer associated with Romanticism, medievalism, and Scotland. Chantrey was no realist, however. His portraits are characterized by distinctive broad surfaces—exceptionally well preserved here—that create a generalized image intended for posterity.

In this Museum the sculpture complements the portraits in the important John H. McFadden Collection of English paintings (which also includes a likeness of Scott) and a marble bust by Joseph Nollekens, the leading portrait sculptor of the generation before Chantrey. In the context of nineteenth-century sculpture, the bust of Scott extends the Museum's group of portraits by Bertel Thorvaldsen, Jean-Baptiste Carpeaux, Vincenzo Gemito, and Auguste Rodin. For a figure of Chantrey's importance, his work is surprisingly uncommon outside England; this rendering of Scott can be considered his finest portrait bust in the United States. DW

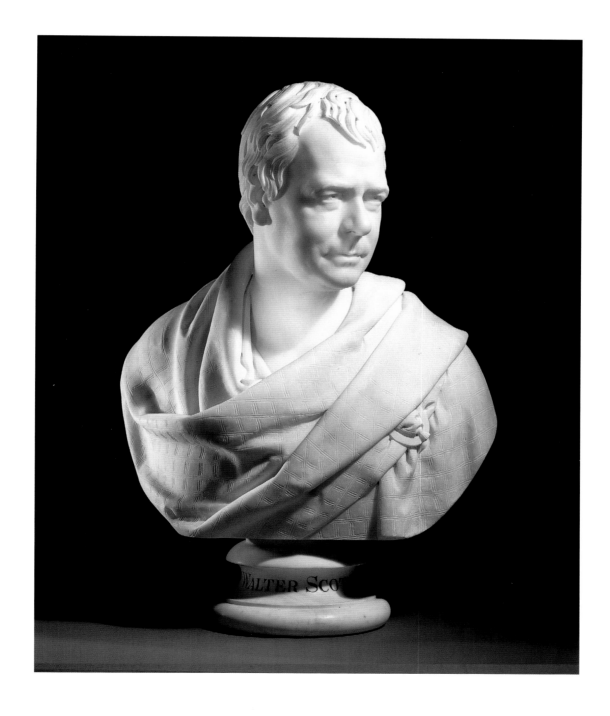

Fireboard

United States, made in Perry County, Pennsylvania; c. 1825–35. Painted pine, height 31 ½ inches (80 cm)

Promised gift of Mary Louise Elliott Krumrine in memory of Jack Milton Krumrine

The vividly colored and tree-dotted landscape of this Pennsylvania fireboard is a rare example of the surviving work of American itinerant decorative painters. The tradition of painting interior paneling was popular in eighteenth-century coastal towns, but fell out of fashion in more style-conscious areas of the post-Revolutionary United States, where the prevailing taste was for Neoclassical architectural styles. However, after 1800 decorative painters moved West, where the homes of the pioneering frontiersmen were greatly enlivened by the vibrant colors of painted panels.

The three known Pennsylvania fireboards, of which this example is one, are believed to have originated in the Perry and Somerset counties near Harrisburg. They differ from those made in New England in their vertical panel construction and compositions of parabola-shaped hills with evenly spaced, tall and lanky trees. The brushstrokes are long and sure, spanning the width of the boards, while several species of trees, variously colored grasses, a fading horizon, and the source of light are all carefully depicted.

This wonderful fireboard joins only one other later example in the Museum's collection, making it a pivotal addition to our holdings of American decorative folk painting. AAK

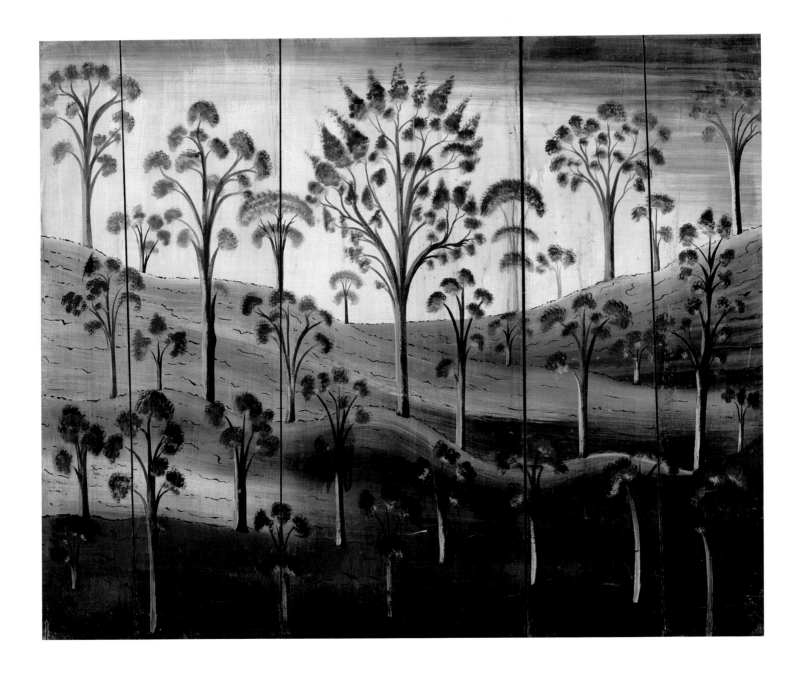

David Drake (known as **Dave the Potter**)
American, 1800–c. 1870
Storage Jar
Made in Lewis Miles Pottery, Edgefield, South Carolina
1859. Alkaline-glazed stoneware, height 26½ inches
(67.3 cm)

Purchased with funds contributed by Keith and Lauren Morgan and with the gifts (by exchange) of John T. Morris, Mrs. John D. Wintersteen, and the Bequest of Maurice J. Crean, and with the Baugh-Barber Fund, the Haas Community Fund, and other Museum funds (by exchange). 1997-35-1

While most slaves in the American South served as agricultural field hands, many others were skilled in crafts related to the rural economy such as pottery-making. The majority of enslaved potters were individuals working in white-owned shops, although in certain areas, such as the Edgefield District of South Carolina, they worked in groups. The black potters of Edgefield were distinguished for their production of large stoneware jars that served mainly as storage containers for staples such as lard and salted meat on farms and plantations.

A spectacular example of the wares of the Edgefield potters, this large storage jar was made in 1859 by Dave, an enslaved African American who adopted the surname Drake once emancipated and became the most accomplished African American potter of the nineteenth century. His work, which spans over forty years and represents the best in the Edgefield tradition, is typically bulbous in form, widest at the top with a thick, rolled rim and high, broad shoulders. His jars were primarily very large food storage containers that he made in turned sections, one layered on top of the other. This example, one of the largest known, is inscribed "Good for Lard or Holding fresh Meat." Dave often incised his works with rhymed couplets, which sometimes refer to the function or reflect his comments on life and religion. Here he wrote, "Blest we were when Peter saw the folded sheet," possibly a reference to an edict allowing early Christians to eat pork. Dave also included the initials of his owner— "LM" for Lewis Miles; the date of its manufacture— "May 3d, 1859"; and his name. As a fine example of African American craftsmanship, this jar is an important addition to the Museum's holdings. MCH

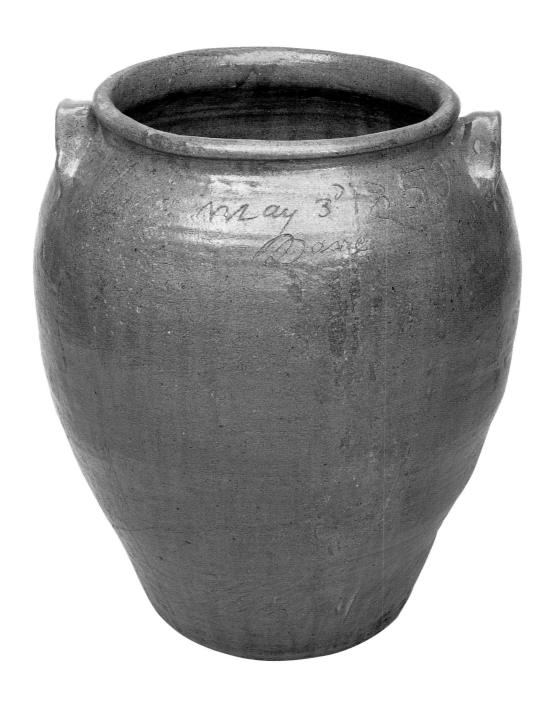

55

William Trost Richards
American, 1833–1905
Landscape with Figure
1866–67. Charcoal and opaque watercolor with ink and
opaque watercolor on wove paper, 22 ¼ x 17 ⅛ inches
(56.5 x 43.5 cm)

Gift of Marguerite and Gerry Lenfest. 2002-55-1

First trained in his native Philadelphia as a designer of ornamental metalwork, William Trost Richards next studied with the German-born painter Paul Weber, whose meticulous style further enhanced the young artist's proclivity for accuracy and minute detail. Given his background and artistic experience, it seems almost inevitable that Richards would have been drawn to John Ruskin's concept of truth to nature in art as well as to the work of the English Pre-Raphaelites, with their preference for graphic clarity and minute detail. During the 1850s Richards was greatly influenced by Ruskin's writings, and by 1863 he was nominated for membership in the Association for the Advancement of Truth in Art—a group of Ruskin's American followers who held that it was the artist's duty to strive for absolute truth to nature insofar that traces of the artist's hand would be virtually effaced from the work.

Soon after joining the association, Richards made several large charcoal landscape drawings, including this example, whose meticulous detail and precision reveal his remarkable ability to control a miniature style throughout a broad surface. In this work, perhaps drawn somewhere in the woods near Philadelphia, Richards uses an astonishing variety of techniques to depict the textures of tree bark and foliage, dappled light and soft shadows, and the subtle progression from a detailed foreground to a more generalized background. The solitary figure—a rare human presence in his forest interiors—provides a measure not only of the immensity of the forest but also of the poetic silence of the spot at a particular moment of the day. With his miraculously precise technique, Richards creates the perfect Ruskinian balance between a loving transcription of the details of nature and an evocation of the sensations it inspires. IHS

William Henry Hunt
English, 1790–1864

Portrait of Mary Bugden Hunt
1827. Watercolor over graphite on wove paper
12⅞ x 8¼ inches (31.7 x 21.1 cm)

A Basket with Grapes and Plums
Late 1820s. Watercolor on wove paper, 7⅜ x 10⁹⁄₁₆ inches
(18.8 x 26.9 cm)

*Promised gift of Charles E. Mather III and Mary
MacGregor Mather*

William Henry Hunt (known as "Bird's Nest" Hunt) learned to sketch from nature during a seven-year apprenticeship with the English painter and draftsman John Varley that began around 1804. A few years later he joined Dr. Thomas Monro's rural academy on the outskirts of Bushey in Hertfordshire, England. There he learned how to draw with the reed pen, copying Monro's collection of drawings by Canaletto and sketching nearby architectural sites.

By 1826 Hunt was made a full member of the Old Watercolor Society and became a regular contributor to its exhibitions. Also around this time he developed a technique of working in broken touches of watercolor, sometimes using a knife to scratch white highlights into the paper. He used this method in the charming portrait of his cousin Mary Bugden Hunt, in which the background wall as well as the sitter's head and arms are painted in tiny stipples, while small white areas scraped out with the knife make points of light on her dainty shoes.

Hunt is best known for his watercolor still-lifes, many of which include the bird's nests that earned him his nickname. Fruit was also a favorite subject, as in this evocative, softly lit composition of grapes and plums. Their surfaces radiate a dull glow that contrasts with the brighter highlights on the finely drawn texture of the woven basket.

These two watercolors are from a gift of five, all of which provide a wonderful range of Hunt's techniques and choice of subject matter (see checklist no. 74). As the first works by the artist to enter the Museum's collection, they are a fine addition to our holdings of British art on paper. IHS

Joseph B. Barry
American, born Ireland, 1757?–1839
Tall Case Clock
Made in Philadelphia, c. 1820–30. Mahogany, mahogany veneer, white pine, and tulip poplar; height 8 feet, 1 inch (2.4 m)

Purchased with funds contributed by Mr. and Mrs. E. Newbold Smith. 2001-81-1

For the amount of early nineteenth-century furniture attributed to Philadelphia cabinetmaker Joseph B. Barry, it is remarkable that only eight objects can be documented to him. Newspaper advertisements and contemporaneous references proclaimed Barry's talent as far exceeding that of other craftsmen. Yet his documented work is limited to a group of chairs, a sideboard, a bed, three pier tables, a bookcase, and this clock—the Museum's first documented and signed Barry object.

Barry was born in Dublin and trained in cabinet shops there and in London. He immigrated to America and began his career in Philadelphia in 1794 as the partner of cabinetmaker Alexander Calder. Beginning in 1797, he operated an independent shop, and in 1805 settled at 134 South Second Street. Barry made brief forays into the furniture markets of Baltimore and Savannah, which helped to disseminate his name and style. In 1811 he traveled to London and Paris, returning with a shipload of European furnishings for sale and a reinvigorated creativity and new sophistication—two attributes synonymous with his furniture.

Barry's remarkable tall case clock is best categorized as classic with a distinctive twist. The hood, or structure that encloses the clock face, was conceived in the traditional style of other eighteenth- and nineteenth-century examples. The carving and veneers are characteristic of nineteenth-century Philadelphia furniture and also demonstrate Barry's signature design: bold, well-conceived, and finely executed. The broken pediment gives rise to a spirited spread-winged eagle. The carved female caryatids, which flank the clock face, are unparalleled in their placement as well as their conception and diminutive size. On the case, the smooth and polished door nearly obscures the inlaid pattern created by the figured veneer. The realistically carved claw-and-ball feet vividly allude to the ancient symbol of the eagle's talons grasping the pearl of wisdom.

Today, when comparing the quality of Barry's furniture design and craftsmanship to that of other American cabinetmakers, it is clear that he still deserves the praise that was bestowed upon him during his own lifetime. AAK

Ammi Phillips
American, 1788–1865
Blonde Boy with Primer, Peach, and Dog
c. 1836. Oil on canvas, 48⅜ x 30 inches
(122.9 x 76.2 cm)

Estate of Alice M. Kaplan. 2001-13-1

Over a career that spanned more than fifty years and is remarkably well documented for an itinerant, self-taught artist, Ammi Phillips may have painted nearly two thousand portraits. Only about five hundred can be securely attributed to the artist today, but these are more than enough to establish him as the most prolific American country portrait painter in the nineteenth century. Phillips's paintings are in such a variety of styles that they have been attributed to several different artists. However, recent research has grouped his paintings chronologically, accounting for their varying approaches by his response to the artistic influences he encountered in his travels. Phillips and his family settled for periods of work in various communities in Massachusetts, Connecticut, and New York State; consequently, his different styles have been named according to their geographic location.

In 1836 Phillips moved to Kent, Connecticut, and the paintings from 1829 to 1838 previously attributed to the "Kent Limner" have been identified as his Kent portraits. _Blonde Boy with Primer, Peach, and Dog_ shows the distinctive style of these paintings at its best. The boy has been identified tentatively as Aaron D. Smith of Catskill, Green County, New York. The dark reddish background, the exquisite subtlety with which the peach, the boy's face, and his hand have been painted, and the variety of ways in which Phillips has boldly abstracted the textures and patterns of costume and setting, all demonstrate the mature skill of an artist without academic training, but one who possesses brilliant talent. The elegance and authority conveyed by this large, full-length, and fully accoutred portrait are equal in spirit to the great aristocratic portraits of any country or age. DS

Made by **Fletcher and Gardiner**
Boston and Philadelphia, active 1808–36
Oval Tray
c. 1820. Silver, width 31¾ inches (80.6 cm)

Thomas Fletcher
American, 1787–1866
Coffee and Tea Service
1839–40. Silver; coffeepot height 12¾ inches (32.4 cm),
teapot height 8¾ inches (22.2 cm) each, sugar bowl
height 9 inches (22.9 cm), cream pot height 6⅞ inches
(17.5 cm), waste bowl height 6 inches (15.2 cm)

*Promised gift of Cordelia Biddle Dietrich, H. Richard
Dietrich III, and Christian Braun Dietrich in memory of
Livingston L. Biddle, Jr., and in honor of Cordelia Frances
Biddle*

Thomas Fletcher was one of the most prolific and inventive silversmiths working in Philadelphia at the beginning of the nineteenth century. This complete coffee and tea service is a grand example of his unique silver designs. Fletcher's masterful skill and distinctive style are evidenced in the full, rounded forms encrusted with ornamental bandings and cast details, the knops that resemble bursting buds, the alternating convex and concave shapes of the pieces, and the way the decorative motifs strengthen the transitions between the various parts of the individual forms.

As the centerpiece of the ensemble, the coffeepot is different in shape and ornament from the other parts of the set. Its tall, smooth, reverse-pear shape and Rococo-style cast spout are reminiscent of eighteenth-century silver design in Philadelphia, while the lively repoussé work of the tall cattails and reeds "growing" out of the base of the pot is a distinctive feature of Fletcher's imaginative style. The retained band of grapevine ornament, which encircles the shoulders on the other pieces, boldly around the midsection of the coffeepot, and dramatically contrasts with the naturalistic cattails and reeds just below.

The coffeepot's ornamentation may refer to the ancestral home of the Craig family, whose coat of arms, motto, and crest are engraved on the set. John Craig was a Scottish shipping merchant who in 1794 bought a tract of land on the Delaware River now known as Andalusia. The vegetation that "grows" from the bottom of the coffeepot may evoke the river's reedy shores, and the unusual placement of the cast grapevine may recall Andalusia's glass grape houses, which by 1835 were celebrated for their abundance. BBG

Made by the **Imperial Porcelain Factory**
Saint Petersburg, Russia, active 1744–present
Pair of Tazzas
c. 1844. Hard-paste porcelain with enamel and gilded decoration, height 13⅜ inches (34 cm) each

Gift of John J. Medveckis in memory of Barbara B. Rubenstein. 2001-156-1, 2

When Augustus II, elector of Saxony and king of Poland, established a porcelain factory at Meissen in Germany in 1710, there was intense competition among the European monarchs to establish their own royal manufactories. After a number of failed attempts, the Imperial Porcelain Factory in Saint Petersburg was founded in 1744 under the patronage of Empress Elizabeth. It flourished during the thirty-year reign of Czar Nicholas I Pavlovich (1825–55), who commissioned dozens of dinner services, many intended for his various residences.

This pair of tazzas, or footed dishes, which bear the crest of the Hessen-Kassel family, was originally part of a large dinner service that was probably a gift from Nicholas I to Wilhelm von Hessen-Kassel and his wife to mark the engagement or wedding of their children, Grand Duchess Alexandra Nikolaevna and Friedrich Wilhelm von Hessen-Kassel, who were married in Saint Petersburg on January 28, 1844. Tragically, in August of that same year, Alexandra died after the birth of their son. The Hessen-Kassel service descended in the family of Friedrich Wilhelm's oldest sister Marie, who inherited it at the time of her parents' death.

Tazzas such as these were piled high with fruit and placed in the middle of the table amid elaborate displays of flowers. By the 1840s fashionable society throughout Europe was dining *à la russe*, or "in the Russian style," meaning that food was passed by servants, thus leaving the table open for such dramatic settings.

These tazzas represent a significant addition to the Museum's collection of Russian porcelain, which previously included only one important piece, a soup plate from Empress Elizabeth's own dinner service, the first one made for her at the imperial factory. DC

Wax Fruit and Dessert Arrangement

United States, c. 1860–80. Beeswax, paraffin, tempera, glass, and wood; height 19 inches (48.3 cm)

Wax Flower-Making Kit

United States, c. 1860–80. Colored paper and board, glass, powder pigments, wire, beeswax, gilded brass, wood, paper patterns, and hair

Promised gift of John Whitenight and Frederick LaValley

From the 1860s to the 1880s, young American women with even the smallest surfeit of time eagerly pursued the art of making wax fruit and flowers.

The colorful arrangements were contained under glass domes, which decorated the most stylish home interiors. All twelve issues of the 1856 volume of *Godey's Lady's Book* featured instructions for fashioning wax parlor art; they explained everything from how to make the plaster of Paris molds to how to paint wilted, bruised, and over-ripened areas of the fruits and flowers for a more realistic effect.

The fine state of preservation of this wax fruit and dessert arrangement reveals the vibrant colors that distinguished wax parlor art. The encasement was made by a specialist whose name is stenciled on the bottom of the wooden base: "John N. Beath, Glass Shades, Wax Flower and Artist Materials. 2100 Frankford Ave. Phila."

Accompanying this splendid gift is an incredibly rare wax flower-making kit, which is contained in a wallpapered box lined with a pre–Civil War era newspaper entitled *The Banner of Liberty.* The kit includes bottled powder pigments, beeswax, wire, wooden tools for modeling the delicate petals, over two dozen ormolu molds for making the wax leaves, and hand-cut paper patterns for making the petals, some of which are labeled "Narcissus," "Lily," and "Rose." The bottom of the kit is inscribed, "To Mrs. Supplee from your most Loving Sister, Kate Cassell," a subtle reminder that parlor arts were reserved for women and represent the domesticity to which women aspired in the era that this Museum was founded. AAK

Made by **R. & W. Wilson**
Philadelphia, active 1825–83
Presentation Urn
c. 1857. Silver, height 26 inches (66 cm)

Gift of Martha Hamilton and I. Wistar Morris III
2001-108-1a, b

The practice of presenting silver objects as tokens of gratitude and honor is first recorded in Western culture in Homer's *Iliad*, where Achilles awards Odysseus a silver bowl for winning a race. This long-standing tradition is represented at the Museum by a number of important pieces of silver, including the 1774 tea urn made by Richard Humphreys for Continental Congress secretary Charles Thomson and this covered urn presented to John Welsh in 1857 by the North Pennsylvania Railroad (later renamed the Reading Line). The inscription on the front indicates that the urn was intended as "a token of respect and gratitude for [his] eminent and disinterested services …when the preservation of Great Public Trust mainly depended on his wisdom and skill."

Welsh was a prosperous Philadelphia merchant who rose to civic and social prominence through a number of philanthropic deeds. He was president of the railroad in 1856 when a train carrying five hundred children from Saint Michael's Church collided with another train in Gwynedd Valley, Pennsylvania. The accident killed over fifty children and injured more than one hundred. Welsh donated five hundred dollars to a relief fund for the victims, a considerable sum at the time and a significant gesture that helped to alleviate the suffering of those affected by the tragedy.

The urn's grand size is equaled by its finely executed decoration. C-scrolls embellished with ruffles, a trademark of eighteenth-century Rococo silver design and its nineteenth-century revival, enclose the inscription. Chased flowers envelope the front, neck, and foot, while Greek keys surround the shoulder. The urn is topped by a cast female figure holding a laurel wreath intended to symbolize honor and distinction. The scene on the obverse of the piece juxtaposes new machinery against nature, and evokes the inherent conflict between the excitement and apprehension that Americans felt about industrialization during this time of great transition. AAK

Portrait of the Son Master Woo Bong-dang

Korea; Chosŏn dynasty (1392–1910), nineteenth century
Ink and colors on paper, 45 x 29 inches (114.3 x 73.7 cm)
(framed)

Promised gift of Allen B. and Heidrun Engler Roberts in honor of the 125th Anniversary of the Museum

Portraiture as a symbol of succession was a Chinese practice introduced in Korea with the advent of Son Buddhism (called Chan Buddhism in China and Zen Buddhism in Japan), which emphasized the direct transmission of essential teachings from master to disciple, with minimal reliance on scriptural sources. Students received portraits of their masters upon obtaining enlightenment. They were also painted after a Son master's death as a commemorative image used in memorial services. This portrait of Woo Bong-dang, whose name is inscribed in the red cartouche at the upper right, is of the latter type.

The frontal pose seen here is typical of these portraits, as are the voluminous gray robe and red cassock. While Chinese clerics are usually shown sitting in a chair, this Korean master is seated on a decorated floor mat, holding a Buddhist rosary in his right hand and a long, lacquered staff—one of the symbols of the Son master's authority—in his left. The richly decorated background serves to emphasize the sitter's strong presence. The artist has not used any modeling or shading, but the clear, unwavering lines of Woo Bong-dang's face, his firm jaw, and penetrating gaze amply suggest the depth of his wisdom. The artist has communicated his subject's otherworldly aura, befitting a man who has attained Buddhist enlightenment and thus is worthy of commemoration.

This exceptional portrait is representative of a group of over twenty Korean and Japanese objects given to the Museum that will complement and transform our growing East Asian art collections (see checklist nos. 12, 26). FF

Ch'aekkori Screen

Korea; Chosŏn dynasty (1392–1910), mid-nineteenth century. Ink and colors on linen, mounted as a ten-fold screen; panel 47 x 12 inches (119.4 x 30.5 cm) each

Purchased with funds contributed by the Korean Heritage Group, the Hollis Family Foundation Fund, and the Henry B. Keep Fund. 2002-74-1

Korean literati of the Chosŏn dynasty were great admirers of the Chinese tradition and sought to surround themselves with the accoutrements of the famed Confucian scholar-official. They collected Chinese ceramics, scrolls, brush pots, and ink stones, many of which are depicted in the screen type known as *ch'aekkori* (scholar's books and utensils). These screens became extremely popular in Korea in the eighteenth and nineteenth centuries, often substituting for the expensive Chinese objects, and the painting styles range from highly sophisticated to folk.

This extraordinary example was obviously executed by a painter of great skill, although he has not signed the piece. The ten panels feature stacks of books, often next to the brushes and ink stones the scholar would use for his calligraphy. Floating above are elegant examples of Chinese ceramics of exotic and archaistic shapes, holding auspicious fruits or flowers such as pomegranates and lotus. One panel includes a large piece of coral from which a gold watch hangs. The artist has rendered all the objects in great detail and subdued colors, reflecting the refined taste of the cultured patron who commissioned the screen.

In 1928 the Museum acquired a nineteenth-century Chinese Scholar's Study as one of its celebrated period rooms, and this elegant Korean screen serves as a beautiful example of the transmission of Chinese culture as reinterpreted by skilled Korean artists. FF

Embroidered by **Caroline E. Bieber** (American, 1827–1885); designed by **Elizabeth B. Mason** (American, 1797–1875)

Embroidered Picture

Made in Kutztown, Pennsylvania; 1843. Plain-weave linen embroidered with tent, seed, and cross stitches in wool and silk; 22 ¼ x 28 ½ inches (56.5 x 72.4 cm)

Gift of Mr. and Mrs. Victor L. Johnson. 1999-173-1

Until the mid-nineteenth century, girls were taught to stitch at school as training for domestic life. A girl as young as four could work a sampler with the cross-stitch alphabets and numbers that were used to mark familial linens. By the time she was in her early teens, she could create showy samplers with pious verses or elaborate but purely decorative needlework pictures. These ornately stitched works were meant to be proudly displayed, exhibiting not only her skill with the needle but also her industry and artistic taste.

A schoolmistress often designed her pupils' compositions, which reflected the patterns she had learned or the style preferred by the local community. Elizabeth B. Mason, who designed this lavish picture, taught needlework at the school she and her husband ran in Kutztown, Pennsylvania. Displaying the colorful aesthetic of the Lehigh Valley, the needlework made under her supervision features abundant flowers and foliage, either serving as a deep border or, as here, dominating the picture. This densely packed composition, in schoolgirl Caroline Bieber's tiny, meticulous stitches, is interspersed with enormous birds feeding a nest of chicks and smaller birds and butterflies. Below, a flock of sheep grazes on an abstract patchwork of paving stones, flanked by a boy with a dog and girl at a well, who dwarfs the building beside her.

An interest in needlework was manifest at the Museum from its founding year, when an elaborate Spanish sampler was acquired. In 1904 the Museum organized the first exhibition of samplers in the United States. The collection now includes nearly seven hundred samplers and embroidered pictures. This impressive object enhances already extensive holdings of schoolgirl embroidery from Pennsylvania, including important eighteenth-century Philadelphia examples and Pennsylvania German work from the late eighteenth to the mid-nineteenth century. HKH

Possibly made by members of the **Independent Order of Odd Fellows**
Album Quilt

Made in Stanford, Dutchess County, New York; 1853
Appliquéd cotton, silk, and velvet; 87¾ x 87¾ inches
(222.9 x 222.9 cm)

Gift of Elizabeth Albert. 2001-204-1

During the mid-nineteenth century, the album quilt reached the height of its popularity; its embroidered or appliquéd blocks with signatures were meant to resemble pages from the pictorial, remembrance, and autograph albums that were common at the time and valued as expressions of affection and friendship. The Museum holds a significant collection of these quilts, including important examples from the Philadelphia and Baltimore areas dating primarily from the 1840s. This quilt from Stanford, New York, is dated 1853 and made up of blocks contributed and signed by the family and friends of Richard H. Mosher. It is the first figurative album quilt to enter the Museum's holdings.

Forty-eight blocks surround a center block that is appliquéd with three intersecting links representing friendship, love, and truth, symbols of the Independent Order of Odd Fellows. The first American branch of this fraternal organization, which originated in eighteenth-century England, was founded in Baltimore in 1819. Guided by their belief in the brotherhood of man, Odd Fellows saw it as their duty to visit the sick, relieve the distressed, bury the dead, and educate the orphaned. Their wives and daughters were also offered a means of supporting these principles with the establishment of the Rebekah degree in 1851. This quilt contains blocks with symbolic references to the Odd Fellowship and the Rebekah degree, such as the moon and stars and the dove. Some of the more topical motifs, possibly based on popular prints of the period, include an image of Topsy from the recently published *Uncle Tom's Cabin*, kittens playing with balls of yarn, a log cabin, and soldiers on horseback.

Initial research has established that Mosher, a laborer and a member of the Society of Friends, died in 1854, a year after the quilt was presented to him. According to the Odd Fellows manual of 1865, Quakers were doubly honored because of their support of the poor. DB

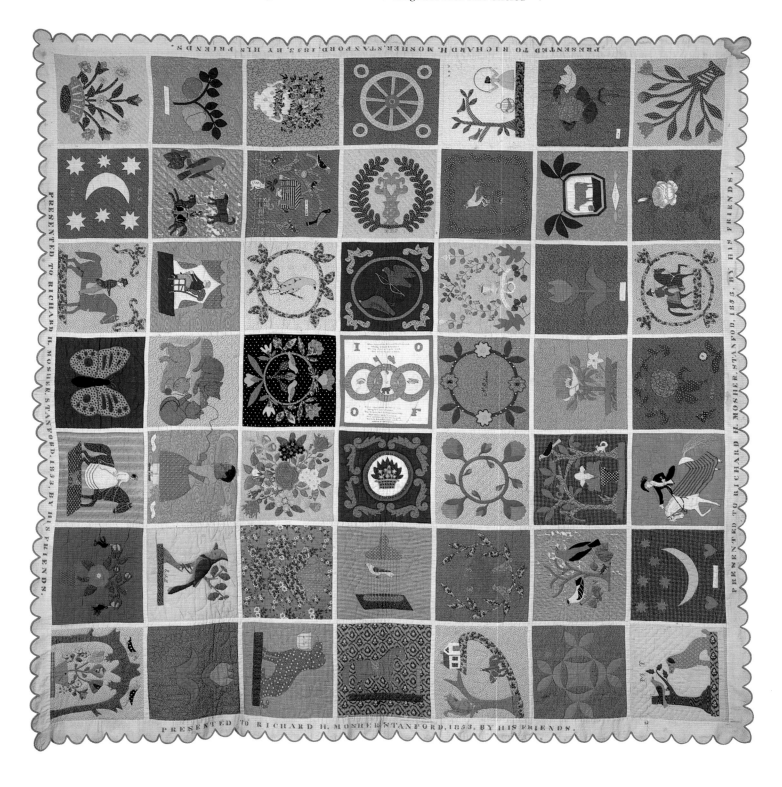

Artist unknown
Possibly French, active United States?
Portrait of Gouverneur Morris
c. 1805–10. Watercolor on ivory, 2 ¹¹⁄₁₆ x 2 ¼ inches (6.7 x 5.7 cm)

Robert Field
American, born England, c. 1769–1819
Portrait of Miss Henrietta Sprigg
c. 1795. Watercolor on ivory, 3 ¾ x 3 inches (9.5 x 7.6 cm)

Elias Brenner
Finnish, 1647–1717
Portrait of King George I of England
c. 1715. Watercolor and gold on parchment, 1 ½ x 1 ¼ inches
(3.7 x 3 cm)

Christian Friedrich Zincke
German, active England, 1683/84–1767
Portrait of an English Nobleman
c. 1720. Enamel on porcelain, 1 ¾ x 1 ½ inches (4.5 x 3.7 cm)

Gift of Mr. and Mrs. Joseph Shanis and Mr. and Mrs. Harris Stern in memory of Jeannette B. S. Whitebook Lasker. 2000-137-20, 3, 13, 16

Worn as pendants and bracelets, carried within a pocket, or hung in a cabinet, portrait miniatures were prized for their likenesses of family members, friends, and loved ones as well as for their minute size, precious materials, and skillful execution. The anniversary gift of a remarkable group of eighteenth- and nineteenth-century miniatures assembled by Jeannette B. S. Whitebook Lasker forms a prominent addition to the Museum's collection, contributing works in innovative and challenging techniques by leading artists (see checklist nos. 52, 143).

In the American republic, prominent citizens of Boston, Philadelphia, and Baltimore commissioned miniatures from itinerant artists. Gouverneur Morris, a member of the Continental Congress and later a senator from New York, sat for his portrait by a foreign-born, possibly French, artist. Presented in the fashionable clothes and hairstyle of the early nineteenth century, he wears a miniature, perhaps depicting his wife, pinned to his chest.

Miss Henrietta Sprigg of Strawberry Hill near Annapolis, Maryland, was painted in a large oval miniature by Robert Field shortly after he arrived from England in 1794. Set against a sweeping red curtain with a pillar and clouds in the background, she has a youthful, fresh expression that demonstrates Field's early talent.

From 1660 to 1720 some miniaturists worked in shades of black and white on card or parchment. A skilled artist in this technique was Elias Brenner, a miniature painter to the Swedish court, engraver, and author of a treatise on pigments. His miniature of the English king George I is delicately worked with watercolors and gold on parchment.

Enamel miniatures in which brilliant colors were fired onto a porcelain base were also popular in the eighteenth century. One of the finest enamelists was Christian Friedrich Zincke, a German artist who worked in England. His miniatures were highly sought for their smooth surfaces, saturated colors, and realistic depictions of velvet and lace, all visible on this portrait of an English nobleman. JT

Designed by **Charles Frederick Worth**
English, active France, 1825–1895
Two-piece Day Dress
c. 1878–80. Silk faille and brocaded silk lampas trimmed
with lace, silk satin, and beads

*Gift of the heirs of Charlotte Hope Binney Tyler
Montgomery. 1996-19-7a, b*

The art of haute couture emerged in the 1860s,
largely through the artistic invention and promo-
tional skills of Charles Frederick Worth. The first great
Parisian couturier, the English-born Worth gained the
patronage of Empress Eugénie and attracted clients
from around the world, including many wealthy
American women who saw a visit to Europe as an
opportunity to acquire an expensive wardrobe from
Maison Worth. Fashion magazines featured and adver-
tised his designs, and characters in novels even dreamt
of owning one of his dresses.

Worth, who began designing dresses in 1857, was
in partnership with Swedish businessman Otto Bobergh
until 1870. Five of the eight garments in this important
gift date to the last years of that successful partnership
(see checklist no. 35). Obviously made for a young
woman, the dresses are youthful in style and, for the
Gilded Age, fairly restrained in trimming and fabric.
Their pristine colors range from lavender and various
pinks to acidic apple green and sickly greenish yellow.

Three dresses from the mid- to late 1870s illustrate
Worth's talent for complex combinations of colors,
textures, and trimmings. In the example pictured here,
Worth used a brightly brocaded floral silk to soften
the austerity of the black silk faille. It also shows the
design and construction features Worth used to
emphasize the ideal feminine figure. Curved seams
give the bodice an hourglass shape, which is accented
by satin-edged triangular inserts of the brocade at
front and back. Full hips are enhanced by a puffed
overskirt, bordered in front by iridescent beaded fringe
over the brocade center panel. The floral fabric is most
dramatic down the back of the skirt, where it emerges
from under the bodice's pert bustle tails to flow into a
graceful train. HKH

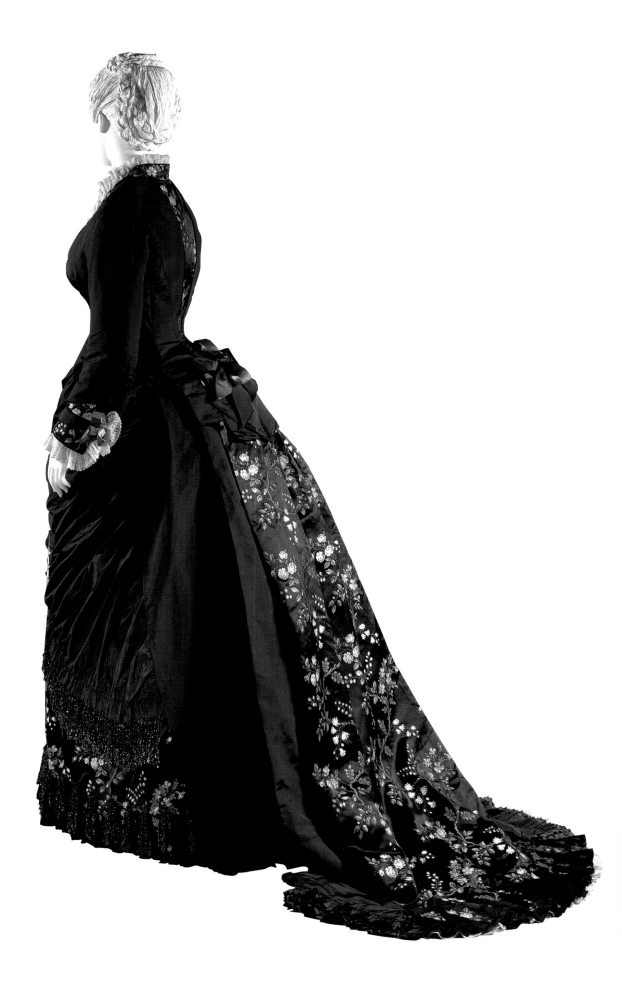

Augustin Amant Constant Fidele Edouart
French, 1789–1861

Married Children of Joseph Lea and Sarah Robeson Lea with Their Children

1843. Silhouette of cut paper adhered to a sheet of beige wove paper, with details drawn in brown ink and brown washes over graphite; sheet approximately 20 x 30 inches (50.8 x 76.2 cm)

Gift of Mrs. Samuel R. Shipley III in honor of Harvey S. Shipley Miller. 2002-6-1

After living and working in France, England, and Scotland, Auguste Amant Constant Fidele Edouart, an accomplished silhouettist, came to the United States in 1839, and over the next decade cut silhouettes all over the country. In 1843, while in Philadelphia, he made more than 350 cuttings of individuals and families living in the city, many of whom were prominent members of the Society of Friends. Edouart's exceptional skill is amply demonstrated in an unusually large pair of silhouettes of the Lea family, one of which is shown here (see also checklist no. 75). The Leas posed for the artist at Milverton, their ancestral home outside of Philadelphia on the Wissahickon Creek.

Edouart's technique was to take a piece of paper, white on one side and black on the other, fold the black side in, sketch his subject's profile in pencil on the white side, and then cut it out. He was a master of detail, seen here in his inclusion of toys, dolls, walking sticks, watches, and furniture, as well as his attention to the architectural features of the rooms. The family is engaged in a variety of activities: the ladies knit and converse, the men talk and hold various objects, while children play and babies wait on tasseled pillows.

Edouart often made duplicates and saved them in albums, allowing him to create future cuttings for customers without having them pose again. When he returned to France in 1849, he lost most of his duplicates, said to have numbered over 50,000, in a shipwreck. The loss so affected him that he never resumed his profession.

Edouart's surviving work is significant in that it records the likenesses of many early nineteenth-century individuals whose features would otherwise be lost. It also provides graphic evidence of contemporary taste in fashion and interior decor as well as changing ideas of childhood and family. The Museum is fortunate to have such a fine example of this folk art form so delicately rendered by a prolific silhouette artist. MCH

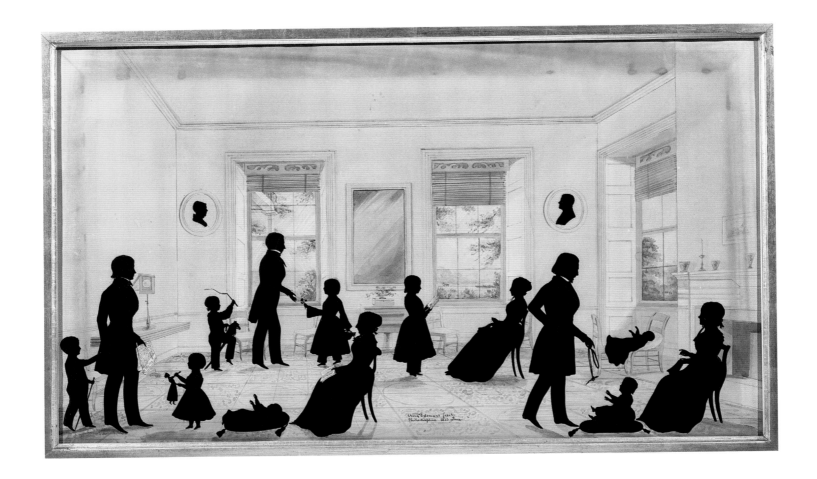

J. Mitchell Elliot
American, 1866–1952
Quakeress
c. 1900–1920. Platinum print on tissue, sheet 9½ x 7⁷⁄₁₆ inches (24.1 x 18.9 cm)

Gift of Harvey Stokes Shipley Miller in memory of Walter Penn Shipley. 2001-220-1

While still a student at Germantown Academy in Philadelphia in 1885, J. Mitchell Elliot became a member of the local photographic society. He later operated a successful portrait studio for forty years. Elected as an associate member of Alfred Stieglitz's Photo-Secession in 1902, Elliot was in the vanguard of the movement to establish photography as a fine art. He exhibited with the group in Europe and was included in the landmark *International Exposition of Pictorial Photography* in Buffalo, New York, in 1910.

Elliot's powerful image *Quakeress* transcends the depiction of a specific individual. The sitter is shown in an austere profile view, her features sharply highlighted against the dark, unfocused background. This dramatic effect is enhanced by Elliot's use of the platinum process—legendary for its softness and tonal richness—coated onto extremely thin tissue instead of traditional photographic paper. The resulting image reveals a level of craftsmanship that was meant to counterbalance the proliferation of amateur snapshots that began to appear after the introduction of the Kodak camera in 1888. In titling his work *Quakeress* instead of with the sitter's name, Elliot shares his intention to make not just a portrait but a picture of the strength and character of the Quaker people, which has been so integral to the history of the city and region. The sitter herself—Sarah Williams Emlen, a resident of Germantown—rightfully claimed the full gravity of that heritage as a descendant of William Penn. KW

Adriano Cecioni
Italian, 1836/38–1886
Boy with a Rooster
c. 1868. Bronze, height 31 inches (78.7 cm)

Gift of Mr. and Mrs. Stewart A. Resnick. 2001-158-1

The Florentine artist Adriano Cecioni made his international reputation in 1870, when this amusing, literal, and compelling statue was shown at the Salon in Paris. Immediately recognized as the central sculptor in the new Italian movement called *Verismo* (Realism), Cecioni's distinctive personality and quick wit made him one of the most original artists associated with this style.

The artist took his subjects from everyday life but rendered them in traditional Tuscan sculptural motifs, all with ingenuity and remarkable technical skill. At first this work seems like a popular and vulgar genre piece of a little boy undone by his own mischief in trying to hitch a rooster to his toy cannon. It is, in fact, a pointed and very modern reference to Andrea del Verrocchio's Renaissance masterpiece *Putto with a Dolphin*, in the Palazzo Vecchio, Florence. The sculpture also harks back to numerous Hellenistic marbles in which children are shown grappling with geese. Cecioni's modernity and innovation are evident in his sculpture's appropriation and popularization of models from the past.

Both the original plaster and a marble are in the Palazzo Pitti, Florence. This exceptionally sharp and finished cast is marked by the French *fondeur* Louis Martin. The inscription, *Medailles Wien*, on the base may refer to the Vienna Exhibition of 1873, where the piece was shown and praised, particularly for the veracity of the casting. JJR

Made by **Jennens and Bettridge**
Birmingham, England, active 1816–64
Work Table
1851. Painted and gilded papier-mâché, mother-of-pearl, silk velvet, and silk; height 29¼ inches (74.3 cm)

Bequest of Emilie deHellebranth. 2001-152-1

Jennens and Bettridge of Birmingham, England, was among the foremost manufacturers of papier-mâché articles in the nineteenth century. The firm was awarded a prize medal in its class at the *Great Exhibition of the Works of Industry of All Nations*, held in London's Hyde Park in 1851. The *Art Journal Illustrated Catalogue*, a contemporary record of the Great Exhibition, fea-tured engravings of a number of objects from Jennens and Bettridge's display, including this work table. Commended by the authors for its novel shape, the table is in the Moorish style, incorporating variations of arabesque ornament and Renaissance-inspired forms. Its top is adorned with imitation gems mounted beneath foiled glass, a method of decoration patented by the firm and thought particularly suitable for objects in the Alhambra style. The jeweled lid opens to reveal a variety of needlework tools arranged in a vel-vet tray, which, when removed, uncovers a silk-lined storage compartment below.

Traditionally, papier-mâché (an English term incorporating the French word for "chewed") was molded from pulped paper and glue. By the middle of the nineteenth century, however, the finer examples of papier-mâché, such as this table, were more commonly made with sheets of paper that were compressed into a mold and heat dried. The surface was then japanned—a process that imitated Asian lacquer-ware—before being ornamented with mother-of-pearl, painted, and gilded.

Evidence suggests that both the work table and a related toilet box (see checklist no. 46) were purchased in England in the 1850s and remained in the buyer's family until entering the Museum's collection. The importance of the manufacturer, the quality of the workmanship, the strength of the provenance, and the association with London's Great Exhibition of 1851 all combine to make the table and the toilet box the most significant articles of papier-mâché among the Museum's holdings. DLM

Jean-Auguste-Dominique Ingres
French, 1780–1867
Antiochus and Stratonice
1860. Oil on canvas, 13¾ x 17¾ inches (35 x 45.1 cm)

Promised gift of Maude de Schauensee and Maxine de S. Lewis in memory of their parents, Williamina and Rodolphe Meyer de Schauensee

When Jean-Auguste-Dominique Ingres created this work for Comte Duchatel in 1860, he returned to the well-known classical story of Antiochus and Stratonice, which he had illustrated many times throughout his career. Taken from Plutarch's *Lives of Illustrious Men*, the tale involves Stratonice, the young bride of Seleucus, king of Syria, and Antiochus, the king's son. When Antiochus inexplicably becomes deathly ill, the royal physician, Erasistrate, discovers that he is literally dying from his love for his father's wife. In order to save his son from a premature death, Seleucus gives Stratonice to him.

Here Ingres chose to depict the moment when Stratonice enters the room and the doctor detects her effect on his ailing patient. Her figure is the focal point of the ornate interior, which is a painstaking reproduction of a Pompeiian palace. Stratonice's captivating expression demonstrates the artist's exceptional ability to convey a sense of psychological complexity in his figures. Antiochus lies face down on the bed, while the doctor takes his pulse and guesses the cause of its fluctuation. Seleucus is reduced to a crumpled heap covered in a red shawl as he kneels beside his dying son. Through his artful composition and use of contrasting colors, Ingres has created an image at once stoic and passionate, historically rich and immediately tangible.

This painting complements the Museum's fine collection of nineteenth-century French art and enhances the holdings of Neoclassical painting. Specifically, it joins two other works by Ingres, the early *Portrait of the Countess of Tournon* of 1812 and *The Martyrdom of Saint Symphorien* of 1865. JZ

Édouard Manet
French, 1832–1883
Basket of Fruit
1882. Oil on canvas, 15 x 18⅛ inches (38.1 x 46 cm)

Anonymous partial and promised gift. 2000-156-1

In the last year of his life Édouard Manet abandoned his most ambitious projects and spent his time painting portraits, still-lifes, and landscapes. The works were modest in scale but experimental in technique. He painted many of them with bold colors and visible brushstrokes and, in his own way, moved closer to abstraction by taking simple objects as his subject matter and concentrating on the physical aspects of the paint.

In this work the artist placed the basket of fruit in the middle of a geometric composition. He hastily sketched the background and tablecloth in brown and white, but the pieces of fruit are an accretion of judiciously applied colors. Manet's rendering of the fruit appears similar to Paul Cézanne's more famous technique, in which thick strokes of paint provide a convincing illusion of geometric form. However, Manet's application of paint is slick, not crusty, and retains a sense of immediacy that enlivens the everyday objects. The shadows of the basket and single apple in the foreground hint at the psychological complexity that charges this simple work with the artist's personal vision.

Basket of Fruit is the first still-life by Manet to enter the Museum's distinguished collection of his work. It is also the latest painting by the artist in our holdings, and represents an important transition between Manet's earlier work and the innovations of later artists such as Cézanne and Auguste Renoir. JZ

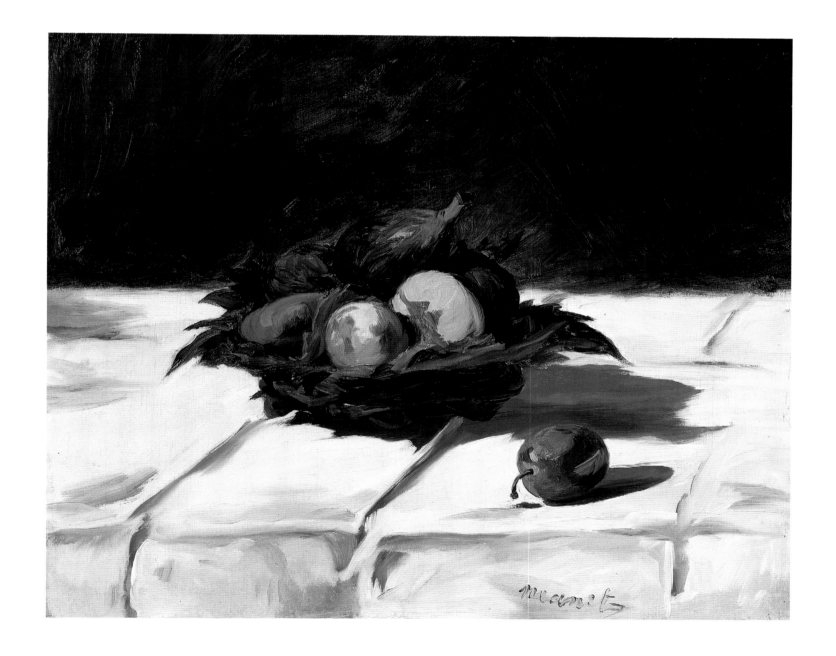

Claude Monet
French, 1840–1926
Path on the Island of Saint Martin, Vétheuil
1881. Oil on canvas, 29 x 23½ inches
(73.7 x 59.7 cm)

Promised gift of John C. and Chara C. Haas

The history of Impressionist landscape painting could be written in large part by tracing the meandering course of the river Seine from Paris to the sea. Claude Monet, at various points in his life, worked (to follow the current) at Argenteuil, Bougival, La Roche-Guyon, and finally Giverny.

In 1879 the artist moved with his extended family to the small and charming village of Vétheuil, on the north bank of the Seine beyond La Roche-Guyon. Over the next three years the town, on a steep bank and dominated by the tower of its twelfth-century church, became his central landscape motif. There are few places (other than Étretat perhaps) that are more central to this restless and ever-exploring artist.

The winter of 1880 was among the most severe in the history of France. The snow and winter weather provided Monet with some of his most poetic subjects while in Vétheuil. Perhaps for this very reason, the artist returned there to paint a series of views from the south bank of the Seine. It has been said that the severity of the winter years earlier was directly related to the gentle and lush pictures that followed, which could, in some measure, explain the present work. This painting is, in effect, a celebration of a summer day: radiant, calm, and reassuring.

By this time Monet had evolved into a master draftsman in paint, completely abandoning the broad, blunt dashes and brushstrokes he used in the 1870s. In this work the entire surface reads like a gauze of spun sugar; long, fine lines web over thinly brushed strokes, creating a remarkably exuberant effect. The poplars in the background read like twirling configurations of blue and green, while the clouds are painted in a broad and wet manner that suggests the flat quality of the sky at midday. JJR

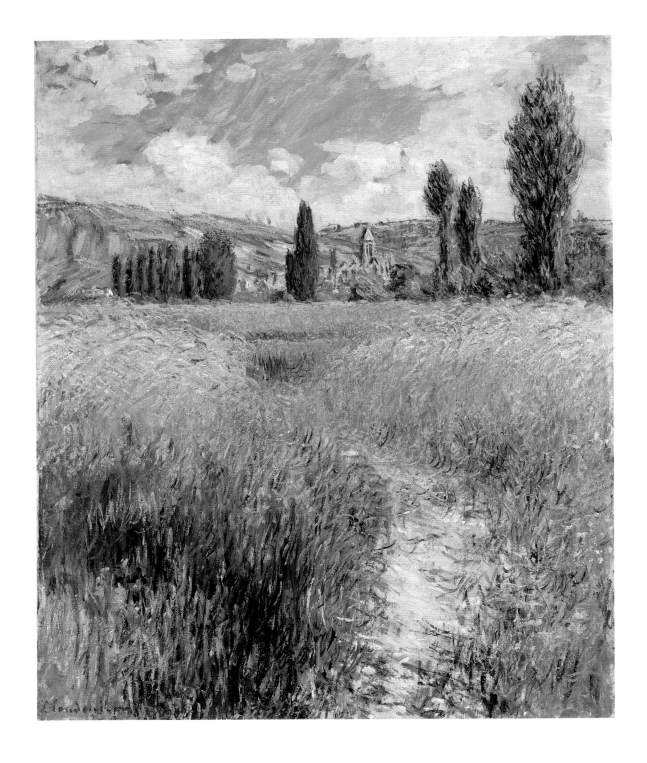

Claude Monet
French, 1840–1926
Under the Pines, Evening
1888. Oil on canvas, 28¾ x 36¼ inches (73 x 92.1 cm)

Gift of F. Otto Haas, and partial gift of the reserved life interest of Carole Haas Gravagno. 1993-151-1

Claude Monet spent the first half of 1888 in Antibes on the French Riviera, where he continued to experiment with painting scenes under varying conditions of light. In this work, painted from the Cap d'Antibes, the artist has adroitly conveyed the evening glow of the Mediterranean Sea. The raking late-day light is fashioned from bright pastel strokes of pigment on the underside of the trees and the ground below, while the rich palette of the cool green treetops provides a striking contrast to the other high-keyed colors. The staccato rhythm of the brushstrokes in the trees creates an overall decorative pattern, invigorating the scene with a vitality that keeps the viewer's eye moving across the surface of the image.

Monet's work in Antibes would eventually lead to his famous series paintings, such as the "Haystacks" and the "Poplars," both from the 1890s. However, unlike these later, more abstract compositions, there is a naturalistic sensibility in this painting, which emerges from the artist's attention to detail with his use of intense color sensations.

At the Museum this work joins *Morning at Antibes* of 1888, and adds greater dimension to our substantial holdings of paintings by the artist. Indeed, this gift, together with *Path on the Island of Saint Martin, Vétheuil* (opposite), helps to confirm the Museum's standing as one of the essential collections of Monet's work. JZ

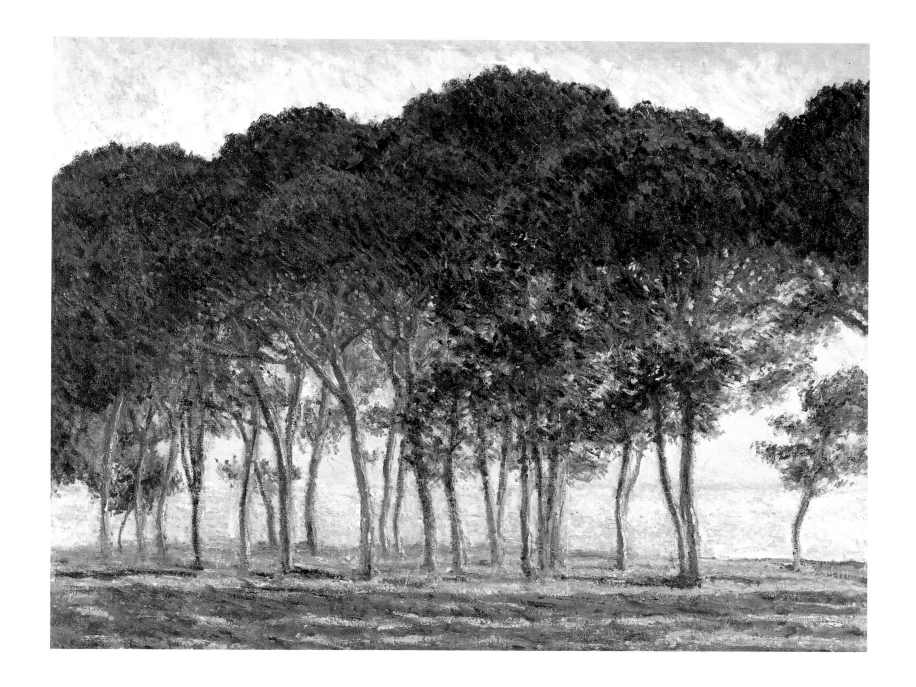

Fireman's Coat

Japan, nineteenth century. Plain-weave cotton with cotton *sashiko* (darning stitches), 39¾ x 46½ inches (101 x 118.1 cm)

Futon Covers

Japan, nineteenth century. Plain-weave cotton with *tsutsugaki* (rice-paste resist); 65¾ x 52¾ inches (167 x 134 cm), 70 x 52⅛ inches (177.8 x 132.4), 68 x 51¾ inches (172.7 x 131.4 cm)

Purchased with funds contributed by the Otto Haas Charitable Trust, The Women's Committee of the Philadelphia Museum of Art, Maude de Schauensee, Theodore R. and Barbara B. Aronson, Edna and Stanley C. Tuttleman, The Hamilton Family Foundation, and Maxine and Howard H. Lewis in honor of the 125th Anniversary of the Museum. 2001-113-14, 35, 7, 1

The purchase of Harry G. C. Packard's notable collection of thirty-eight traditional Japanese textiles has significantly enhanced the Museum's holdings of textiles and clothing from Japan by adding outstanding examples in the *mingei* tradition—crafts made for use in daily life (see checklist no. 7).

The Museum's hitherto modest collection of Japanese folk textiles was formed relatively recently with such acquisitions as the *kasuri* fabrics (textiles woven with dye-resistant yarns) purchased in 1965 from Mrs. Edgar J. Stone's collection, and a varied group of garments acquired in 1996, which included a fisherman's coat, a sledding vest, and a fireman's helmet. The purchase of Packard's collection expands the holdings to include bed coverings *(futonji)*, entry curtains *(noren)*, and clothing that ranges from firemen's coats to Okinawa kimonos to garments made by the Ainu people. Over half of the textiles in the collection feature masterful examples of the *tsutsugaki* technique—a process by which designs are drawn freehand in a rice paste that resists the indigo dye and colored pigments. These textiles, which traditionally formed part of a bride's trousseau, were often decorated with bold designs that carry auspicious meaning. The mythical phoenix on one futon cover, for example, symbolized peace and happiness, while the tea utensils on another reflect the significance of the tea ceremony. The decoration on the inside of this fireman's coat is inspired by the folktale of Momotaro, a boy born from a peach who set out to vanquish the ogres living in the Japanese countryside.

Packard's approach to acquiring Japanese art in all mediums was marked by the outstanding connoisseurship evident in his collections now dispersed to the Metropolitan Museum of Art in New York, the Asian Art Museum in San Francisco, and this Museum. DB

Designed by **Louis Comfort Tiffany**
(American, 1848–1933); made by **Tiffany & Co.** (New
York, active 1837–present)
Column
c. 1898–1902. Iridescent favrile glass, wood, metal, and
gilding; height 11 feet, 2 inches (3.4 m)

*Purchased with funds contributed by Marguerite and
Gerry Lenfest, Jaimie and David Field, The Tiffany & Co.
Foundation, the Robert Saligman Charitable Foundation,
Mr. and Mrs. William T. Vogt, Mr. and Mrs. Robert A. Fox,
the Young Friends of the Philadelphia Museum of Art, the
Philadelphia Fountain Society, Mrs. Eugene W. Jackson,
Betty J. Marmon, and other donors in honor of the 125th
Anniversary of the Museum. 2001-79-1*

As early as 1899, Museum curator Edwin AtLee
Barber began to acquire vases and other works of
art by the contemporary glassmaker and designer
Louis Comfort Tiffany. The recent acquisition of this
eleven-foot column covered with iridescent favrile
glass mosaic has added a new and spectacular dimen-
sion to the Museum's collection of works by this
important artist, and enhances the scope of our hold-
ings of important architectural elements.

Tiffany, originally trained as a painter, began study-
ing medieval glassmaking processes and techniques at
an early age. He believed that nature should be the
primary source of design inspiration and frequently
experimented with new methods of glass manufacture
to produce objects exhibiting a wide variety of color
and texture.

During the 1890s Tiffany developed an interest in
the ancient art of mosaic and achieved unparalleled
effects in his modern creations in this technique. This
unusual glass mosaic column, one of a series of six,
exemplifies his experimentation with and mastery of
the medium. The character of these columns resonates
with those found at Pompeii; they are covered with
individual tesserae of iridescent favrile glass that grad-
ually blend from bright peacock blue at the top to
midnight blue and then iridescent black at the bot-
tom. The design reflects a combination of popular
motifs that looked to ancient and exotic sources for
inspiration, such as the gilded diaper pattern and long
cords with tassels, reminiscent of Turkish textiles.

The columns were originally displayed in the show-
rooms of the Tiffany Studios in New York. They were
eventually moved to Laurelton Hall, the artist's resi-
dence in Long Island, New York, which was completed
in 1904. The house burned down in 1957, but fortu-
nately at that point the columns had been stored in
the stable and survived the fire. Five of the columns,
including this one, now belong to museums; the sixth
is in a private collection. MCH

Made by **Mintons, Ltd.**
Stoke-on-Trent, England, active 1793–present
Pair of Vases
c. 1905. Earthenware with relief-molded and block-printed
decoration, height 18 inches (45.7 cm) each

Gift of the Levitties Family. 2001-155-2, 3

In 1901 the Mintons factory, inspired in part by the continental Art Nouveau style, began producing a line of slip-decorated ceramics that was marketed as "Secessionist Ware." The new product took its name from the Viennese Secession, an organization of artists, designers, and architects founded in Vienna in 1897, which sought a modern style and lent its name to the Austrian version of Art Nouveau. Although

Mintons Secessionist wares had little in common with the ceramics designed in Vienna, the name nevertheless signaled the company's interest in producing pieces that reflected contemporary design trends.

The Secessionist line was originally designed by Léon Victor Solon and John W. Wadsworth. Solon was the son of Marc-Louis-Emmanuel Solon, one of the foremost ceramicists of his day and the most famous practitioner of *pâte-sur-pâte* decoration—a complicated and expensive method of decorating porcelain in relief. The young Solon began his association with Mintons in the late 1890s and specialized in slip-decorated ceramics. After leaving the Mintons factory in 1905 and immigrating to the United States in 1909, Solon became interested in architectural decoration. In 1921 he was commissioned to provide the polychromed terra-cotta figures for the pediments of this

Museum's new building on Fairmount.

As seen in this pair of vases, raised-slip decoration, whether applied by hand or relief-molded, was particularly well suited to the linear character of the Art Nouveau style. In addition, it could be produced quickly and inexpensively. On the wares, the slip decoration often appeared in conjunction with colored block-printing, a process that was patented in 1848 and used extensively on Mintons tiles.

Among the purchases that the newly founded Philadelphia Museum of Art made at the Centennial Exhibition in 1876 were two vases with *pâte-sur-pâte* decoration designed by Solon's father and made at Mintons in 1875. It is fitting, therefore, that these two Secessionist ware vases join them 125 years later to enrich and expand the Museum's holdings of ceramics by both father and son. DC

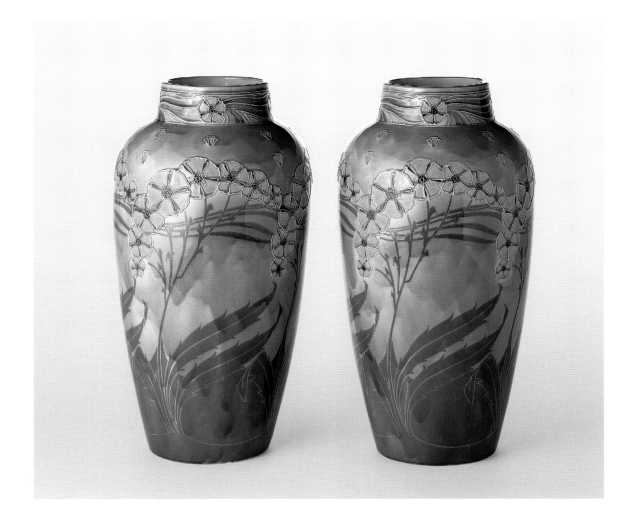

Joseph Keiley
American, 1869–1914
Miss de C.
c. 1902. Glycerine platinum print, sheet 6⅝ x 3¹³⁄₁₆ inches (16.8 x 9.5 cm)

Alvin Langdon Coburn
British, born United States, 1882–1966
Self-Portrait
c. 1902. Platinum print, sheet 11⅛ x 8¾ inches (28.3 x 22.2 cm)

Purchased with the Lola Downin Peck Fund, the Alice Newton Osborn Fund, and with funds contributed by The Judith Rothschild Foundation in honor of the 125th Anniversary of the Museum. 2002-19-41, 12

In 1902 Alfred Stieglitz initiated the Photo-Secession movement, which advocated the highest standards for photography at a time when the medium was considered relatively artless. Stieglitz handpicked a dozen founding members from across the United States, including Frank Eugene, Gertrude Käsebier, and Edward Steichen. The movement was the springboard for Stieglitz's exhibition space, "The Little Galleries of the Photo-Secession," later called "291" for its address on Fifth Avenue in New York City.

The Museum is fortunate to have acquired a distinctive group of ninety photographs by artists affiliated with the Photo-Secession from the collection of the eminent art historian William Innes Homer. Formed over the course of several decades, the holding was assembled to demonstrate the scope and creative accomplishments of this important chapter in the history of photography. All of the major members of the group are represented, along with even rarer works by less-recognized artists. These strikingly beautiful images show the photographers' use of a wide range of printing techniques, including platinum, gum, and carbon prints, cyanotype, and prints on tissue. The collection complements the Museum's select but modest number of Photo-Secessionist photographs and enhances our holding of Stieglitz's work by representing his early circle of associates (see checklist no. 202).

Though not a founding member, Alvin Langdon Coburn was a vital part of the Photo-Secession. In its founding year he joined the movement and opened his first photography studio in New York. He made this self-portrait when he was about twenty years of age, an eventful time in his life when he was beginning to shape his image as an artist.

Joseph Keiley was a photographer and critic affiliated with the Camera Club of New York when Stieglitz asked him to be a founding member of the movement. The striking look of Mercedes de Cordoba, wife of the painter Arthur Carles, inspired several portraits by Keiley included in this collection. KW

Edwin Hale Lincoln
American, 1848–1938

Birches at Dalton
From *Trees of the Berkshire Hills*
1929. Platinum print, sheet 9½ x 7½ inches (24.1 x 19 cm)

Narcissus and **Horse Chestnut**
From *Studies of Cultivated Flowers*
1929. Platinum prints, sheet 9½ x 7½ inches (24.1 x 19 cm) each

Gift of Beatrice B. Garvan. 2001-50-29, 2000-25-26, 18

Born in Westminster, Massachusetts, Edwin Hale Lincoln began his photography career in 1876 in Brockton, a city not far from Boston. At a time when soft-focus, picturesque views were the dominant artistic aesthetic, Lincoln was unusual in his desire to join science and art in his photographs, choosing a more straightforward means of rendering his subjects. In the 1890s he made his home in the Berkshires, where he began a systematic study of regional wildflowers. These photographs were sold as a small-edition folio of platinum prints titled *Wild Flowers of New England* that were used by university botany departments and art schools alike.

Lincoln was a charter member of the American Orchid Society and often uprooted plants to study and photograph them under optimum conditions in his studio before replanting them out of doors. While the wildflowers are his best-known body of work, he also made studies of trees, landscapes, and cultivated flowers. The latter subjects appear to be fairly scarce in public collections and on the market, which suggests the rarity and uniqueness of the three albums that have recently been given to the Museum (see checklist nos. 213–15). Though the pictures were made over several years, the albums were probably bound or assembled at the same time, as the bindings and pages are identical and are embossed on the spine with their titles and the year 1929. Each photograph in the albums is hand-captioned in ink, with the artist's signature appearing on each title page as well. KW

Left to right:

Marcel Duchamp
American, born France, 1887–1968

Stood Up
1909. Charcoal on paper, 10½ x 13⅞ inches
(26.7 x 35.2 cm)

Promised gift of The Judith Rothschild Foundation

Bachelor Apparatus, 1. Plan and 2. Elevation
1913. Ink and pencil on paper (cut in two pieces and later
rejoined), 10½ x 13⅞ inches (26.7 x 35.2 cm)

Bequest of Alexina Duchamp. 2001-3-1

Portrait of John Quinn
1915. Pen and ink on paper, 7⅛ x 5¼ inches
(18.1 x 13.3 cm)

Promised gift of Alice Saligman

Jean Joseph Crotti
French, 1878–1958
Portrait of Marcel Duchamp
1915. Graphite and charcoal on wove paper, 21½ x 13⅝
inches (54.6 x 34.6 cm)

Gift of C. K. Williams, II. 2001-49-2

Man Ray
American, 1890–1976

**Photograph of a lost Jean Crotti sculpture
entitled *Portrait of Marcel Duchamp (Sculpture
Made to Measure)***
c. 1915–16. Gelatin silver print, sheet 9⁷⁄₁₆ x 7¹⁄₁₆ inches
(24 x 17.9 cm)

Marcel Duchamp with Shaving Cream
c. 1924. Gelatin silver print, sheet 3¼ x 2¼ inches
(8.3 x 5.7 cm)

Promised gift of Alice Saligman

This choice selection of works on paper by and/or
of Marcel Duchamp greatly enhances our ability to
show the artist's consummate skill and imagination as
a draftsman, and offers a rare opportunity to exhibit
his development through drawings and sketches made
during his formative years. Like many other artists of
his generation, Duchamp began his career working as
a caricaturist for the popular magazines in France.
Published in *Le Courrier Français* in January 1909,
Stood Up (also known as *The Rabbit,* since the French
phrase *"poser un lapin à quelqu'un"* loosely means to
stand someone up) depicts a fashionably dressed
young woman bemoaning the fact that her date has
failed to meet her. Although Duchamp's mechanical
bride would later replace such Belle Epoque images of
women, the ribald humor of these cartoons would be
retained in the artist's mature work.

Duchamp's interest in allegorical imagery and the
female nude would ultimately lead to his greatest
work, *The Bride Stripped Bare by Her Bachelors, Even
(The Large Glass)* of 1915–23, the towering painting on

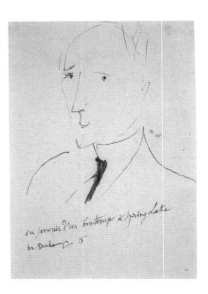

two panes of glass that dominates the artist's gallery at the Museum. Duchamp began working on *The Large Glass* around 1912, preparing intricate notes and studies that would aid him in the painstaking realization of the work. The artist's approach was fundamentally that of an architect or engineer, as can be seen in *Bachelor Apparatus, 1. Plan and 2. Elevation* of 1913, which is made in the dry, mechanical manner of technical drawing, drawn to scale (1:10), with specific measurements noted. Duchamp later made precise copies of both sections of this drawing for inclusion in the *Green Box* of 1934, and it was probably around that time that the work was sliced in two to facilitate the tracing process, with the two elements only being reunited in the early 1970s.

Duchamp took his notes and studies for *The Large Glass* with him to New York, where he arrived in June 1915. Later that summer, he sketched this spontaneous pen and ink portrait of John Quinn, the great collector of advanced art who had acquired three Duchamp works even before the artist landed in the United States.

Duchamp's gaunt appearance during this time, probably due to the long sea voyage from France and the scarcity of provisions in wartime Europe, can also be gauged in Jean Crotti's delicate drawing of the artist, in which the emphasis has been placed on his piercing gaze and pronounced forehead, denoting a keen intellect. The first work by Crotti to enter the Museum's collection, this drawing records (and may even have been a preparatory study for) the artist's first Dada work, a striking portrait sculpture of Duchamp made of metal and wire with glass eyes that is now thought to have been either lost or destroyed. Made around 1915, this unique sculpture is recorded in a Man Ray photograph that is also an anniversary gift to the Museum, thus allowing us to fully document the appearance of Crotti's homage to his friend and future brother-in-law.

This "amiable character," as Crotti called him, is captured again in Man Ray's photograph of *Marcel Duchamp with Shaving Cream*, an image made at the same time as another more famous photograph of

Duchamp with his hair styled into two horns held in place by the shaving foam—the latter photograph was used in his *Monte Carlo Bond* of 1924. The horseplay recorded in Man Ray's photographs thus goes hand-in-hand with the more serious side of Duchamp's character, which led to his efforts to develop a strategy for breaking the bank at Monte Carlo (in the end he merely broke even). It is this marriage of impious irreverence and intellectual seriousness that ultimately links all of these drawings and photographs, which will now join their cousins at the Philadelphia Museum of Art, home to the largest collection of Duchamp's work in the world, thus deepening our enjoyment and understanding of the artist's infinite capacity for invention. MT

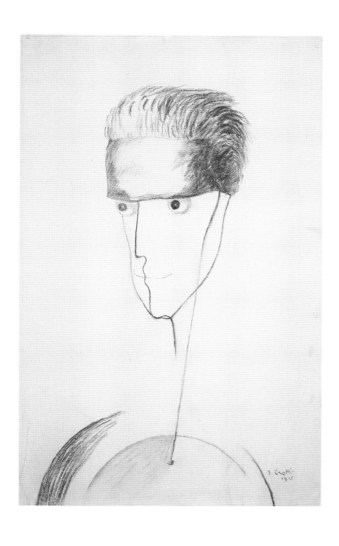

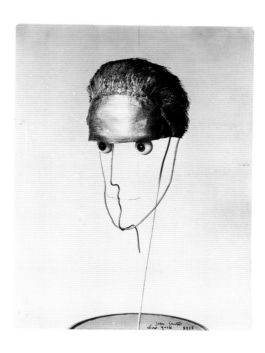

Georgia O'Keeffe
American, 1887–1986
Special No. 15
1916. Charcoal on paper, 18⅞ x 24⅜ inches
(47.9 x 61.9 cm)

*Purchased with the gift (by exchange) of Dr. and Mrs. Paul
Todd Makler, with funds contributed by Mr. and Mrs. John
J. F. Sherrerd, the Alice Newton Osborn Fund, and the
Lola Downin Peck Fund, and gift of The Georgia O'Keeffe
Foundation. 1997-39-1*

Alfred Stieglitz
American, 1864–1946
Georgia O'Keeffe: A Portrait
1918. Palladium print, sheet 9¾ x 7⅞ inches (24.8 x 20 cm)

Promised gift of The Georgia O'Keeffe Foundation

This large, finished charcoal drawing of 1916 was
created at the moment when Georgia O'Keeffe set
aside what she had been taught and decided to use an
entirely personal set of shapes and ideas in her work.

With the conscious intention of making art unlike
anything others had done before her, she stopped
painting and made a series of bold, quasi-abstract
charcoal drawings. Clearly this drawing was one in
which she felt she had succeeded in her aim, for she
kept it in her possession until her death and gave it
the title *Special*—a name she reserved for the works
that held particular meaning for her.

The drawing's composition of broad, intersecting
and opposing curves portrays the Palo Duro Canyon
near Canyon, Texas, where O'Keeffe moved in 1916 to
teach art at the West Texas Normal State College. She

wrote of her explorations of the vast quiet canyon, populated only by cattle, and of the frightening climbs down its plunging banks. O'Keeffe made many small sketches of the place, but *Special No. 15* is the culminating image of the subject.

In 1917 the photographer Alfred Stieglitz, who later became O'Keeffe's husband, included *Special No. 15* in the first exhibition of O'Keeffe's work at his New York Gallery "291." The following year, he placed the drawing in the background of photographic portraits of her. This particular photograph was lent by Stieglitz and O'Keeffe to the Museum's 1944 exhibition entitled *History of an American: Alfred Stieglitz, "291" and After.*

Special No. 15 is the earliest of four O'Keeffe drawings that are the partial gift of The Georgia O'Keeffe Foundation (see checklist nos. 180, 184, 185, 196); they are the first drawings by her to enter the collection, which holds seven of her paintings. The Museum's great collection of nearly six hundred photographs and gravures by Stieglitz is greatly enriched by the addition of twelve of his portraits of O'Keeffe (see checklist nos. 205, 206). IHS

Left to right:

Rookwood Pottery (Cincinnati, Ohio, active 1880–1967)

Decorated by **William E. Hentschel** (American, active 1907–39)

Vase
1925. Glazed white clay, height 14⅜ inches (36.5 cm)

Vase
1927. Glazed porcelain, height 17½ inches (44.5 cm)

Vase
1931. Glazed porcelain, height 13¼ inches (33.7 cm)

Decorated by **Kataro Shirayamadani** (Japanese, active United States, 1887–1911, 1921–48)
Monumental Vase
1889. Porcelain, height 26¼ inches (66.7 cm)

Decorated by **Matthew A. Daly** (American, active 1882–1903)
Vase
1895. Glazed white clay, height 7⅛ inches (18.1 cm)

Decorated by **William E. Hentschel**
Vase
1914. Glazed porcelain, height 15⅛ inches (38.4 cm)

Decorated by **Matthew A. Daly**
Claret Jug
1885. Glazed yellow clay, height 8⅛ inches (20.6 cm)

Decorated by **William E. Hentschel**
Persian Bottle
1920. Glazed porcelain, height 15 inches (38.1 cm)

Gerald and Virginia Gordon Collection. 2002-21-44, 63, 64; 1999-58-13, 25; 2002-21-76; 1999-58-8; 2002-21-54

Using her family's financial resources, Maria Longworth Nichols Storer established the Rookwood pottery manufactory in Cincinnati, Ohio, in November 1880. Almost immediately, the company attracted the finest ceramic artists, who began wonderfully innovative experiments with colored glazes to complement their designs. Both the artistic caliber of the potters and the rich variety of the glazes they used distinguish Rookwood pottery as some of the finest

wares made through the mid-twentieth century in the United States.

Edwin AtLee Barber, Museum director from 1907 to 1916, was particularly interested in the history and collection of ceramics. During his tenure, he purchased examples of Rookwood pottery directly from the artists at various international exhibitions for the Museum's burgeoning collection of decorative arts. It is, therefore, fitting that this institution has become the repository for over one hundred pieces of Gerald and Virginia Gordon's spectacular collection of Rookwood pottery (see checklist no. 127). The Gordons' magnanimous gift raises the Museum's rank to the premier venue in which to view the finest late nineteenth- and early twentieth-century American art pottery.

While the Rookwood manufactory marketed its products based on the different glazes, the Gordons collected their pieces with an eye for the numerous aesthetic styles that motivated the artists. The representative pieces illustrated here show the breadth of artistic influences embodied in the Gordon's collection as well as the variety of shapes and glazes that make Rookwood pottery so desirable. AAK

Manuel Alvarez Bravo
Mexican, born 1902
Mannequin with Voice
1930. Gelatin silver print, sheet 18 x 14¹⁄₁₆ inches (23.3 x 18.7 cm)

Eugène Atget
French, 1857–1927
Versailles
c. 1911. Albumen print, sheet 8⅜ x 6⅞ inches (21.2 x 17.4 cm)

The Lynne and Harold Honickman Gift of the Julien Levy Collection. 2001-62-34, 278

Julien Levy was not simply a collector of photographs, but a gallery owner who committed his charisma, connections, and personal resources to establishing photography's importance in the field of modern art. From 1931 to 1948, Levy owned a gallery on Madison Avenue in New York, where he exhibited the work of many of the artists he had met or befriended in Paris and elsewhere. His interest in Surrealism led to an exhibition in January 1932, before the first museum's treatment of the subject at The Museum of Modern Art in 1936. By the end of 1933, he had already organized at least fifteen exhibitions of photographs in addition to the shows devoted to other forms of contemporary art.

Many of the artists who exhibited at the Levy Gallery are now widely recognized as masters of the photographic medium. However, at the time, Levy's selection of work was guided by his own taste and his interest in the process of art-making more than in the individual masterpiece. As a result, the collection contains some surprising pictures by familiar artists as well as compelling bodies of work by relatively unknown photographers. Levy's interests ranged from the history of photography, evidenced by the work of such nineteenth- and early twentieth-century photographers as Nadar, Alvin Langdon Coburn, and Gertrude Käsebier, to Surrealism, seen in the photographs by Dora Maar, Brassaï, Luis Buñuel, and Salvador Dalí, to name only a few.

Fifteen prints from 1930 come from the Mexican photographer Manuel Alvarez Bravo, whose work was

adopted by the Surrealists. The dress form in *Mannequin with Voice* echoes the Surrealist fixation with the female torso and humorously juxtaposes the dummy with the living man behind it. The gaping bell of the gramophone suggests a voice for the headless figure.

The centerpiece of the collection is a group of 362 photographs by Eugène Atget, two of his glass negatives, and one of the original albums in which the artist displayed his work. With the help of the photographer Berenice Abbott, Levy was responsible for rescuing Atget's work from destruction after the artist's death. *Versailles* was part of the photographer's project to document the statuary and fountains of the park surrounding the famous French palace. In this photograph he renders this woman of stone as a graceful portrait.

The gift of the Levy Collection—a group of nearly 2,500 objects—imparts a more distinct international flavor to the Museum's photography holdings, which hitherto were predominantly American (see checklist no. 211). It also augments our renowned holdings of the work of Alfred Stieglitz and Paul Strand. One of the delights of the collection is its group of eleven pictures by Anne Brigman, a California photographer whose works were collected by Stieglitz and published in his journal *Camera Work*. Other gems include a gelatin silver print of Charles Sheeler's *Side of White Barn* and two platinum prints by Paul Outerbridge. Even Levy himself is represented by his series of semi-nude portraits of the Mexican painter Frida Kahlo. KW

John Singer Sargent

American, active Paris, London, and Boston, 1856–1925

Landscape with Women in Foreground

c. 1883. Oil on canvas, 25 x 30½ inches (63.5 x 77.5 cm)

Gift of Joseph F. McCrindle. 2002-49-1

The two young women walking arm in arm along a country path in John Singer Sargent's *Landscape with Women in Foreground* could easily have stepped out of one of his early Venetian scenes of 1880–82. Their poses are similar to those of the promenading women in the *Venetian Interior* from around 1882 in the Carnegie Museum of Art, Pittsburgh.

In 1883 in Nice, where his parents were then living, Sargent turned away from the urban imagery of Venice to paint some bold and colorful landscapes that mark the beginning of his Impressionist phase. It is fairly certain that these works, which include this painting, were made in the early months of that year. Generally they show trees in blossom and fresh green foliage. This work is the only one to include figures. The two young women wear contrasting skirts of dark gray and lilac. Sargent probably intended for them to resemble country folk, but they look more like models than workers. Their hair is worn up over their ears with a fringe in front. They are dark-complexioned, Mediterranean in type, slender, graceful, and alluring.

The artist carefully modeled the figures, but the sur-rounding landscape is painted in broad, swift strokes and a high-keyed palette. The women stroll down a tree-lined path, with a bank to their right that is dotted with flowers. To the left, an olive grove stretches away to a long gray wall, with more trees beyond it and a partially concealed building. Blossom, probably almond, fills the upper-right corner, to which one of the women reaches up in a gesture that is expressive of her carefree character as well as springtime joie de vivre.

This work joins five other oil paintings by Sargent in the Museum's collection. It is a charming companion to *In the Luxembourg Gardens* of 1879, another rendering of modern life in France, in which a rather stiff couple strolls in the formal park at dusk. RO

Winslow Homer
American, 1836–1910
Building a Smudge
1891. Watercolor over traces of graphite on watercolor
paper, 13½ x 20⅝ inches (34.3 x 52.4 cm)

Gift of Ann R. Stokes. 2002-10-1

Winslow Homer's group of approximately eighty-five watercolors, created in the Adirondacks between 1889 and 1895, are considered to be his most accomplished. They are the products of an intensively prolific period when the artist seems to have experimented with every aspect of the watercolor medium, from the effects of the Japanese "broken ink" technique to the methods of scraping and blotting often used by British watercolorists.

Entries in the register of the North Woods Club near Minerva, New York, for 1891, record two visits by Homer, one in June–July and the other in October. Most likely he made this work in June, when black flies congregate in the Adirondacks. Here two guides, seated on a rock at water's edge, build a smoky fire to ward off the swarming insects that attract the feeding fish. The young guide bends to this task while the older one watches intently, as the flies rise into a patch of bright sky between the trees.

While at the North Woods Club, Homer boldly began to apply colored washes in broad, liquid strokes that would flow together in puddles on the paper. At the same time he experimented with using pigments of different densities, apparent here in the contrasting fluid green washes and the thicker applications of glossy green pigment in the forest background. For the bright water in the foreground, Homer applied color with a dry brush, then added more liquid strokes for the reflections; in the middle ground he used the point of a knife to scrape out flat white circles meant to indicate the rings left by darting fish. IHS

Pablo Ruiz y Picasso
Spanish, 1881–1973

Mademoiselle Léonie Seated on a Chaise-longue
From Max Jacob, *Saint Matorel* (Paris: Kahnweiler, 1911)
1910. Etching in printed book with tooled leather binding
(edition 100); plate 7 ¾ x 5 ½ inches (19.7 x 14 cm), book
11 x 8 ⅞ inches (27.9 x 22.5 cm)

Gift of The Judith Rothschild Foundation. 2001-48-1c

Mademoiselle Léonie Seated on a Chaise-longue
1910. Etching, first state (one of two proofs printed by the
artist); plate 7 ¾ x 5 ½ inches (19.7 x 14 cm)

Promised gift of The Judith Rothschild Foundation

In 1910 the Paris dealer Daniel-Henry Kahnweiler began to publish work by young avant-garde poets with illustrations by their painter friends. Pablo Picasso's illustrated volume of Max Jacob's novel *Saint Matorel* was the first of Kahnweiler's *Livres d'artistes* to appear; its four etchings have come to be considered defining works of Analytical Cubist printmaking.

Jacob, one of Picasso's first friends in Paris, was a poet of great whimsy and mysticism, who experienced religious visions and converted to Catholicism from Judaism. *Saint Matorel*, Jacob's novel about the adventures of Brother Victor Matorel and his conversion to sainthood, was a story that Picasso clearly associated with Jacob's own life and conversion. The third plate of the book, *Mademoiselle Léonie Seated on a Chaise-longue* (left), is the richest and most complex of Picasso's illustrations, with forms composed entirely of shattered planes and a system of lighting that is completely arbitrary. Hints of the chaise-longue's profile appear here and there to lend an organizing structure. Shading and modeling are produced by light parallel

strokes and dense cross-hatchings along the edges of planes, while areas of foul biting on the plate animate and give substance to the space around the figure.

The complicated development of Picasso's composition is made visible in the rare proof that he pulled himself as he worked on the plate (right). Initially he focused solely upon the simple schematic figure, drawn with long, straight lines and minimal areas of shading. The chaise-longue was introduced only in the final state, where Picasso also reversed the direction of the figure's head and lowered the level of her shoulders. Traces of the artist's fingerprints and the evident difficulties with printing give the proof the immediacy of a preliminary sketch.

Illustrated here are only two examples from a larger gift of Cubist prints, which includes Picasso's illustrated volume of Jacob's *Le Siège de Jérusalem* (1914) as well as etchings and drypoints by Picasso and Georges Braque, executed between 1909 and 1915 (see checklist nos. 66–68). IHS

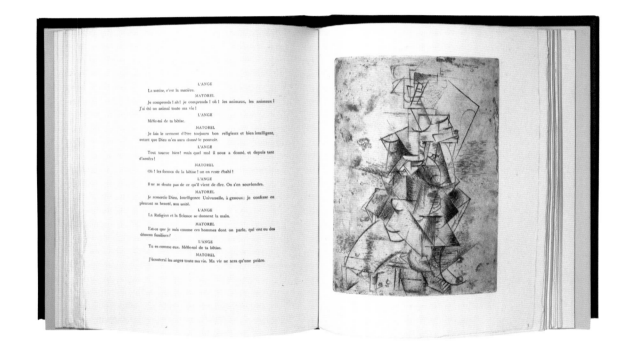

Juan Gris
Spanish, 1887–1927
Self-Portrait No. 1
1909–10. Charcoal on paper, 17 x 12½ inches
(43.2 x 31.7 cm)

Promised gift of The Judith Rothschild Foundation

In this dusky, youthful self-portrait, Juan Gris's alert, dignified demeanor brings to mind the erect postures and arresting sideward glances of Francisco de Goya's portraits of Spanish noblemen. Created on the cusp of his transition to a Cubist style, at a time when he was a neighbor of Pablo Picasso in Paris, Gris's drawing provides evidence of this imminent development. He skillfully partitions areas of light and shadow into abstract shapes that appear in the shading of the brow and the highlights beneath the left eye and the chin. In subsequent self-portraits, Gris would turn to caricature, graphic stylization, or Cubist faceting of his features, but never again to such a dramatic and penetrating rendering of himself. For this reason the drawing has become a signature image, serving more than once as the frontispiece to an exhibition catalogue.

The self-portrait originally belonged to Gris's dealer and biographer, Daniel-Henry Kahnweiler. In 1967 the artist Judith Rothschild chose the work from a New York show of Kahnweiler's drawings for the collection of her parents, Herbert and Nannette Rothschild, who considered Gris to be the greatest of the Cubists. Eventually the couple gave the drawing to their daughter, who shared their enthusiasm for the artist. In the Museum's collection, the self-portrait will become the earliest of seventeen paintings and works on paper by Gris; the others formerly belonged to the collections of A. E. Gallatin and Louise and Walter Arensberg, collectors of modern art who also favored his work. IHS

Jacques Villon

French, born Gaston Duchamp, 1875–1963

Portrait of the Artist's Father Reading

1913. Drypoint on Rives laid paper (trial proof), 15 ⁵⁄₁₆ x 11 ⁹⁄₁₆ inches (38.9 x 29.3 cm)

Gift of The Judith Rothschild Foundation. 2001-9-15

This veiled yet dynamic Cubist portrait of Jacques Villon's father is the last and most abstract of a series of large drypoint portraits the artist made in rapid succession in 1913. Each portrait was a step in his methodical development of a Cubist style based solely in the medium of printmaking. The Judith Rothschild Foundation's gift to the Museum of thirty-three of Villon's Cubist prints, as well as one of his drawings, includes superb impressions of each of these great portraits (see checklist no. 70).

Using a system of pyramidal construction inspired by Leonardo da Vinci's *Treatise on Painting*, Villon's precisely spaced lines and careful inking made it possible to suggest volume as well as space filled with light and shadow. In this composition, the figure is shattered into many converging planes defined by fine parallel strokes. Villon lets a curtain of vertical lines fall so that the planes of the figure shift in and out, both revealing and obscuring the forms. Such a technique endows the image with a subdued quality that is punctuated in the lower right by the small, diagonal planes that shoot like arrows from the sitter's fingers.

This trial proof is both rare and exceedingly rich; it was printed while the artist was experimenting with inking the plate. The drypoint burr is particularly dense, and even the finest lines show up clearly because the plate had not yet become worn from successive printings. But the work is also exceptionally dark and shadowy because Villon left a thin residue of ink on the plate, creating a painterly effect. IHS

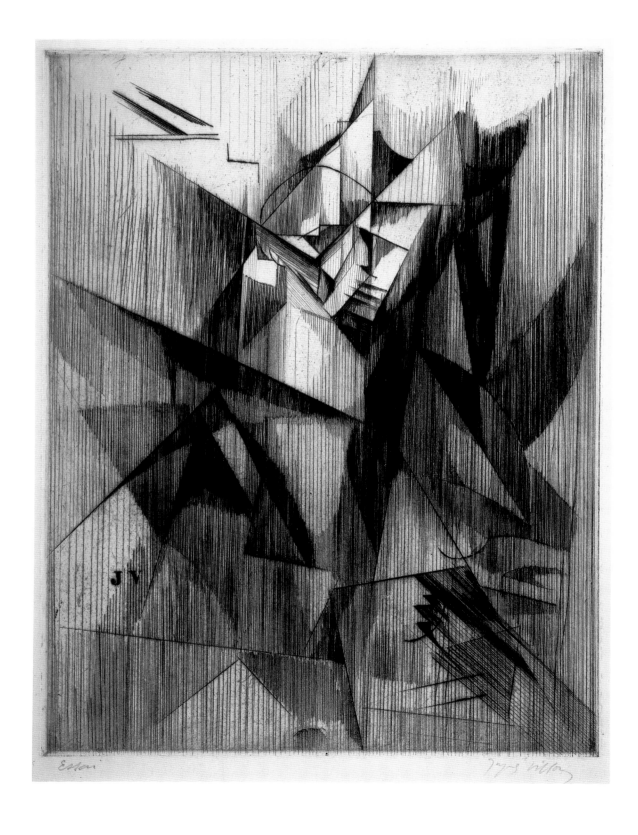

Raymond Duchamp-Villon
French, 1876–1918

Yvonne with a Knot of Hair (Face of a Child)
1907–8. Terra cotta, height 9¾ inches (24.8 cm)

Gift of Jacqueline Matisse Monnier. 2002-9-1

Head
c. 1917. Bronze (unique cast), height 5⅛ inches (13 cm)

Promised gift of Anne d'Harnoncourt in memory of Alexina Duchamp

Raymond Duchamp-Villon, together with his brothers Jacques Villon and Marcel Duchamp, helped to advance the Cubist movement begun in Paris by Pablo Picasso and Georges Braque before World War I. Never trained as an academic artist,

Duchamp-Villon turned to sculpture around 1900, having previously studied medicine. By 1907 the artist had established his studio in the Paris garden suburb of Puteaux—an artistic enclave that attracted many of the leading members of the Parisian avant-garde, including František Kupka, Alexander Archipenko, Fernand Léger, and Juan Gris.

These two sculptures signal the enormous changes that Duchamp-Villon's work underwent during the next decade, as he began to respond to the latest developments in modern art. The portrait of Yvonne, a frequent model for all three brothers, joins other representations of their younger sister in the Museum's collection, such as Marcel Duchamp's *Yvonne and Magdeleine Torn in Tatters* of 1911, and Jacques Villon's painting *Young Girl* of 1912. The Art Nouveau striations of her hair and bun, together with her hieratic facial features, perhaps inspired by Paul Gauguin's paintings of Tahitian women, show Duchamp-Villon

experimenting with new formal ideas. More radical yet, the dynamic bronze *Head* reveals the artist's subsequent discovery of Cubism and African art. The masklike abstraction, seen especially in the deeply incised grooves that form the buglike eyes, suggests a strong affinity with African sculpture, which had begun to fascinate Picasso and the international avant-garde in the preceding decade.

When Duchamp-Villon died of typhoid fever in 1918 at the age of forty-two, he left a strong legacy as a pioneer of Cubist sculpture and theory along with a studio filled with plasters awaiting further development or casting in bronze. Together with the Musée des Beaux Arts in Rouen and the Musée d'Art Moderne in Paris, this Museum has one of the three great collections of Duchamp-Villon's work, thanks in large part to the generosity of Marcel Duchamp's family, who have over the years given many of these precious plasters, terra cottas, and bronzes to our holdings. MT

Olga Vladimirova Rozanova
Russian, 1886–1918
Suprematist Design (Decorative Motif)
1916. Brush and ink and watercolor over graphite on paper, 9⅞ x 6⅝ inches (25.1 x 16.8 cm)

Kasimir Malevich
Russian, 1878–1935
Supremus No. 18
1916–17. Graphite on paper, sheet 7 x 8⅝ inches (17.8 x 21.9 cm)

Promised gift of The Judith Rothschild Foundation

During the years of political upheaval in Russia, which culminated in the Bolshevik Revolution in 1917, a parallel insurrection in the arts took place.

Traditional painterly realism was toppled by a legion of young iconoclasts in an overlapping succession of utopian art movements: Primitivism, Cubism, Futurism, Rayonnism, and ultimately Suprematism, which advocated abstraction as the ideal art form of the future. A splendid 125th Anniversary gift of nine drawings and prints from The Judith Rothschild Foundation constitutes a compact survey of this pivotal moment in the evolution of modern art (see checklist nos. 69, 81). Chief among them are two works by two of the leading figures of the period, an important compositional design *Supremus No. 18* of 1916–17, by Kasimir Malevich, and a colorful *Suprematist Design* of 1916, by Olga Rozanova.

It was Malevich's 1913 design for a picture that would consist solely of a solid black square that launched the Suprematist art movement and swept away age-old Western modes of representation, creating a new non-objective art, purged of traditional subject matter and reduced to flat forms executed in solid colors without shading. Malevich is known to have executed several versions of *Supremus No. 18* between 1916 and 1927. It has recently been suggested by Andréi Nakov that the present drawing may be a copy of one of them by Malevich's younger colleague El Lissitzky.

Before her early death in 1918, Olga Rozanova was also to play a central role in these artistic revolutions. In 1913 she became one of the first Russian artists to embrace the dynamic forms of Futurism. Two years later she enthusiastically adopted the plain colors and bold geometry of Malevich's Suprematism, which must have had a special appeal for an artist who was already a committed champion of color and abstraction as the essential elements for a new art. JI

Alfred Stieglitz
American, 1864–1946

Equivalent ES10
1929. Gelatin silver print, sheet 4¹¹⁄₁₆ x 3⅝ inches (11.9 x 9.2 cm)

Equivalent ES6
1929. Gelatin silver print, sheet 4⅝ x 3⅝ inches (11.8 x 9.3 cm)

From the Collection of Dorothy Norman. 1997-146-95, 2

A native of Philadelphia who studied art at The Barnes Foundation in nearby Merion, Pennsylvania, the young and vibrant Dorothy Norman met Alfred Stieglitz in New York in 1927 and quickly became indispensable at his last gallery, "An American Place." Her work as a social activist and writer, as well as publisher and editor of the journal _Twice a Year_, introduced Norman to many of the most influential artists, writers, and thinkers of her time. She was also an accomplished photographer who studied closely with Stieglitz. During their nineteen-year association, Stieglitz gave Norman many of his own photographs, including prints made for her and inscribed especially to her.

A selection of these photographs, along with others by celebrated twentieth-century artists including Ansel Adams, Paul Strand, Edward Weston, and Minor White were donated by Norman in 1968 to establish the Alfred Stieglitz Center for Photography at the Philadelphia Museum of Art. This remarkable body of master works forms an important nucleus of the Museum's collection of photographs and was intended to encourage the appreciation of photography as an art form. Norman bequeathed an additional 225 objects to the Museum upon her death in 1997, bringing the holdings of the Dorothy Norman Collection to more than eight hundred images (see checklist no. 207). Among these are several fine examples of Stieglitz's _Equivalents_, a series begun in the early 1920s, in which he sought to create with photography a visual experience parallel to the act of listening to music. KW

Lyonel Feininger
American, active Germany, 1871–1956
Ehringsdorf I
1916. Charcoal over ink on paper, 9 7/16 x 12 5/16 inches
(24 x 31.3 cm)

Gift of C. K. Williams, II. 2001-49-1

This subtle yet sumptuous Cubist cityscape by Lyonel Feininger, with its rich and velvety handling of charcoal, is a stellar addition to the Museum's widely known holdings of early modern European and American drawings made just before or during World War I. Feininger, a painter, draftsman, and printmaker, had equally distinguished careers first in Europe and then in the United States. He was born in New York City to concert-musician parents. At the age of sixteen he was sent to study music in Hamburg, Germany, but turned to art studies instead. After an early career as a cartoonist and illustrator, Feininger began painting around 1907. The previous year he had produced his first prints, launching what would become an impressive output of more than four hundred etchings, drypoints, woodcuts, and lithographs created over half a century. About 1911 he first encountered Cubism, a dominant influence in the formation of his mature style.

As an important member of several German avant-garde art movements, Feininger taught printmaking at the Weimar Bauhaus from 1919 to 1924, formed the Blue Four group with Paul Klee, Wassily Kandinsky, and Alexei Jawlensky, and served as artist-in-residence at the Dessau Bauhaus from 1925 to 1932. In 1937 he resettled permanently in New York, where he won major prizes and honors and had a joint retrospective with Marsden Hartley at The Museum of Modern Art in 1944.

Feininger's favorite subjects were landscapes, seascapes, and cityscapes, executed after 1912 or 1913 in a fragmented, abstracted, and Cubist-influenced manner. The addition of *Ehringsdorf I*—a relatively early, powerfully executed, and markedly Cubist work—to our holdings of four works on paper by the artist that date between 1911 and 1941 enables the Museum to display a telling encapsulation of his drawing style and its development. AP

Giacomo Balla
Italian, 1871–1958
Abstract Speed
1912. Oil on paper, mounted on wood; 5 x 7 inches
(12.7 x 17.8 cm)

Promised gift of The Judith Rothschild Foundation

A decade older than his pupils Umberto Boccioni and Gino Severini, Giacomo Balla was invited to join them in signing the *Manifesto of Futurist Painting* in 1910. Soon thereafter he began applying separate strokes of color—a technique he had used in earlier work—to analytical studies of dynamic movement, beginning with a series on the flight of swifts, then another on speeding cars. Eventually he progressed to abstract renderings of speed and became the first Italian Futurist painter to practice pure abstraction.

Whether created in oil, charcoal, or graphite, Balla's studies of movement tend to charge from right to left, intentionally clashing head-on with the way a (Western) viewer customarily reads images, from left to right. In *Abstract Speed*, the format of the tiny picture is divided vertically by an ever-widening series of arcs, which are pierced by a horizontal force moving swiftly against them. Dark, roiling waves and opposing spirals disturb the cadence of the arcs' forms, while light, diagonal touches of white enliven them throughout. The borders of the composition scarcely contain the energy within, as a sequence of short, staccato black points emerges from the top to suggest that the motion continues somewhere beyond its edge.

The collector Nannette Rothschild, who purchased *Abstract Speed* in Milan in 1954, captured the essence of this powerful composition in her memoirs, observing that, despite its postcard size, the work contains the power of a much larger Futurist painting because of the intense concentration of its composition.

The first example of Balla's work to enter the collection, *Abstract Speed* is a superb Futurist image that expands the Museum's distinguished early modern holdings. IHS

Aleksandr Rodchenko
Russian, 1891–1956
White Sea—Baltic Canal Lock
1933. Gelatin silver print, sheet 12 x 19½ inches
(30.5 x 49.5 cm)

Promised gift of The Judith Rothschild Foundation

In the aftermath of Vladimir Lenin's death in 1924, Josef Stalin came to power in the Soviet Union and instituted a program of ambitious industrial development and agricultural collectivism. His Five-Year-Plan was supported by many of the country's artists, notably the Constructivists. Initiated in 1910, the Constructivist movement rejected traditional art forms as ineffectual and elitist. Instead, its members advocated the creation of socially useful art for all people. Originally from Saint Petersburg, Rodchenko joined this vanguard group in 1914 when he moved to Moscow, where he studied graphic design and later taught metalwork. In keeping with his commitment to the philosophy of utilitarian arts, Rodchenko took up the camera in 1924.

By the late 1920s, as Stalin's plan was being implemented, Rodchenko acquired one of the new hand-held Leica cameras and passionately adopted as his subjects the Russian laborer and the country's rapid industrial growth. One of his most important series, commissioned in 1933 for the magazine *SSR na Stroike* (USSR in Construction), shows the construction of a canal between the White Sea and the Baltic Sea. Rodchenko designed the layout for this picture spread, although ultimately he did not include the photograph shown here. The unusually large print is infused with his political idealism, despite the fact that the canal was built by prisoners forced into hard labor. As the first work of art by Rodcheckno to enter the Museum's collection, *White Sea—Baltic Canal Lock* is an important addition to our holdings of Constructivist work. KW

Stuart Davis
American, 1892–1964
Boats Drying, Gloucester
c. 1916. Oil on canvas, 18½ x 22¼ inches (47 x 56.5 cm)

Partial and promised gift of Hannah L. and J. Welles Henderson. 1999-171-1

This rare early painting by Stuart Davis was made in Gloucester, Massachusetts, where the artist began spending his summers in 1915. The work was probably painted during his second visit and reflects the profound impact that the 1913 Armory Show in New York had on his art. The thickly painted white forms depict the upturned hulls of local fishing boats, which Davis then simplified into almost abstract geometric shapes. As a whole, the composition is informed by the principles of Cubism he had encountered in the work of such artists as Pablo Picasso and Marcel Duchamp.

A native of Philadelphia, Davis is best known for the boisterous, colorful abstractions that he began making in the 1920s. The dynamic, rhythmic designs of these works successfully reconcile the artist's knowledge of the latest trends in European abstract painting with his passion for jazz, the game of pool, advertising posters, and other aspects of American vernacular culture. It was this subtle combination of intensely colored, cosmopolitan imagery with Cubist-derived pictorial scaffolding that pushed Davis to the forefront of abstract painting in the United States between the two World Wars. The artist thus forms a crucial link between the work of the pioneering American artists gathered around Alfred Stieglitz's "291" Gallery in New York in the 1910s and the later advances of the Abstract Expressionists, who often credited Davis as an important formal influence. In *Boats Drying, Gloucester*, the repetition of the white crescent shapes of the rowboats, marooned on their piles at low tide, can be seen as a tentative step toward his mature style of allover, patterned abstraction. As such, the work represents an important addition to the Museum's collection of American modernism, which also includes a vibrant late work by the artist, entitled *Something on the Eight Ball*, of 1953–54. MT

Female Portrait Mask

Côte d'Ivoire, Baule; late nineteeth–early twentieth century
Wood, height 11 ¼ inches (28.6 cm)

Promised gift of Harvey S. Shipley Miller and J. Randall Plummer in memory of Margaret F. Plass

Reliquary Guardian Figure

Gabon, Kota; late nineteenth century. Copper alloy and wood, height 23 inches (58.4 cm)

Promised gift of The Judith Rothschild Foundation

Crest Mask

Mali, Bamana, Bougouni region; late nineteenth–early twentieth century. Wood and fiber, height with base 27 ⅛ inches (68.9 cm)

Promised gift of Anne d'Harnoncourt and Joseph Rishel

While unrelated in cultural origin or use, these three works do share one common element: they are all classic examples of artistic genres whose formal qualities have long appealed to Western admirers of African sculpture. In the early twentieth century, collectors began to seek certain types of African objects for their artistic excellence. The canon that subsequently developed was profoundly shaped by the aesthetic preferences of these influential early collectors, including Louise and Walter Arensberg, who bequeathed their small but important collection of African sculpture to the Museum in 1950. Demonstrating the Museum's commitment to strengthening its holdings of African art, these recent acquisitions also reflect the impact of modernism on our perception of these objects.

The female portrait mask with lobed coiffure, known as Mblo, represents an artistic genre that is considered by some Baule to be the preeminent form of sculpture. Early modern collectors and artists also prized such works for their dark, glossy surface and finely carved sculptural details. Created to honor a particular woman respected for her beauty and dancing skill, the mask conveys Baule ideals of moral and physical beauty.

The abstract, metal-wrapped guardian figures of the Kota were created for use in Bwiti, which is a religious institution honoring ancestors, relics of whom—typically the skull and other symbolically relevant bones—were kept as protective devices by their relatives. Bound in a bundle, the relics were lashed to the base of a figural sculpture, or *mbulu ngulu*, and placed inside a woven bark barrel or basket. The guardian figure shown here is a style often characterized as "classic" by Western connoisseurs of African art. The geometric conceptualization of the human form seen in such Kota reliquary statuary is thought to have inspired a number of early modernist artists, assuredly including Pablo Picasso.

Perhaps the best-known African sculptural tradition is the Bamana crest mask, or *chi wara kun*, collected by Westerners since the late nineteenth century. Such masks were owned by members of a male initiation society called *chi wara*, and worn during annual performances celebrating successful farmers. This example, which retains its basketry skullcap, combines the features of a pangolin, anteater, and antelope—all animals associated with digging the earth—and also incorporates two small human figures. CC

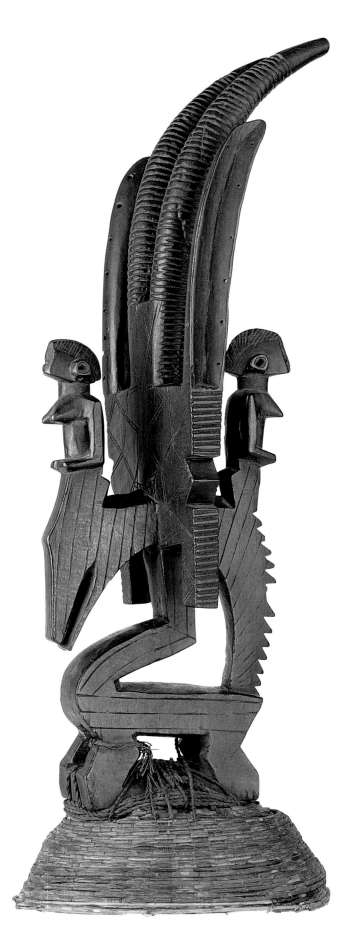

Man Ray
American, 1890–1976
Untitled Rayograph
1923. Gelatin silver print, sheet 11⁹⁄₁₆ x 8¹⁵⁄₁₆ inches (29.4 x 22.7 cm)

Purchased with funds from the bequest of Dorothy Norman, the Alfred Stieglitz Center Revolving Fund, the Lola Downin Peck Fund and the Carl and Laura Zigrosser Collection (by exchange), the Lynne and Harold Honickman Fund for Photography, and with contributions from The Judith Rothschild Foundation, Marion Boulton Stroud, Harvey S. Shipley Miller and J. Randall Plummer, Ann and Donald W. McPhail, and Audrey and William H. Helfand in honor of the 125th Anniversary of the Museum 1999-134-1

Not long after arriving in Paris in the summer of 1921, Man Ray embarked on what was to be one of the most fruitful years of his artistic career. Galvanized by his new surroundings and a circle of revolutionary writers and artists introduced to him by Marcel Duchamp, Man Ray continued with the work he had begun in New York of divorcing art-making from the artist's hand. The camera had been one of his principal tools in this undertaking, but in his Paris darkroom Man Ray rejected even it and found a way to make photographs without a lens. Known as photogenic drawing when it was first discovered in the nineteenth century, this process involves placing objects on photo-sensitive paper and exposing them to light.

Man Ray delighted in using objects to delineate their own outlines while simultaneously creating nothing recognizable: ordinary things appear ambiguous, allowing the artist to fashion something utterly new and requiring each viewer to look inward in order to discover its meaning. Here the bold forms and cascading layers of translucent fabric elude our understanding. The artist selected this *Rayograph* to illustrate a 1925 article on his cameraless photographs in the French journal *Les Feuilles libres*. It is the first of his unique cameraless prints to join the Museum's collections and a spectacular example of Man Ray's creative enterprise. KW

Joseph Stella
American, born Italy, 1877–1946
Red Amaryllis
c. 1929. Gouache on paper, 30 x 24 inches
(76.2 x 61 cm)

Promised gift of Marion Boulton Stroud

Joseph Stella's life was peripatetic and his personality unpredictable. So also was his art, which ranged widely (and sometimes concurrently) from Realism, to Cubism and Futurism, to tinges of Surrealism seen in his bold studies of nature. Stella was first and foremost a prodigious draftsman and ardent colorist, talents that served as the foundation for the bizarre variety of his imagination and artistic output.

In the second half of his career, after traveling to North Africa and Barbados, Stella created a striking series of paintings and works on paper inspired by the flowers and birds of the tropics. While many of the works were dark, mysterious fantasies, some were more direct studies from nature that nonetheless seem possessed by an almost surreal inner life. This life-size rendering of five huge amaryllis blossoms rising from three stems is such an example. Viewed close-up against an opaque, dark blue-black ground, the crisp contours of the blooms with their pointed tips are vibrating with life and appear to flicker and curl like flames. Flattened, decoratively arranged, and cut off at their bases, the green and blue leaves have a cooler but equally odd vitality.

Although he was a friend of Marcel Duchamp and the collectors Louise and Walter Arensberg, Stella is not well represented in the Museum's collection, which includes only a watercolor and a small painting on glass of 1914 and an important silverpoint self-portrait drawing from the 1920s. His wide variety of subjects and styles allows the Museum many directions in which to expand the representation of this important American modernist's work. As a ravishing example of Stella's renderings of tropical flowers, *Red Amaryllis* adds a new dimension to our holdings of his work and to the collection of American modernist works on paper as a whole. IHS

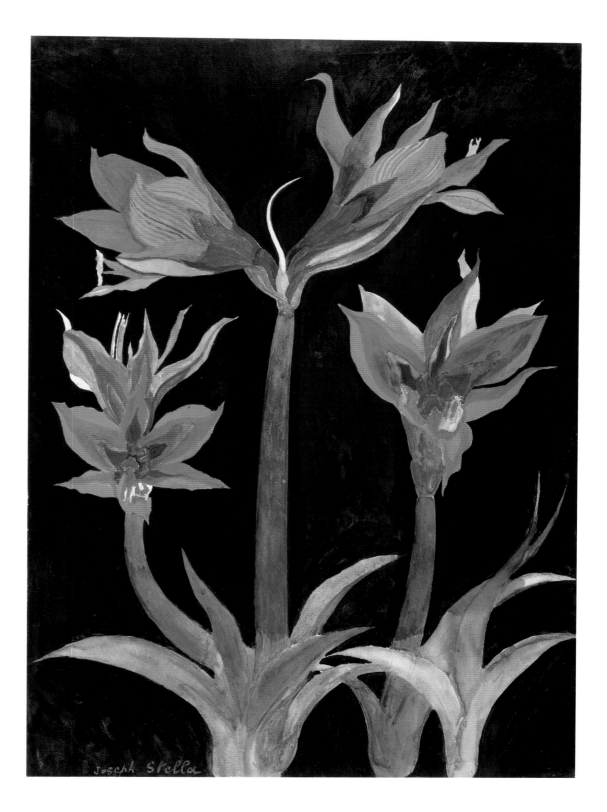

Henri Matisse
French, 1869–1954
Portrait of Henri de Montherlant
1937. Charcoal on paper, 22⅜ x 15³⁄₁₆ inches
(56.9 x 38.5 cm)

Promised gift of Dr. Luther W. Brady, Jr.

Henri Matisse was a prolific draftsman for whom drawing was an integral part of his work in painting, sculpture, and printmaking. To him drawing was a means of not merely capturing the likeness of an object but also discovering the essence of a subject—and his own emotional response to it—in a masterful display of minimal line. This example, like much of his late graphic work, relates to a book illustration project. The sitter, Henri de Montherlant, was a renowned French writer who approached Matisse about illustrating one of his works. Matisse expressed interest in Montherlant's contemporary retelling of the story of Pasiphaë, the wife of King Minos (the mythological ruler of Crete). This drawing was one of several sketches of the author executed in various poses and degrees of finish in 1937. Matisse would later use a profile of Montherlant as the basis for an image of King Minos in the book, which was published in 1944 with fifty linoleum cuts by the artist.

Here Matisse's fascination with the expressive power of contours is revealed in the vibrating, searching outline of the figure's head. Manipulating tonal values by smearing and rubbing the charcoal used to model the face, he creates a sculptural sense of solid form in two dimensions. Matisse used a similar technique in a number of self-portraits he drew the same year. SRL

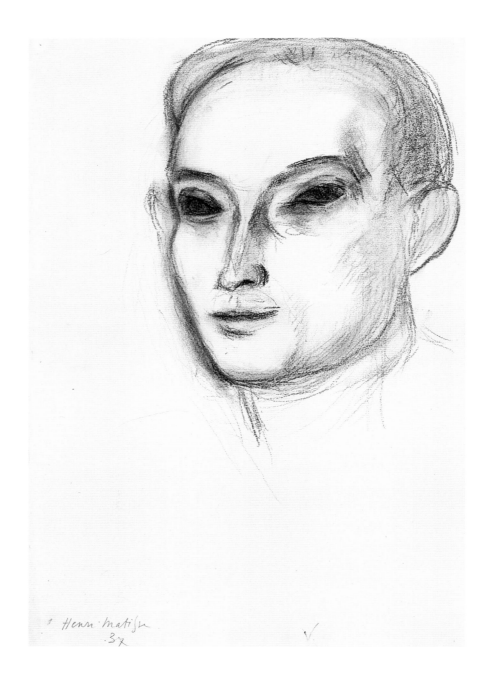

Beauford Delaney
American, 1901–1979
Portrait of James Baldwin
1945. Oil on canvas, 22 x 18 inches (55.9 x 45.7 cm)

Purchased with funds contributed by The Dietrich Foundation in memory of Joseph C. Bailey and with a grant from The Judith Rothschild Foundation. 1998-3-1

After growing up in Knoxville, Tennessee, and attending art school in Boston, Beauford Delaney arrived in New York in 1929 in time for the rich stimulation of the Harlem Renaissance. He soon became a popular and respected figure among uptown artists and musicians, Greenwich Village bohemians, and the circle of artists centered around the midtown gallery of Alfred Stieglitz. Both his cityscapes and portraits of this period reflect his joy in this dynamic milieu as well as the bold innovations he brought to traditional genres of oil painting.

This portrait of James Baldwin was made when he and Delaney had only recently met, and the aspiring writer was just twenty-one years old. The intensity of the image recalls the portraits of Vincent van Gogh, whom Delaney revered. The piercing eyes, the strongly defined nose and lips, and the trunklike neck give Baldwin the unforgettable presence of an icon, as does the close-up viewpoint of the composition. The daringly juxtaposed passages of raw color radiate with the energy of the mind and heart of this young man, the future author of such novels as *Go Tell It on the Mountain* (1952) and *Giovanni's Room* (1956).

Baldwin, who later wrote eloquently about Delaney's paintings, would call the artist his "principal witness." The term could be understood literally: over the course of the next thirty years, Delaney portrayed Baldwin in at least ten drawings and paintings. In the 1950s they both joined the growing circle of African American expatriates in Paris, where they remained lifelong friends. Delaney's move to France explains in part the belated development of his reputation in the United States. In the company of the Museum's portraits by artists such as Thomas Eakins, Henry Ossawa Tanner, Mary Cassatt, and Alice Neel, *Portrait of James Baldwin* powerfully affirms Delaney's distinguished contribution to American modernism. AT

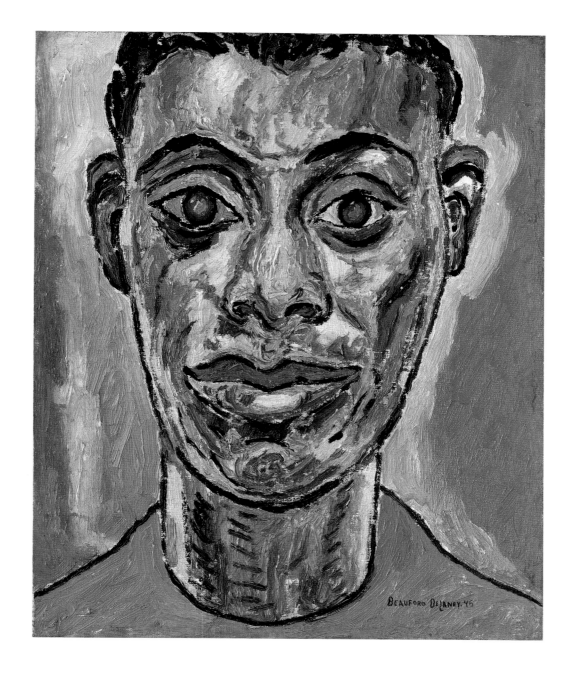

Edgar Alexander McKillop
American, 1879–1950
Mountain Lion
Made in Balfour, North Carolina; c. 1935–38. Black walnut and glass, height 14¼ inches (36.2 cm)

Gift of Melanie Gill in memory of her husband, Robert Lee Gill, and in honor of Jack L. Lindsey. 2001-193-1

The mountains and foothills of western North Carolina have long nurtured rich traditions of folklore and craftsmanship. The region's early demographics included Native American, Scotch Irish, Welsh, German, and African American populations. This diversity ensured a wide range of traditional belief systems as well as a blending and hybridization of various earlier artistic traditions and visual aesthetics. Folk artists among these cultural and ethnic groups played an important role in establishing the artistic traditions of their communities. They combined communally held preferences of style with an individual, interpretive vision to produce expressive and distinctive works of art.

Edgar Alexander McKillop was such an artist. Born in 1879 in rural western North Carolina, McKillop's early adolescence and career included agricultural labor, lumbering, and textile-mill machinery repair. Known and respected locally as a talented, intuitive repairman and tinkerer, he undertook a marked and intense exploration of wood carving in the late 1920s that would last until about 1938. Working almost exclusively in local black walnut, McKillop produced a dramatic and amazing menagerie of animal, human, and imaginary creatures. Striking for their expressive quality and rough-hewn surfaces, while immediately engaging in their humor and directness, McKillop's rare carved works bear testimony to his inspired talent and singular imagination.

The demographics and folk traditions present in the western mountains and Piedmont regions of the rural South are closely parallel to those in early rural Pennsylvania. The similarities between such diverse regions provide important comparative information and value to the Museum's growing collections of American folk art. The gift of this impressive figure of a mountain lion joins a smaller yet equally lively carving of a squirrel by McKillop acquired in 1998, and significantly advances the institution's efforts to diversify and expand its collections of sculpted American folk expressions. JLL

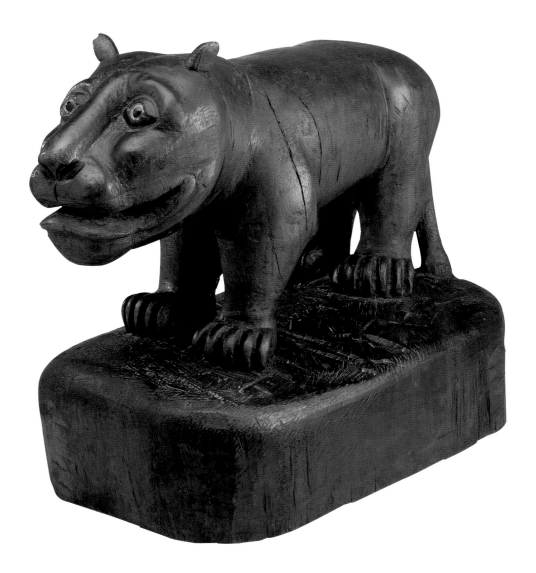

Royal Seat

Côte d'Ivoire, Baule, Toumodi region; twentieth century
Wood and pigment, height 17½ inches (44.5 cm)

Gift of William C. Bertolet. 2000-159-1

This royal seat, or *ulimbi bia*, takes the form of a powerful leopard grasping between its teeth a smaller animal, most likely its prey rather than its offspring. Its muscular form is enlivened by a surface flecked with spots. On the leopard's back is a stool with a gently curving seat and vertical supports deco- rated with incised geometric motifs. The artist has cre- ated a dynamic composition that balances the solid monumentality of the animal figure with the delicate detailing of the gold-painted stool.

Carved as an allegory of power and authority, this object of prestige is a wonderful example of the lively cultural exchange among Akan-speaking groups in Ghana and Côte d'Ivoire. The stool on the leopard's back replicates the well-known royal seats made by the Asante peoples of Ghana. Asante stools, known as *dwa*, have been imitated by admiring neighbors since the beginning of the twentieth century. In this seat the combination of the royal stool of the Asante and the leopard—an animal associated with rulers throughout Africa—makes it the ultimate symbol of leadership and power.

Although borrowing from the artistic repertoire of the Asante, the artist of this work is from the neigh- boring Baule, Akan-speaking peoples who live in Côte d'Ivoire. Other seats in this style, including one in the collection of the Barbier-Mueller Museum in Geneva, have been identified as originating among the Faafwe, a Baule people living in the Toumodi region of Côte d'Ivoire. CC

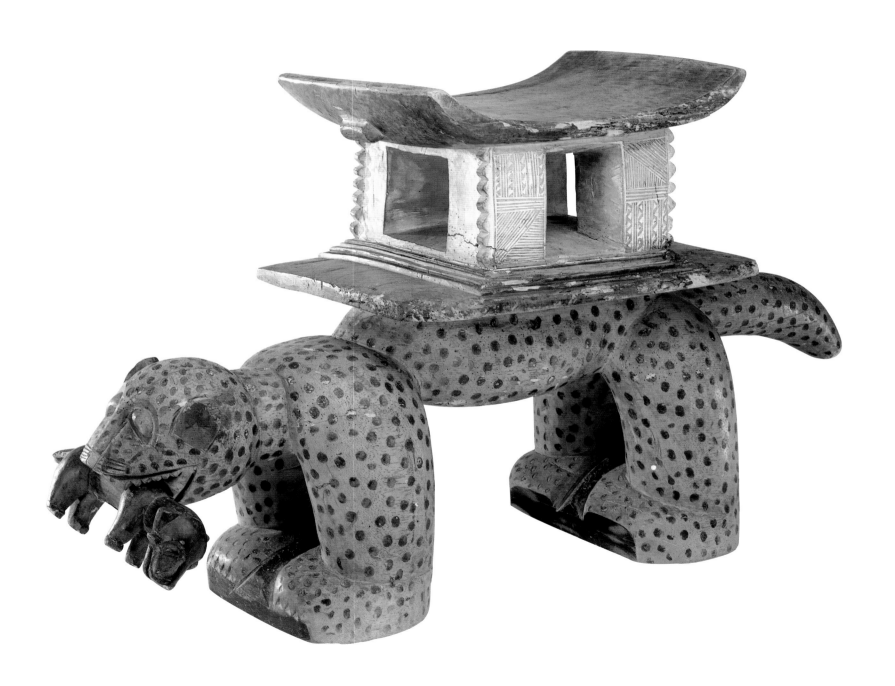

Rudolf Staffel
American, 1911–2002

Head
1938. Glazed stoneware, height 8⅜ inches (21.3 cm)

Purchased with funds contributed by Daniel W. Dietrich, Henry S. McNeil, Jr., Betty Gottlieb, Frances and Bayard Storey, Robert Tooey and Vicente Lim, June and Perry Ottenberg, The Acorn Club, and with the gift of Helen Williams Drutt English in honor of the artist. 2001-109-1

Light Gatherer
c. 1985. Porcelain, diameter 12 inches (30.5 cm)

Gift of Margaret Chew Dolan and Peter Maxwell 2001-191-1

As a ceramic artist of international distinction and professor of ceramics at the Tyler School of Art, Rudolf Staffel was a central figure in the Philadelphia art community for more than fifty years. In the early 1960s he became fascinated by the translucency and crystalline luminescence of porcelain, relishing the challenges of mastering a material that is extraordinarily difficult to work by hand. He called many of these porcelain vessels "light gatherers," and their unique beauty and breathtaking expertise won Staffel national and international renown.

Some of these works were turned on a wheel, then altered by pinching, scoring, and denting; others were formed over a balloon. This light gatherer from 1985 is one of the most audacious examples of the latter technique. Its variously shaped patches of thin white and blue clay seem to have been applied at random and barely cohere into a structure; the rounded base contributes to the effect of instability. The bowl appears insubstantial and casual, yet it is expertly constructed, and its luminosity belies the hard, strong body of the fired porcelain.

Before he adopted porcelain as his chosen medium, Staffel worked with stoneware clay for thirty years, making functional ware and occasionally sculpture. This rare sculptural head was inspired by the racial injustice of the notorious case of the "Scottsboro Boys" that occurred in 1931. Made in 1938, while the artist was teaching ceramics in New Orleans, the piece was never shown until it was included in the exhibition of Staffel's work at the Museum of Art and Design in Helsinki, Finland, and the Philadelphia Museum of Art in 1996–97. A powerful image in its own right, this sculpture stands as a reminder of the commitment and passion that underlie all of Staffel's work, even the most luminous and serene. DS

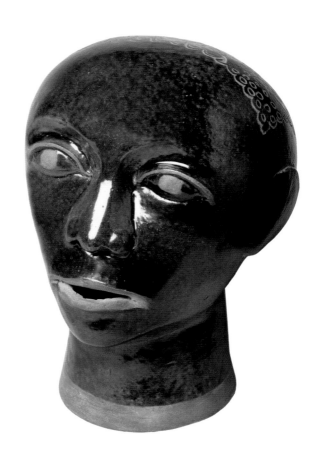

Wharton Esherick
American, 1887–1970

Phonograph Cabinet
1936–37. Cherry, height 27 ½ inches (69.9 cm)

Partial and promised gift of Enid Curtis Bok Okun, daughter of Curtis and Nellie Lee Bok. 2001-201-3

Steps with Elephant and Donkey Finials
1935. Hickory, height 35 inches (88.9 cm)

Gift of Rachel Bok Goldman and Allen S. Goldman, M.D. 2001-14-1

Born in Philadelphia, Wharton Esherick was trained as a painter at the Pennsylvania Academy of the Fine Arts and began working with wood in order to make frames for his canvases. By the mid-1920s he was devoting himself to the carved wooden sculpture and the distinctive furniture for which he would become famous. In the 1930s Esherick began to create whole interiors. A 1936 commission from Judge and Mrs. Curtis Bok to renovate the living rooms on the first floor of their home in Radnor, Pennsylvania, was one of the most extensive of his entire career, and he made it a masterpiece. The dramatic, freestanding spiral staircase (now in the Wolfsonian Museum in Miami Beach), the massive library fireplace and doorway, and the music room remain as outstanding examples of Esherick's art. When the Bok house was demolished in 1989, the Museum acquired the music room woodwork and the library fireplace and doorway.

Looking toward the future installation of the Bok music room as the latest in the Museum's famous collection of period architectural settings, the Bok's two children—Rachel Bok Goldman and Enid Curtis Bok Okun—have donated furnishings that will help to re-create the room's original appearance. Among their gifts for the Museum's anniversary year are this phonograph cabinet and these wooden steps.

The sculptural phonograph cabinet epitomizes the angular style of modern design that Esherick adapted for the paneling of the music room walls, ceiling, and built-in shelving. Holding a turntable and amplifier of the newest make, the phonograph was rolled out into the room for use. Otherwise, it fit into an alcove in the wall of shelves that Esherick devised to hold sheet music and record albums.

The steps, one of Esherick's most famous designs, were used to retrieve heavy albums of 78-rpm records from the upper shelves in the music room. With their curving lines and whimsical donkey and elephant finials, the steps display the playful spirit as well as the distinctive, idiosyncratic design and expert craftsmanship that Esherick brought to all of his work. DS

William H. Johnson
American, 1901–1970
Sunflowers
c. 1931. Oil on burlap, 20½ x 25 inches (52.1 x 63.5 cm)

Promised gift of Marguerite and Gerry Lenfest

William H. Johnson was one of a large number of African American artists who lived and worked in Europe in the 1920s and 1930s. Following his rigorous formal training at the National Academy of Design in New York, Johnson moved to Paris in 1926, joining what African American painter Hale Woodruff called the "Negro Colony" on the bohemian Left Bank of the French capital. During this time, Paris was the epicenter of modern art, and its infatuation with Josephine Baker, jazz, and African art and culture encouraged African American artists, writers, and musicians to leave behind the racial intolerance of the United States for the exhilarating freedom of the "City of Light."

While there, Johnson quickly established a reputation as a sophisticated, avant-garde artist whose work combined the subtleties of his hero, Henry Ossawa Tanner, with the latest advances in Expressionist painting, perhaps best exemplified by the work of Chaim Soutine and Emil Nolde. In 1930 Johnson moved to Denmark and married Holcha Krake, a Danish weaver and ceramicist he had met in France. It was while living in Scandinavia that the artist made this still-life arrangement with sunflowers, a theme that had become inextricably linked with the work of Vincent van Gogh. The tempestuous energy of Johnson's work, with its frenzied brushstrokes and brilliant hues, boldly salutes Van Gogh's famous paintings of sunflowers, one of which it joins in the Museum's permanent collections.

Johnson's desire to align himself with the European tradition of Expressionist painting, which had its origins in the Dutch artist's work, later gave way to a new style upon his return to the United States in 1937. He began to use bold outlines, simplified shapes, and primary colors in his paintings and concentrated mainly on aspects of daily African American life. Johnson's deliberately naive style, derived from the strong patterns of Scandinavian and African American folk art and the abstract, pictorial language of Synthetic Cubism, cemented his reputation as one of the leading painters of the African American experience in the rural South and urban North. MT

Alma Thomas
American, 1895–1978
Hydrangeas Spring Song
1976. Acrylic on canvas, 6 feet, 6 inches x 4 feet (1.9 x 1.2 m)

Purchased with funds contributed by Mr. and Mrs. Julius Rosenwald II in honor of René and Sarah Carr d'Harnoncourt, and by The Judith Rothschild Foundation, and with other funds being raised in honor of the 125th Anniversary of the Museum and in celebration of African American art. 2002-20-1

Alma Thomas was the first woman graduate of Howard University's fledgling art department in 1924. She went on to teach art in a Washington, D.C., junior high school for the next thirty-six years, all the while painting in her spare time. It was during the 1950s that her interest in abstract art blossomed under the tutelage of the New York painter Jacob Kainen, who introduced her to the latest work of the Abstract Expressionists. In 1960, at the age of 69, Thomas finally retired from teaching to devote herself full-time to what she called "serious art-making." During the next two decades the artist would produce a series of vibrant canvases, whose shimmering, mosaic-like patterns reveal her study of color theory and sensory perception. A contemporary of the color-field painters Morris Louis, Gene Davis, and Kenneth Noland, Thomas shared their interest in hard-edged abstraction, while retaining a sense of the rhythms and forms of nature.

Hydrangeas Spring Song is a superb example of the artist's accomplished late work, which during the 1970s saw a leap in scale and a renewed sense of joie de vivre. Like many of her large-scale canvases of this time, this intensely lyrical painting was chiefly inspired by natural phenomena, in this case the hydrangeas and other plants and flowers she admired in the gardens near her home. However, the scattered, abstract shapes and letters that form the puzzle-like composition also reference a wide range of sources for the artist's unique pictorial vocabulary, including the late cutout collages of Henri Matisse, Byzantine mosaics, and African textiles. The astonishing achievement of this monumental painting is bolstered by the knowledge that Thomas made it while she was in her eighties and suffering from severe arthritis. It is thus an uplifting image of springtime, in which the newly bloomed hydrangeas are transformed into a towering abstract canvas, whose lyricism celebrates the artist's own joy in the act of painting. MT

Andrew Newell Wyeth
American, born 1917

Left to right:

Public Sale
1943. Tempera on panel, 22 x 48 inches
(55.9 x 121.9 cm)

Bequest of Margaret McKee Breyer. 2000-1-1

Cooling Shed
1953. Tempera on Masonite, 25 x 13 inches
(63.5 x 33 cm)

Study for Cooling Shed
c. 1953. Watercolor on wove paper, 17 15⁄16 x 11 15⁄16 inches
(45.6 x 30.4 cm)

*Gift of Frank A. Elliott, Josiah Marvel, and Jonathan H.
Marvel in memory of Gwladys Hopkins Elliott. 1998-180-1, 5*

An artist of tremendous popular appeal, Andrew Wyeth has returned repeatedly in his paintings to the rural countryside, people, and buildings of his native Chadds Ford, Pennsylvania. His strong emotional connection with the land and its inhabitants can be seen in *Public Sale*, which depicts the forced auction of a farm and its contents. Wyeth's decision to focus on the landscape, rather than the people whose lives are about to be changed forever, imbues this already poignant scene with an air of haunting melancholy. The painting rises above the mundane social realism of many of Wyeth's contemporaries and exemplifies his consummate ability to create memorable images out of the ordinary, humdrum existence that surrounded him. The tire tracks that have churned up the earth in the foreground, perhaps redolent of the artist's gut-wrenching feelings at such a tragic time, are rendered with an attention to detail that has become Wyeth's hallmark.

Cooling Shed, painted in 1953, a key year in Wyeth's career, has an altogether different mood that reflects the great changes that had taken place in the artist's personal and public life. As his subject, Wyeth paints the light-flooded milk sheds on the farm of one of his neighbors, the Wylie family. During this period, Wyeth often ate lunch with the Wylies, and their farm appears in several paintings. The artist's private associations with this cooling shed are condensed into an evocative image of the afternoon sun streaming in and reflecting along the whitewashed boards.

Wyeth painted both of these works in tempera, a painstaking medium that demands time and patience as well as skill. He learned to use tempera from his brother-in-law Peter Hurd in the 1930s; the medium's aerial effects of light are well suited to Wyeth's vision. Meticulous craftsmanship enables the artist to render with exquisite clarity what seems like every blade of grass in *Public Sale* and every detail of the sunlit wooden

interior of the *Cooling Shed*, including a pair of milk pails and the golden piece of chamois leather hanging above them.

A close friend and supporter of Wyeth, Gwladys Hopkins Elliott acquired *Cooling Shed* directly from the artist in 1953, together with five exquisite watercolors and drawings relating to the composition, one of which is shown here. His gratitude for this show of support is evidenced in the receipt, which included a thumbnail sketch of the painting. A gift to the Museum from Mrs. Elliott's husband and sons in her memory, the group of works affords a rare sense of Wyeth's working method (see checklist nos. 158, 194).

Since 1959 the Museum has owned another tempera painting by the artist, the magnificent *Groundhog Day* of the same year. The addition of these earlier paintings gives significant depth to our collection of Wyeth's work. MT

Joseph Cornell
American, 1903–1972

Untitled (Woodpecker Habitat)
1946. Box construction, 13⅝ x 9⅛ x 3 inches (34.6 x 23.2 x 7.6 cm)

Observatory American Gothic
c. 1954. Box construction, 17⁹⁄₁₆ x 11⁵⁄₁₆ x 2¹¹⁄₁₆ inches (44.5 x 28.9 x 6.7 cm)

Partial gift of Mrs. Edwin A. Bergman, and purchased with the gift (by exchange) of Anna Warren Ingersoll. 2000-5-2, 1

Joseph Cornell, one of modern art's great individualists, was a self-taught artist who spent much of his time scavenging in junk shops and bookstores for the raw material that he used in his box constructions and collages. Back in his studio, these scraps of paper, bric-a-brac, and assorted odds and ends were transformed into magical works of art that take the form of a deeply romantic visual poetry.

Untitled (Woodpecker Habitat) exemplifies Cornell's playfulness. The woodpeckers in their sawdust-filled environment reflect the artist's fascination with birds, while the spirals look back to Marcel Duchamp's experiments with optical disks in his spinning "Rotoreliefs." In contrast, the compartmentalized *Observatory American Gothic* is more abstract in its conception, with its rigid geometry of glass chimneys and white cork balls set against a pale blue ground. It

belongs to an important series of dovecote constructions that Cornell had been working on since the early 1940s.

These box constructions have deep affiliations with the work of Duchamp and Kurt Schwitters, another inveterate forager, whose "Merz" collages exerted a powerful formal influence on Cornell. The artist's fascinating relationship with Duchamp was the subject of the exhibition *Joseph Cornell/Marcel Duchamp . . . in Resonance*, which opened at the Philadelphia Museum of Art in October 1998. This show explored the rich interplay between the artists' work, especially with regard to Duchamp's *Boite-en-valise*, the portable museum that Cornell helped his friend to assemble in the 1940s. These very different boxes will complement the Museum's holdings of Cornell's work, including the important *Homage to Juan Gris,* of about 1953–54. MT

Adolph Gottlieb
American, 1903–1974
Pictograph
1944. Oil on canvas, 36 x 25 inches (91.4 x 63.5 cm)

Promised gift of The Judith Rothschild Foundation

Adolph Gottlieb's pictographs were among the most important and original contributions to the rise of the New York School in the 1940s. This compelling work builds upon the Museum's strong collection of paintings by his contemporaries from that decade, including Mark Rothko, Willem de Kooning, Jackson Pollock, and Arshile Gorky. Two distinctive moments in Gottlieb's career are now represented in the Museum's holdings by the acquisition of *Pictograph*, which joins his 1954 painting *The Cadmium Sound*.

Gottlieb's first pictograph was painted in 1941. In response to the cataclysm of World War II, he and many of his contemporaries began seeking a vocabulary that would return art to its earliest sources in human culture: mythology and the collective unconscious. The urgent desire for a visual language that would be universal, immediate, and spiritually appropriate for the time led Gottlieb to seek models among the so-called primitive arts of Africa and Northwest Coast Indians.

This painting follows the typical format of Gottlieb's pictographs by locating invented visual signs within the discrete compartments of an overall grid. The treatment of shapes, atmosphere, and color evoke the work of Joan Miró, who was the subject of a 1941 retrospective exhibition at The Museum of Modern Art in New York. In contrast to Gottlieb's earlier pictographs, which take literature as the point of departure for individual symbols, this example is more directly influenced by the Surrealist technique of automatic writing. Although it includes a reference to one of the artist's favorite subjects—the themes of vision and blindness as told in the classical story of Oedipus—the results show a more improvisatory and painterly direction in Gottlieb's work. SR

Left to right:

William Edmondson
American, c. 1870–1951
Untitled (Three Doves)
c. 1935–40. Limestone, height 7¼ inches (18.4 cm)

William Traylor
American, 1856–1949
Untitled (House with Multiple Figures)
1939–40. Graphite on cardboard, 20 x 30 inches
(50.8 x 76.2 cm)

Martín Ramírez
American, born Mexico, 1895–1963
Untitled (Large Cowboy and Rider)
c. 1950–53. Colored wax crayon and graphite on wove
paper, 42¾ x 35⅜ inches (108.6 x 89.9 cm)

Partial and promised gift of Jill and Sheldon Bonovitz

The collection of twentieth-century American folk art assembled by Jill and Sheldon Bonovitz of Philadelphia is widely considered one of the most distinguished in the United States. Inspired by significant early exhibitions, such as *Black Folk Art in America,* *1930–1980,* held in 1982 at the Corcoran Gallery of Art in Washington, D.C., and with encouragement from Jill's mother, the pioneering collector and gallery owner Janet Fleisher, the collection brilliantly illustrates the wide-ranging subject matter and creativity of many of the country's most important self-taught artists. The Bonovitzes' gift of three spirited works by William Edmondson, William Traylor, and Martín Ramírez provides additional depth to the Museum's growing contemporary folk collections.

One of the only early twentieth-century self-taught artists to have received widespread recognition during his lifetime, William Edmondson was the first African American artist to have a solo show at The Museum of

Modern Art in New York, in 1937. Born around 1870 near Nashville, Tennessee, Edmondson was the son of freed slaves. He spent most of his life working in menial occupations until, at age sixty-two, he experienced what he felt was a divine vision that instructed him to turn to stone carving. Although he was self-taught and largely unaware of prevailing artistic movements, Edmondson's straightforward figural compositions, such as this sculpture of three doves, chiseled from local Tennessee limestone, relate stylistically to the work of academically trained contemporary American sculptors such as John Flannagan, Elie Nadelman, and William Zorach.

William Traylor was born into slavery in 1854. After emancipation he remained on the plantation of his former master George Traylor and adopted his surname. He stayed there as a field worker until 1938, when, at age eighty-four, he moved to Montgomery, Alabama, and was suddenly inspired to draw, producing a fantastic body of imaginative and bold yet minimally rendered drawings. Many of his narrative compositions recall scenes from the streets of the urban American South or recollections from his life on the plantation, as suggested in *Untitled (House with Multiple Figures)*.

Martín Ramírez suffered from severe mental instability and spent much of his life in a public institution (see page 122). As seen in this intricate composition, regimentation and repetitive patterning defined the landscapes and imagined topographies of his drawings. The traditional image of the horse and rider provided sustained inspiration for the artist and emerged frequently as the subject of his numerous drawings. Many of his riders, as here, appear in the center of a framed architecture or stagelike proscenium. JLL

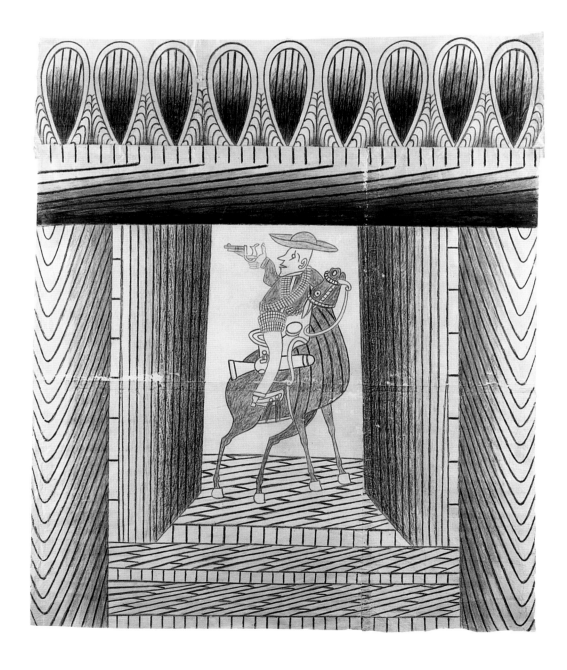

Martín Ramírez
American, born Mexico, 1895–1963
Madonna
c. 1950–53. Mixed media on paper, 50 x 28 inches
(127 x 71.1 cm) (framed)

Promised gift of Josephine Albarelli

In the spring of 1993 Josephine Albarelli, a Philadelphia collector and long-term Museum guide, gave the Museum its first significant work by a mid-twentieth-century self-taught master: a monumental drawing of a train by the Mexican American artist Martín Ramírez. The drawing, over ten feet in length and meticulously rendered in repetitive, boldly graphic yet abstract linear patterns, created much interest during its initial exhibition in the galleries. That work is now joined by an additional gift of two drawings, Ramírez's *Madonna* and an unusual rendering of objects and figures by William Traylor (see checklist no. 186), from Mrs. Albarelli in honor of the Museum's anniversary year. Both donations have helped to inspire and augment the Museum's ambitious and active program of interdepartmental acquisitions, exhibitions, and research into important twentieth-century American folk, self-taught, and "outsider" artists.

Little is known of Ramírez's early childhood and life in Mexico. It is uncertain exactly when he immigrated to California, but in 1930 he was found homeless and in a deteriorated mental condition in Los Angeles. Mute, undernourished, and deemed unable to care for himself, Ramírez was committed to the DeWitt State Mental Hospital in Auburn, California, where he began to draw sometime around 1948. His obsession with drawing brought the notice of one of his physicians, Dr. Tarmo Pasto, who was intrigued by the content and intensity of his patient's work and the calming focus it seemed to provide him.

The image of the Madonna apparently held a special importance for Ramírez; she is the subject of a number of his drawings and is often rendered colorfully with a reassuring smile. Perhaps inspired by his memory of traditional Mexican *santos* figures and other folk art from his childhood, these works suggest that such imagery may have been a source of comfort for the artist. JLL

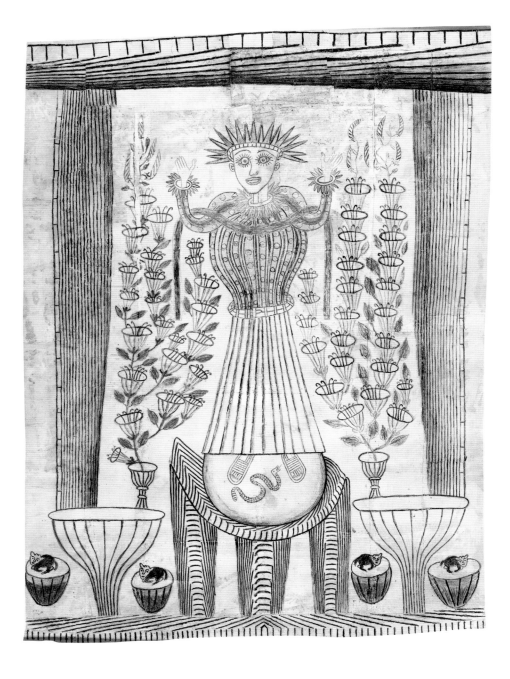

Peter Charlie Besharo
American, born Syria, 1898–1960
Untitled
1950s. House enamel and mixed media on canvas,
31¼ x 25 inches (79.4 x 63.5 cm)

Promised gift of Ann and John Ollman

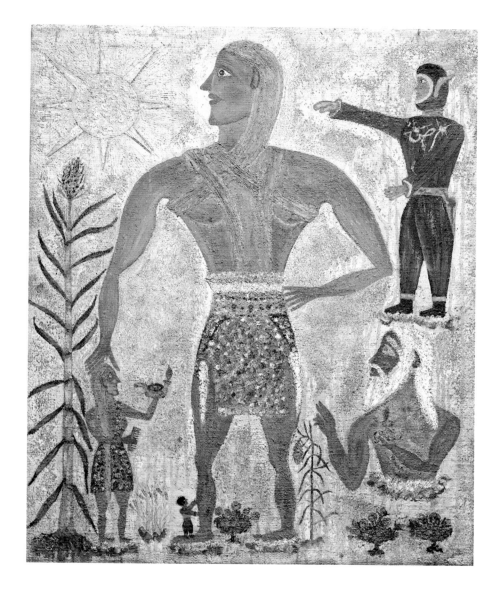

In 1912 Peter Charlie Besharo (also known as Peter Attie, Charlie Peter, Bochero, and Boshegan) immigrated as a teenager to the United States from the region of Mount Lebanon, Syria. One of two residents of Arab descent in the rural town of Leechburg, Pennsylvania, Besharo worked briefly for a haberdasher and then as a traveling peddler, selling yard goods, clothing, and other wares to the residents of the small mining camps that were located within a fifty-mile radius of the town. During the last twenty years of his life, he supported himself as a sign painter, and it is thought that the majority of his artistic output occurred during this period.

A devout Catholic, Besharo's startling and direct compositions incorporate traditional Christian symbolism with references to his obsession with and perception of the cosmic order, knowledge of traditional Middle Eastern motifs, Masonic imagery, and the devices of atomic power and weaponry. While he seems to have been somewhat private in regard to his painting and its specific meaning, he was not a social recluse and remained an active member of the local Catholic church and the Loyal Order of the Moose, a fraternal organization.

Like many visionary self-taught artists whose work has surfaced during the last half of the twentieth century, Besharo created his colorful and mysterious iconographic, narrative compositions in relative seclusion. Only after his death in 1960 were approximately seventy of his paintings found in the garage of J. E. McGeary, a neighbor, friend, and hardware store owner who rented storage and work space to the artist. This brilliantly colored figure painting, considered one of Besharo's masterworks, was among them; it provides the Museum with an extraordinarily rare and vibrant example of this important Pennsylvania artist's work. JLL

Left to right:

William Traylor
American, 1856–1949

Farm Scene with Cow and Man
c. 1939–42. Gouache on cardboard, 14 x 22 inches
(35.6 x 55.9 cm)

Joseph Yoakum
American, 1890–1972

**"The Hills of Old Wyoming in the Valley of the
Moon near Casper Wyoming"**
c. 1969. Graphite and colored pencil on paper, 12 x 19
inches (30.5 x 48.3 cm)

**"Mtns Caernaryon of Caernaryon Mts Range
New Snow Down Wales England"**
c. 1968–69. Ballpoint pen, colored pencil, and pastel on
paper; 9 x 12 inches (22.9 x 30.5 cm)

Bequest of Derrel DePasse. 2002-53-32, 17, 24

The bequest of the collection of twentieth-century American self-taught artists' works assembled by Derrel DePasse greatly enriches the Museum's holdings of several artists of significance, including Martín Ramírez, William Traylor, Eddie Arning, and, in particular, Joseph Yoakum (see checklist no. 193). During the last ten years of her life, DePasse devoted much

time, research, and energy to the study, documentation, and collecting of Yoakum's abstract and colorful landscapes.

Yoakum was born on Feburary 20, 1890, in the rural community of Ash Grove, Missouri, to parents of African American, Cherokee Creek, and European descent. At age ten, he left home to work as a horse handler with the Great Wallace Circus, and through his association with this and several other circuses, he traveled throughout much of North America and occasionally to Europe. Yoakum's later occupations included various jobs with several railway companies and brief forays as a miner. After army service during World War II, he settled in Chicago, where he started to experiment with drawing and painting in the 1950s,

although his greatest period of artistic production began in the early 1960s. Through the extensive documentary evidence compiled by DePasse, we now understand that the fantastic imagery and dreamlike environments depicted in Yoakum's colorful landscapes were the artist's recollections of his adventures and experiences from his travels.

During a visit to Philadelphia in 1989, DePasse first saw the work of Yoakum at the Janet Fleisher Gallery, a pioneer in the exhibition of self-taught artists. It is indeed fortunate and fitting that the fruits of DePasse's research and collecting will now, through this important gift to the Museum, serve as permanent testimony to the vision and brilliance of both the artist and the collector. JLL

The promised anniversary pledge of a future gift of a rich and diverse group of more than fifty works by various American self-taught and visionary folk artists from the collection of Dr. Nancy F. Karlins Thoman and her husband, Mark Thoman, greatly expands the Museum's ability to exhibit these important artists (see checklist no. 192). In addition to assembling a significant number of works by such artists as William L. Hawkins, Louis Monza, Nellie Mae Rowe, William Traylor, and Vestie Davis, Dr. Karlins researched, documented, and preserved one of the most extensive and complete representations of the imaginative paintings and drawings of the Pennsylvania folk painter Justin McCarthy, over twenty of which are included in this gift.

McCarthy grew up in one of the wealthiest families in the small town of Weatherly in Carbon County, Pennsylvania. His father, John, was a newspaper publisher who experienced extreme financial reversals just after the turn of the twentieth century and died in 1908, leaving the family in economic distress. Needing to help support his mother but failing in his attempt to complete law school, Justin suffered a nervous breakdown and was hospitalized from 1915 to 1920 at the Pennsylvania State Home for the Insane at Rittersville. It was there that he started to draw, and thus began his eclectic experimentation with a wide variety of subjects and mediums that continued throughout his life.

After leaving the hospital, McCarthy returned to the family mansion in Weatherly, where he lived with his mother. Although he held several jobs throughout the rest of his life, his main interest became drawing and painting on various found materials—salvaged paper, Masonite, canvas, and wood—with pencil, crayon, ink, oil, watercolor, and eventually after 1970, acrylic. Newspapers, fashion and travel magazines, religious and historical events, and glamorous celebrities supplied him with a vast range of subjects. The confident yet unconventional composition, nontraditional use

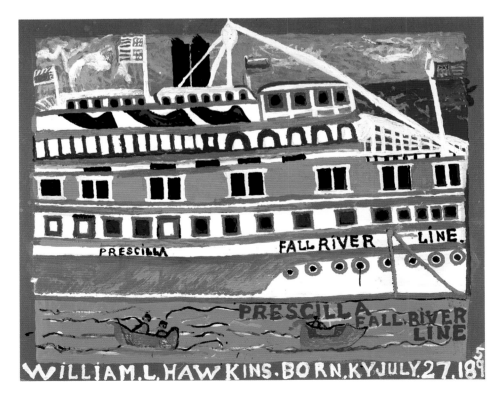

of color, and heavily textured brushstrokes seen here in *Jesus Bearing the Cross* are typical of McCarthy's distinctively expressive style.

Further demonstrating the variety and importance of the works included in this gift are the rare wartime scene of a military hospital ward by the Italian American artist Louis Monza and the boldly colorful, abstract painting of the riverboat *Prescilla* by the African American artist William Hawkins. Monza, who immigrated to America in 1913 to escape World War I, became an ardent pacifist as he grew older. His larger works depict the tragedy and human suffering of war and record his experiences and memories, either directly or through the recounted stories of family members.

Born near Lexington, Kentucky, in 1895, Hawkins moved to Columbus, Ohio, in 1916 and began to paint sometime in the 1930s. While little is known of

his earliest works, his later paintings of public buildings, ships, and prize farm animals often drew inspiration from the simple black-and-white photographs he took of such scenes. Hawkins sought to record and interpret the landscape, animals, people, and events of his experience, and like Monza, left a remarkable group of expressive and powerful paintings in the course of his efforts. JLL

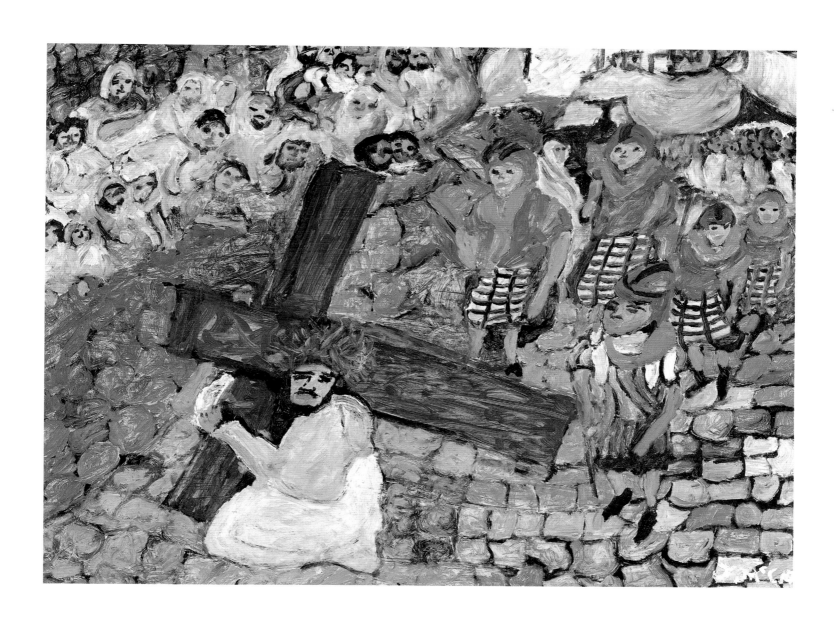

Elizabeth Catlett
American, born 1915
Mother and Child
1954. Terra cotta, height 11½ inches (29.2 cm)

Purchased with funds contributed by Dr. Constance E. Clayton and Mr. and Mrs. James B. Straw in honor of the 125th Anniversary of the Museum and in celebration of African American art. 2000-36-1

The universal theme of the mother and child has been of central importance to the work of the sculptor and printmaker Elizabeth Catlett. Indeed, it was a limestone *Mother and Child* that first brought her national attention, when it won first prize for sculpture at the historically important *American Negro Exposition*, held in 1940 at the Chicago Coliseum.

In the early 1940s Catlett moved to New York to work in the studio of the Russian émigré sculptor Ossip Zadkine. In 1946 she went to Mexico with the assistance of a Julius Rosenwald Fellowship. Profoundly influenced by the political idealism and social-realist aesthetic of Mexican artists such as David Alfaro Siqueiros, Diego Rivera, and her close friend Frida Kahlo, Catlett developed a personal vocabulary that emphasized human rights and the heroism of the common person, especially the dignity and strength of women of color. Small in size yet monumental in vision, *Mother and Child* is a masterful statement from the groundbreaking period of the artist's first decade in Mexico. The sculpture was created when she was working at the famous Taller de Gráfica Popular (Popular Graphics Workshop), a communal printmaking collective, where artists came together to design posters and leaflets for any number of causes aimed at bettering social conditions for the working classes, the poor, and the dispossessed.

Catlett still lives and works in Cuernavaca, Mexico, where her sculpture and printmaking continue to be inspired by the socialist and populist ideals of the Mexican muralist movement, as well as by Pre-Columbian art. The Museum also owns three works on paper by the artist: *Army Nurse* (1943); *La Lectura* (1950); and *Sharecropper* (1952), one of her best-known images. The addition of this major sculpture by Catlett greatly enriches the Museum's holdings of works by contemporary African American artists, for whom she remains a powerful and enduring role model. MT

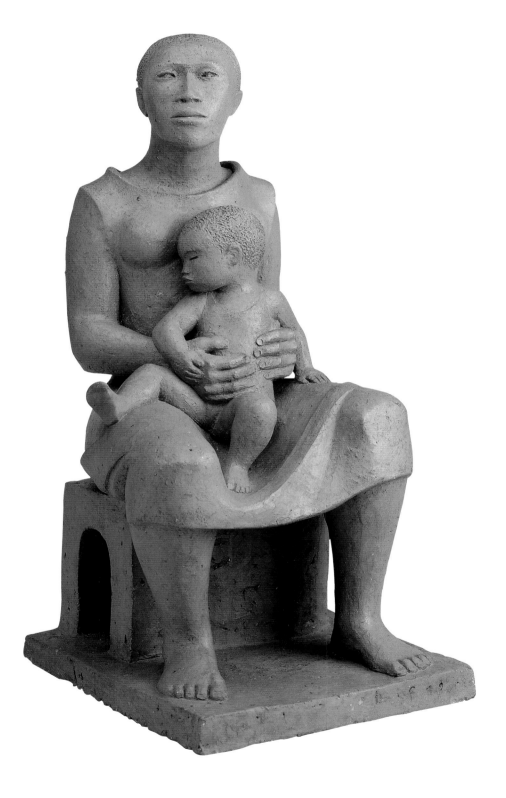

Alice Neel
American, 1900–1984
Last Sickness
1953. Oil on canvas, 30 x 22 inches (76.2 x 55.9 cm)

Promised gift of Richard Neel and Hartley S. Neel

Born in 1900, Alice Neel was one of the most important American portrait painters of the twentieth century. She grew up in Philadelphia, and graduated from the Philadelphia School of Design for Women (now Moore College of Art and Design) in 1921. Although she moved to New York shortly thereafter, her training impressed upon her the indelible stamp of local predecessors such as Thomas Eakins, Cecilia Beaux, and Robert Henri. Neel's artistic roots were reinforced during the resurgence of social realism in Greenwich Village in the 1930s. As the honesty and compassion evident in this portrait of Neel's mother attest, those artistic convictions never left her, even as the mainstream art world at mid-century entered an era dominated by abstract painting. Neel's interest remained focused on channeling her virtuosity toward the portrayal of the human condition, with a frank wit and wisdom unparalleled among her peers.

Neel's family served as one of her primary subjects; the artist's apartments doubled as studios throughout her life, and painting was as much a part of an ordinary day as sharing conversations and meals. *Last Sickness* is one of four portraits that Neel painted of her mother, Alice Hartley Neel, who lived most of her life just outside Philadelphia in Colwyn, Pennsylvania. This painting was made while she was staying with her daughter in New York during her final months. With heartrending directness, the portrait conveys the loneliness and fear of an elderly person facing death. Despite the occasion of a portrait sitting, vanity is nowhere in evidence: the model is too worn out to try to look cheerful or proud. But Neel deftly captured the intelligent sparkle that remained in her mother's eyes and her skeptical curiosity in the face of this poignant encounter between mother and daughter. AT

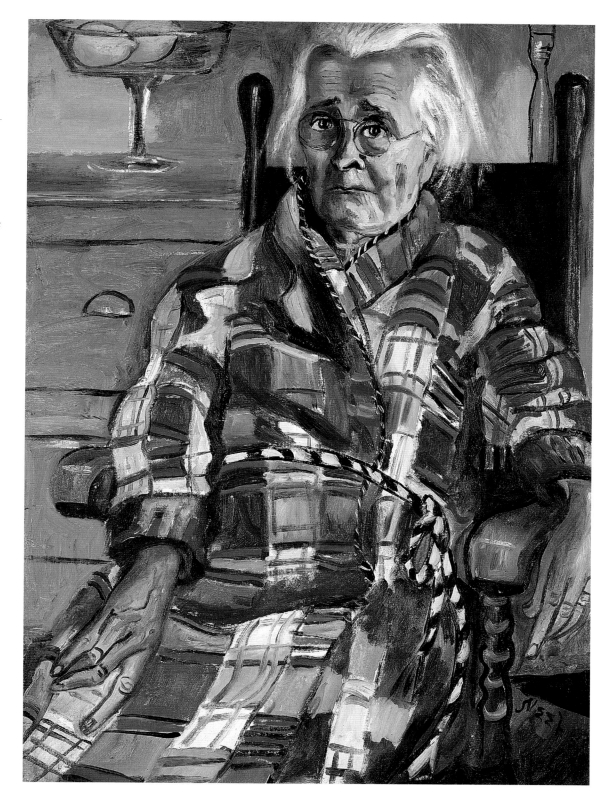

Man Ray
American, 1890–1976

Le Beau Temps

1939. Oil on canvas, 6 feet, 10¾ inches x 6 feet, 6¾ inches (2.1 x 2 m)

Promised gift of Sidney Kimmel

Man Ray painted *Le Beau Temps*, a phrase he understood to mean "the good times," just before the outbreak of World War II; its disturbing imagery and bitterly ironic title reflect his anxiety and despair over the impending conflict. The brightly colored composition was inspired by a series of haunting nightmares. It is also a fascinating compendium of several of Man Ray's most famous images, such as the two small stones tied with string that he had photographed earlier and the upturned billiard table used in a painting from the previous year.

A strange door divides the work into two distinct sections, perhaps alluding to day and night, or to reality and dream. In a macabre touch that only adds to the overwhelming atmosphere of foreboding, blood trickles from the keyhole of the door and gathers in a pool below. A robotlike harlequin hesitates to open the door and enter an unknown, darker world, where a female figure with a conical head and hourglass-shaped torso awaits him. The harlequin's head, which resembles a magic lantern, is illuminated by a burning candle covered by a lampshade. Since André Breton once described Man Ray in similar terms, the painting may be read as a kind of autobiography.

On one side of the bloody threshold lies an arid landscape, enclosed by a decaying stone wall that looks as if it has been breached by cannon shot, a sure sign of warfare. On the other side, two shadowy lovers embrace in the artist's studio, while above them a bull-like animal sinks its teeth into a reptile's throat with such ferocity that it seems not only to devour the reptile but also to copulate with it. The monstrous creatures, making love and war, salute the minotaur of Picasso, whose recent *Guernica* mural may have inspired Man Ray to make his own painting of this dark moment in world history. MT

Designed by **Max Ernst**
American, born Germany, 1891–1976
Bed-cage and Screen
1974. Walnut, alder wood, brass, mirror, offset lithograph collage, and mink; bed 7 feet, 4 inches x 8 feet, 10 inches x 8 feet, 4 inches (2.2 x 2.6 x 2.5 m), three-panel screen 6 feet, 1 inch x 5 feet, 4⅝ inches (1.8 x 1.6 m)

Gift of Lannan Foundation, Santa Fe, New Mexico
1999-14-1a, b

This bed-cage and screen are one of nine groups of furniture acquired by the entrepreneur and collector Patrick J. Lannan for his Palm Beach estate, Four Winds. Designed variously by Max Ernst, Diego Giacometti, Alberto Giacometti, Pedro Friedeberg, and Robert Wilson, these pieces are a major addition to the Museum's collection, which hitherto housed little artist-designed furniture beyond its holdings of American crafts (see checklist nos. 50, 133).

In collecting the furniture, Lannan favored elements of fantasy and whimsy, exemplified by artists who explored the Surrealist interest in the irrational. Lannan's last purchases before his death in 1983 included this bed and screen by Max Ernst, a major contributor to the Surrealist movement, whose sometimes hallucinatory work seems to emerge directly from the realm of dreams. Advertised as an apparatus for dreaming, these pieces were the first in a limited-edition series Ernst created in 1974 for the Geneva art fund, Modern Art Associates.

A birdcage/bed-cage with vertical brass rails at either end and a floor frame, Ernst's bed is fitted with a movable mirror at each end (both decorated with a signed lithograph); a leafy trellis that climbs up the foot rail; and a black mink bedcover. A three-panel screen entitled *The Great Ignoramus,* also embellished with a signed color lithograph, accompanies the bed. The set was sold with a certificate of authenticity from Ernst stating that the furniture had evolved from his designs and maquettes based on the theme of the aeolian harp.

Before its purchase by Lannan, the bed belonged to Nelson Rockefeller, who installed it in the vice-presidential mansion in Washington, D.C., in 1975. KBH

Dorothea Tanning
American, born 1910
Birthday
1942. Oil on canvas, 40¼ x 25½ inches (102.2 x 64.8 cm)

Purchased with funds contributed by C. K. Williams, II
1999-50-1

Self-portraiture might seem to be a paradoxical enterprise for a Surrealist artist, whose vocabulary and vision had more to do with dreams and desires than actual reality. Dorothea Tanning's exquisitely powerful *Birthday* resolves this paradox. Although the painting presents an astonishing likeness of the artist, the portrayal does far more to create a character than to reveal a preexisting one. An exotically dressed, unsmiling young woman stands on a steeply tilted floor and grasps a white porcelain doorknob. She is precisely set in space, but it is more fantasy than reality, with its shimmering mother-of-pearl light, infinite recession of doors, and extraordinary perspective. The woman's ruffled purple brocade jacket, opened to reveal her bare chest, tops a skirt of long, green tendrils, which, upon scrutiny, assume the form of human bodies. She is attended by a fantastic furry creature with wings and a long tail, ready to accompany her on the adventures that lie beyond the doors.

According to Tanning, *Birthday* was titled by the Surrealist émigré artist Max Ernst, who found it on her easel while scouting for gallery owner Peggy Guggenheim's upcoming exhibition of art made by women. Captivated by the model as well as by the painting, Ernst would become Tanning's husband and lifelong admirer of her work. The two were married in Los Angeles in 1946, at the home of the art collectors Louise and Walter Arensberg, in a double wedding with Juliet Browner and Man Ray. Tanning and Ernst also were close friends of Alexina (Teeny) and Marcel Duchamp. *Birthday* comes home, in a sense, as it joins the Surrealist treasures in a museum collection so richly flavored by Tanning's artistic circle. AT

Barbara Chase-Riboud
American, born 1939
Malcolm X, No. 3
1970. Bronze and silk, height 9 feet, 10 inches (2.9 m)

Purchased with funds contributed by Regina and Ragan A. Henry, and with other funds being raised in honor of the 125th Anniversary of the Museum and in celebration of African American art. 2001-92-1

Best known for her lavish abstract sculptures that fuse fiber and bronze, Barbara Chase-Riboud has pursued a long and successful artistic career that began at the age of seven, when she enrolled in art classes at the Philadelphia Museum of Art and its affiliated Samuel S. Fleisher Art Memorial. *Malcolm X, No. 3*, is one of a series of four sculptures that she dedicated to the African American civil rights activist and Muslim minister, who, following his pilgrimage to Mecca, eloquently advocated brotherhood between the races. The reconciliation of opposites has long been a goal for Chase-Riboud; she has described her work as uniting such opposing forces as male and female, black and white. This approach is clearly apparent in *Malcolm X, No. 3*, with its subtle combination of bronze and silk, hard and soft forms, rough and smooth textures, ancient and modern sources.

Born and raised in Philadelphia, Chase-Riboud studied at the Tyler School of Art in the late 1950s. Following her graduation, she won a John Hay Whitney Fellowship to study in Rome. She later traveled extensively in Africa, where she encountered the art and artifacts of ancient cultures, especially Egypt, that would have a profound impact on her own art. Other inspirations for her work include Chinese art and such giants of modern sculpture as Alberto Giacometti, David Smith, and Isamu Noguchi. In *Malcolm X, No. 3*, the influence of African art resonates in the hanging ropes and threads of silk that bear a resemblance to the raffia, netting, and fringe found in certain African masks. Ultimately, though, the artistic expression of the sculpture is distinctly Chase-Riboud's. Her dignified homage to the militant African American leader, in the form of a towering golden-hued monument, celebrates the spirit of one of the most charismatic and provocative figures of the twentieth century. MT

Isamu Noguchi
American, 1904–1988
Avatar
1948 (cast in bronze in 1982). Bronze, height 6 feet,
6½ inches (1.9 m)

Gift of the Isamu Noguchi Foundation, Inc. 2001-45-1

The son of the Japanese poet Yonejiro (Yone) Noguchi and the American writer Leonie Gilmour, Isamu Noguchi forged an aesthetic vision that reflected his dual heritage. His earliest sculptures were made under the tutelage of Constantin Brancusi, with whom the artist worked in the late 1920s in Paris. Noguchi achieved the poetic effects evident in these works through direct stone carving and the simplicity of their forms and structure. Although stone would remain his material of choice, the sculptor also worked in clay, paper, wood, and bronze. He became celebrated as a designer of rock garden landscapes, Akari lanterns, furniture, and stage sets (most notably for the pioneering modern dancer Martha Graham). In works such as this one, Noguchi solidified his reputation as a preeminent modern sculptor in New York in the 1940s. He combined the fragile, ephemeral, and sensuous qualities of Japanese art with intersecting abstract forms that shared a biomorphic vocabulary with the work of Joan Miró, Alexander Calder, and Jean (Hans) Arp.

Noguchi often sought inspiration in the ritualistic objects, mythologies, and belief systems of non-Western cultures. *Avatar*, an anthropomorphic standing sculpture, refers to a descendant or earthly incarnation of a deity, oftentimes associated with the Hindu god Vishnu. Throughout the ages, avatars have taken on various forms in Indian folklore, including that of a fish, a tortoise, a boar, and a human-lion hybrid. Noguchi's spectral creature is anatomically ambiguous, half-real and half-imagined, a six-foot-tall tripod of interlocking bone shapes whose nexus suggests a head. The attenuated and flattened forms have a great refinement, like pebbles on the beach that have been worn smooth by the grinding motion of sea and sand. This sculpture was originally conceived in precariously thin slabs of pink Georgia marble in 1948. Noguchi returned to the piece later in life, casting it in bronze at an Italian foundry in 1982. It is the fourth in an edition of eight casts, and the first major work by Noguchi to enter the Museum's distinguished collection of twentieth-century sculpture. MT

Eva Hesse
American, born Germany, 1936–1970
Untitled
1965. Gouache and ink on paper, 11½ x 16¼ inches
(29.2 x 41.3 cm)

Promised gift of Werner H. Kramarsky

After escaping as a young girl from Nazi Germany, Eva Hesse grew up in the United States and studied art at the Cooper Union and Yale University. Together with contemporaries such as Sol LeWitt, Robert Ryman, Mel Bochner, and Robert Morris, she was a member of the group of young New York artists who emerged in the late 1950s and 1960s. Although Hesse's career spanned little over ten years, her output was prolific, powerful, and memorable.

For Hesse, drawing was always an important and independent medium. Early in 1965 she wrote to LeWitt from Germany about her most recent drawings, which she divided into three stages. This work is clearly among those described in the second stage, with hard, machinelike forms often enclosed in boxes. Here Hesse masterfully balances strong linear contours, subtle shading, and flat color applied to an organized group of organic forms contained within a clear grid structure. The shading of the strongly outlined shapes has been attributed to the artist's admiration of the work of Fernand Léger, which Hesse had seen in France and Switzerland. The drawing's bold, Léger-like style represents a clearly defined moment in her artistic development, distinct from the free-floating, fluctuating forms that had characterized her earlier drawings.

In the Museum's collection, Hesse's drawing will join a strong body of work by her New York contemporaries. It also complements and amplifies the presence of her large fiberglass sculpture *Tori* of 1969. IHS

Sam Francis
American, 1923–1994
Red
1955–56. Oil on canvas, 10 feet, 2 inches x 6 feet, 2 inches
(3.1 x 1.8 m)

Partial and promised gift of Gisela and Dennis Alter
2000-94-1

Sam Francis's _Red_ brings to the Museum's collection its first major work by one of the most important postwar artists associated with the San Francisco Bay area. This magnificent painting reveals the artist at the height of his creativity, when he responded to the natural world through his distinctive painting language.

Francis was born in San Mateo, California, in 1923. He studied botany and medicine at the University of California at Berkeley, but World War II brought a hiatus to his studies. He became a fighter pilot, was injured, and then suffered from spinal tuberculosis. While bedridden in France from 1943 to 1946, Francis began making watercolors and decided to become an artist. He returned to California and studied painting at Berkeley until 1950. Francis then went back to Paris, where he ultimately established his reputation in 1952 with an exhibition at the Galerie du Dragon.

In 1955 the artist moved to a larger studio in Paris in order to work on a mural scale, as he did in _Red_, begun the same year. Divided into separate zones of color, the canvas is a tumbling accumulation of cell-like forms, realized through the use of soaking and dripping paint as well as virtuoso brushwork. Powerfully suggestive of a landscape, the artist's nuanced exploration of the painting process and the dynamics of color evoke comparison with the work of Mark Rothko, who had taught at Berkeley from 1946 to 1950, when Francis studied there.

Red is emblematic of Francis's lifelong homage to Henri Matisse and Claude Monet. Indeed, this unique marriage of New York School abstraction with elements of the French painting tradition remained the hallmark of Francis's work for the rest of his life. SR

Sam Francis
American, 1923–1994
The White Line
1960. Color lithograph (edition 75), sheet 35¾ x 24⅞ inches
(90.8 x 63.2 cm). Printed by Emil Matthieu, Zurich;
published by Kornfeld und Klipstein, Bern, Switzerland

Promised gift of Mr. and Mrs. Jack M. Friedland

When Sam Francis completed his first sixteen lithographs in Zurich in 1960 at the age of thirty-seven, the California-born artist had already won international acclaim as a leading Abstract Expressionist painter of the postwar generation. As an artist for whom the act of painting was a voyage of discovery, Francis was entranced by the mysterious properties of printmaking. Lithography easily accommodated his customary rhythmic application of broad brush-strokes, haphazard drips, and flung splatters. It also offered an unexpected advantage over watercolor and oil painting. In *The White Line*, Francis drew on six different stones (one for each color), using a similar choreography of gestures each time. Since the stones were to be inked and printed separately, it was easy for the artist to try out various color combinations before choosing the exact shade of red, orange, blue, yellow, green, and black he preferred.

Francis's oils and watercolors of the early 1950s employ a patchwork of subtle colors that stain the entire surface of the canvas or paper, but during the second half of the decade he began to allow unpainted areas to balance the vibrant energy of his increasingly brilliant hues. *The White Line* shares its title with several related oils and watercolors of 1958–59 in which a central channel divides the composition vertically. The last of Francis's pivotal early investigations into the forcefulness of unworked areas, *The White Line* was awarded the grand prize at the *Third Biennial Exhibition of Prints* in 1962 in Tokyo. Forty years later this dazzling lithograph is still regarded as a masterpiece of modern printmaking. JI

137

Bob Thompson
American, 1937–1966
The Deposition
1961. Oil on canvas, 5 feet, 6 inches x 6 feet, 3 ½ inches
(1.6 x 1.9 m)

Purchased with funds contributed by Harvey S. Shipley
Miller and J. Randall Plummer, and with other funds being
raised in honor of the 125th Anniversary of the Museum
and in celebration of African American art. 2000-37-1

Bob Thompson's signature work depicts religious-mythic themes derived from the compositions of the old master paintings that he admired. The artist reinvigorated the traditional subject matter through his use of hot, vibrant colors and flat shapes, inspired in part by the work of Paul Gauguin and Henri Matisse.

Thompson studied art at the University of Louisville in his native Kentucky before moving to New York in 1959. He soon became a prominent figure in the burgeoning Manhattan art scene, exhibiting his colorful Symbolist works at the Zabriskie Gallery and participating in some of the earliest "Happenings" staged in the United States. In 1961 Thompson moved to Paris, where his work underwent a dramatic change, reflecting the impact of the Renaissance and Baroque paintings that he encountered on his daily sketching excursions to the Louvre.

Like many of the paintings that Thompson made during his first year in Paris, at the age of twenty-four, *The Deposition* deals with images of death and martyrdom, in this case the descent of Christ's body from the cross. Although the picture was probably based on an existing painting—the subject matter is particularly associated with the work of Peter Paul Rubens—the exuberant colors and absence of modeling and anatomical detail in the figures are hallmarks of Thompson's distinctive style. In the artist's view, his appropriation of traditional imagery was linked to the methods of jazz musicians, such as his friend Ornette Coleman, who continually reinvented existing musical compositions through spontaneous improvisation.

Thompson's tragic early death at the age of twenty-eight, following complications from surgery and prolonged drug addiction, cut short a prolific career in which he had produced nearly one thousand paintings and drawings in a mere six years—a testament to his feverish imagination and unique artistic vision. MT

Robert Motherwell
American, 1915–1991
Elegy to the Spanish Republic
1958–60. Oil and charcoal on canvas, 6 feet, 6 inches x
8 feet, 3¼ inches (2 x 2.5 m)

*Gift (by exchange) of Miss Anna Warren Ingersoll and par-
tial gift of the Dedalus Foundation, Inc. 1998-156-1*

In his career-long series of paintings and works on
paper entitled "Elegy to the Spanish Republic,"
Robert Motherwell used the tragic consequences of the
Spanish Civil War as a vehicle for exploring archetypal
themes of freedom and loss. Motherwell was only
twenty-one years old when the war broke out in 1936,
but the traumatic conflict between the democratically
elected Republican government and Franco's armed
Fascist forces made an indelible impression on him.
He began the "Spanish Elegy" series in 1948, when he
illustrated a poem for a never-published issue of the
art magazine *Possibilities*. The starkness of the imagery
and the symbolic use of color—the smoldering black-
ness of death and the vital whiteness of life—present-
ed the artist with a somber yet powerful visual state-
ment capable of infinite variations that he would
explore over the next four decades.

Motherwell was very attached to this particular
painting and refused to part with it during his lifetime,
preferring to keep it in his studio as a catalyst for new
works. Its raw and aggressive characteristics contrast to
another more lyrical and elegant version that Motherwell
also kept, now in the Museum of Modern Art in Fort
Worth, Texas. Both works provided the artist with the
two poles of his creative expression in the series. The
pared-down composition of this painting, consisting
of a massive column of funereal black that separates
the three oval shapes, is a masterpiece of tension and
balance. Its combative atmosphere is intensified by the
splatters and drips of paint and the irregular, freely
brushed edges of the forms. This monumental work is
the first from Motherwell's Abstract Expressionist peri-
od to enter the Museum's collection, and communi-
cates his passionate feelings about the doomed
Spanish Republican cause. Like Francisco de Goya and
Édouard Manet before him, Motherwell went beyond
the specific tragedy of the war to create a haunting
meditation on life and death. MT

Jacob Lawrence
American, 1917–2000
Taboo
1963. Tempera on hardboard, 19⅞ x 23⅞ inches
(50.5 x 60.6 cm)

Gift of the Zelda and Josef Jaffe Family

Throughout his long and distinguished career, Jacob Lawrence demonstrated a passionate interest in African American history and in his people's collective struggle for racial equality. Born in Atlantic City, New Jersey, Lawrence spent much of his early childhood in Pennsylvania, before moving with his family to Harlem in 1930. The burgeoning cultural scene of the Harlem Renaissance nurtured the prodigious young artist, who quickly developed his own inimitable approach to painting while studying at the Harlem Art Workshop. Working in bright primary colors and flat, cutout shapes in a narrative representational style, Lawrence explored African American themes, many of which had never before been used as subject matter in the history of Western art.

Executed in vibrant tempera colors, *Taboo* exemplifies Lawrence's expressive trademark style as well as his lifelong concern for social equality and justice. The painting comes from a period in the artist's career when he turned to civil rights issues, inspired by the struggles for integration in the American South. Here he depicts two pairs of newlyweds, linked arm in arm, who stiffly face us as in a traditional, formal wedding portrait: on the one side, we see a white groom and a black bride, and on the other, a black groom and a white bride. The painting's title alerts us to the social transgression of this double wedding, since in 1963 there were still anti-miscegenation statutes in several states forbidding interracial marriage. However, Lawrence's pair of finely attired, newly married couples have proudly overcome the obstacles of legal and societal censure, thus breaking the taboo against marrying outside of their race, in a gesture of extreme courage. MT

Jacques Lipchitz
American, born Lithuania, 1891–1973

Barnes Foundation Relief: *Musical Instruments*
1922–24. Plaster, height 33 inches (83.8 cm)

Reader II
1919. Plaster, height 30½ inches (77.5 cm)

Gift of the Jacques and Yulla Lipchitz Foundation, Inc.

Philadelphia is an important destination for admirers of Jacques Lipchitz's sculpture. Work from all periods of the artist's long and prolific career has an important presence inside and outside the Museum, in the center of the city, and along the Schuylkill River, as well as at The Barnes Foundation in Merion, just beyond the city limits. Throughout his life, Lipchitz enjoyed a special connection with area collectors, including Dr. Albert C. Barnes, who in 1922 commissioned him to execute the reliefs for Paul Cret's handsome Beaux-Arts building for the Barnes Foundation, and R. Sturgis Ingersoll, longtime president of this Museum, who became a close friend after the artist arrived in New York in 1941.

While Lipchitz is best known for the Cubist work he made in Paris during the 1910s, for the next five decades his output was characterized by ongoing metamorphosis, as amply evident from the examples in Philadelphia's collections. This gift of four works in plaster and one in terra cotta richly adds to the eleven sculptures already owned by the Museum (see checklist no. 226). In this context the works possess special resonance; for example, the painted plaster *Reader II* is an informative counterpart to the Museum's two important Cubist bronze sculptures by the artist, *Sailor* and *Woman with Braid,* both of 1914. It also makes an excellent partner to Juan Gris's painted plaster *Harlequin* of 1918, the Spanish artist's sole sculpture, made with the help of Lipchitz, one of his good friends. *Musical Instruments,* on the other hand, is a study for one of the stone reliefs on the facade of the Barnes Foundation. The plaster *Lesson of a Disaster* (checklist no. 226) exemplifies the last decade of Lipchitz's career, in which the allegorical power so important to all of his work becomes more boldly eloquent than ever. AT

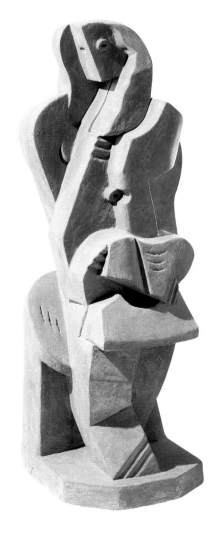

Harry Callahan
American, 1912–1999

Cape Cod
1972. Gelatin silver print, sheet 9¹⁵⁄₁₆ x 8 inches
(25.2 x 20.2 cm)

Purchased with funds contributed by John J. Medveckis
1997-37-37

Aix-en-Provence
1957. Gelatin silver print, sheet 8⁷⁄₁₆ x 7 inches
(21.4 x 17.7 cm)

Promised gift of Susan P. MacGill in memory of
Harry Callahan

While many photographers are drawn by the mystique of faraway lands, Harry Callahan found inspiration in his immediate surroundings. Born in Michigan and self-trained as a photographer, he worked in a commercial darkroom but developed his artistic vision photographing weeds and grasses around Detroit. Ansel Adams was an early influence. However, instead of emulating Adams's grand views and vistas, Callahan chose a highly nuanced approach to landscape photography by showing the wealth of detail in a small patch of ground. His attention to the wonder of commonplace scenery elevates the ordinary to a level of transcendence. Only a few years after he started taking pictures, Callahan's work began to be recognized as original and groundbreaking, and in 1947 he had his first one-person exhibition.

The one hundred photographs by Callahan pur-

chased with funds from John J. Medveckis and the partial and promised gift of twenty-one photographs from Susan P. MacGill provide the Museum with a comprehensive range of Callahan's landscapes (see checklist no. 222). The earliest prints in the gifts are from the artist's beginnings in Michigan in the early 1940s. Though Callahan did photograph other subjects, he continued working in the outdoors throughout the next four decades, exploring the use of abstraction, multiple exposure, and seriality. The group concludes with examples of his powerful photographs of the early 1980s and 1990s taken in Georgia. Besides greatly expanding our collection of works by this important master, the recent gifts are a wonderful addition to the Museum's strong holdings of American landscape photography. KW

William Eggleston
American, born 1939

Untitled (Tricycle, Memphis)
1972 (negative); 1980 (print). Dye transfer print, sheet
15⅞ x 19¹⁵⁄₁₆ inches (40.3 x 50.6 cm)

Untitled (Christmas Candle)
c. 1979 (negative); 1980 (print). Dye transfer print, sheet
15⅜ x 19¼ inches (39.1 x 48.9 cm)

Gift of Walter Hopps and Caroline Huber. 2001-216-2, 5

William Eggleston took the photography world by storm with his 1976 exhibition at The Museum of Modern Art, the first one-person show of color photography at a museum in New York. The attendant publication *William Eggleston's Guide* introduced his work to an even wider audience and was especially influential for young photographers.

Eggleston was born in Memphis, Tennessee, and for most of his life has remained in the Mississippi Delta area, where he has photographed extensively. He started making photographs as a teenager, but it was not until about 1962, when he discovered the photographs of Henri Cartier-Bresson and other masters, that he was inspired to pursue the medium with greater dedication. Though Eggleston initially worked in black-and-white, as any serious photographer of his generation did, by the late 1960s he started experimenting with color, which at the time was considered a predominantly commercial medium that was not accepted into the established vocabulary of artistic expression until the 1970s. Eggleston was attracted to color because of its lushness as well as its ability to be truer to life, and his pictures caused nothing short of a revolution.

In addition to the sensation created by his use of the color medium, Eggleston's habit of "photographing democratically" was also controversial. He rejected the idea of banality and believed that the visual richness of the world made utterly ordinary subjects worthy of scrutiny by the camera's lens, as these two examples from a gift of five photographs attest (see checklist no. 224). His picture of a tricycle, which appeared in the 1976 New York show, monumentalizes a child's rusting toy parked on the sidewalk. In another photograph, a plastic Christmas candle on the counter of a diner is presented as being as interesting as the nearby vase of flowers and the palm tree that echo its shape. KW

James Castle
American, 1900–1977

Counterclockwise:

Sugar Honey-Maid Graham Crackers
n.d. Soot on paper, in flattened cardboard box cover, bound with string; 13 pages including cover (one page torn out), 9¾ x 8½ inches (24.8 x 21.6 cm)

Camel Turkish & Domestic Blend Cigarettes
n.d. Soot on paper, in flattened cigarette package cover, bound with string; 12 pages including cover, 3⁵⁄₁₆ x 3¹⁄₁₆ inches (8.4 x 7.8 cm)

Val Vita Brand
n.d. Pigment and graphite on lined paper, in flattened can label cover, bound with string; 6 pages including cover, 3⅜ x 3¹⁄₁₆ inches (8.6 x 7.8 cm)

Campbell's Condensed Tomato Soup
n.d. Soot on paper, in flattened soup can label cover, bound with string; 8 pages including cover, 3⅜ x 3¹⁄₁₆ inches (8.6 x 7.8 cm)

Peet's Crystal White Granulated Soap
n.d. Soot on paper, in cardboard box front cover, bound with string; 8 pages including cover, 4 x 6⅜ inches (10.2 x 16.2 cm)

Gift of the Wade Family James Castle Collection
2001-166-5, 6, 9, 8, 10

The special quality of James Castle's art derives from the fact that his life was spent in profound silence. Born totally deaf and never learning to use the tools of sign language, reading, writing, or speaking, Castle lived out his seventy-seven years on small subsistence farms near Boise, Idaho. Drawing, his means of connecting and communicating with those around him, was virtually his sole occupation, and he pursued it almost daily with great diligence.

The surfaces Castle chose to work on were usually made from things found around the house, such as used grocery bags, old letters, or cigarette wrappers. He created his own materials by combining stove soot and saliva or, for polychrome works, colored paper pulped and dissolved in water. The reused and irregular piece of paper or cardboard and the gritty and unpredictable homemade ink or pigment appealed to him over the neatness and uniformity of commercially made artists' materials. In the hard-worked surfaces of his pictures, mundane subjects such as barns, sheds, and farmhouse interiors take on a magical quality, still but powerful. A sense of mystery infuses them through his use of motifs like little imaginary square-headed, flat-bodied figures and strange, totemic treelike shapes standing like sentinels in the farmyards.

The inspirations behind the two to three hundred handmade "books" Castle created are particularly difficult to fathom. Perhaps derived from comic strips or calendars, they often present numerous small images in gridlike arrangements or seem to depict the illustrated pages of printed books or family photograph albums. The sheets of paper, battered and worn at the edges, are carefully stitched with twine into covers made from used cigarette packs or the like.

These books are among ten recently given to the Museum from the artist's estate (see checklist no. 191). Combined with four other Castle drawings, they form part of the Museum's significant and growing collection of work by self-taught artists. AP

Jasper Johns
American, born 1930

Foirades/Fizzles, with text by Samuel Beckett
1975–76. Bound book with thirty-three aquatints and
etchings (edition 250), plus box with color lithograph; page
13⅛ x 9⅞ inches (33.3 x 25.1 cm), box 13⁹⁄₁₆ x 10½ x 2¼
inches (34.8 x 26.7 x 5.7 cm). Printed by Aldo Crommelynck,
Paris; published by Petersburg Press, London

Promised gift of Mildred L. and Morris L. Weisberg

The harmonious marriage of text and image pre-
sented in *Foirades/Fizzles* is the result of a most
unusual collaboration between writer and artist.
Disinclined to oblige Jasper Johns's request for snippets
of unused work for a proposed joint project, Samuel
Beckett resuscitated five short pieces he had written in
French and translated them into English. Johns, in
turn, responded to the ambiguity of Beckett's bleak lan-
guage by recycling items from his own opaque vocabu-
lary of images. Stenciled numbers and letters, cross-
hatching and flagstones, plaster casts of body parts—
all elements used by Johns in earlier paintings and
prints—are recombined with studied serendipity on
thirty-three etched plates among the pages of Beckett's
prose.

It was the artist's idea to have all five texts printed
in both languages (French followed by English), a
decision that determined the layout of the book and
also inspired its most magnificent plate, seen here. At
left, the names of body parts and other cast fragments
are spelled out in block letters in English. This stacked
scumble of familiar English words disappears into the
darkened centerfold, only to reemerge on the right in
French, as in the first line, where *buttocks* changes to
fesses. Clearly relishing his newly acquired facility with
etching and aquatint, Johns has repeated the entire
composition of this double-page layout in reverse, as a
ghostly image that appears faintly under the surface
lettering (on line three, *ETTE*, the final letters of
chausette can be easily seen, preceding *sock*).

Now widely celebrated as one of the twentieth
century's most beautiful books, *Foirades/Fizzles* was
included in the major exhibition *Jasper Johns: Work
since 1974*, which was organized by the Museum for
the United States of America Pavilion at the forty-
third Venice Biennale in 1988. That this very copy was
shown on that occasion makes it an ideal addition to
our growing collection of major works by the artist. JI

John Woodrow Wilson
American, born 1922
Martin Luther King, Jr.
1981. Charcoal on paper, 38⅛ x 29⁷⁄₁₆ inches
(96.8 x 74.8 cm)

Purchased with funds contributed by the Young Friends of the Philadelphia Museum of Art in honor of the 125th Anniversary of the Museum and in celebration of African American art. 2000-34-1

For approximately the past thirty years, with increasing momentum from the mid-1990s, the Museum has been actively acquiring drawings by African American artists. This monumental charcoal drawing of Martin Luther King, Jr., by John Woodrow Wilson enhances our growing collection of figurative, abstract, and conceptual works by such artists as Jacob Lawrence, Betye Saar, and Romare Bearden as well as Philadelphians Dox Thrash, Quentin Morris, Charles Burwell, and Ellen Powell Tiberino.

Wilson, a draftsman and sculptor, grew up in Boston and attended the School of the Museum of Fine Arts. Courses of study with Fernand Léger in Paris in 1949 and encounters with Asian, African, and other non-Western objects in the Musée de l'Homme in that city were important early influences on his work. From 1950 to 1955 he lived in Mexico, absorbing the style and spirit of community espoused by the modern Mexican muralists and printmakers. As Wilson's art developed, he sought to combine the sculptural, curving figures and bold graphic compositions of the Mexican artists with the robust use of color, space, and stylized form that he admired in the work of Léger.

In the early 1970s Wilson's inclination for sculptural forms led to a shift to sculpture as his primary medium. Long fascinated by the human figure, and drawing on Buddhist, Olmec, and Easter Island examples, the artist began to conceive of a monumental, genderless, and idealized African head that would serve as a universal icon representing humankind. In 1982 he won a competition to create a monument to Martin Luther King for the Buffalo Arts Commission in New York. Wilson's idea took the form of an eight-foot-tall bronze sculptured head that was confrontational and impossible to deny, while also capturing the civil rights leader's humanity and the universality of the ideals he advanced. The Museum's drawing was made as a study for this important project and reveals Wilson's sensibility for dark tonalities and sculptural effects as well as his strong interest in the human condition. SRL/AP

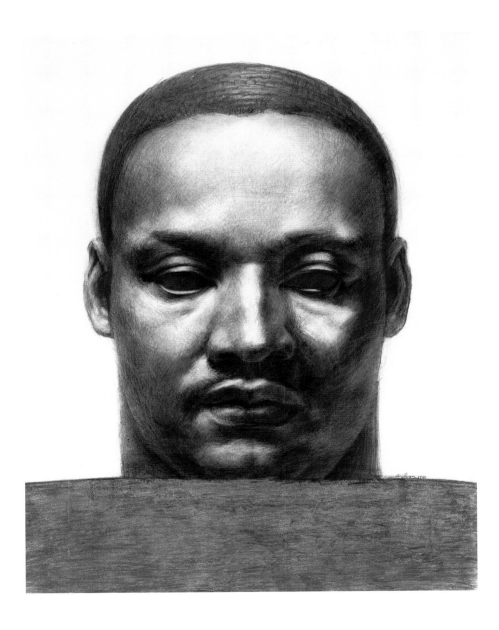

John Chamberlain
American, born 1927
Glossalia Adagio
1984. Painted and chrome-plated steel, height 6 feet,
8 inches (2 m)

Gift of Mr. and Mrs. David N. Pincus. 2000-96-1

A spectacular and monumental sculpture, John Chamberlain's *Glossalia Adagio* is a major addition to the Museum's already distinguished collection of postwar art. The work reflects the maturation of Chamberlain's distinctive sculptural idiom, which emerged in the 1950s and 1960s at the crossroads of Abstract Expressionism and Pop art. Chamberlain first scavenged among junk dealers for automobile parts in the late 1950s after studying at Black Mountain College, an environment where the concerns of the New York School cross-fertilized with those of a new generation. Adopting crushed car parts as his signature medium, he evolved a collage-based approach, treating these found objects as three-dimensional brushstrokes selected according to their color and shape, and then bent and twisted in response to his vision.

Fascinated by industrial color as a peculiarly American form of expression, Chamberlain works on a heroically large scale. He uses only discarded sheet metal—no other parts of the car—and composes according to intuition and chance to arrive at the right "fit," then fixes the arrangement with bolts and welding. The year he made *Glossalia Adagio* marked the artist's first use of sandblasting to achieve the multicolored surfaces that comprise the work. Extending its reach in many directions, the sculpture balances ribbonlike horizontal and vertical elements, and incorporates the surrounding space and shadows into its grand composition. With its title evocative of words and music, *Glossalia Adagio* pays tribute to poetry and painting, the two art forms Chamberlain has always credited as his most important inspirations. SR

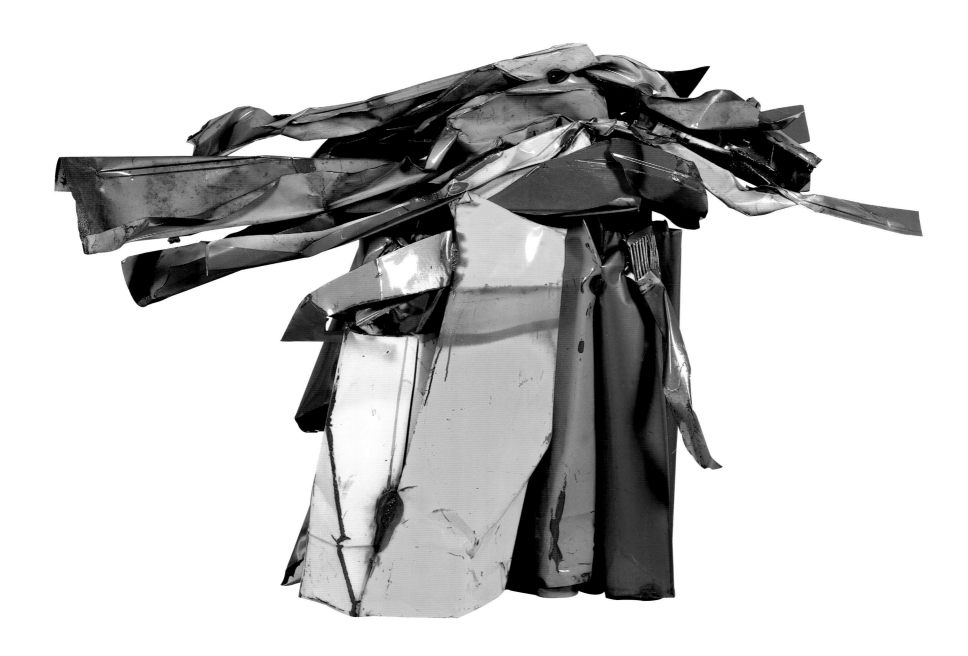

Wayne Higby
American, born 1943

Frozen Day Mesa
1984. Glazed raku-fired earthenware, height 12½ inches
(31.8 cm)

*Promised gift of Harvey S. Shipley Miller and
J. Randall Plummer*

White Granite Bay
1982. Glazed raku-fired earthenware, height approximately
12 inches (30.5 cm) each

Gift of Mrs. Robert L. McNeil, Jr. 2001-23-1a, b–4a, b

A distinguished ceramist and teacher at Alfred University in New York State, Wayne Higby has been an influential figure in the field of American ceramics since the early 1970s. While he was still an undergraduate art student on a round-the-world trip, ancient Minoan wares in a museum on Crete opened his eyes to the profound historical and cultural significance of the medium. A few years later, a drive across the American Southwest prompted Higby to realize that a keen awareness of the landscape had permeated his life since his childhood in Colorado. Shortly afterward, he began to explore landscape imagery in raku-fired ceramics, selecting two forms—a high, oval bowl and groups of lidded containers—that have provided fertile ground for his aesthetic investigations over three decades.

In his landscapes, Higby depicts the shapes of earth, air, and water. As *Frozen Day Mesa* and *White Granite Bay* suggest, the titles evoke the grand expanses of the wilderness, but they do not refer to specific geographic places. Both works beautifully demonstrate the full expression of Higby's ideas in his unique combination of subject and form. He sees a tension or a balance between the three-dimensionality of his ceramics and the illusion of projecting and receding space drawn upon them.

In *Frozen Day Mesa*, Higby created a continuous surface of decoration in the interior and exterior of the bowl. It can be turned and studied from one position to another, allowing for the landscape's remarkable illusion of endless space to unfold gracefully before the viewer. In *White Granite Bay*, the four lidded jars are tightly grouped in a fixed relationship, providing only an exterior surface for the spectator to move around in order to comprehend the landscape. DS

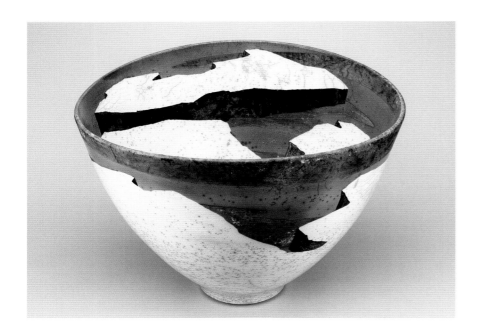

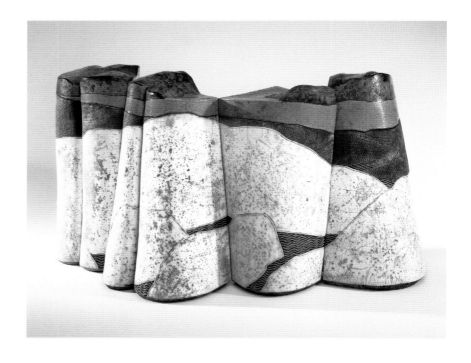

Wendell Castle
American, born 1932
Table with Gloves and Keys
1980. Mahogany, height 34½ inches (87.6 cm)

Gift of Mrs. Robert L. McNeil, Jr. 2001-15-1

By the mid-1960s Wendell Castle achieved a new, distinctive furniture style that was inspired by the sculptural forms of Wharton Esherick's furniture and interior designs and by the older artist's rebellion against the formal and conceptual rigidity of machine-made objects. To make his furniture, Castle drew upon the technical skills and aesthetic ideas about architecture, design, and sculpture he had learned in college. By laminating large blocks of wood together, he developed a vocabulary of pods, scooped volumes, sinuously curved edges, and thin, cantilevered planes that he used to create sculptural furniture unlike any ever made before. These pieces were widely exhibited and brought the artist national and international acclaim.

By the mid-1970s, however, Castle's attention had begun to shift toward more traditional aspects of woodworking. His exploration of eighteenth- and nineteenth-century American furniture, sparked by the Bicentennial in 1976, signaled a new interest in the historical styles and technical refinement of the furniture and decorative arts of ages past. He began carving objects illusionistically, such as a wooden umbrella in an umbrella stand or a full-sized overcoat hanging from a coat tree.

Table with Gloves and Keys of 1980 perfectly exemplifies this major turning point in Castle's career. On the top of a freely interpreted American Federal-style half-round table, elegantly constructed using traditional cabinetmaking techniques, the artist carved a pair of fur-lined gloves and a set of keys. The objects, however, are not colored or finely detailed to complete the illusion. Therefore, the deception is not total, nor was it intended to be. Instead, the expertise with which the gloves and keys are carved stands as a tribute to Castle's mastery of his art.

Three versions of the table were made, each slightly different in the placement and definition of the objects. Although they were not intended to be functional, the owner of this example placed it in her home as a hall table, adding another layer of content to the witty deception. DS

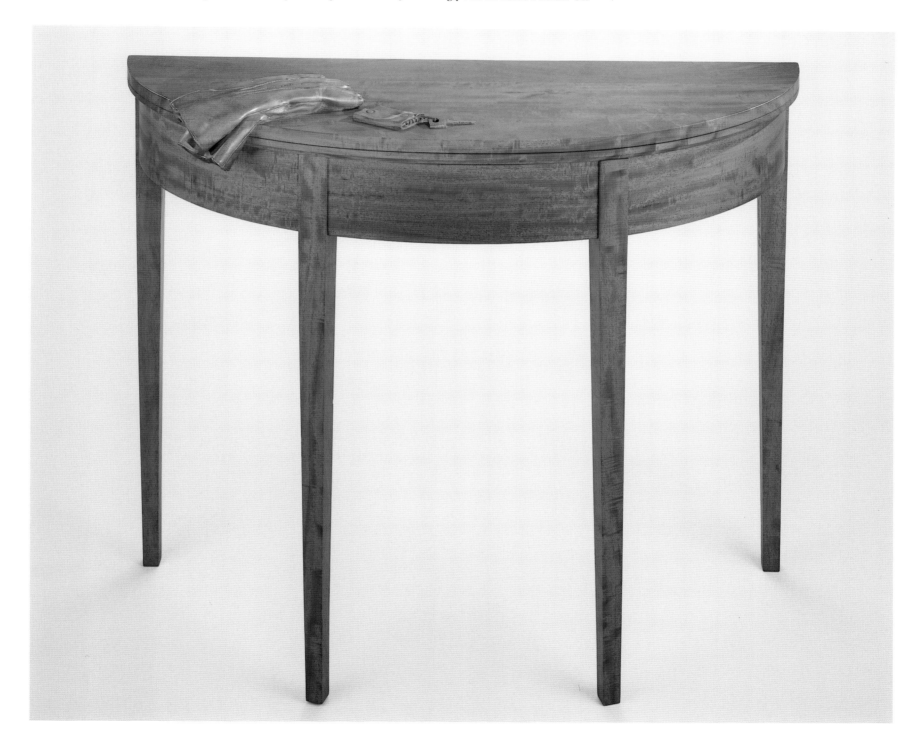

Designed by **Joe Colombo**
Italian, 1930–1971
Living Center
Made by Rosenthal AG (Selb, Germany, active 1879–
present); designed 1970, made from 1971. Laminated
wood, plastic, metal, and wool upholstery; chaise 25½ x
32¾ x 63 inches (64.8 x 83.2 x 160 cm) each, food trolley
28 x 25½ x 67 inches (71.1 x 64.8 x 170.2 cm), bar trolley
25½ x 19¾ x 55¼ inches (64.8 x 50.2 x 140.3 cm)

*Gift of Collab: The Group for Modern and Contemporary
Design at the Philadelphia Museum of Art. 2001-42-10–13*

One of the most revolutionary figures in twentieth-century Italian design, Joe Colombo argued that objects must respect their physical and sociocultural context and should accommodate the user's constantly changing needs. The 1970 *Living Center,* composed of two adjustable chaises and two serving trolleys on wheels, typifies Colombo's philosophy by allowing multiple modes of use and arrangement. Each chaise-longue is fitted with corner cushions that can serve either as headrests or footrests and flat surfaces with ashtrays can be pulled out of the arms. The trolley for bar service and entertainment and the food-service trolley are both equipped with a variety of compart-ments for such items as bottles, glasses, flatware, and china, as well as an electric hot plate, radio, and turntable.

The *Living Center* is one of fifteen groups of objects designed by Colombo for several manufacturers between 1964 and 1971 that were purchased for the Museum by Collab, the Museum's committee for modern and contemporary design (see checklist no. 51). Long out of production, the objects transform the Museum's collection by virtue of their designer, range, date, and rarity. KBH

Yohji Yamamoto
Japanese, born 1943

Man's Coat with Mermaid Pinup Girl
Fall/winter 1991–92. Wool/nylon and silk-screened rayon lining

Man's Jacket with Miró-Inspired Designs
Fall/winter 1991–92. Wool/nylon with wool/nylon appliqué

Gift from the private collection of John Cale. 2000-65-55, 57

In the mid-1960s, musician John Cale helped found the Velvet Underground, perhaps the first avant-garde rock band. After leaving the group in 1969, he became a well-known music producer and determinedly maverick solo artist. Fittingly for one who explores uncharted musical territory, Cale favors innovative apparel. By the early 1990s he had acquired a self-confessed penchant for expensive designer clothes. He appeared as a catwalk model for Japanese designers Rei Kawakubo of Comme des Garçons and Yohji Yamamoto, both renowned for exploring new ways of dressing, even in the traditionally staid realm of menswear. The garments illustrated here, from a Yohji Yamamoto collection that Cale modeled, evidence the designer's restrained simplicity that emphasizes his use of sensuous details. Yamamoto's signature black is juxtaposed with bright colors and bold images inspired by diverse sources: an image of mid-twentieth-century pinup art is alluringly placed on the coat's lining, while the appliqué of the jacket was influenced by the work of Spanish artist Joan Miró.

The garments in Cale's gift to the Museum redefine traditional tailoring or explore new directions in fashion design and also reflect his globally eclectic taste (see checklist no. 37). Included is the work of other designers from Japan, such as Mitsuhiro Matsudo and Issey Miyake, France's Jean-Paul Gaultier, England's Vivienne Westwood, Italy's Gianni Versace, and Belgium's Walter van Beirendonck, who designed clothes for his labels "Wild & Lethal Trash" and "aestheticterrorists.®" Cale embraced these differing and subversive design sensibilities, which embodied the anarchic aesthetic of late twentieth-century fashion. His large donation now expands the Museum's menswear collection to express that rebellious modernist spirit. HKH

Left to right:

Emanuel Ungaro
French, born 1933
Woman's Evening Suit
Fall 1989. Silk twill with metallic and silk brocading and pearls, silk velvet with silk and metallic machine embroidery, silk satin, silk crushed velvet with cutwork and metallic machine embroidery, and rhinestone buttons

Hubert de Givenchy
French, born 1927
Woman's Evening Dress and Shawl
Spring 1990. Silk taffeta and cotton lace embroidered with raffia

Valentino
Italian, born 1932
Woman's Evening Ensemble: Coat, Skirt, and Belt
Fall 1989. Silk satin, wool knit lining, and plastic buttons

The Diane Wolf Collection. 1999-95-103a–c, 73a–c, 95a–d

Diane Wolf's love of clothes, her attention to fabrics and trimmings, and her enjoyment of color are all evident in her extensive donation of apparel and accessories by numerous fashion luminaries from the 1980s and 1990s (see checklist no. 36).

Wolf's appreciation of a masterful mix of textures and prints is showcased by twenty outfits designed by Emanuel Ungaro, including this evening suit. While it is composed of three extremely decorative and luxurious fabrics—royal blue metallic brocade, embroidered black velvet, and cutworked red crushed velvet—the suit remains sleek and form-fitting, reflecting the designer's impeccable tailoring skills.

The refined elegance of Hubert de Givenchy is represented by twelve examples, many accompanied by the designer's sketches. This short evening dress, its delicate lace bodice given dimension by raffia embroidery, has a navy and white dotted shawl and asymmetrically draped skirt with an oversized side loop. The combined effect of these disparate elements is at once sophisticated and exuberant.

The third ensemble—one of thirteen outfits by the Italian designer Valentino—epitomizes his flamboyant yet completely wearable style. The reversible satin coat in bright orange, a bold but less predictable choice than the designer's signature red, has a loose trapeze cut punctuated by black buttons that attach the removable quilted lining.

The fifty-five exquisite ensembles and eighty-two examples of superbly crafted accessories reflect Wolf's individualistic, self-confident, and feminine taste, and elevate the Museum's holdings of late twentieth-century fashion to a new level. HKH

Pierre Cardin
French, born 1922
Short Evening Dress
1987. Silk taffeta with silk organza flower

Promised gift of Kathleen P. Field

Vera Wang
American, born 1949
Wedding Dress
1999. Silk satin and synthetic stretch net; metallic and silk ribbon embroidery with beading, rhinestones, and sequins

Gift of Mrs. Sidney Kimmel

The Museum's collection of twentieth-century women's fashion has been enhanced by two separate gifts from Kathleen P. Field and Caroline Kimmel. Mrs. Field's ensembles complement our representation of women's haute-couture garments from the late twentieth century (see checklist nos. 38, 98), while Mrs. Kimmel's bridal gown joins our extensive collection of wedding dresses that spans more than two centuries.

Mrs. Field's gift includes the work of leading designers from the 1970s and 1980s such as Donald Brooks, Adolfo, Pierre Cardin, Yves Saint Laurent, Emanuel Ungaro, Christian Lacroix, and Marc Bohan for Christian Dior—all of whom understood modern elegance. This gray dress from 1987 illustrates Cardin's love of architectonic forms. His exquisite handling of fabric allows the softly gathered, form-fitting body of the garment to flow seamlessly into a dramatic asymmetrical ruffle. Under the ruffle's peak, an oversized organza flower tops the bare left arm that contrasts with the long, tailored right sleeve.

Mrs. Kimmel's made-to-order gown was designed in 1999 by Vera Wang, who opened her New York bridal salon in 1990 and quickly became renowned for her revolutionarily simple yet luxuriously sophisticated designs. The gown features a net yoke and sleeves and an embroidered and beaded bustierlike bodice that enhances a slim figure. The flowing satin skirt is given subtle back interest by the traditional row of small satin bodice buttons that continue down the full length of the train. The epitome of Wang's elegant style, this dress adds a vital component to the Museum's collection of wedding fashions, which includes Grace Kelly's romantic, fairy-tale gown for her marriage to Prince Ranier of Monaco in 1956. HKH

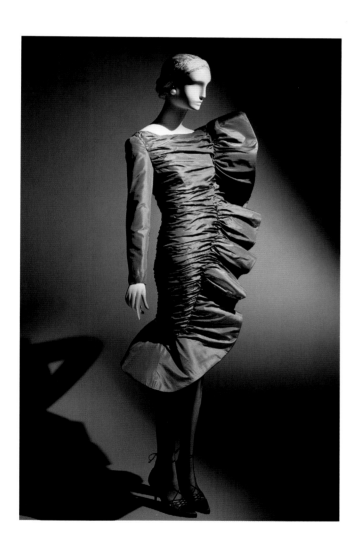

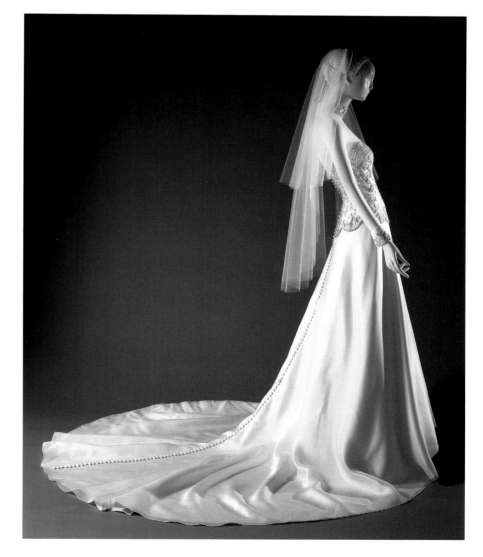

Lucian Freud

English, born 1922

Man Posing

1985. Etching (edition 50), plate 27½ x 21⅝ inches (70 x 55 cm). Printed by Terry Wilson and Marc Balakjian, London; co-published by James Kirkman Limited, London, and Brooke Alexander, New York

Promised gift of Harold S. Goldman and John A. Bonavita

Lucian Freud's reputation as the greatest living figure painter rests securely on a series of arresting portraits and nude studies painted with uncompromising candor during a career that now spans more than six decades. Less familiar, but equally deserving of signal recognition, are the artist's masterful prints. Although he made a handful of etchings in the 1940s, Freud took up printmaking as a serious pursuit only in 1982 and to date has produced more than sixty etchings. Like many of his prints, *Man Posing* is related to a painting, in this case *Painter and Model* (1986–87), which depicts two figures instead of one.

Although closely related, both etching and painting are self-sufficient works, each characterized by its distinctive medium. In the oil, the undulating terrain of flesh and tangled hair is painstakingly built up in layers of muted russet and brown tones with roughly applied brushstrokes. In the etching—a medium that allows for a quicker and more direct approach to the same subject—Freud maps the contours of the nude model in black and white with all of the delicacy and precision of a surgeon wielding a scalpel. By common consent, *Man Posing* is one of the artist's most coveted prints; it is also the first work by Freud in any medium to enter this Museum's collection, making it doubly welcome as a 125th Anniversary gift. JI

Philip Guston
American, 1913–1980
Entrance
1979. Oil on canvas, 5 feet, 9 inches x 7 feet, 9 inches
(1.7 x 2.3 m)

Promised gift of Agnes Gund and Daniel Shapiro

During the last few years of his life Philip Guston produced an outpouring of paintings that are the most profoundly moving of his career. They directly address the plight of the artist, one of the loneliest, most frightening vocations a person could ever choose. Like the late work of such predecessors as Francisco de Goya and Rembrandt van Rijn, Guston's last paintings forsake accepted beauty for an apparent crudeness, and abandon idealism for a hardy acceptance of the tragicomic reality of life. They are at once painful and liberating, not unlike the plays of Samuel Beckett or the music of John Cage, two of Guston's contemporary heroes. The works admit to the impossibility of painting, of living, and contradict the admission with their very existence.

The first of his paintings to enter the Museum's collection, *Entrance* is typical of Guston's late work in the weighty materiality of both its paint surface and subject matter. The door, which is ajar in an undefined space, cannot contain the flood of disembodied legs, bent at the knees, that march forward to form an impenetrable wall of mute physicality. The legs are a common motif in Guston's late paintings; always conjoined, never independent, they have the doomed feeling of humans stuck together in a cosmic *Titanic*, while they also suggest piles of thick paintbrushes stubbornly attached to palettes. The shoes, represented by horseshoelike soles, are less an aid to agility than immobilizing ballast. As one scrutinizes *Entrance*, only belatedly does one discover the long, hairy legs of the three bugs that have entered the scene, almost camouflaged among the soles of the shoes. The confrontation between the agile insects and the motionless mound of legs leaves open the questions of whether it implies hope or despair, and whether the painter (or viewer) ever can trust himself to be sure of the difference. AT

Wendy Maruyama
American, born 1952
Red Cabinet
1990. Polychromed poplar and maple, height 5 feet, 11½
inches (1.8 m)

Gift of Mr. and Mrs. Leonard I. Korman. 2001-97-2

One of the few successful women furniture-makers
in a male-dominated profession, Wendy
Maruyama has cleared a bold path within the field.
She mastered traditional furniture-making techniques
at Boston University's Program in Artistry and went
on to receive her masters of fine arts in 1980 from
Rochester Institute of Technology in New York State.
Inspired by the creative license of the prominent
1980s Italian design group Memphis, she set out to
pursue her own expressive ends in furniture-making.

Maruyama explored a wide range of aesthetic
options en route to her mature work. As a graduate
student, she began investigating the artistic possibili-
ties of furniture by freely painting her surfaces and
experimenting with angular compositions. In the early
1980s she simplified the form and color, painting or
blanching all of her pieces white, and presented this
work as warning of the effects of nuclear war as made
manifest in furniture.

Following this relatively stark phase, Maruyama
resumed her exploration of painted surfaces and
strong sculptural forms. Having gone to extremes in
her earlier work, she now balances contrasting ele-
ments in her furniture, which features unexpected
combinations of tradition and innovation, function
and fancy, restraint and energy, angles and curves. A
fine example of this aesthetic balancing act is found
in her 1990 *Red Cabinet*, which transforms a standard
furniture form into an extravagant sculptural state-
ment with sleek, tapered pods asserting themselves
across the facade of a boldly colored chest. SuR

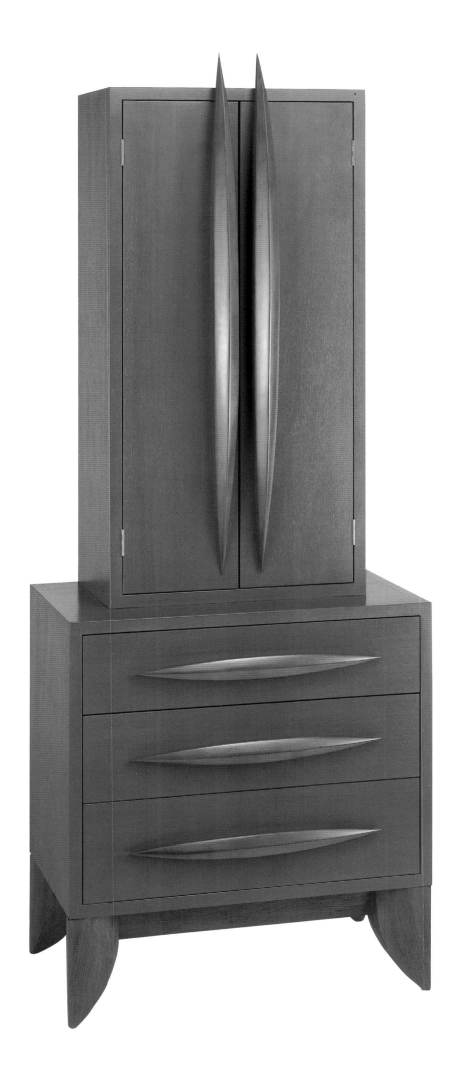

Betty Woodman
American, born 1930
Spring Outing
2000. Glazed earthenware, epoxy resin, lacquer, and paint; height approximately 38 inches (96.5 cm) each

Gift of The Women's Committee of the Philadelphia Museum of Art in honor of the 125th Anniversary of the Museum. 2001-16-1a–c

A central figure in contemporary American ceramics for more than three decades, Betty Woodman is famous for her encyclopedic knowledge of the history of the medium, which she incorporates into her work with a light touch. After first making functional wares, Woodman soon developed a personal style in which the stocky shapes of Mediterranean folk pottery were freely interpreted and combined with seemingly incongruous approaches to decoration and glazes, such as those used on Tang-dynasty Chinese ceramics. Since then she has exuberantly stretched the ceramic tradition in a variety of ways, decorating her work with expressionistically applied, brightly colored glazes, and exploring the sculptural implications of the medium in works ranging from individual pieces to room-size installations.

A vestige of function remains an important factor in Woodman's art. For example, each element of *Spring Outing* is based on three sturdy vase forms that are stacked to make a tall cylinder. Projecting on either side are flat clay silhouettes whose shapes suggest other pitchers and vases. On one side of the piece, Woodman further develops this motif with paintings of more multisize vases and handled pitchers. The interplay between the subdued colors of the painted images, the energetic lines of the silhouettes, and the continuous movement of the decoration over three-dimensional and flat surfaces perfectly embodies Woodman's sophisticated goal of making ceramics that refer to the vernacular of pottery yet remain completely individual.

In contrast to these linear elements, the other side of *Spring Outing* is decorated with strongly colored, boldly brushed images of three kimono-clad women posed against a continuous green and orange wall. Woodman gives the women's bodies volume by placing them on the central cylinder of each element. Their clothing, blown by the spring breeze, gracefully expands over the flat silhouettes. Abrupt truncations of their drapery and anatomy punctuate the flowing rhythms and implied grace of the work, producing a delightfully complex puzzle of form and decoration with the confidence and freedom of a mature artist working at the peak of her creativity. DS

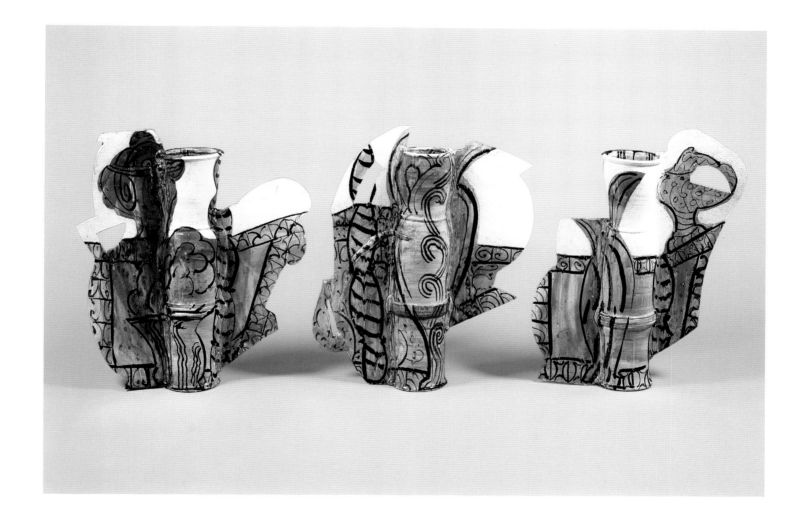

157

Martin Puryear
American, born 1941
Generation
1988. Red cedar and gourd, height 8 feet, 5 inches (2.5 m)

Promised gift of Mr. and Mrs. Leonard I. Korman

Martin Puryear's sculpture *Generation* is one of the artist's most lucid declarations of his essential artistic concerns. This wall-mounted sculpture is a welcome complement to *Old Mole* of 1985, the free-standing work acquired by the Museum in 1986.

A poetic composite of elements both made and found, *Generation* brings together a delicately hand-crafted and painted loop of cedar and the readymade natural form of a gourd. At once graceful and improbable, the sculpture charts a path between art and artisanship and an uncertain unity based on modernist principles of construction and juxtaposition. Puryear's vocabulary itself was formed at the crossroads of cultural traditions. He learned woodworking while in the Peace Corps in Sierra Leone in Africa (1964–66) and studied furniture-making when he was an art student in Stockholm, Sweden (1966–68). At a time when many American artists were turning to impersonal techniques of fabrication or repetitive process-based approaches, Puryear made craft the foundation of his art and adopted simplified organic shapes that speak in dialogue with the prevailing trend toward minimalism in sculpture.

Loosely related to a group of ring-shaped sculptural reliefs that he began making in 1977, *Generation* traces an undulating enclosure that projects unevenly from the wall. An asymmetrical shape that rises to different heights, the sculpture is poised on a diagonal that takes its impetus from the gourd. Comprised of patiently joined parts that are barely visible, the cedar form's smooth, graphic profile contrasts with the raw presence of the gourd—an object that introduces less comfortable associations with anatomy, ritual, and survival into an otherwise weightless and elegant composition. SR

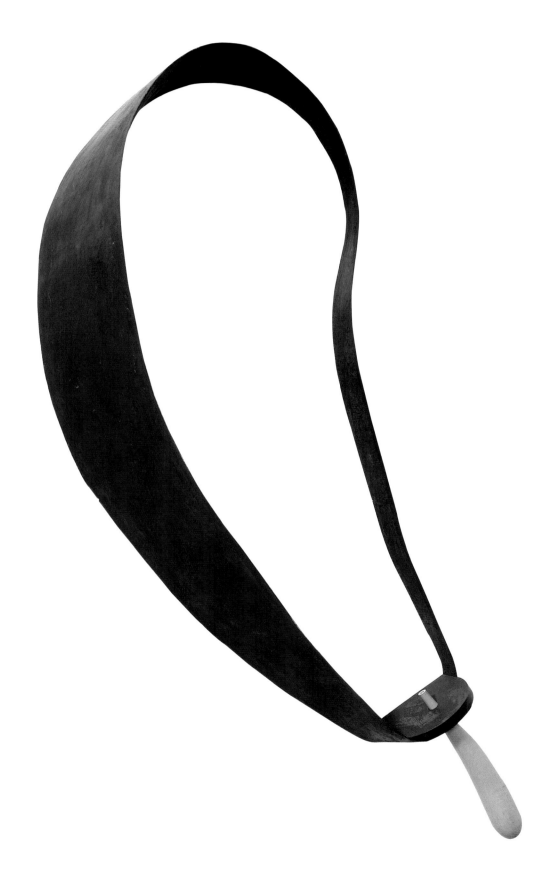

Gerhard Richter
German, born 1932
Swan (2)
1989. Oil on canvas, 9 feet, 10 inches x 8 feet, 2 inches
(2.9 x 2.4 m)

Partial and promised gift of Keith L. and Katherine Sachs
2000-31-1

The career of Gerhard Richter, who turned seventy years old this year, has been marked by astonishing variety and virtuosity. In the mid-1960s, he rejected the rules set by a century of "isms," in which an artist's identification with a certain art movement defined his or her lifelong stylistic approach. The only constant in his work, which shifts between representation and abstraction, monochrome and lush color, has been his strong dedication to the practice of painting, as he continually recharges a tradition whose death has been mourned several times over the last hundred years.

Richter has lived through a tumultuous time in Germany, and while his work only rarely confronts specific political issues, it is touched deeply by the drama of his historical circumstances. He was born in 1932 in a small village near Dresden, and as a boy his art school and museum experience was defined by Hitler's anti-modernist dictates. Richter left for West Germany in 1961 and soon enrolled at the Düsseldorf Art Academy. There he came under the influence of Joseph Beuys, who was leading a one-man campaign to bring German art back into the twentieth century after decades of repression. But whereas Beuys's efforts centered on sculpture and performance, many of his students, such as Richter, sought to renew the tradition of painting. First reacting directly to the influence of Pop art in the early sixties, Richter set off on a personal journey that allowed the restless exploration of manifold themes and techniques. His rejection of aesthetic ideology was a moral choice.

Swan (2) hails from 1989, a year in which Richter made an unusually large number of majestic abstract paintings. His "abstractions" are conspicuously real in their lavish attention to the concrete components of structure, paint, and surface. In Richter's three closely related, identically sized *Swan* paintings, the striated composition seems to dissolve before one's eyes, and the colors threaten to disappear into black and white. This remarkably fluid, mysteriously compelling painting encapsulates both the rigor and the vulnerability at the center of Richter's enterprise. AT

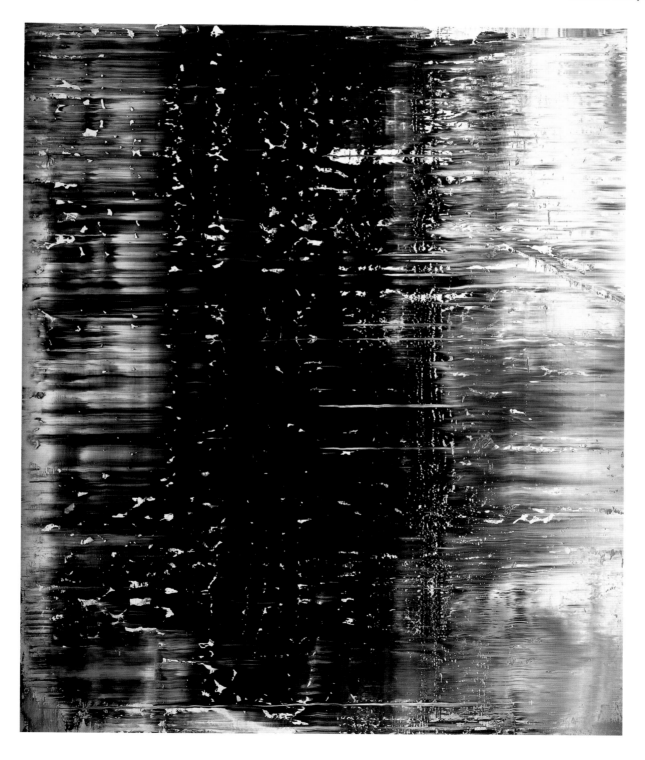

Dan Graham
American, born 1942
Heart Pavilion, Version II
1992–93. Two-way mirror, glass, and stainless steel; 8 feet x 12 feet, 9 inches x 16 feet, 4 inches (2.4 x 3.8 x 4.9 m)

Promised gift of Eileen Rosenau

Since the late 1980s Dan Graham has focused on designing two-way mirror pavilions that have been built all over the world. They are sculptures that come alive only through people's use of them, and that are meant to be experienced both from the inside and from the outside. Depending on weather conditions, the number and actions of their temporary inhabitants, and the surrounding environment, the effects of the pavilions are in constant flux. They provide ever-changing laboratories for investigating the phenomena of transparency and reflection, stasis and movement, solitude and socializing. These works expand Graham's early investigations in film, video, performance, and photography—seminal aspects of the art of the 1960s and 1970s—into the fields of sculpture and architecture.

Graham's elegant structures take their place in a rich historical tradition of small-scale outdoor architecture in Europe and Asia, from Chinese moon-viewing pavilions to Renaissance garden follies to twentieth-century bus shelters. *Heart Pavilion* adapts the shape of the common symbol of love, simple in form but infinite in associations. The first version of the work was made in 1991 for the Carnegie International in Pittsburgh, where it was displayed in the entrance lobby of the Carnegie Museum of Art. In that version, both straight sides of the heart are two-way mirrors; here one of the sides is made of perforated stainless steel. Graham's glass pavilions toy knowingly with the assumptions we bring to public and private spaces: when are we the watched, when are we the watchers, when are we neither or both? The presence of *Heart Pavilion, Version II*, at the Museum will provide ongoing pleasure and provocation for the visitors who bring it to life. AT

Jasper Johns
American, born 1930
The Seasons (Spring, Summer, Fall, and Winter)
1987. Color etchings with aquatint (edition 73), sheet 26 x 19⅞ inches (66 x 48.3 cm) each. Printed and published by Universal Limited Art Editions, West Islip, New York

Promised gift of Edna and Stanley C. Tuttleman

Few great painters have been so thoroughly captivated by the process of printmaking as Jasper Johns. The relationship between his prints and his work in other mediums has always been extremely close, and, like Rembrandt van Rijn and Edgar Degas before him, Johns now maintains his own printmaking facilities within easy reach of his painting studio. The intimate intersection of these two mediums is nowhere more evident than in the series of four paintings titled "The Seasons" (1985–86) and the prints that they inspired. Johns's re-presentation of the group in eleven print editions, published between 1985 and 1991, underscores the crucial role printmaking plays in his artistic process.

The poetic use of the seasons to symbolize the transience of all living things and the promise of rebirth is deeply rooted in the arts of every culture. From Johns this universal theme has elicited a deeply personal response, wittily elaborated in a set of allusive images combining traditional symbols with overt and hidden autobiographical references. Rain is standard for spring, a leafing tree for summer, and snow and snowman for winter, while only a warning sign in French for falling ice appears to serve as a punning allusion to fall. In each of the seasons, an arm rotating within a circle is easily identifiable as the hour hand of a clock marking the passage of time. But less obvious is the fact that Johns has used a tracing of the outline of his own body as the shadow that drifts across all four compositions.

This stunning set of prints is the prime version among the various editions of *The Seasons*—and the only one printed in full color—making it a welcome addition to the Museum's other works by the artist. Since it is our good fortune to have Johns's painting *Fall* on long-term loan, visitors are now able to compare two distinctive versions of one of his most poetic inventions. JI

Jasper Johns
American, born 1930
Catenary (I Call to the Grave)
1998. Encaustic on canvas with wood and string, 6 feet,
6 inches x 9 feet, 10 inches (2 x 2.9 m)

*Purchased with funds contributed by Gisela and Dennis
Alter, Keith L. and Katherine Sachs, Frances and Bayard
Storey, The Dietrich Foundation, Marguerite and Gerry
Lenfest, Mr. and Mrs. Brook Lenfest, Marsha and Jeffrey
Perelman, Mr. and Mrs. Leonard I. Korman, Mr. and Mrs.
Berton E. Korman, Mr. and Mrs. William T. Vogt, Dr. and
Mrs. Paul Richardson, Mr. and Mrs. George M. Ross, Ella
B. Schaap, Eileen and Stephen Matchett, and other
donors in honor of the 125th Anniversary of the Museum.
2001-91-1*

Catenary (I Call to the Grave) belongs to Jasper Johns's most recent group of paintings and works on paper, begun in 1997. It is the fourth major work in the series and, together with the first painting, *Bridge* (San Francisco Museum of Modern Art), the largest. The group is remarkable for the austerity of its forms and the apparent emptiness of its compositions; of no other work in the series is this more true than *Catenary*. Like all of Johns's art over the past forty-five years it simultaneously invites and firmly resists interpretive analysis.

Monumental in scale, *Catenary* is brushed in tones of gray encaustic (pigment mixed with wax) inflected with strokes of red, green, purple, and ocher. A diamond-patterned harlequin motif appears at the far right. The painting also incorporates a sculptural element, consisting of a length of white string suspended across the front of the canvas from wooden slats that tilt outward along the left and right edges; Johns has inscribed a second arc in the painted surface just behind it. The term "catenary" (usually associated with suspension bridges) refers to the arc of string, which assumes its shape due to the force of gravity. The string motif is present throughout the series, whether in actuality or drawn or painted.

While the tone of the painting and its title may be elegiac, it bespeaks a passionate exploration of formal process that has fueled Johns's career. It is a work that captures an artistic mind and spirit still youthful and in search of new beginnings.

In the Museum's gallery devoted to Johns's work, *Catenary (I Call to the Grave)* resonates eloquently with the thirteen paintings and sculptures on extended loan from the artist. AT

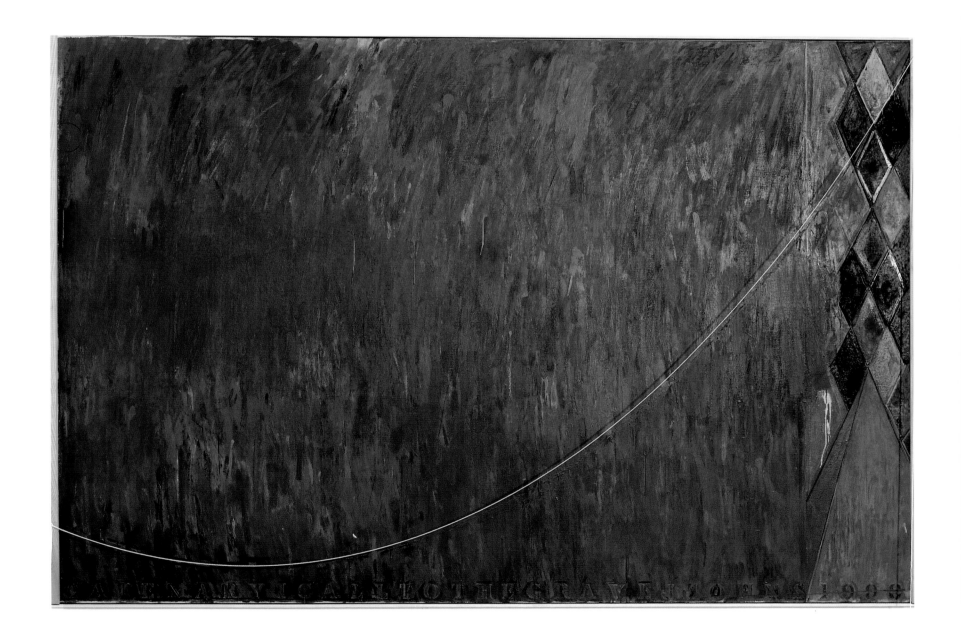

Checklist of Anniversary Acquisitions

As of August 1, 2002

Note to the Reader

The works of art illustrated in color in the preceding pages represent a selection of the objects in the exhibition *Gifts in Honor of the 125th Anniversary of the Philadelphia Museum of Art*. The Checklist that follows includes all of the Museum's anniversary acquisitions, not just those in the exhibition.

The Checklist has been organized by geography (Africa, Asia, Europe, North America) and within each continent by broad category (Costume and Textiles; Decorative Arts; Paintings; Prints, Drawings, and Photographs; Sculpture). Within each category, works of art are listed chronologically.

An asterisk indicates that an object is illustrated in black and white in the Checklist. Page references are to color plates.

For gifts of a collection numbering more than forty objects, an overview of the contents of the collection is provided in lieu of information about each individual object.

Certain gifts have been the subject of separate exhibitions with their own catalogues. In such instances, the reader is referred to the section For Further Reading.

AFRICA

Sculpture

1. Reliquary Guardian Figure (*mbulu ngulu*)
Gabon, Kota; late nineteenth century. Copper alloy
and wood, height 23 inches (58.4 cm)
Promised gift of The Judith Rothschild Foundation
See page 104

2. Crest Mask (*chi wara kun*)
Mali, Bamana, Bougouni region; late nineteenth–early
twentieth century. Wood and fiber, height with base
27⅛ inches (68.9 cm)
Promised gift of Anne d'Harnoncourt and Joseph Rishel
See page 105

3. Female Mask with Horns (*kpan pre*)
Côte d'Ivoire, Baule; late nineteenth–early
century. Wood, height 9¾ inches (24.8 cm)
Promised gift of Harvey S. Shipley Miller and J.
Randall Plummer in memory of Margaret F. Plass

4. Female Portrait Mask (Mblo)
Côte d'Ivoire, Baule; late nineteenth–early twentieth
century. Wood, height 11¼ inches (28.6 cm)
Promised gift of Harvey S. Shipley Miller and J.
Randall Plummer in memory of Margaret F. Plass
See page 104

*__**5. Granary Shutter and Lock**
Mali, Dogon; possibly late nineteenth–early twentieth
century. Wood and iron, height 19¾ inches (50.2 cm)
Promised gift of Harvey S. Shipley Miller and J.
Randall Plummer

6. Royal Seat (*ulimbi bia*)
Côte d'Ivoire, Baule, Toumodi region; twentieth century.
Wood and pigment, height 17½ inches (44.5 cm)
Gift of William C. Bertolet. 2000-159-1
See page 111

No. 5 Granary Shutter and Lock

ASIA

Costume and Textiles

7. Thirty-eight traditional textiles and costumes
Japan and Okinawa, nineteenth–early twentieth century.
Purchased with funds contributed by the Otto Haas
Charitable Trust, The Women's Committee of the
Philadelphia Museum of Art, Maude de Schauensee,
Theodore R. and Barbara B. Aronson, Edna and
Stanley C. Tuttleman, The Hamilton Family
Foundation, and Maxine and Howard H. Lewis in
honor of the 125th Anniversary of the Museum

*This superb group of thirty-eight Japanese traditional tex-
tiles and costumes includes stunning examples of futon
covers, entry curtains, and a rare Ainu coat and apron.
With the purchase of these objects from the collection of
Harry Packard, a leading collector of Japanese art, the
Museum now has one of the most significant holdings of
Japanese folk textiles on the east coast.*

Japan

Futon Covers

Phoenix with Wave
Plain-weave cotton with *tsutsugaki* (rice-paste
resist), 68 x 51¼ inches (172.7 x 131.4 cm)
2000-113-1
See page 79

Flying Phoenix with Paulownia Tree
Plain-weave cotton with *tsutsugaki* (rice-paste
resist), 76 x 53¼ inches (193 x 135.3 cm)
2000-113-2

Phoenix with Long Tail above Leaves and Flowers
Plain-weave cotton with *tsutsugaki* (rice-paste
resist), 75¾ x 54¼ inches (192.4 x 137.8 cm)
2000-113-3

Standing Phoenix
Plain-weave cotton with *tsutsugaki* (rice-paste
resist), 61 x 45¾ inches (154.9 x 116.2 cm)
2000-113-4

Noshi (auspicious dried abalone strips)
Plain-weave cotton with *tsutsugaki* (rice-paste
resist), 64 x 54 inches (162.6 x 137.2 cm)
2000-113-5

Waves with Chrysanthemums and Family Crests
Plain-weave cotton with *tsutsugaki* (rice-paste
resist), 75½ x 54 inches (191.8 x 137.2 cm)
2000-113-6

Karakusa (scrolling vine)
Plain-weave cotton with *tsutsugaki* (rice-paste
resist), 70 x 52⅛ inches (177.8 x 132.4 cm)
2000-113-7
See page 79

Karakusa (scrolling vine)
Plain-weave cotton with *tsutsugaki* (rice-paste
resist), 59 x 52 inches (149.9 x 132.1 cm)
2000-113-8

Floral, Leaf, Crane, and Turtle Roundels
Plain-weave cotton with *tsutsugaki* (rice-paste
resist), 57 x 54 inches (120.7 x 115.6 cm)
2000-113-9

Floral Sprigs and Leaf Roundels
Plain-weave cotton with *tsutsugaki* (rice-paste
resist), 62 x 52⅛ inches (157.5 x 132.4 cm)
2000-113-12

Floral and Bamboo Roundels with Floral Sprigs
Striped plain-weave cotton with *tsutsugaki* (rice-
paste resist), 62 x 53¾ inches (157.5 x 136.5 cm)
2000-113-13

**Bamboo Circle with Floral Sprays
and Bird/Turtle Roundel**
Plain-weave bast fiber with *tsutsugaki* (rice-paste
resist), 60½ x 57½ inches (153.7 x 146.1 cm)
2000-113-24

Six Motifs with Ducks and Waves
Plain-weave cotton with *tsutsugaki* (rice-paste
resist), 76⅛ x 54 inches (194 x 137.2 cm)
2000-113-31

Phoenix with Paulownia Leaves
Plain-weave cotton with *tsutsugaki* (rice-paste
resist), 79½ x 54 inches (201.9 x 137.2 cm)
2000-113-32

Phoenix Surrounded by Buddhist Treasures
Plain-weave cotton with *tsutsugaki* (rice-paste
resist), 89 x 64 inches (226.1 x 162.6 cm)
2000-113-34

Tea Ceremony Utensils
Plain-weave cotton with *tsutsugaki* (rice-paste
resist), 65¾ x 52¼ inches (167 x 134 cm)
2000-113-35
See page 79

Entry Curtains

Family Crest with Bamboo and Rocks
Plain-weave bast fiber, 63¾ x 66½ inches (161.9 x
168.9 cm)
2000-113-10

*__*Chidori* (plovers) over Waves**
Plain-weave bast fiber, 57½ x 44½ inches
(146.1 x 113 cm)
2000-113-11

**Family Crest with Pine Tree, Bamboo, Waves,
Crane, and Tortoise**
Plain-weave bast fiber, 65½ x 67¼ inches (166.4 x
170.8 cm)
2000-113-36

Clothing

Ainu Apron
Apron: plain-weave elm bark with cotton appliqué
and cotton embroidery in stem stitch, 25 x 19¾
inches (63.5 x 50.2 cm). Tie: tape-woven elm bark
and cotton, 1¾ x 92 inches (4.4 x 233.7 cm)
2000-113-30

No. 7 Entry Curtain (2000-113-11)

Ainu Coat
Plain-weave elm bark with cotton appliqué and cotton embroidery in stem stitch, 50¼ x 52 inches (127.6 x 132.1 cm)
2000-113-38

Children's Kimonos (3)
Plain-weave bast fiber and plain-weave cotton with cotton *kogin* (geometric darning stitches) (2000-113-21), 38¼ x 37¾ inches (97.2 x 95.9 cm); plain-weave bast fiber with *kasuri* (ikat) (2000-113-23), 34¾ x 33⅜ inches (88.3 x 84.8 cm); plain-weave cotton with painted designs (2000-113-33), 45 x 38 inches (114.3 x 96.5 cm)
2000-113-21, 23, 33

Firemen's Coats (2)
Plain-weave cotton with cotton *sashiko* (darning stitches) (2000-113-14), 39¾ x 46½ inches (101 x 118.1 cm); (2000-113-15), 41 x 47¼ inches (83.8 x 102.9 cm)
2000-113-14, 15
See page 78

Kimonos (4)
Patchwork plain-weave cottons with *sashiko* (darning stitches) (2000-113-16), 42 x 45 inches (106.7 x 114.3 cm); plain-weave *shifu* (cotton warp and paper weft) (2000-113-20), 43½ x 51¼ inches (110.5 x 130.2 cm); plain-weave bast fiber and plain-weave cotton with cotton *kogin* (geometric darning stitches) (2000-113-22), 38 x 40½ inches (96.5 x 102.9 cm); patchwork plain-weave cottons (2000-113-37), 62¼ x 48¼ inches (158.1 x 122.6 cm)
2000-113-16, 20, 22, 37

Kimono (with sleeves removed)
Sakiori (cotton warp with wefts of torn cotton fabric) and plain-weave cotton, 46½ x 25 inches (118.1 x 63.5 cm)
2000-113-19

Vests (2)
Plain-weave cotton with cotton *sashiko* (darning stitches) (2000-113-17), 30¼ x 24 inches (77.5 x 61 cm); plain-weave *shifu* (cotton warp and paper weft) with knotted fringe (2000-113-18), 31½ x 24 inches (80 x 61 cm)
2000-113-17, 18

Okinawa

Clothing

Kimonos (3)
Striped plain-weave *bashofu* (banana fiber); (2000-113-25), 45½ x 42 inches (115.6 x 106.7 cm), (2000-113-26), 47½ x 44½ inches (120.7 x 113 cm); plain-weave *bashofu* (banana fiber) with *kasuri* (ikat)(2000-113-27), 57¼ x 42½ inches (145.4 x 108 cm)
2000-113-25–27

Vests (2)
Plain-weave cotton with geometric *kasuri* (ikat) and supplementary weft patterning; (2000-113-28), 28½ x 17 inches (72.4 x 43.2 cm); (2000-113-29), 30½ x 24⅜ inches (77.5 x 61.9 cm)
2000-113-28, 29

8. Temple Hanging
Tibet, eighteenth–nineteenth century. Silk brocade appliqué with embroidery, 4 feet, 3⅛ inches x 19 feet, 7 inches (129.9 x 596.9 cm)
Purchased with the Stella Kramrisch Fund. 1999-43-1

[Late twentieth-century Japanese avant-garde menswear and designer shoes; Gift from the private collection of John Cale; see checklist no. 37]

Decorative Arts

9. Jar
Japan, Middle Jōmon period (2500–1500 B.C.) Earthenware, height 14⅛ inches (35.9 cm)
Purchased with the Hollis Family Foundation Fund, the Henry B. Keep Fund, and the East Asian Art Revolving Fund. 1999-130-1
See page 2

10. Cocoon Jar
China; Western Han dynasty (206 B.C.–A.D. 9), second century B.C.–early first century A.D. Earthenware with painted decoration, height 14¼ inches (36.2 cm)
Promised gift of Ann and Donald W. McPhail
See page 3

11. Thirty-eight objects, from a gift of forty-one
(see also checklist no. 20)
Gift of Colonel Stephen McCormick in honor of the Korean Heritage Group
See page 7

Colonel Stephen McCormick's continued generosity to the Museum in the form of the gift of an impressive group of forty-one Korean and Chinese objects is especially remarkable for the variety and depth it offers as a survey of Korean ceramic production, effectively doubling the Museum's holdings in this area. Also included are two paintings, an important eight-panel screen, and the first two Korean bronze mirrors to enter the collection.

Lidded Bowl
Korea, Silla period (57 B.C.–A.D. 935). Bronze, diameter 5½ inches (14 cm)
2001-134-9a,b

Lidded Pedestal Dish
Korea, Silla period (57 B.C.–A.D. 935). Stoneware, diameter 5¼ inches (14.6 cm)
2001-134-8a,b
See page 7

Six-lobed Dish
China; Northern Song dynasty (960–1127), tenth–eleventh century. Glazed porcelain (white ware), diameter 4⅝ inches (11.7 cm)
2001-134-17

Bottle
Korea; Koryo dynasty (918–1392), twelfth–thirteenth century. Bronze, height 12⅝ inches (32.1 cm)
2001-134-10

Bowl
Korea; Koryo dynasty (918–1392), twelfth century Glazed porcelain (celadon), diameter 6¹¹⁄₁₆ inches (17 cm)
2001-134-5

Cup Stand (shard)
Korea, Koryo dynasty (918–1392). Glazed porcelain (celadon), width 6⅝ inches (16.8 cm)
2001-134-6

Dish
Korea, Koryo dynasty (918–1392). Glazed porcelain (celadon), diameter 5⅞ inches (14.9 cm)
2001-134-4

Foliate Mirror
Korea, Koryo dynasty (918–1392). Bronze, diameter 4¾ inches (12.1 cm)
2001-134-13

Lidded Bowl
Korea, Koryo dynasty (918–1392). Bronze, diameter 7 inches (17.8 cm)
2001-134-11a, b

Square Mirror
Korea, Koryo dynasty (918–1392). Bronze, 4⅝ x 4⅝ inches (11.7 x 11.7 cm)
2001-134-12
See page 7

Bowls (2)
China; Northern Song dynasty (960–1127), eleventh century. Glazed stoneware with incised decoration (Northern celadon) (2001-134-24), diameter 6⁵⁄₁₆ inches (16 cm); glazed stoneware with molded decoration (Northern celadon) (2001-134-26), diameter 7⁹⁄₁₆ inches (19.5 cm)
2001-134-24, 26

Cups (2)
China; Northern Song dynasty (960–1127), eleventh century. Glazed stoneware (Northern celadon) (2001-134-27), 1¹⁵⁄₁₆ x 4³⁄₈ inches (4.9 x 11.1 cm); glazed stoneware with molded decoration (Northern celadon) (2001-134-28), 1¼ x 4⁵⁄₁₆ inches (3.2 x 11 cm)
2001-134-27, 28

Dish
Korea; Koryo dynasty (918–1392), eleventh century Glazed porcelain (celadon), diameter 7¹⁄₈ inches (18.1 cm)
2000-80-10

Dishes (3)
China; Northern Song dynasty (960–1127), eleventh century. Glazed porcelain (*Qingbai* ware); (2001-134-19), diameter 4³⁄₈ inches (11.1 cm), (2001-134-20), diameter 4½ inches (11.4 cm), (2001-134-23), diameter 4³⁄₈ inches (11.1 cm)
2001-134-19, 20, 23

Dishes (2)
China; Northern Song dynasty (960–1127), eleventh century. Glazed porcelain (white ware); (2001-134-21), diameter 4¹⁄₈ inches (10.5 cm), (2001-134-22), diameter 4¼ inches (10.8 cm)
2001-134-21, 22

Dish
China; Northern Song dynasty (960–1127), eleventh century. Glazed stoneware with incised decoration (Northern celadon), diameter 5³⁄₈ inches (13.7 cm)
2001-134-25

Eleven-lobed Dish
China; Northern Song dynasty (960–1127), eleventh century. Glazed porcelain (*Qingbai* ware), diameter 4½ inches (11.4 cm)
2001-134-18

Bottle
Korea; Koryo dynasty (918–1392), eleventh–twelfth century. Glazed porcelain (celadon), height 8⁵⁄₈ inches (21.9 cm)
2000-80-6

Bowl
Korea; Koryo dynasty (918–1392), twelfth century Glazed porcelain (celadon) with molded decoration, diameter 6³⁄₈ inches (16.2 cm)
2000-80-9

Wine Ewer
Korea; Koryo dynasty (918–1392), twelfth century Glazed porcelain (celadon) with underglaze iron decoration, height with lid 7¾ inches (19.7 cm)
2000-80-5
See page 7

Fishbowl
Korea; Koryo dynasty (918–1392), twelfth century Glazed porcelain (celadon), diameter 9¼ inches (23.5 cm)
2000-80-7

Covered Box
Korea; Koryo dynasty (918–1392), thirteenth century. Glazed porcelain (celadon), diameter 3⁷⁄₈ inches (9.8 cm)
2000-80-8a, b

Flask
Korea; Chosŏn dynasty (1392–1910), sixteenth–seventeenth century. Porcelain with underglaze iron decoration, height 7½ inches (19.1 cm)
2001-134-3
See page 7

Flask
Korea; Chosŏn dynasty (1392–1910), seventeenth–eighteenth century. Porcelain with underglaze cobalt decoration, height 7³⁄₈ inches (18.7 cm)
2000-80-3

Water Dropper
Korea; Chosŏn dynasty (1392–1910), eighteenth century. Glazed porcelain (white ware), height 4 inches (10.2 cm)
2000-80-11
See page 7

Incense Burner
Korea; Chosŏn dynasty (1392–1910), eighteenth century. Glazed porcelain, height 6½ inches (16.5 cm)
2000-80-12a,b

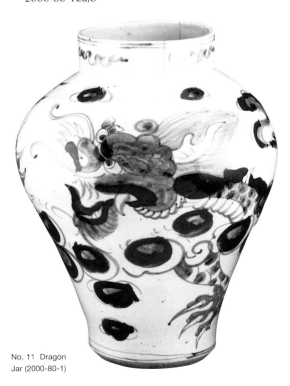

No. 11 Dragon Jar (2000-80-1)

Kundika
Korea, Koryo dynasty (918–1392). Bronze, height 13¾ inches (34.9 cm)
2001-134-14

Water Dropper
Korea; Chosŏn dynasty (1392–1910), eighteenth–nineteenth century. Porcelain with underglaze iron decoration, height 3¼ inches (8.3 cm)
2001-134-7

*Dragon Jar
Korea; Chosŏn dynasty (1392–1910), late eighteenth–early nineteenth century. Porcelain with underglaze cobalt and iron decoration, height 13¾ inches (34.9 cm)
2000-80-1

Dragon Jar
Korea; Chosŏn dynasty (1392–1910), nineteenth century. Porcelain with underglaze cobalt decoration, height 11¾ inches (29.8 cm)
2001-134-1

Jar
Korea; Chosŏn dynasty (1392–1910), nineteenth century. Porcelain with underglaze cobalt decoration, height 3½ inches (8.9 cm)
2000-80-4

Vase
Korea; Chosŏn dynasty (1392–1910), nineteenth century. Porcelain with underglaze cobalt decoration, height 13 inches (33 cm)
2000-80-2

Jar
Korea; Chosŏn dynasty (1392–1910), early twentieth century. Glazed porcelain (white ware), height 10 inches (25.4 cm)
2001-134-2
See page 7

12. Sixteen objects, from a gift of twenty-three
(see also checklist no. 26)
Promised gift of Allen B. and Heidrun Engler Roberts in honor of the 125th Anniversary of the Museum

The Museum's growing collection of Korean art has received its most recent, welcome promised gift from Allen B. and Heidrun Engler Roberts. The choice group of twenty-three examples of early stoneware, screens, album paintings, calligraphy, and furniture provides a perfect complement to the Museum's holdings by filling several important gaps with such objects as the twelve tomb ceramics and the eight-panel munjado screen.

Pedestal Vase with Handles
Korea; Silla period (57 B.C.–A.D. 935), fifth century Stoneware, height 10½ inches (26.7 cm)

Stand
Korea; Silla period (57 B.C.–A.D. 935), fifth century Stoneware, height 11 inches (27.9 cm)

Pedestal Vase
Korea; Silla period (57 B.C.–A.D. 935), fifth–sixth century. Stoneware, height 16 inches (40.6 cm)

No. 15 Dish

Footed Bowl
Korea; Silla period (57 B.C.–A.D. 935), sixth century
Stoneware, height 8 inches (20.3 cm)

Footed Cups (2)
Korea; Silla period (57 B.C.–A.D. 935), sixth century
Stoneware; height 7 inches (17.8 cm), 4 inches
(10.2 cm)

Lidded Jar
Korea; Silla period (57 B.C.–A.D. 935), sixth century
Stoneware, height 14 inches (35.6 cm)

Pedestal Vases (2)
Korea; Silla period (57 B.C.–A.D. 935), sixth century
Stoneware; height 12½ inches (31.8 cm),
15 inches (38.1 cm)

Vases (2)
Korea; Silla period (57 B.C.–A.D. 935), sixth century
Stoneware, 15 inches (38.1 cm) each

Vase with Handles
Korea; Silla period (57 B.C.–A.D. 935), sixth century
Stoneware, 13 inches (33 cm)

Blanket Chest
Korea; Chosŏn dynasty (1392–1910), nineteenth
century. Wood with iron fittings, height 37½
inches (95.3 cm)

Marriage Chest
Korea; Chosŏn dynasty (1392–1910),
nineteenth century. Persimmon wood with brass
fittings, height 51½ inches (130.8 cm)

Set of Three Nesting Boxes
Korea; Chosŏn dynasty (1392–1910), late nineteenth–
early twentieth century. Lacquered paper; largest
box 11 x 15 inches (27.9 x 38.1 cm)

Rice Chest
Korea; Chosŏn dynasty (1392–1910), early twentieth
century. Wood, height 30 inches (76.2 cm)

13. Dish
Vietnam, fifteenth–sixteenth century. Stoneware with
underglaze cobalt decoration, diameter 13½ inches
(34.3 cm)
Purchased with funds contributed by Warren H.
Watanabe and the George W. B. Taylor Fund.1998-148-1
See page 15

14. Vase
Japan; Muromachi period (1392–1573), sixteenth
century. *Negoro* lacquer, height 10 inches (25.4 cm)
Purchased with the Hollis Family Foundation Fund
2001-181-1
See page 17

* 15. Dish
Japan; Momoyama period (1568–1615), late sixteenth
century. Stoneware with underglaze iron decoration
(*Shino* ware), diameter 11⅝ inches (29.5 cm)
Purchased with funds contributed by Warren H.
Watanabe and with the Henry B. Keep Fund and the
Hollis Family Foundation Fund. 2000-32-1

16. Hand Drum
Japan; Momoyama period (1568–1615), seventeenth
century. Kōdai-ji *makie-e* lacquer, height 10 inches
(25.4 cm)
Purchased with funds contributed by the Mary
Livingston Griggs and Mary Griggs Burke Foundation,
The Annenberg Foundation, Priscilla Grace, Colonel
Stephen McCormick, the Honorable Ida Chen, Mr.
and Mrs. Gary Graffman, Hannah L. and J. Welles
Henderson, and other donors in honor of the 125th
Anniversary of the Museum
See page 17

17. Ogata Kenzan (Japanese, 1663–1743)
Set of Five Dishes (*mukōzuke*)
Edo period (1615–1868), late seventeenth–early
eighteenth century. Glazed stoneware, diameter
approximately 5½ inches (14 cm) each
Purchased with funds contributed by Marguerite and
Gerry Lenfest, Maxine and Howard H. Lewis, Maude
de Schauensee, Alexandra Q. and Fred A. Aldridge, Jr.,
and other donors in honor of the 125th Anniversary
of the Museum. 2002-75-1–5
See page 20

18. *Harinegameshin Transfers Mahavira's Embryo*
Page from a dispersed manuscript of the *Kalpasutra*
India, Gujarat or Rajasthan; c. 1300–1350
Opaque watercolor, ink, and gold on palm leaf;
2½ x 12 inches (6.4 x 30.5 cm)
Purchased with the Stella Kramrisch Fund and with
funds contributed by the Committee on Indian and
Himalayan Art in honor of Alvin O. Bellak on the occa-
sion of the 125th Anniversary of the Museum. 2001-184-1
See page 5

* 19. Eighty-eight miniature paintings
India, fourteenth–nineteenth century
Alvin O. Bellak Collection (partial and promised gift)
See pages 5, 22, 23; for the publication, see page 191

*One of the world's finest private collections of Indian
miniature paintings was acquired when the Museum
received the gift of the Alvin O. Bellak Collection. This
group of eighty-eight paintings spans the period
from before the rise of Islamic Mughal rule in northern
India during the 1500s to the heyday of the British Raj
in the late nineteenth century. Works range from the
robust compositions of Rajasthan to the delicate idealism
of the Panjab Hills, and from the earliest use of paper to
the late interplay with photography. With the addition of
the Bellak Collection, which complements the paintings
in the Kramrisch Collection as well as earlier purchases,
the Museum has become one of the foremost repositories
of Indian painting in the United States.*

20. Three paintings, from a gift of forty-one objects
(see also checklist no. 11)
Gift of Colonel Stephen McCormick in honor of the
Korean Heritage Group

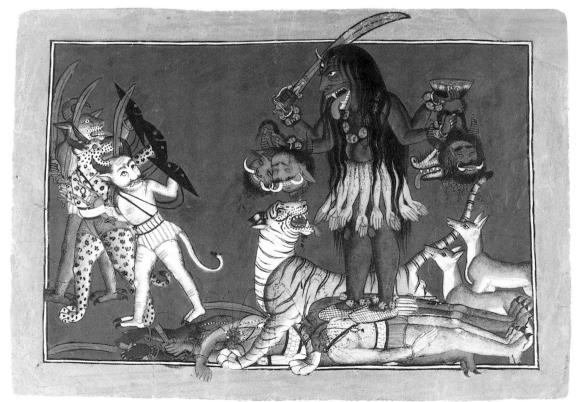

No. 19 *The Goddess Kali Slaying Demons*

Sin Wi (Korean, 1769–1845)
Bamboo (2 paintings)
Chosŏn dynasty (1392–1910), early nineteenth century. Ink on paper, mounted as hanging scrolls; 56¾ x 11⁷⁄₁₆ inches (144.1 x 29.1 cm) each
2001-134-15, 16

General Guo Ziyi's Banquet
Korea; Chosŏn dynasty (1392–1910), late eighteenth–early nineteenth century. Ink and color on paper, mounted as an eight-fold screen; panel 60 x 19¼ inches (152.4 x 50.2 cm) each
2000-80-13

21. Attributed to **Kanō Motonobu** (Japanese, 1476–1559)
Dragon
Muromachi period (1392–1573), late fifteenth–early sixteenth century. Ink on paper, mounted as a hanging scroll; 33¼ x 17¼ inches (84.5 x 43.8 cm)
Purchased with the Edith H. Bell Fund, the Edward and Althea Budd Fund, the Hollis Family Foundation Fund, the J. Stogdell Stokes Fund, and the East Asian Art Revolving Fund. 2000-114-1
See page 16

22. Attributed to **Kanō Motonobu** (Japanese, 1476–1559)
Tiger
Muromachi period (1392–1573), late fifteenth–early sixteenth century. Ink on paper, mounted as a hanging scroll; 33¼ x 21¾ inches (84.5 x 55.2 cm)
Purchased with the Edith H. Bell Fund, the Edward and Althea Budd Fund, the Hollis Family Foundation Fund, the J. Stogdell Stokes Fund, and the East Asian Art Revolving Fund. 2000-114-2
See page 16

23. *Mahasamvara Kalachakra Mandala*
Central Tibet, c. first half of the sixteenth century
Opaque watercolor on cotton with silk framing; painting with mount 33 x 22½ inches (83.8 x 57.2 cm)
Purchased with the Stella Kramrisch Fund
2000-7-1
See page 14

24. *Vaishravana, Lord of Wealth*
Tibet, late sixteenth–seventeenth century. Gold ground with opaque watercolor on cotton, 44½ x 28⅞ inches (113 x 73.3 cm)
Promised gift of John and Berthe Ford
See page 13

25. **Hon'ami Kōetsu** (Japanese, 1558–1637)
Poems from the *Shinkokin wakashū*
Edo period (1615–1868), early seventeenth century
Ink, gold, and silver on paper; 1 foot, 1⁵⁄₁₆ inches x 27 feet, 3 inches (33.7 cm x 8.3 m)
Purchased with funds contributed by the members of the Committee on East Asian Art in honor of the 125th Anniversary of the Museum. 1999-39-1
See page 21

26. **Eight paintings, from a gift of twenty-three objects**
(see also checklist no. 12)
Promised gift of Allen B. and Heidrun Engler Roberts in honor of the 125th Anniversary of the Museum

Screen
Japan; Edo period (1615–1868), seventeenth century. Ink on paper, mounted as a six-fold screen; height 60⅝ inches (154 cm)

Pair of Calligraphy Panels
Korea; Chosŏn dynasty (1392–1910), eighteenth century. Ink on paper, panel 40 x 13 inches (101.6 x 33 cm) each

Two Students
Korea; Chosŏn dynasty (1392–1910), eighteenth century. Ink on paper, mounted as an album leaf; 10½ x 11½ inches (26.7 x 29.2 cm) (framed)

Portrait of the Son Master Woo Bong-dang
Korea; Chosŏn dynasty (1392–1910), nineteenth century. Ink and colors on paper, 45 x 29 inches (114.3 x 73.7 cm) (framed)
See page 64

Munjado (painting of characters) **Screen**
Korea; Chosŏn dynasty (1392–1910), nineteenth century. Ink and colors on paper, mounted as an eight-fold screen; panel 26 x 14 inches (66 x 35.6 cm) each

Calligraphy Screen
Korea; Chosŏn dynasty (1392–1910), nineteenth century. Ink on paper, mounted as a four-fold screen; panel 40 x 12½ inches (101.6 x 31.8 cm) each

Grapevines and Cicada
Korea; Chosŏn dynasty (1392–1910), nineteenth century. Ink on paper, mounted as an album leaf; panel 36 x 12½ inches (91.4 x 31.8 cm) each

27. **Votive Plaques of the Thirty-six Immortal Poets**
Japan; Edo period (1615–1868), 1698. Ink and colors on wood, height 19½ inches (49.5 cm) each
Promised gift of Dr. Luther W. Brady, Jr.
See page 19

28. *Cosmic Man*
Tibet, nineteenth century. Opaque watercolor on cotton, 50½ x 33 inches (128.3 x 83.8 cm)
Promised gift of John and Berthe Ford

29. *Ch'aekkori* (scholar's books and utensils) **Screen**
Korea; Chosŏn dynasty (1392–1910), mid-nineteenth century. Ink and colors on linen, mounted as a ten-fold screen; panel 47 x 12 inches (119.4 x 30.5 cm) each
Purchased with funds contributed by the Korean Heritage Group, the Hollis Family Foundation Fund, and the Henry B. Keep Fund. 2002-74-1
See page 65

Sculpture

30. **Tomb Figures:** *Mounted Cymbal Player* **and** *Mounted Lute Player*
China; Tang dynasty (618–907), late seventh–early eighth century. Earthenware with painted decoration, height 17⅝ inches (45.4 cm) each
Promised gift of Ann and Donald W. McPhail
See page 3

31. *Two Musicians*
From the sanctum door of the Chaturbhuj Temple
India, Rajasthan, Isawal; c. 990. Wood, height 14½ inches (36.8 cm) each
Gift of Dr. David R. Nalin. 2001-212-1, 2
See page 4

No. 35 Charles Frederick Worth, Dress with Day and Evening Bodices (1996-19-5b, c)

32. Eleven-Headed Avalokiteshvara, Lord of Compassion
Tibet, c. early fourteenth century. Copper alloy, silver-colored inlay, copper-colored inlay, coral, turquoise, lapis lazuli, and cold gold; height 20¾ inches (52.7 cm)
Purchased with the Stella Kramrisch Fund. 2001-90-1
See page 6

33. Celestial Dancer
Nepal, probably Bhaktapur; c. mid-fifteenth century
Wood with polychrome, height 43½ inches (110.5 cm)
Purchased with the Stella Kramrisch Fund. 2000-7-4
See page 18

34. Purnabhadra, King of Vaishravana's Attendants
Tibet or China, c. late fifteenth or early sixteenth century. Gilded copper alloy with turquoise, height 8¼ inches (21 cm)
Partial and promised gift of Hannah L. and J. Welles Henderson. 2001-44-1
See page 12

EUROPE

Costume and Textiles

35. Eight dresses
Gift of the heirs of Charlotte Hope Binney Tyler Montgomery

Designed by **Charles Frederick Worth** (English, active France, 1825–1895) for **Worth & Bobergh** (Paris, active 1857–70)

Two-piece Evening Dress
c. 1867–70. Silk taffeta with silk faille stripes
1996-19-4a–d

Dress with Day and Evening Bodices
c. 1867–70. Silk faille and silk tulle
1996-19-1a–c

* **Dress with Day and Evening Bodices**
c. 1867–70. Silk satin with lace and silk tulle
1996-19-5a–c

Two-piece Evening Dress
c. 1867–70. Ribbed silk with silk satin and lace
1996-19-2a,b

Two-piece Evening Dress
c. 1867–70. Silk faille with lace
1996-19-3a,b

Designed by **Charles Frederick Worth** (English, active France, 1825–1895)

Dress with Day and Evening Bodices
c. early 1870s. Silk satin
1996-19-8a–c

Dress with Day and Evening Bodices
c. 1875. Silk faille with silk satin, silk velvet, embroidered appliqué, sheer pleated silk, silk fringe, and artificial flowers
1996-19-6a–c

Two-piece Day Dress
c. 1878–80. Silk faille and brocaded silk lampas trimmed with lace, silk satin, and beads
1996-19-7a,b
See page 69

36. Fifty-five examples of late twentieth-century women's couture and boutique designer garments and ensembles, fifty-three pairs of shoes, and twenty-nine handbags from Europe and the United States
The Diane Wolf Collection. 1999-95-1–117, 2000-150-1–8, 2001-35-1–3, 2001-135-1–9, 2002-39-1–6
See page 152

While the sheer volume of Diane Wolf's extensive donation of 137 European and American designer garments and accessories from the 1980s and 1990s is impressive, it is also their supreme quality and exuberance that transform the Museum's collection of late twentieth-century fashion. Included in the fifty-five examples of day and evening wear are garments and ensembles by leading Parisian designers, with twenty examples by Emanuel Ungaro, thirteen by Valentino, twelve by Hubert de Givenchy, and six by Yves Saint Laurent, along with representations of the work of Americans Adolfo and James Galanos. The wealth of beautiful accessories, including fifty-three pairs of footwear and twenty-nine handbags (some made to match donated outfits), both complements the garments and enhances our existing holdings. Included among the shoes and boots are eleven examples by the Italian master cobbler René Caovila and thirty by the renowned American design team of Susan Bennis/Warren Edwards. Twenty-one of the handbags are the work of the celebrated Budapest-born American designer Judith Leiber. Together, the Wolf gift will allow the Museum to confidently display complete presentations of the best of late twentieth-century couture and craftsmanship.

37. One hundred two examples of late twentieth-century avant-garde menswear, and nine pairs of designer shoes from Europe, the United States, and Japan
Gift from the private collection of John Cale
2000-65-1–57, 2000-139-1–3, 2002-24-1–50
See page 151

With the acquisition of 102 examples of European, American, and Japanese menswear from John Cale, the Museum has updated its holdings of men's clothing to represent the most avant-garde sartorial aesthetics of the late twentieth century. The work of many of the designers who seminally redefined clothing in the 1980s and 1990s is included in Cale's gift, such as fourteen examples by Rei Kawakubo for Comme des Garçons, eleven by Yohji Yamamoto, ten by Mitsuhiro Matsuda, and six by Issey Miyake. The flamboyance of late twentieth-century design is represented with the twenty-three examples by Jean-Paul Gaultier and three by Gianni Versace, as well as garments by American Todd Oldham and Italy's Dolce & Gabbana. The ten garments by Belgian Walter van Bierendonck's labels of Wild & Lethal Trash and aestheticterrorists® and those by English designers Vivienne Westwood and Alexander McQueen represent the anarchic extremes of fashion of the period. Cale's donation also includes examples of cutting-edge men's footwear, and garments by some of the trendy but esoteric international labels that illustrate the eclectic

No. 38 Yves Saint Laurent, Evening Ensemble with Jacket

nature of late twentieth-century fashion, such as English labels Voyage and Vexed Generation, Italian Paradise Calling, German NO2, and Japanese Ato and World Wide Web.

38. Ten couture garments and ensembles, from a gift of twelve (see also checklist no. 98)
Partial and promised gift of Kathleen P. Field

Pierre Cardin (French, born 1922)

Dress and Belt
1970s. Cotton corduroy
1997-17-2a, b

Short Evening Dress and Belt
c. 1987. Synthetic lace over nylon horsehair
1997-17-1a, b

Short Evening Dress
1987. Silk taffeta with silk organza flower
See page 153

Yves Saint Laurent (French, born 1936)

Jacket and Blouse
1970s. Wool twill, silk velvet, and silk satin
1997-17-6a, b

*Evening Ensemble with Jacket
1983. Silk velvet with sequins, beads, rhinestones, and metallic cord; silk crepe; silk chiffon with beads and sequins; silk velvet with beads and silk cord

Marc Bohan (French, born 1926) for **Christian Dior**

Suit (Jacket, Skirt, and Blouse)
1980s. Plain-weave printed silk, printed silk chiffon, and pleated plain-weave silk
1997-17-5a–c

Evening Dress and Cape
1985. Silk gazar

Emanuel Ungaro (French, born 1933)

Dress with Scarf
1980s. Figured silk and synthetic lace
1997-17-4a, b

Suit (Jacket, Skirt, and Blouse)
1985. Wool twill with rayon piping, braid, and tassels; silk chiffon/satin stripe with lace
1997-17-3a–c

Christian Lacroix (French, born 1951)

Short Evening Dress
1988. Printed cotton cloqué with polyester ribbons and silk flowers

Decorative Arts

39. Seventy-one ceramics
Italy, sixteenth century. Tin-glazed earthenware (maiolica)
The Howard I. and Janet H. Stein Collection (partial and promised gift)
See pages 10–11; for the publication, see page 191

The Stein Collection comprises maiolica, primarily from the 1500s, from many of the leading centers of production. Included in depth are pieces painted by some of the finest masters and their workshops, who excelled in the demanding depictions of literary subjects, called istoriato. *Also represented are pottery containers commissioned for pharmacies as well as a wide variety of objects for daily use. The range and quality of the Stein gift transform the Museum's previously heterogeneous holdings into a collection that is distinguished by American and European standards.*

40. Seventeen ceramics
Germany, sixteenth–mid-eighteenth century
Stoneware
Promised gift of Charles W. Nichols

Bartmann Jug
Cologne or Frechen, c. 1525–50. Height 6 inches (15.2 cm)
See page 30

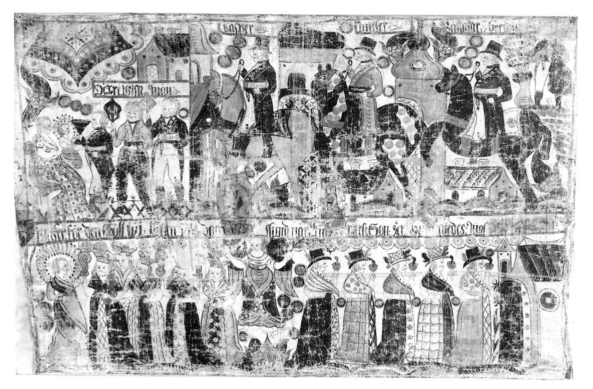

No. 43 Wall Hanging

Bartmann Jug
Cologne or Frechen, c. 1550. Height 10 inches (25.4 cm)

Bartmann Jug
Possibly Cologne, c. 1550–1600. Height 8½ inches (21.6 cm)

Jug (with applied monogram of Johann Mennicken)
Raeren or Westerwald region, probably 1590s
Height 9½ inches (24.1 cm)
See page 30

Jug
Raeren or Westerwald region, late 1590s–early 1600s. Height 10 inches (25.4 cm)

Bartmann Jug
Frechen, c. 1600. Height 9¼ inches (23.5 cm)

Jug (with applied monogram of Jan Emens Mennicken)
Raeren or Westerwald region, c. 1600. Height 11 inches (27.9 cm)

Spouted Globular Jug
Frechen, c. 1600. Height 8 inches (20.3 cm)

Jug
Westerwald region, c. 1650–1700. Height 9¾ inches (24.8 cm)

Jug
Westerwald region, c. 1650–1700. Height 9 inches (22.9 cm)
See page 30

Jug
Westerwald region, 1661. Height 14 inches (35.6 cm)
See page 30

Flowerpot
Westerwald region, late seventeenth century. Height 10½ inches (26.7 cm)

Tankard
Saxony, possibly Annaberg; late seventeenth century. Height 8¼ inches (21 cm)

Mug
Westerwald region, 1690s. Height 6 inches (15.2 cm)

Mug
Westerwald region, late 1690s. Height 8 inches (20.3 cm)

Tankard
Westerwald region, c. 1700. Height 6 inches (15.2 cm)

Jug
Westerwald region, probably c. 1750. Height 13½ inches (34.3 cm)

41. Cradle
Italy, Tuscany, perhaps Florence; c. 1570. Walnut with remains of gilded and painted decoration, height 35 inches (88.9 cm)
Purchased with the John D. McIlhenny Fund
2000-117-1
See page 10

42. Apothecary Tiles (3)
England, London; eighteenth century. Tin-glazed earthenware; octagonal height 10½ inches (26.7 cm), shield-shaped height 12½ inches (31.8 cm), heart-shaped height 12⅛ inches (30.8 cm)
Gift of Audrey and William H. Helfand
2000-153-1–3
See page 26

43. Twenty-eight folk objects from Switzerland, Sweden, Norway, and Germany
Promised gift of Irene and Walter Wolf

In the 1930s, Irene and Walter Wolf began to collect brightly painted European peasant furniture large and small. They appreciated the variety of such objects that demonstrate an ongoing engagement with fashionable styles as well as the way in which the earlier works contain motifs that were transplanted to America. The promised gift of their collection is significant for the Museum's European and American collections, offering for the first time another major subject: the achievement and influence of European folk traditions in the decorative arts.

Chest
Switzerland, Appenzell region; 1725. Partially painted wood, width 58 inches (147.5 cm)

Three-cornered Hatbox
Sweden, eighteenth century. Painted wood, width 17 inches (43.2 cm)

Cupboard
Switzerland, Appenzell region; c. 1725–50. Partially painted wood, height 73 inches (185.5 cm)

Chair
Possibly Switzerland, 1741. Wood, height 32 inches (81.3 cm)

Plank Chair
Possibly Switzerland, 1745. Wood, height 35¼ inches (89.5 cm)

Box
Switzerland, mid-eighteenth century. Painted wood, width 18¼ inches (46.4 cm)

Double Wardrobe
Switzerland, Appenzell region; 1753. Painted wood, height 6 feet, 3 inches (1.9 m)

Miniature Chest
Switzerland, Appenzell region; 1773. Painted wood, height 12 inches (30.5 cm)

Box
Switzerland, 1796. Painted wood, width 8½ inches (21.6 cm)

Chair
Switzerland, possibly eighteenth century. Wood, height 33 inches (83.8 cm)

Draw Table
Switzerland, Lucerne, found near Küssnacht am Rigi; possibly eighteenth century. Wood with slate panel, height 29½ inches (75 cm)

Chair
Switzerland, late eighteenth–early nineteenth century. Wood, height 23¼ inches (59.2 cm)

Almanac Frame
Switzerland, nineteenth century. Painted wood with mirror glass, 17 x 11¾ inches (43.2 x 29.8 cm)

Almanac from 1827 and Almanac Frame
Switzerland, nineteenth century. Almanach: printed ink on bound paper. Almanac frame: painted wood, 16½ x 12 inches (41.3 x 30.5 cm)

Baking Molds Made into Tabletops (2)
Switzerland, nineteenth century. Carved wood; diameter 10¾ inches (27.3 cm), 12½ inches (31.8 cm)

Bellows
Switzerland, Appenzell region; nineteenth century
Painted wood, leather, and metal; length 53 inches (134.7 cm)

Tall Case Clock
Switzerland, Appenzell region; nineteenth century
Painted wood, with later clockworks, height 6 feet, 4 inches (1.9 m)

Hanging Cupboard
Norway, early nineteenth century. Wood with metal hardware, height 34 inches (86.4 cm)

Plank Chairs (2)
Switzerland, early nineteenth century. Painted wood; height 35½ inches (90.2 cm), 33½ inches (85.1 cm)

Wall Hanging
Sweden, Halland region; early nineteenth century
Painted cloth, framed and glazed; 26 x 28¼ inches (66 x 71.8 cm)

*****Wall Hanging**
Sweden, Halland region; c. 1800–1830. Painted cloth, 34 x 58 inches (86.4 x 147.3 cm)

Child's Sleigh (without runners)
Switzerland, Appenzell region; 1809. Painted wood, length 53 inches (134.7 cm)

Cupboard
Switzerland, Appenzell region; 1811. Painted wood, height 5 feet, 2 inches (1.6 m)
See page 45

Four-poster Bed and Related Foot Stool
Switzerland, Appenzell region; 1812
Painted wood, bed height 5 feet, 9 inches (1.7 m)

Wardrobe
Switzerland, Appenzell region; 1827
Painted wood, height 5 feet, 10 inches (1.7 m)

Box
Germany, c. 1830. Painted wood, width 18¼ inches (46.4 cm)

44. Made by the Imperial Porcelain Factory (Saint Petersburg, Russia, active 1744–present)
Pair of Tazzas
c. 1844. Hard-paste porcelain with enamel and gilded decoration, height 13⅜ inches (34 cm) each
Gift of John J. Medveckis in memory of Barbara B. Rubenstein. 2001-156-1, 2
See page 61

45. Made by Jennens and Bettridge (Birmingham, England, active 1816–64)
Work Table
1851. Painted and gilded papier-mâché, mother-of-pearl, silk velvet, and silk; height 29¼ inches (74.3 cm)
Bequest of Emilie deHellebranth. 2001-152-1
See page 73

46. Made by Jennens and Bettridge (Birmingham, England, active 1816–64)
Toilet Box
c. 1851. Painted and gilded papier-mâché, leather, glass, velvet, silver plate, and mother-of-pearl; 5½ x 12¼ inches (14 x 31.1 cm)
Bequest of Emilie deHellebranth. 2001-152-2

47. Made by Mintons, Ltd. (Stoke-on-Trent, England, active 1793–present)
Pair of Vases
c. 1905. Earthenware with relief-molded and block-printed decoration; height 18 inches (45.7 cm) each
Gift of the Levitties Family. 2001-155-2, 3
See page 81

*****48. Designed by Josef Hoffmann** (Austrian, 1870–1956)
Armchair
c. 1908. Made by Jacob and Josef Kohn (Vienna), c. 1908–c. 1916. Bent beechwood, laminated wood, and metal; height 43½ inches (110 cm)
Purchased with funds contributed by The Judith Rothschild Foundation in memory of Herbert M. Rothschild, and with the European Decorative Arts Revolving Fund. 2002-77-1

No. 48 Designed by Josef Hoffmann, Armchair

49. Designed by **Walter Crane** (English, 1845–1915); decorated by **William S. Mycock** (English, born 1872); made by **Pilkington's Royal Lancastrian Pottery and Tile Company** (Clifton Junction, England, active 1891–1937)
Sea Maiden **Vase**
c. 1914. Earthenware with luster decoration, height 10½ inches (26.7 cm)
Gift of the Levitties Family. 2001-155-1

50. Five groups of furniture, from a gift of nine
(see also checklist no. 133)
Gift of Lannan Foundation, Santa Fe, New Mexico

Designed by **Alberto Giacometti** (Swiss, 1901–1966) and **Diego Giacometti** (Swiss, active France, 1902–1985)

Pair of Standing Lamps
c. 1933. Bronze, height 63½ inches (161.3 cm) each
1999-14-9, 10

Designed by **Diego Giacometti** (Swiss, active France, 1902–1985)

Pair of Armchairs
c. 1963. Bronze, height 31 inches (78.7 cm) each
1999-14-2, 3

Pair of Tables
c. 1970. Bronze and glass, height 17 inches (71.2 cm) each
1999-14-6, 7

Pair of Armchairs
c. 1973. Bronze, height 31 inches (78.7 cm) each
1999-14-4, 5

Table
c. 1973. Bronze and glass, height 28 inches (71.1 cm)
1999-14-8

51. Designed by **Joe Colombo** (Italian, 1930–1971)
Fifteen groups of objects
Gift of Collab: The Group for Modern and Contemporary Design at the Philadelphia Museum of Art

Armchair
Made by Kartell S.p.A. (Milan, active 1949–present); designed 1964, made from 1964. Molded and painted plywood, height 23½ inches (59.7 cm)
2001-42-2

Smoke **Drinking Glasses** (2 water, 1 sherry)
Made by Arnolfo di Cambio (Colle Val d'Elsa, Italy, active 1963–present); designed 1964, made from 1964. Glass; water height 5⅜ inches (13.7 cm) each, sherry height 3½ inches (8.9 cm)
2001-42-14–16

Asimmetrico **Drinking Glasses** (2 champagne)
Made by Riedel GmbH (Kufstein, Austria, active 1756–present); designed 1964, made from 1968. Glass, height 7⅜ inches (18.7 cm) each
2001-42-17, 18

Universale **Chair**
Made by Kartell S.p.A. (Milan, active 1949–present); designed 1965, made from 1967. ABS plastic, height 28½ inches (72.4 cm)
2001-42-3

Vademecum **Folding Lamp**
Made by Kartell S.p.A. (Milan, active 1949–present); designed 1968, made from 1969. ABS plastic and stainless steel, height 3 inches (7.6 cm)
2001-42-4

Menissa **Bowls** (3)
Made by Ceramica Franco Pozzi (Gallarate, Italy); designed 1968, made from 1970. Industrial ceramic; (2001-42-19), diameter 13 inches (33 cm), (2001-42-20), diameter 9¾ inches (24.8 cm), (2001-42-21), diameter 9¼ inches (23.5 cm)
2001-42-19–21

Conchiglia **Lamp**
Made from 1980 by Sem-Luci (Milan); made from 1994 by Lamperti (Milan, active 1861–present); designed 1968. Opaline glass and enameled metal, height 6 feet, 5 inches (1.9 m)
2001-42-6

Robot **Mobile Trolley**
Made by Bellato-Elco (Scorze, Italy); designed 1969, made from 1970. ABS plastic, height 17 inches (43.2 cm)
2001-42-22

Alogena **Lamp**
Made by O-Luce Italia S.p.A. (Milan, active 1945–present); designed 1970, made from 1970. Enameled metal, height 6 feet, 3 inches (1.9 m)
2001-42-23

Boby **Mobile Trolley** (3-tier)
Made by Bieffeplast S.p.A. (Padua, active 1953–present); designed 1970, made from 1970 (this version first production). ABS plastic, height 28¾ inches (73 cm)
2001-42-7

Boby **Mobile Trolley** (6-tier)
Made by Bieffeplast S.p.A. (Padua, active 1953–present); designed 1970, made from 1970. ABS plastic, height 54 inches (137.2 cm)
2001-42-8

Living Center
Made by Rosenthal AG (Selb, Germany, active 1879–present); designed 1970, made from 1971. Laminated wood, plastic, metal, and wool upholstery; chaise depth 5 feet, 3 inches (1.6 m) each, bar trolley depth 4 feet, 7¼ inches (1.4 m), food trolley depth 5 feet, 7 inches (1.7 m)
2001-42-10–13
See page 150

Linea 72 **In-flight Service for Alitalia**
Made by Richard Ginori S.p.A. (Milan, active 1735–present); designed 1970, made from 1972. Porcelain, stainless steel, plastic, and linen; case 17 x 11 x 12 inches (43.2 x 27.9 x 30.5 cm)
2001-42-24

Triedro **Lamp**
Made by Stilnovo S.p.A. (Milan); designed 1970, made from 1972. Metal, height 20 inches (50.8 cm)
2001-42-9

Rotocenere **Ashtray** (table version)
Made by Kartell S.p.A. (Milan, active 1949–present); designed 1971, made from 1972. Melomine, 3 x 3 inches (7.6 x 7.6 cm)
2001-42-5

52. Twenty-three portrait miniatures, from a gift of forty (see also checklist no. 143)
Gift of Mr. and Mrs. Joseph Shanis and Mr. and Mrs. Harris Stern in memory of Jeannette B. S. Whitebook Lasker

Worn as pendants and bracelets, carried within a pocket or hung in a cabinet, portrait miniatures were prized for their likenesses of loved ones as well as their minute size, precious materials, and skillful execution. The gift of a remarkable group of forty European and American miniatures assembled by Jeannette B. S. Whitebook Lasker marks a prominent addition to the Museum's collection, contributing works by significant artists in innovative and challenging techniques.

No. 52 Pierre Adolphe Hall, *Young Man in Landscape* (2000-137-25)

Elias Brenner (Finnish, 1647–1717)
King George I of England
c. 1715. Watercolor and gold on parchment, 1½ x 1¼ inches (3.7 x 3 cm)
2000-137-13
See page 68

Christian Friedrich Zincke (German, active England, 1683/84–1767)

English Nobleman
c. 1720. Enamel on porcelain, 1¾ x 1½ inches (4.5 x 3.7 cm)
2000-137-16
See page 68

Walter Rolleston
c. 1725. Enamel on porcelain, 1 7/8 x 1 9/16 inches
(4.8 x 4 cm)
2000-137-14

Artist unknown (Dutch)
Pieter van Noort
Mid-seventeenth century. Oil on copper, 2 3/4 x 2 1/8
inches (7 x 5.4 cm)
2000-137-33

Artist unknown (British)
Gentleman with Brass Buttons
Mid-eighteenth century. Watercolor on ivory,
1 5/16 x 1 1/16 inches (3.4 x 2.7 cm)
2000-137-21

*****Pierre Adolphe Hall** (Swedish, active France,
1739–1793)
Young Man in Landscape
Mid-eighteenth century. Watercolor on ivory,
2 7/8 x 2 13/16 inches (7.3 x 7.2 cm)
2000-137-25

Artist unknown (British)
Gentleman
c. 1775. Watercolor on ivory, 1 9/16 x 1 1/4 inches
(4 x 3.2 cm)
2000-137-34

Artist unknown (Spanish)
Gentlewoman
c. 1780. Watercolor on ivory, 1 3/4 x 1 7/16 inches
(4.4 x 3.6 cm)
2000-137-31

Richard Cosway (English, 1742–1821)
Self-Portrait
c. 1780. Watercolor on wove paper, 2 15/16 x 2 7/16
inches (7.4 x 6.2 cm)
2000-137-12

Jean-Henri Cless (French)
Gentleman
1783. Watercolor on ivory, 2 7/16 x 2 3/8 inches
(6.2 x 6 cm)
2000-137-17

Kristoffer Nøragger (Danish, 1751–1807)
King Christian VII of Denmark
c. 1784. Watercolor on ivory, 1 5/8 x 1 1/4 inches
(4.1 x 3.2 cm)
2000-137-22

Artist unknown (Viennese)
Gentleman in Profile
c. 1790. Watercolor on ivory, 2 x 1 5/8 inches
(5.1 x 4.1 cm)
2000-137-23

Jean-Baptiste Isabey (French, 1767–1855)
Jean-Baptiste Jacques Augustin
c. 1790. Watercolor on ivory, 2 5/8 x 2 9/16 inches
(6.6 x 6.5 cm)
2000-137-32

Gerard? (French)
John Mouster Clymer of Philadelphia
c. 1795. Watercolor on ivory, 1 15/16 x 1 9/16 inches
(4.9 x 3.9 cm)
2000-137-24

Andrew Plimer (English, 1763–1837)
Queen Charlotte
c. 1795. Watercolor on ivory, 3 x 2 7/16 inches
(7.6 x 6.2 cm)
2000-137-30

Jakob Axel Gillberg (Swedish, 1769–1845)
Young Man
1796. Watercolor on ivory, 2 7/8 x 2 5/16 inches
(7.3 x 5.8 cm)
2000-137-35

Foch (Russian)
Gentleman in Military Dress
1799. Watercolor on ivory, 3 5/16 x 2 5/8 inches
(8.4 x 6.6 cm)
2000-137-19

John Miers (English, 1757–1821)
Thomas Pagan, Esq.
c. 1801–12. Watercolor and gold on plaster, 15/16 x 5/8
inches (2.4 x 1.6 cm)
2000-137-18

Artist unknown
Pope Pius VII
c. 1805. Watercolor, reverse-painted on glass; 1 5/16 x
1 1/16 inches (3.3 x 2.7 cm)
2000-137-36

Edward Miles (English, 1752–1828)
Self-Portrait
c. 1807. Watercolor on ivory, 2 13/16 x 2 5/16 inches
(7.2 x 5.9 cm)
2000-137-39

Artist unknown
Joseph Bonaparte, King of Spain
c. 1808–13. Watercolor on ivory, 1 7/8 x 1 7/16 inches
(4.7 x 3.7 cm)
2000-137-40

Artist unknown (French)
Joachim Murat, King of Naples (front)
Caroline Bonaparte, Queen of Naples (back)
c. 1810. Watercolor on ivory, 1 5/16 x 1 5/16 inches
(3.3 x 3.3 cm)
2000-137-15

Artist unknown (Austrian)
Emperor Francis Joseph of Austria
c. 1849. Watercolor on ivory, 1 9/16 x 1 1/8 inches
(4 x 2.8 cm)
2000-137-27

53. Attributed to **Peter Van Dyck** (English, born
Holland, 1729)
Portrait of the Right Honorable Thomas Penn
c. 1751–52. Oil on canvas, 36 1/8 x 31 1/8 inches
(92 x 78.2 cm)
Promised gift of Susanne Strassburger Anderson,
Valerie Anderson Readman, and Veronica Anderson

Macdonald from the estate of Mae Bourne and Ralph
Beaver Strassburger
See page 35

54. Attributed to **Peter Van Dyck** (English, born
Holland, 1729)
Portrait of Lady Juliana Penn
c. 1751–52. Oil on canvas, 36 1/8 x 31 1/8 inches
(92 x 78.2 cm)
Promised gift of Susanne Strassburger Anderson,
Valerie Anderson Readman, and Veronica Anderson
Macdonald from the estate of Mae Bourne and Ralph
Beaver Strassburger
See page 35

55. **Joseph Wright of Derby** (English, 1734–1797)
Portrait of William Rastall
c. 1763. Oil on canvas, 30 1/8 x 25 inches
(76.5 x 63.5 cm)
Purchased with funds contributed by John H.
McFadden. 1997-1-1
See page 29

56. **Jean-Auguste-Dominique Ingres** (French,
1780–1867)
Antiochus and Stratonice
1860. Oil on canvas, 13 3/4 x 17 3/4 inches (35 x 45.1 cm)
Promised gift of Maude de Schauensee and Maxine
de S. Lewis in memory of their parents, Williamina
and Rodolphe Meyer de Schauensee
See page 74

57. **Claude Monet** (French, 1840–1926)
Path on the Island of Saint Martin, Vétheuil
1881. Oil on canvas, 29 x 23 1/2 inches (73.7 x 59.7 cm)
Promised gift of John C. and Chara C. Haas
See page 76

58. **Édouard Manet** (French, 1832–1883)
Basket of Fruit
1882. Oil on canvas, 15 x 18 1/8 inches (38.1 x 46 cm)
Anonymous partial and promised gift. 2000-156-1
See page 75

59. **John Singer Sargent** (American, active Paris,
London, and Boston, 1856–1925)
Landscape with Women in Foreground
c. 1883. Oil on canvas, 25 x 30 1/2 inches (63.5 x 77.5 cm)
Gift of Joseph F. McCrindle. 2002-49-1
See page 92

60. **Claude Monet** (French, 1840–1926)
Under the Pines, Evening
1888. Oil on canvas, 28 3/4 x 36 1/4 inches (73 x 92.1 cm)
Gift of F. Otto Haas, and partial gift of the reserved life
interest of Carole Haas Gravagno. 1993-151-1
See page 77

61. **Gerhard Richter** (German, born 1932)
Swan (2)
1989. Oil on canvas, 9 feet, 10 inches x 8 feet, 2 inches
(2.9 x 2.4 m)
Partial and promised gift of Keith L. and Katherine
Sachs. 2000-31-1
See page 159

Prints

62. Israhel van Meckenem (German, 1440/45–1503)
Self-Portrait with His Wife, Ida
c. 1490. Engraving, sheet 5 1/4 x 7 1/16 inches
(13.3 x 17.9 cm)
Gift of Suzanne A. Rosenborg. 2002-59-1
See page 8

63. Philipp Otto Runge (German, 1777–1810)
The Four Times of Day (Morning, Day, Evening, Night)
1805. Four etchings (edition 25), sheet 28 3/4 x 19 1/4
inches (73 x 48.9 cm) each
Purchased with the Lola Downin Peck Fund and the
Carl and Laura Zigrosser Collection (by exchange),
The James D. Crawford and Judith N. Dean Fund, and
with funds contributed by The Judith Rothschild
Foundation, Marilyn L. Steinbright, The Henfield
Foundation, Mildred L. and Morris L. Weisberg, Mr.
and Mrs. John J. F. Sherrerd, Audrey and William H.
Helfand, Harvey S. Shipley Miller and J. Randall
Plummer, Marion Boulton Stroud, George M. Cheston,
Peter Benoliel, Joseph A. O'Connor, Jr., Mr. and Mrs.
M. Todd Cooke, and Helen Cunningham and
Theodore T. Newbold in honor of the 125th
Anniversary of the Museum. 2001-94-1–4
See pages 40–41

64. Johann Anton Ramboux (German, 1790–1866)
The Brothers Eberhard
1822. Lithograph with tint stone, image 12 9/16 x 13 11/16
inches (31.9 x 34.7 cm)
Purchased with the Lola Downin Peck Fund and the
Carl and Laura Zigrosser Collection (by exchange)
2000-119-1
See page 52

65. Ferdinand Olivier (German, 1785–1841)
*Seven Places in Salzburg and Berchtesgaden, Arranged
According to the Seven Days of the Week, United by
Two Allegorical Plates* (Vienna, 1823)
1823. Lithographs with tint stone (set of nine),
image 7 11/16 x 10 5/8 inches (19.5 x 27 cm) each
Purchased with the Lola Downin Peck Fund and the
Carl and Laura Zigrosser Collection (by exchange)
1997-170-1–9
See page 51

66. Six Cubist prints
Promised gift of The Judith Rothschild Foundation

 Pablo Ruiz y Picasso (Spanish, 1881–1973)

 Two Nude Figures
 1909. Drypoint (edition 100), plate 5 1/8 x 4 3/8
 inches (13 x 11.1 cm)

 Still-life with a Compote
 1909. Drypoint (edition 100), plate 5 1/4 x 4 1/4
 inches (13.3 x 10.8 cm)

 Mademoiselle Léonie Seated on a Chaise-longue
 1910. Etching, first state (one of two proofs printed
 by the artist); plate 7 3/4 x 5 1/2 inches (19.7 x 14 cm)
 See page 94

 * *Still-life with a Bottle of Marc*
 1912. Drypoint (edition 100), plate 17 1/2 x 12
 inches (44.5 x 30.5 cm)

No. 66 Pablo Ruiz y Picasso, *Still-life with a Bottle of Marc*

 Man with Guitar
 1915. Etching (one of five unsigned proofs),
 plate 6 x 4 1/2 inches (15.2 x 11.4 cm)

 Georges Braque (French, 1882–1963)
 Fox
 1911. Etching with drypoint (unsigned proof),
 plate 21 9/16 x 14 15/16 inches (54.8 x 38 cm)

67. Pablo Ruiz y Picasso (Spanish, 1881–1973)
*Mademoiselle Léonie, The Table, Mademoiselle Léonie
Seated on a Chaise-longue, The Monastery*; 1910
From Max Jacob, *Saint Matorel* (Paris: Kahnweiler,
1911)
Etchings in printed book with tooled leather binding
(edition 100); plate 7 3/4 x 5 1/2 inches (19.7 x 14 cm)
each, book 11 x 8 7/8 inches (27.9 x 22.5 cm)
Gift of The Judith Rothschild Foundation
2001-48-1a–d
See page 94

68. Pablo Ruiz y Picasso (Spanish, 1881–1973)
Nude Woman, 1913–14; *Still-life with Skull*, 1914;
Woman, 1914
From Max Jacob, *Le Siège de Jérusalem: Grand Tentation
céleste de Saint Matorel* (Paris: Kahnweiler, 1914)
Etchings with drypoint in printed book with leather
and stamped vellum binding (edition 100); plate
6 1/8 x 4 1/2 inches (15.6 x 11.4 cm) each, book 8 1/8 x 6 1/4
inches (20.6 x 15.9 cm)
Gift of The Judith Rothschild Foundation
2001-48-2a–c

**69. Four prints, from a gift of nine Russian works
on paper** (see also checklist no. 81)
Promised gift of The Judith Rothschild Foundation

Olga Vladimirova Rozanova (Russian, 1886–1918)
*Destruction of the City, Excerpt from a Newspaper
Bulletin: "During the Execution . . . ," Battle, To the
Death*; 1915–16
From Aleksei Kruchenykh, *Voina* (War) (Petrograd:
Andrei Shemshurin, 1916)
Four linocuts (edition 100), sheet 16 1/4 x 12 1/16 inches
(41.2 x 30.6 cm) each

70. Jacques Villon (French, born Gaston Duchamp,
1875–1963)
Thirty-four works on paper, including thirty-three
Cubist prints and one drawing
Gift of The Judith Rothschild Foundation. 2001-9-1–34
See page 96; for the publication, see page 191

*The gift from The Judith Rothschild Foundation of thirty-
three prints and one drawing by the French master print-
maker Jacques Villon has transformed the Museum's
holdings into one of the greatest public collections of his
Cubist prints. Home since 1954 to the world's richest
and most extensive collection of work by Villon's auda-
cious youngest brother, Marcel Duchamp, and since
1978 to an important group of sculpture by their middle
brother, Raymond Duchamp-Villon, the Museum may
now boast a splendid representation of Jacques Villon's
brilliant Cubist prints, including several rare trial proofs.*

71. Lucian Freud (English, born 1922)
Man Posing
1985. Etching (edition 50), plate 27 1/2 x 21 5/8 inches
(70 x 55 cm). Printed by Terry Wilson and Marc
Balakjian, London; co-published by James Kirkman
Limited, London, and Brooke Alexander, New York
Promised gift of Harold S. Goldman and John A.
Bonavita
See page 154

Drawings

72. Jean-Honoré Fragonard (French, 1732–1806)
Useless Resistance
c. 1770–73. Brush and washes over chalk underdraw-
ing, watercolor, and opaque watercolor on paper;
9 1/8 x 13 5/8 inches (23 x 34.7 cm)
Promised gift of George M. Cheston
See page 37

**73. Drawing, from a gift of nine objects that
descended in the Morris and Wheeler families of
Philadelphia** (see also checklist no. 106)
Promised gift of the Family of Samuel Wheeler Morris

 Charles Balthazar Julien Fevret de Saint-Memin
 (French, 1770–1852)
 Portrait of Samuel Morris
 n.d. Chalk on wove paper, 19 x 14 3/16 inches
 (48.3 x 35.9 cm)
 See page 34

74. William Henry Hunt (English, 1790–1864)
Five watercolors
Promised gift of Charles E. Mather III and Mary
MacGregor Mather

 The Main Door of Bushey Church
 1823. Pen and ink and watercolor washes over
 traces of graphite on heavy wove paper, 14 1/8 x 10 15/16
 inches (35.9 x 26.5 cm)

Dead Game Hanging, with Lobster and Cabbage on a Barrel
c. 1827. Transparent and opaque watercolor over graphite on paper, 10 9/16 x 7 5/16 inches (26.8 x 18.6 cm)

Portrait of Mary Bugden Hunt
1827. Watercolor over graphite on wove paper, 12 7/8 x 8 1/4 inches (31.7 x 21.1 cm)
See page 57

A Basket with Grapes and Plums
Late 1820s. Watercolor on wove paper, 7 3/8 x 10 9/16 inches (18.8 x 26.9 cm)
See page 57

Study of a Rosehip and a Bird's Egg Against a Mossy Bank
Late 1820s. Transparent and opaque watercolor over graphite on paper, 5 15/16 x 4 3/4 inches (15.1 x 12.1 cm)

75. Augustin Amant Constant Fidele Edouart (French, 1789–1861)
Married Children of Joseph Lea and Sarah Robeson Lea with Their Children; Joseph Lea and Sarah Robeson Lea with Their Unmarried Children
1843. Two silhouettes of cut paper adhered to a sheet of beige wove paper, with details drawn in brown ink and brown washes over graphite; sheet approximately 20 x 30 inches (50.8 x 76.2 cm) each
Gift of Mrs. Samuel R. Shipley III in honor of Harvey S. Shipley Miller. 2002-6-1, 2
See page 70

No. 80 Vincenzo Gemito, *Portrait of the Bertolini Son*

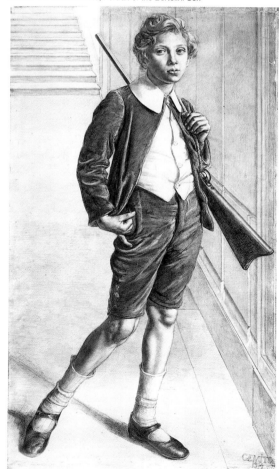

76. Two drawings, from a gift of eleven works on paper (see also checklist nos. 167, 175, 204)
Promised gift of Alice Saligman

 Jacques Villon (French, born Gaston Duchamp, 1875–1963)
 Portrait of Suzanne and Marcel Duchamp
 c. 1904. India ink (?) on paper

 Suzanne Duchamp (French, 1889–1963)
 The Man with Tired Eyes
 c. 1921. India ink and wash, 15 1/8 x 10 13/16 inches (38.4 x 27.5 cm)

77. Juan Gris (Spanish, 1887–1927)
Self-Portrait No. 1
1909–10. Charcoal on paper, 17 x 12 1/2 inches (43.2 x 31.7 cm)
Promised gift of The Judith Rothschild Foundation
See page 95

78. Giacomo Balla (Italian, 1871–1958)
Abstract Speed
1912. Oil on paper, mounted on wood; 5 x 7 inches (12.7 x 17.8 cm)
Promised gift of The Judith Rothschild Foundation
See page 101

79. Vincenzo Gemito (Italian, 1852–1929)
Portrait of Laura Bertolini
1913. Graphite and crayon on wove paper, 53 5/8 x 30 1/4 inches (136.2 x 78.1 cm)
Purchased with the Lola Downin Peck Fund, the Alice Newton Osborn Fund, and with funds contributed by Marilyn L. Steinbright and John J. Medveckis. 1999-4-1

***80. Vincenzo Gemito** (Italian, 1852–1929)
Portrait of the Bertolini Son
1914. Graphite and crayon on wove paper, 55 3/16 x 31 7/16 inches (140.2 x 79.8 cm)
Purchased with the Lola Downin Peck Fund, the Alice Newton Osborn Fund, and with funds contributed by Marilyn L. Steinbright and John J. Medveckis. 1999-4-2

81. Five drawings, from a gift of nine Russian works on paper (see also checklist no. 69)
Promised gift of The Judith Rothschild Foundation

 Kirill Zdanevich (Russian, 1892–1969)
 Two Cubist Compositions (Untitled)
 c. 1914–20. Recto: pen and ink and brush and wash with watercolor and tempera on paper; 11 x 5 inches (28 x 12.7 cm). Verso: pen and ink and brush and wash; 5 7/8 x 5 inches (14.8 x 12.7 cm)

 Olga Vladimirova Rozanova (Russian, 1886–1918)
 Suprematist Design (Decorative Motif)
 1916. Brush and ink and watercolor over graphite on paper; 9 7/8 x 6 5/8 inches (25.1 x 16.8 cm)
 See page 98

 Kasimir Malevich (Russian, 1878–1935)

 Suprematist Study (Triangle and Two Rectangles)
 1916–17. Graphite on paper, sheet 5 7/8 x 4 1/2 inches (15 x 11.5 cm)

No. 83 Otto Dix, *Thoughtful Man*

 Supremus No. 18
 1916–17. Graphite on paper, sheet 7 x 8 5/8 inches (17.8 x 21.9 cm)
 See page 98

 Aleksandr Rodchenko (Russian, 1891–1956)
 Abstract Composition with a Duck (Untitled)
 1940. Ink and graphite on paper, 7 5/8 x 5 1/2 inches (19.4 x 14 cm)

82. Jean Joseph Crotti (French, 1878–1958)
Portrait of Marcel Duchamp
1915. Graphite and charcoal on wove paper, 21 1/2 x 13 5/8 inches (54.6 x 34.6 cm)
Gift of C. K. Williams, II. 2001-49-2
See page 85

***83. Otto Dix** (German, 1891–1969)
Thoughtful Man
1918. Graphite, crayon, brush, and ink on wove paper; 15 1/2 x 15 1/2 inches (39.4 x 39.4 cm)
Promised gift of The Judith Rothschild Foundation

84. Henri Matisse (French, 1869–1954)
Portrait of Henri de Montherlant
1937. Charcoal on paper, 22 3/8 x 15 3/16 inches (56.9 x 38.5 cm)
Promised gift of Dr. Luther W. Brady, Jr.
See page 108

Photographs

 [**Approximately 2,500 European and American photographs**; The Lynne and Harold Honickman Gift of the Julien Levy Collection; see checklist no. 211]

85. Frank Eugene (German, born United States, 1865–1936)
Reclining Female Nude in Landscape
c. 1904. Gelatin silver print, sheet 6 1/2 x 8 7/16 inches (16.5 x 21.4 cm)
Gift of Harvey S. Shipley Miller and J. Randall Plummer. 2000-163-2

86. Aleksandr Rodchenko (Russian, 1891–1956)
White Sea—Baltic Canal Lock
1933. Gelatin silver print, sheet 12 x 19½ inches
(30.5 x 49.5 cm)
Promised gift of The Judith Rothschild Foundation
See page 102

Sculpture

87. *Apostle,* probably *Saint Judas Thaddeus*
Southern Netherlands or northeastern France,
c. 1450–60. Alabaster, height 13⁹/₁₆ inches (34.5 cm)
Purchased with the John D. McIlhenny Fund and
with funds bequeathed by Carl and Joan Tandberg
1999-131-1
See page 9

88. Reliefs of Cherubim in Clouds
France, Paris region; c. 1710–20. Gilded bronze, height
30⅞ inches (78.5 cm) each
Purchased with the gift (by exchange) of Mr. and Mrs.
Orville H. Bullitt and with funds contributed by
Maude de Schauensee. 1998-5-1,2
See page 36

89. Jean-Antoine Houdon (French, 1741–1828)
Bust of Benjamin Franklin
1779. Marble, height with socle 20½ inches (52.1 cm)
Purchased with a generous grant from The Barra
Foundation, Inc., matched by contributions from the
Henry P. McIlhenny Fund in memory of Frances P.
McIlhenny, the Walter E. Stait Fund, the Fiske Kimball
Fund, and with funds contributed by Mr. and Mrs.
Jack M. Friedland, Hannah L. and J. Welles Henderson,
Mr. and Mrs. E. Newbold Smith, Mr. and Mrs. Mark E.
Rubenstein, Mr. and Mrs. John J. F. Sherrerd, The
Women's Committee of the Philadelphia Museum of
Art, Marguerite and Gerry Lenfest, Leslie A. Miller and
Richard B. Worley, Mr. and Mrs. John A. Nyheim, Mr.
and Mrs. Robert A. Fox, Stephanie S. Eglin, Maude de
Schauensee, Mr. and Mrs. William T. Vogt, and with
funds contributed by individual donors to the Fund for
Franklin. 1996-162-1
See page 33

90. Sir Francis Chantrey (English, 1781–1841)
Bust of Sir Walter Scott
1828. Marble, height with socle 26¼ inches (66.7 cm)
Promised gift of Martha J. McGeary Snider
See page 53

No. 96 Serape

91. Adriano Cecioni (Italian, 1836/38–1886)
Boy with a Rooster
c. 1868. Bronze, height 31 inches (78.7 cm)
Gift of Mr. and Mrs. Stewart A. Resnick. 2001-158-1
See page 72

92. Raymond Duchamp-Villon (French, 1876–1918)
Yvonne with a Knot of Hair (Face of a Child)
1907–8. Terra cotta, height 9¾ inches (24.8 cm)
Gift of Jacqueline Matisse Monnier. 2002-9-1
See page 97

93. Raymond Duchamp-Villon (French, 1876–1918)
Head
c. 1917. Bronze (unique cast), height 5⅛ inches (13 cm)
Promised gift of Anne d'Harnoncourt in memory of
Alexina Duchamp
See page 97

North America

Costume and Textiles

94. Embroidered by **Caroline E. Bieber** (American,
1827–1885); designed by **Elizabeth B. Mason**
(American, 1797–1875)
Embroidered Picture
Made in Kutztown, Pennsylvania; 1843. Plain-weave
linen embroidered in tent, seed, and cross stitches in
wool and silk; 22¼ x 28½ inches (56.5 x 72.4 cm)
Gift of Mr. and Mrs. Victor L. Johnson. 1999-173-1
See page 66

95. Possibly made by members of the **Independent
Order of Odd Fellows**
Album Quilt
Made in Stanford, Dutchess County, New York; 1853
Appliquéd cotton, silk, and velvet; 87¾ x 87¾ inches
(222.9 x 222.9 cm)
Gift of Elizabeth Albert. 2001-204-1
See page 67

*****96. Serape**
Mexico, Teotitlan del Valle, Oaxaca; c. 1920. Wool,
31 x 69¾ inches (78.7 x 177.2 cm)
Promised gift of Anne d'Harnoncourt and Joseph Rishel
in memory of René and Sarah Carr d'Harnoncourt

97. Serape
Mexico, Teotitlan del Valle, Oaxaca; 1928. Wool,
31½ x 83 inches (80 x 210.8 cm)
Promised gift of Anne d'Harnoncourt and Joseph Rishel
in memory of René and Sarah Carr d'Harnoncourt

98. Two couture ensembles, from a gift of twelve
(see also checklist no. 38)
Partial and promised gift of Kathleen P. Field

Donald Brooks (American, born 1928)
Evening Dress
1978. Silk chiffon with beads, sequins, and
rhinestones
1997-17-8

Adolfo (American, born Cuba, 1933)
Evening Dress with Shawl
1980s. Silk tulle with sequins
1997-17-7a, b

99. Charlie Logan (American, 1891–1984)
Twenty-nine garments and accessories
1978–84
Gift of the Friends of the Philadelphia Museum of Art
and partial gift of Kate and Ken Anderson

*The embellished garments and accessories created by
Charlie Logan are strongly connected to African
American folk aesthetics. The twenty-nine examples of
intricately decorated clothing, hats, bags, canes, and jew-
elry in this gift of works by this Saint Louis artist demon-
strate the layering of patterns, geometric designs, and use
of charmlike attachments that are found in other tradi-
tional work. Logan's very personal and expressive cos-
tumes, which he wore daily, incorporate found materials,
including thread and yarn from unraveled socks and
other textiles.*

"Saved" Coat, Hat, Bag, and Cane
Fabrics covered with yarn and thread embroidery
trimmed with buttons, coins, and tassels
(1998-19-1–3); wood covered with knit fabric,
embroidered and wrapped with yarn and thread
with safety pins, metal, and nails at tip (1998-19-4)
1998-19-1–4

***"Diamond" Coat, Hat, Bag, and Cane**
Fabrics covered with yarn and thread embroidery
trimmed with buttons, coins, tassels, American
flags, and metal and rhinestone decoration
(1998-19-5–7); wood wrapped with plain-weave
cotton and wool crepe, embroidered and wrapped
with yarn and thread with pennies and buttons
(1998-19-8)
1998-19-5–8

Jacket
Plain-weave wool with appliqués covered with yarn
and thread embroidery with button decoration
1998-19-18

Trousers
Synthetic knit with synthetic and cotton appliqués
with thread and yarn embroidery
1998-19-19

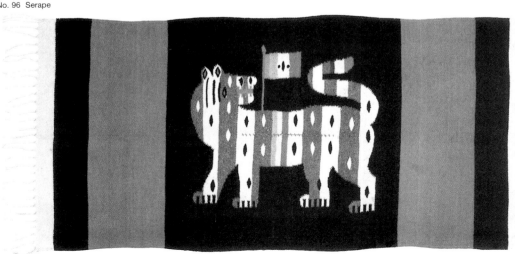

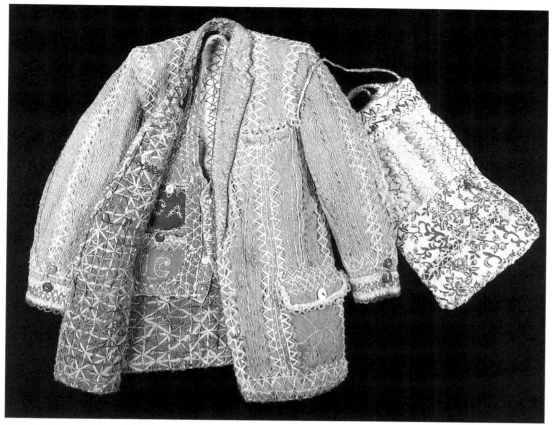

No. 99 Charlie Logan, "Diamond" Coat, Hat, Bag, and Cane (1998-19-5–8)

"Bible" Vest
Wool knit with cotton and synthetic appliqués with thread and yarn embroidery
1998-19-20

Canes (3)
Wood wrapped with fabrics, embroidered and wrapped with yarn and thread with coins and metal
1998-19-9–11

Bag with Cover
Synthetic and cotton fabrics with thread and yarn embroidery and button decoration (1998-19-12a); cotton terry cloth with thread and yarn embroidery (1998-19-12b)
1998-19-12a,b

Bags (2)
Fabrics with thread and yarn embroidery, buttons, and metallic cording (1998-19-21); patchwork of cotton and synthetic fabrics with thread and yarn embroidery (1998-19-22)
1998-19-21, 22

"Heaven" Bow Tie
Wool-plush and plain-weave cotton with thread and yarn embroidery and button decoration
1998-19-13

Watch Fobs on Chain
Metal chain and safety pins with fobs wrapped in embroidered thread and yarn with button decoration
1999-19-14

Pins (2)
Coins wrapped with yarn and thread
1998-19-15, 23

Rings (7)
Dime wrapped with yarn and thread (1998-19-16); button wrapped with yarn and thread (1998-19-17, 26–28); button wrapped with yarn and thread with additional button (1998-19-24, 25)
1998-19-16, 17, 24–28

Yarn Holder
Paper wrapped with yarn with inserted needle
1998-19-29

100. Vera Wang (American, born 1949)
Wedding Dress
1999. Silk satin and synthetic stretch net; metallic and silk ribbon embroidery with beading, rhinestones, and sequins
Gift of Mrs. Sidney Kimmel
See page 153

[Late twentieth-century American women's couture and boutique designer garments and ensembles, shoes, and handbags; The Diane Wolf Collection; see checklist no. 36]

[Late twentieth-century American avante-garde menswear and designer shoes; Gift from the private collection of John Cale; see checklist no. 37]

Decorative Arts

101. Hadley Chest
America, made in Hartford, Connecticut; c. 1695–1715
Oak and white pine, height 45¼ inches (116.2 cm)
Promised gift of The Anne H. and Frederick Vogel III Collection for the Philadelphia Museum of Art
See page 24

102. Jacobus Van der Spiegel (American, 1666–1716)
Tankard
c. 1690–1708. Silver, height 7½ inches (19.1 cm)
Gift of Robert Montgomery Scott. 1996-176-1
See page 31

103. Easy Chair
America, made in Boston; c. 1700–1710. Maple and pine, eighteenth-century flamestitch needlework upholstery; height 51 inches (129.5 cm)
Gift of Anne H. and Frederick Vogel III. 1999-62-1
See page 25

104. Chest on Stand
America, made in Philadelphia or southeastern Pennsylvania; 1710–25. Walnut, cedar, white pine, and tulip poplar; height 56 inches (142.2 cm)
Promised gift of Martha Stokes Price
See page 27

105. Francis Richardson, Sr. (American, 1681–1729)
Tankard
c. 1715–20. Silver, height 7 inches (17.8 cm)
Gift of Mr. and Mrs. Harold P. Starr. 1999-142-1
See page 31

106. Eight objects, from a gift of nine that descended in the Morris and Wheeler families of Philadelphia (see also checklist no. 73)
Promised gift of the Family of Samuel Wheeler Morris
See page 34

Johannis Nys (American, 1671–1734)
Tankard
c. 1718–22. Silver, height 7½ inches (19.1 cm)

Mary Flower (American, 1744–1778) or **Ann Flower** (American, 1743–1778)
Bible Cover
c. 1750; Bible printed by John Baskett (London, 1723). Worsted wool and silk on linen, 20¼ x 13¾ inches (52.7 x 34.9 cm)

Edward Milne (American, 1724–1813)
Porringer
c. 1755–70. Silver, diameter 5 inches (12.7 cm)

Artist unknown (English)
Cream Pot
Made for the North American market
1760–75. Silver, height 4 inches (10.2 cm)

Jason Ribouleau (active London, 1761–73)
Pocket Watch
Made for the North American market
c. 1761–73. Silver, width 2⅝ inches (6.7 cm)

Mary Flower (American, 1744–1778) or **Ann Flower** (American, 1743–1778)
Pocketbook or Wallet
1765. Worsted wool and silk on linen, length 6⅛ inches (15.9 cm)

Artist unknown (probably American)
Child's Whistle and Bells
1765–75. Silver and coral, length 5¾ inches (14.6 cm)

Joseph Richardson, Jr. (American, 1752–1831)
Ladle
c. 1801. Silver, length 13 inches (33 cm)

***107. Cann with Penn Family Coat of Arms**
China, made for export to the Western market
c. 1725–40. Porcelain, enamel, and gilded decoration;
height 5 inches (12.7 cm)
Gift of the Eckenhoff Family in honor of Myra Boyle
Narbonne. 2001-107-1

No. 107 Cann with Penn Family Coat of Arms

108. Desk and Bookcase
America, made in Philadelphia; c. 1740–50
Mahogany, white cedar, pine, and tulip poplar; height
8 feet, 9 inches (2.7 m)
Gift of Daniel Blain, Jr. 1997-67-3
See page 32

109. China Table
America, probably made in Virginia; c. 1765–75
Mahogany, tulip poplar, and pine; height 29 1/4 inches
(74.3 cm)
Promised gift of Charlene Sussel
See page 28

110. Attributed to the Workshop of Thomas Affleck
(American, born Scotland, 1740–1795)
Easy Chair
Made in Philadelphia, 1770–71. Mahogany, yellow
pine, white oak, white cedar, black walnut, and tulip
poplar, modern upholstery; height 45 inches (114.3 cm)
Partial and promised gift of H. Richard Dietrich, Jr.
2001-12-1
See page 39

***111. Joseph Richardson, Jr.** (American, 1752–1831)
and **Nathaniel Richardson** (American, 1754–1827)
Coffeepot
Made in Philadelphia; c. 1785–93. Silver and wood,
height 13 1/4 inches (33.7 cm)
Gift of Pemberton Hutchinson in memory of his wife

112. Inscribed by John Townsend (American,
1733–1809)
Pembroke Table
Made in Newport, Rhode Island; c. 1790–1800
Mahogany, maple, and tulip poplar; height 27 1/4 inches
(70.5 cm)
Gift of the Family in memory of Dorothy and Irvin
Stein. 2000-136-1
See page 28

113. Side Chairs (2)
United States, made in Baltimore; c. 1790–1810
Mahogany, tulip poplar, and satinwood inlay; height
37 5/8 inches (95.6) each
Promised gift of Mr. and Mrs. M. Todd Cooke

114. Robert Gaw (American, active c. 1793–1833)
Suite of Windsor Armchairs (24)
Made in Philadelphia; c. 1808. Painted tulip poplar
and hickory, height 33 1/4 inches (84.5 cm) each
Promised gift of Keith and Lauren Morgan
See pages 42–43

***115. Blanket Chest**
United States, 1810–40. Mixed hard and soft woods,
painted
Promised gift of Harvey S. Shipley Miller and J.
Randall Plummer

116. Made by Fletcher and Gardiner (Boston and
Philadelphia, active 1808–36)
Oval Tray
c. 1820. Silver, width 31 1/4 inches (80.6 cm)
Promised gift of Cordelia Biddle Dietrich, H. Richard
Dietrich III, and Christian Braun Dietrich in memory
of Livingston L. Biddle, Jr., and in honor of Cordelia
Frances Biddle
See page 60

117. Attributed to Joseph B. Barry (American, born
Ireland, 1757?–1839)
Pair of Gaming Tables
Probably made in Philadelphia, c. 1820–30
Mahogany, mahogany veneer, rosewood veneer, tulip

No. 111 Joseph Richardson, Jr., and Nathaniel Richardson, Coffeepot

poplar, pine, and brass inlay; height 29 inches
(73.7 cm) each
Purchased with the Henry P. McIlhenny Fund in mem-
ory of Frances P. McIlhenny. 2001-80-1
Gift of Judith Hollander. 2001-96-1

118. Joseph B. Barry (American, born Ireland,
1757?–1839)
Tall Case Clock
Made in Philadelphia, c. 1820–30. Mahogany,
mahogany veneer, white pine, and tulip poplar; height
8 feet, 1 inch (2.4 m)
Purchased with funds contributed by Mr. and Mrs. E.
Newbold Smith. 2001-81-1
See page 58

119. Fireboard
United States, made in Perry County, Pennsylvania;
c. 1825–35. Painted pine, height 31 1/2 inches (80 cm)
Promised gift of Mary Louise Elliott Krumrine in
memory of Jack Milton Krumrine
See page 54

120. Thomas Fletcher (American, 1787–1866)
**Coffee and Tea Service: Coffeepot, Two Teapots,
Sugar Bowl, Cream Pot, and Waste Bowl**
1839–40. Silver; coffeepot height 12 3/4 inches (32.4
cm), teapot height 8 3/4 inches (22.2 cm) each, sugar
bowl height 9 inches (22.9 cm), cream pot height 6 7/8
inches (17.5 cm), waste bowl height 6 inches
(15.2 cm). Promised gift of Cordelia Biddle Dietrich,
H. Richard Dietrich III, and Christian Braun Dietrich
in memory of Livingston L. Biddle, Jr., and in honor of
Cordelia Frances Biddle
See page 60

121. Wax Fruit and Dessert Arrangement
United States, c. 1860–80. Beeswax, paraffin, tempera,
glass, and wood; height 19 inches (48.3 cm)
Promised gift of John Whitenight and Frederick
LaValley
See page 62

122. Wax Flower-Making Kit
United States, c. 1860–80. Colored paper and board,
glass, powder pigments, wire, beeswax, gilded brass,
wood, paper patterns, and hair
Promised gift of John Whitenight and Frederick
LaValley
See page 62

123. Made by R. & W. Wilson (Philadelphia, active
1825–83)
Presentation Urn
c. 1857. Silver, height 26 inches (66 cm)
Gift of Martha Hamilton and I. Wistar Morris III
2001-108-1a, b
See page 63

124. David Drake (known as **Dave the Potter**)
(American, 1800–c. 1870)
Storage Jar
Made in Lewis Miles Pottery, Edgefield, South
Carolina; 1859. Alkaline-glazed stoneware, height 26 1/2
inches (67.3 cm)
Purchased with funds contributed by Keith and Lauren
Morgan and with the gifts (by exchange) of John T.
Morris, Mrs. John D. Wintersteen, and the Bequest of
Maurice J. Crean, and with the Baugh-Barber Fund, the

No. 115 Blanket Chest

Haas Community Fund, and other Museum funds (by exchange). 1997-35-1
See page 55

125. Made by **Wood & Hughes** (New York, active 1845–99)
Tea Service: Teapot, Cream Pot, Sugar Bowl, and Waste Bowl
c. 1865–75. Silver, teapot height 8 ¼ inches (21 cm)
Promised gift of John Whitenight and Frederick LaValley

126. George B. Sharp (American, active 1848–70)
Berry and Ice Cream Service
Made in Philadelphia, c. 1865–70. Gilded silver, longest spoon length 10 ¼ inches (26 cm)
Promised gift of John Whitenight and Frederick LaValley

127. One hundred twenty-six pieces of Rookwood pottery (Cincinnati, Ohio, 1880–1960)
Gerald and Virginia Gordon Collection
1999-58-1–30; 2002-21-1–96
See pages 88–89

With its strong tradition of collecting American ceramics, the Museum is a fitting repository for Gerald and Virginia Gordon's superb gift of 126 pieces of Rookwood pottery from their collection. Founded in Cincinnati in 1880, the Rookwood manufactory would become distinguished for producing some of the finest American art pottery through the mid-twentieth century. With the acquisition of the Gordons' collection, which is noteworthy for the range of aesthetic styles represented, the Museum now owns the finest holdings of these wares in the United States.

128. Designed by **Louis Comfort Tiffany** (American, 1848–1933); made by **Tiffany & Co.** (New York, active 1837–present)
Column
c. 1898–1902. Iridescent favrile glass, wood, metal, and gilding; height 11 feet, 2 inches (3.4 m)
Purchased with funds contributed by Marguerite and Gerry Lenfest, Jaimie and David Field, The Tiffany & Co. Foundation, the Robert Saligman Charitable Foundation, Mr. and Mrs. William T. Vogt, Mr. and Mrs. Robert A. Fox, the Young Friends of the Philadelphia

Museum of Art, the Philadelphia Fountain Society, Mrs. Eugene W. Jackson, Betty J. Marmon, and other donors in honor of the 125th Anniversary of the Museum. 2001-79-1
See page 80

* **129. Franz Brandt** (American, 1895–1906)
Model of the Steamboat *The Republic*
c. 1910. Glass lampwork, cotton, wood, and mica; height 12 ⅜ inches (31.4 cm)
Purchased with funds contributed by Hannah L. and J. Welles Henderson and other donors. 2001-82-1

130. Wharton Esherick (American, 1887–1970)
Steps with Elephant and Donkey Finials
1935. Hickory, height 35 inches (88.9 cm)
Gift of Rachel Bok Goldman and Allen S. Goldman, M.D. 2001-14-1
See page 113

131. Wharton Esherick (American, 1887–1970)
Upholstered Settees (2)
1936–37. Hand-carved oak frame with upholstered seat and back; larger settee width 83 ½ inches (212.1 cm), smaller settee width 53 ½ inches (135.9 cm)
Partial and promised gift of Enid Curtis Bok Okun, daughter of Curtis and Nellie Lee Bok. 2001-201-1,2

132. Wharton Esherick (American, 1887–1970)
Phonograph Cabinet
1936–37. Cherry, height 27 ½ inches (69.9 cm)
Partial and promised gift of Enid Curtis Bok Okun, daughter of Curtis and Nellie Lee Bok. 2001-201-3
See page 113

133. Four groups of furniture, from a gift of nine (see also checklist no. 50)
Gift of Lannan Foundation, Santa Fe, New Mexico

Designed by **Pedro Friedeberg** (Mexican, born Italy, 1936)

Foot Table
c. 1964. Gilded wood and glass, height 13 ¾ inches (34.9 cm)
1999-14-15

Pair of *Hand* Chairs
c. 1964. Gilded wood and glass, height 34 inches (86.4 cm) each
1999-14-13,14

No. 129 Franz Brandt, Model of the Steamboat *The Republic*

Designed by **Max Ernst** (American, born Germany, 1891–1976)
Bed-cage and Screen
1974. Walnut, alder wood, brass, mirror, offset lithograph collage, and mink; bed 7 feet, 4 inches x 8 feet, 10 inches x 8 feet, 4 inches (2.2 x 2.6 x 2.5 m), screen 6 feet, 1 inch x 5 feet, 4 ⅝ inches (1.8 x 1.6 m)
1999-14-1a, b
See page 131

Robert Wilson (American, born 1941)
Pair of *Queen Victoria* **Chairs**
1974. Lead over plywood, brass, and electric lights; height 68 ⅝ (174.3 cm) each
1999-14-11,12

134. Wendell Castle (American, born 1932)
Table with Gloves and Keys
1980. Mahogany, height 34 ½ inches (87.6 cm)
Gift of Mrs. Robert L. McNeil, Jr. 2001-15-1
See page 149

135. Wendell Castle (American, born 1932)
Looking Glass
1982. Mahogany and glass, 30 ¼ x 23 ½ inches (76.8 x 59.7 cm)
Gift of Mrs. Robert L. McNeil, Jr. 2001-15-2

136. Wayne Higby (American, born 1943)
White Granite Bay
1982. Glazed raku-fired earthenware, height approximately 12 inches (30.5 cm) each
Gift of Mrs. Robert L. McNeil, Jr. 2001-23-1a,b–4a,b
See page 148

137. Wayne Higby (American, born 1943)
Frozen Day Mesa
1984. Glazed raku-fired earthenware, height 12 ½ inches (31.8 cm)
Promised gift of Harvey S. Shipley Miller and J. Randall Plummer
See page 148

138. Rudolf Staffel (American, 1911–2002)
Light Gatherer
c. 1985. Porcelain, diameter 12 inches (30.5 cm)
Gift of Margaret Chew Dolan and Peter Maxwell 2001-191-1
See page 112

139. Wendy Maruyama (American, born 1952)
Red Cabinet
1990. Polychromed poplar and maple, height 5 feet, 11 ½ inches (1.8 m)
Gift of Mr. and Mrs. Leonard I. Korman. 2001-97-2
See page 156

140. Betty Woodman (American, born 1930)
Spring Outing
2000. Glazed earthenware, epoxy resin, lacquer, and paint; height approximately 38 inches (96.5 cm) each
Gift of The Women's Committee of the Philadelphia Museum of Art in honor of the 125th Anniversary of the Museum. 2001-16-1a–c
See page 157

No. 141 John Cederquist, *Steamer (Cabinet)*

***141. John Cederquist** (American, born 1946)
Steamer (Cabinet)
2000. Various stained woods, height 5 feet, 10 inches
(1.7 m)
Gift of The Women's Committee of the Philadelphia
Museum of Art and Franklin Parrasch in honor of the
125th Anniversary of the Museum. 2001-17-1

Paintings

142. John Singleton Copley (American, 1738–1815)
Portrait of Mr. and Mrs. Thomas Mifflin (Sarah Morris)
1773. Oil on ticking, 60½ x 48 inches (153.7 x 121.9 cm)
Bequest of Mrs. Esther F. Wistar to The Historical
Society of Pennsylvania in 1900, and acquired by the
Philadelphia Museum of Art by mutual agreement
with the Society through the generosity of Mr. and
Mrs. Fitz Eugene Dixon, Jr., and significant contribu-
tions from Stephanie S. Eglin, Maude de Schauensee
and other donors to the Philadelphia Museum of Art,
as well as the George W. Elkins Fund and the W. P.
Wilstach Fund, and through the generosity of Maxine
and Howard H. Lewis to the Historical Society of
Pennsylvania. EW1999-45-1
See page 38

**143. Seventeen portrait miniatures, from a gift of
forty** (see also checklist no. 52)
Gift of Mr. and Mrs. Joseph Shanis and Mr. and Mrs.
Harris Stern in memory of Jeannette B. S. Whitebook
Lasker

John Ramage (American, born Ireland,
c. 1748–1802)

Benjamin Ledyard
1780. Watercolor on ivory, 1¾ x 1⁵⁄₁₆ inches
(4.4 x 3.4 cm)
2000-137-4

William Dandridge Peck
Late eighteenth century. Watercolor on ivory,
1⅛ x ⅞ inches (3.5 x 2.3 cm)
2000-137-9

Artist unknown (American)
Captain John Dand Train
c. 1790–1800. Watercolor on ivory, 2½ x 2½ inches
(6.4 x 6.4 cm)
2000-137-38

Artist unknown (American)
Colonel Tobiaz Drayton
c. 1795. Watercolor on ivory, 1⅞ x 1¹⁄₁₆ inches
(4.7 x 2.7 cm)
2000-137-28

Robert Field (American, born England, c. 1769–1819)

Miss Henrietta Sprigg
c. 1795. Watercolor on ivory, 3¾ x 3 inches
(9.5 x 7.6 cm)
2000-137-3
See page 68

Colonel Cambell of the Royal Americans
1798–1803. Watercolor on ivory, 3¹⁄₁₆ x 2⁷⁄₁₆ inches
(7.8 x 6.2 cm)
2000-137-6

Edward Greene Malbone (American, 1777–1807)

Dr. G. Patten of Newport, Rhode Island
c. 1798. Watercolor on ivory, 2¹¹⁄₁₆ x 2¼ inches
(6.8 x 5.7 cm)
2000-137-10

Edward Martin
1802–3. Watercolor on ivory, 2¹³⁄₁₆ x 2¹⁄₁₆ inches
(7.2 x 5.3 cm)
2000-137-37

No. 148 William Glackens, *Wickford Harbor, Rhode Island*

Raphaelle Peale (American, 1774–1825)
Gentleman
c. 1800. Watercolor on ivory, 1⅞ x 1⅜ inches
(4.7 x 3.5 cm)
2000-137-8

James Peale (American, 1749–1831)

William Sargeant
1801. Watercolor on ivory, 2¹⁵⁄₁₆ x 2⅜ inches
(7.5 x 6 cm)
2000-137-2

Thomas McKean
1802. Watercolor on ivory, 2⅞ x 2¹⁄₁₆ inches
(7.3 x 5.3 cm)
2000-137-11

Anson Dickinson (American, 1779–1852)
Middle-Aged Gentleman
c. 1805. Watercolor on ivory, 2¹⁵⁄₁₆ x 2¹⁄₁₆ inches
(7.4 x 5.2 cm)
2000-137-5

Philippe Abraham Peticolas (American, born
France, 1760–1841)
Thomas Heyward, Jr.
c. 1805. Watercolor on ivory, 2⅝ x 2³⁄₁₆ inches
(6.7 x 5.5 cm)
2000-137-1

Artist unknown (possibly French, active United
States?)
Gouverneur Morris
c. 1805–10. Watercolor on ivory, 2¹¹⁄₁₆ x 2¼ inches
(6.7 x 5.7 cm)
2000-137-20
See page 68

Benjamin Trott (American, c. 1770–1843)
Charles Rhind
c. 1810–20. Watercolor on ivory, 2¹³⁄₁₆ x 2³⁄₁₆ inches
(7.1 x 5.6 cm)
2000-137-7

Charles Fraser (American, 1782–1860)
Gentleman
c. 1820. Watercolor on ivory, 2⁵⁄₁₆ x 1¹⁵⁄₁₆ inches
(5.9 x 5 cm)
2000-137-29

Artist unknown (American)
Gentleman
c. 1850. Watercolor on ivory, 1⁵⁄₈ x 1⁷⁄₁₆ inches
(4.1 x 3.7 cm)
2000-137-26

144. Joshua Johnson (American, active c. 1795–1825)
Portrait of Edward Aisquith
c. 1810. Oil on canvas, 22½ x 18⅛ inches
(57.2 x 46.7 cm)
Purchased with funds contributed by Dr. Benjamin F.
Hammond, and with other funds being raised in
honor of the 125th Anniversary of the Museum and in
celebration of African American art. 2001-11-1
See page 49

145. John Lewis Krimmel (American, born Germany,
1786–1821)
Pepper-Pot: A Scene in the Philadelphia Market
1811. Oil on canvas, 19½ x 15½ inches (49.5 x 39.4 cm)
Gift of Mr. and Mrs. Edward B. Leisenring, Jr.
2001-196-1
See page 46

146. Thomas Cole (American, born England,
1801–1848)
View of Fort Putnam
1825. Oil on canvas, 27 x 34 inches (68.6 x 86.4 cm)
Promised gift of Charlene Sussel
See page 50

147. Ammi Phillips (American, 1788–1865)
Blonde Boy with Primer, Peach, and Dog
c. 1836. Oil on canvas, 48⅜ x 30 inches
(122.9 x 76.2 cm)
Estate of Alice M. Kaplan. 2001-13-1
See page 59

148. William Glackens (American, 1870–1938)
Wickford Harbor, Rhode Island
c. 1908. Oil on canvas, 26 x 32 inches (66 x 81.3 cm)
Bequest of Margaret McKee Breyer. 2000-1-2

149. Stuart Davis (American, 1892–1964)
Boats Drying, Gloucester
c. 1916. Oil on canvas, 18½ x 22¼ inches
(47 x 56.5 cm)
Partial and promised gift of Hannah L. and J. Welles
Henderson. 1999-171-1
See page 103

150. William H. Johnson (American, 1901–1970)
Sunflowers
c. 1931. Oil on burlap, 20½ x 25 inches (52.1 x 63.5 cm)
Promised gift of Marguerite and Gerry Lenfest
See page 114

No. 156 Enrico Donati, *Carnaval de Venise*

151. Man Ray (American, 1890–1976)
Le Beau Temps
1939. Oil on canvas, 6 feet, 10¾ inches x 6 feet, 6¾ inches
(2.1 x 2 m)
Promised gift of Sidney Kimmel
See page 130

152. Dorothea Tanning (American, born 1910)
Birthday
1942. Oil on canvas, 40¼ x 25½ inches (102.2 x 64.8 cm)
Purchased with funds contributed by C. K. Williams, II
1999-50-1
See page 132

153. Andrew Newell Wyeth (American, born 1917)
Public Sale
1943. Tempera on panel, 22 x 48 inches
(55.9 x 121.9 cm)
Bequest of Margaret McKee Breyer. 2000-1-1
See page 116

154. Adolph Gottlieb (American, 1903–1974)
Pictograph
1944. Oil on canvas, 36 x 25 inches (91.4 x 63.5 cm)
Promised gift of The Judith Rothschild Foundation
See page 119

155. Beauford Delaney (American, 1901–1979)
Portrait of James Baldwin
1945. Oil on canvas, 22 x 18 inches (55.9 x 45.7 cm)
Purchased with funds contributed by The Dietrich
Foundation in memory of Joseph C. Bailey and with a
grant from The Judith Rothschild Foundation. 1998-3-1
See page 109

* **156. Enrico Donati** (American, born Italy, 1909)
Carnaval de Venise
1946. Oil on canvas, 40 x 50 inches (101.6 x 127 cm)
Gift of Adele Donati

157. Peter Charlie Beshara (American, born Syria,
1898–1960)
Untitled
1950s. House enamel and mixed media on canvas,
31¼ x 25 inches (79.4 x 63.5 cm)
Promised gift of Ann and John Ollman
See page 123

158. Painting, from a gift of six objects (see also
checklist no. 194)
Gift of Frank A. Elliott, Josiah Marvel, and Jonathan H.
Marvel in memory of Gwladys Hopkins Elliott

> **Andrew Newell Wyeth** (American, born 1917)
> *Cooling Shed*
> 1953. Tempera on Masonite, 25 x 13 inches
> (63.5 x 33 cm)
> 1998-180-1
> See page 117

159. Alice Neel (American, 1900–1984)
Last Sickness
1953. Oil on canvas, 30 x 22 inches (76.2 x 55.9 cm)
Promised gift of Richard Neel and Hartley S. Neel
See page 129

160. Sam Francis (American, 1923–1994)
Red
1955–56. Oil on canvas; 10 feet, 2 inches x 6 feet,
2 inches (3.1 x 1.8 m)
Partial and promised gift of Gisela and Dennis Alter
2000-94-1
See page 136

No. 178 Abraham Walkowitz, *Improvisation: Coney Island #1*

161. Robert Motherwell (American, 1915–1991)
Elegy to the Spanish Republic
1958–60. Oil and charcoal on canvas, 6 feet, 6 inches
x 8 feet, 3¼ inches (2 x 2.5 m)
Gift (by exchange) of Miss Anna Warren Ingersoll and
partial gift of the Dedalus Foundation, Inc. 1998-156-1
See page 139

162. Bob Thompson (American, 1937–1966)
The Deposition
1961. Oil on canvas; 5 feet, 6 inches x 6 feet, 3½ inches
(1.6 x 1.9 m)
Purchased with funds contributed by Harvey S.
Shipley Miller and J. Randall Plummer, and with other
funds being raised in honor of the 125th Anniversary
of the Museum and in celebration of African American
art. 2000-37-1
See page 138

163. Jacob Lawrence (American, 1917–2000)
Taboo
1963. Tempera on hardboard, 19⅞ x 23⅞ inches
(50.5 x 60.6 cm)
Gift of the Zelda and Josef Jaffe Family
See page 140

164. Alma Thomas (American, 1895–1978)
Hydrangeas Spring Song
1976. Acrylic on canvas, 6 feet, 6 inches x 4 feet
(1.9 x 1.2 m)
Purchased with funds contributed by Mr. and Mrs.
Julius Rosenwald II in honor of René and Sarah Carr
d'Harnoncourt, The Judith Rothschild Foundation,
and with other funds being raised in honor of the
125th Anniversary of the Museum and in celebration
of African American art. 2002-20-1
See page 115

165. Philip Guston (American, 1913–1980)
Entrance
1979. Oil on canvas; 5 feet, 9 inches x 7 feet, 9 inches
(1.7 x 2.3 m)
Promised gift of Agnes Gund and Daniel Shapiro
See page 155

166. Jasper Johns (American, born 1930)
Catenary (I Call to the Grave)
1998. Encaustic on canvas with wood and string;
6 feet, 6 inches x 9 feet, 10 inches (2 x 2.9 m)
Purchased with funds contributed by Gisela and
Dennis Alter, Keith L. and Katherine Sachs, Frances and
Bayard Storey, The Dietrich Foundation, Marguerite
and Gerry Lenfest, Mr. and Mrs. Brook Lenfest, Marsha
and Jeffrey Perelman, Mr. and Mrs. Leonard I. Korman,
Mr. and Mrs. Berton E. Korman, Mr. and Mrs. William
T. Vogt, Dr. and Mrs. Paul Richardson, Mr. and Mrs.
George M. Ross, Ella B. Schaap, Eileen and Stephen
Matchett, and other donors in honor of the 125th
Anniversary of the Museum. 2001-91-1
See page 163

**[Fifteen paintings, from a gift of fifty works by
twentieth-century folk and self-taught artists;**
partial and promised gift of Nancy F. Karlins
Thoman and Mark Thoman; see checklist no. 192]

Prints, Drawings, and Photographs

Prints

167. Print, from a gift of eleven works on paper
(see also checklist nos. 76, 175, 204)
Promised gift of Alice Saligman

 Marcel Duchamp (American, born France, 1887–
 1968) and **Jacques Villon** (French, 1875–1963)
 The Bride
 1934. Etching and aquatint, plate 25⁹⁄₁₆ x 19¹¹⁄₁₆
 inches (64.9 x 50 cm)

168. Sam Francis (American, 1923–1994)
The White Line
1960. Color lithograph (edition 75), sheet 35¼ x 24⅞
inches (90.8 x 63.2 cm). Printed by Emil Matthieu,
Zurich; published by Kornfeld und Klipstein, Bern,
Switzerland
Promised gift of Mr. and Mrs. Jack M. Friedland
See page 137

169. Jasper Johns (American, born 1930)
Foirades/Fizzles, with text by Samuel Beckett
1975–76. Bound book with thirty-three aquatints and
etchings (edition 250), plus box with color lithograph;
page 13⅛ x 9⅞ inches (33.3 x 25.1 cm), box 13⁹⁄₁₆ x
10½ x 2¼ inches (34.8 x 26.7 x 5.7 cm). Printed by
Aldo Crommelynck, Paris; published by Petersburg
Press, London
Promised gift of Mildred L. and Morris L. Weisberg
See page 145

170. Jasper Johns (American, born 1930)
The Seasons (Spring, Summer, Fall, and Winter)
1987. Four color etchings with aquatint (edition 73),
sheet 26 x 19⅞ inches (66 x 48.3 cm) each. Printed
and published by Universal Limited Art Editions, West
Islip, New York
Promised gift of Edna and Stanley C. Tuttleman
See page 162

Drawings

171. Carl Edward Munch (American, born Germany,
1769–1833)
Birth Certificate for Georg Negely
Made in Dauphin County, Pennsylvania; 1805
Watercolor, ink, and gum arabic on paper;
12½ x 15½ inches (31.8 x 39.4 cm)
Promised gift of Mary Louise Elliott Krumrine in
memory of Jack Milton Krumrine
See page 44

172. Attributed to Martin Gottschall (American, born
Germany, 1785–1857)
The Temptation of Eve
Made in Bucks County, Pennsylvania; c. 1830–35
Watercolor, ink, and gum arabic on paper; 9¾ x 13¾
inches (24.8 x 34.9 cm)
Promised gift of Mr. and Mrs. Victor L. Johnson
See page 48

173. William Trost Richards (American, 1833–1905)
Landscape with Figure
1866–67. Charcoal and opaque watercolor with ink
and opaque watercolor on wove paper, 22¼ x 17⅛
inches (56.5 x 43.5 cm)
Gift of Marguerite and Gerry Lenfest. 2002-55-1
See page 56

174. Winslow Homer (American, 1836–1910)
Building a Smudge
1891. Watercolor over traces of graphite on watercolor
paper, 13½ x 20⅝ inches (34.3 x 52.4 cm)
Gift of Ann R. Stokes. 2002-10-1
See page 93

**175. Six drawings, from a gift of eleven works on
paper** (see also checklist nos. 76, 167, 204)
Promised gift of Alice Saligman

Marcel Duchamp (American, born France, 1887–1968)

Man on a Stool
1904–5. Pencil and watercolor on paper, 8¼ x 5⅛ inches (21 x 13 cm)

Peasant Woman
1904–5. Watercolor and pencil on paper, 8⁷⁄₁₆ x 5¼ inches (21.4 x 13.3 cm)

Study of a Kneeling Nude
1910. India ink on laid paper, 20 x 13¹⁄₁₆ inches (50.8 x 33.2 cm)

Portrait of John Quinn
1915. Pen and ink on paper, 7⅛ x 5¼ inches (18.1 x 13.3 cm)
See page 84

L.H.O.O.Q. Shaved
1965. Playing card reproduction of the *Mona Lisa* mounted on a dinner invitation, 3½ x 2⁷⁄₁₆ inches (8.9 x 6.2 cm)

Beatrice Wood (American, 1893–1998)
Doubts
1926. Pencil and watercolor on paper, 10¼ x 10 inches (26 x 25.4 cm)

176. Marcel Duchamp (American, born France, 1887–1968)
Stood Up
1909. Charcoal on paper, 10½ x 13⅞ inches (26.7 x 35.2 cm)
Promised gift of The Judith Rothschild Foundation
See page 84

177. Marcel Duchamp (American, born France, 1887–1968)
Bachelor Apparatus, 1. Plan and 2. Elevation
1913. Ink and pencil on paper (cut in two pieces and later rejoined), 10½ x 13⅞ inches (26.7 x 35.2 cm)
Bequest of Alexina Duchamp. 2001-3-1
See page 84

*178. **Abraham Walkowitz** (American, born Russia, 1878–1965)
Improvisation: Coney Island #1
1915. Transparent and opaque watercolor, brush, ink, charcoal, and graphite on wove paper; 21¹¹⁄₁₆ x 29¹⁵⁄₁₆ inches (55.1 x 76 cm)
Purchased with funds contributed by Marion Boulton Stroud. 1999-133-1

179. Lyonel Feininger (American, active Germany, 1871–1956)
Ehringsdorf I
1916. Charcoal over ink on paper, 9⁷⁄₁₆ x 12⁵⁄₁₆ inches (24 x 31.3 cm)
Gift of C. K. Williams, II. 2001-49-1
See page 100

180. Georgia O'Keeffe (American, 1887–1986)
Special No. 15
1916. Charcoal on paper, 18⅞ x 24⅜ inches (47.9 x 61.9 cm)
Purchased with the gift (by exchange) of Dr. and Mrs. Paul Todd Makler, with funds contributed by Mr. and Mrs. John J. F. Sherrerd, the Alice Newton Osborn Fund, and the Lola Downin Peck Fund, and gift of The Georgia O'Keeffe Foundation. 1997-39-1
See page 86

*181. **Maurice B. Prendergast** (American, 1859–1924)
Bathers, New England
c. 1916–19. Watercolor, pastel, and pencil on paper; 15⅝ x 22½ inches (39.7 x 57.1 cm)
Promised gift of C. K. Williams, II

182. Joseph Stella (American, born Italy, 1877–1946)
Red Amaryllis
c. 1929. Gouache on paper, 30 x 24 inches (76.2 x 61 cm)
Promised gift of Marion Boulton Stroud
See page 107

No. 188 Myron Stout, *Untitled*

183. Edward Hopper (American, 1882–1967)
Corn Hill
c. 1930. Watercolor over graphite on watercolor paper, 13⅞ x 20 inches (35.2 x 50.8 cm)
Promised gift of C. K. Williams, II

184. Georgia O'Keeffe (American, 1887–1986)
Special No. 40
1934. Graphite on paper, 16 x 11 inches (40.6 x 27.9 cm)
Purchased with the gift (by exchange) of Dr. and Mrs. Paul Todd Makler, with funds contributed by Barbara Rothschild Michaels, The Herbert and Nannette Rothschild Memorial Fund in memory of Judith Rothschild, and Mr. and Mrs. W. B. Dixon Stroud, and gift of The Georgia O'Keeffe Foundation 1997-40-1

185. Georgia O'Keeffe (American, 1887–1986)
Portrait of Beauford Delaney
1940s. Charcoal on paper, 24¾ x 18⅝ inches (62.9 x 47.3 cm)
Purchased with funds contributed by Marion Boulton Stroud, with the gift (by exchange) of Dr. and Mrs. Paul Todd Makler, and gift of The Georgia O'Keeffe Foundation. 1997-41-1

186. William Traylor (American, 1856–1949)
Untitled
1939–40. Pencil on cardboard, 12 x 20 inches (30.5 x 50.8 cm)
Promised gift of Josephine Albarelli

187. William Traylor (American, 1856–1949)
Untitled (House with Multiple Figures)
1939–40. Graphite on cardboard, 20 x 30 inches (50.8 x 76.2 cm)
Partial and promised gift of Jill and Sheldon Bonovitz
See page 120

*188. **Myron Stout** (American, 1908–1987)
Untitled
c. mid-1950s. Charcoal on paper, 25 x 19 inches (63.5 x 48.2 cm)
Promised gift of The Judith Rothschild Foundation

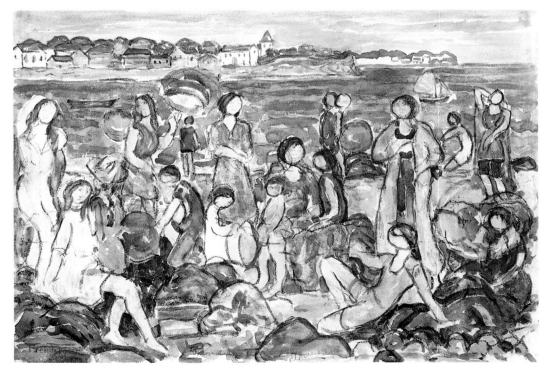

No. 181 Maurice B. Prendergast, *Bathers, New England*

189. Martín Ramírez (American, born Mexico, 1895–1963)
Madonna
c. 1950–53. Mixed media on paper, 50 x 28 inches (127 x 71.1 cm) (framed)
Promised gift of Josephine Albarelli
See page 122

190. Martín Ramírez (American, born Mexico, 1895–1963)
Untitled (Large Cowboy and Rider)
c. 1950–53. Colored wax crayon and graphite on wove paper; 42³⁄₄ x 35¹⁄₈ inches (108.6 x 89.9 cm)
Partial and promised gift of Jill and Sheldon Bonovitz
See page 121

191. James Castle (American, 1900–1977)
Ten books
Undated
Gift of the Wade Family James Castle Collection

Philip Morris & Co. Ltd. Inc. English Blend
Pigment on paper, in flattened cigarette package cover, bound with string; 6 pages including cover, 3³⁄₈ x 3¹⁄₈ inches (8.6 x 7.9 cm)
2000-166-1

"Scribble"
Soot and pigment on paper, in flattened cardboard box cover, bound with string; 10 pages including cover, 9¹⁵⁄₁₆ x 6³⁄₈ inches (25.2 x 16.2 cm)
2000-166-2

Soot "Landscape"
Soot on paper, bound with string; 14 pages including cover, 3³⁄₈ x 3¹⁄₈ inches (8.6 x 7.9 cm)
2000-166-3

Value Highest [. . .]ned to Dealer
Soot and graphite on printed book pages, in cardboard cover, bound with string, with printed "Mutt & Jeff" cartoon loosely inserted; 50 pages including cover, 5¹³⁄₁₆ x 5¹⁄₁₆ inches (14.8 x 12.9 cm)
2000-166-4

Sugar Honey-Maid Graham Crackers
Soot on paper, in flattened cardboard box cover, bound with string; 13 pages including cover (one page torn out), 9³⁄₄ x 8¹⁄₂ inches (24.8 x 21.6 cm)
2000-166-5
See page 144

Camel Turkish & Domestic Blend Cigarettes
Soot on paper, in flattened cigarette package cover, bound with string; 12 pages including cover, 3⁵⁄₁₆ x 3¹⁄₁₆ inches (8.4 x 7.8 cm)
2000-166-6
See page 144

Lucky Strike "It's Toasted" Cigarettes
Soot on paper, in flattened cigarette package cover, bound with string; 8 pages including cover, 3⁵⁄₁₆ x 3¹⁄₁₆ inches (8.4 x 7.8 cm)
2000-166-7

Campbell's Condensed Tomato Soup
Soot on paper, in flattened soup can label cover, bound with string; 8 pages including cover, 3³⁄₈ x 3¹⁄₁₆ inches (8.6 x 7.8 cm)
2000-166-8
See page 144

Val Vita Brand
Pigment and graphite on lined paper, in flattened can label cover, bound with string; 6 pages including cover, 3³⁄₈ x 3¹⁄₁₆ inches (8.6 x 7.8 cm)
2000-166-9
See page 144

Peet's Crystal White Granulated Soap
Soot on paper, in cardboard box front cover, bound with string; 8 pages including cover, 4 x 6³⁄₈ inches (10.2 x 16.2 cm)
2000-166-10
See page 144

192. Thirty-three works on paper, fifteen paintings, and two sculptures by twentieth-century folk and self-taught artists
Partial and promised gift of Nancy F. Karlins Thoman and Mark Thoman
See pages 126–27

The gift of fifty works by self-taught and folk artists from the distinguished collection of Nancy F. Karlins Thoman will immensely enhance both the size and significance of the Museum's already substantial holdings in this area. Particularly notable for its large and varied number of works by Justin McCarthy, the gift also includes fine drawings by several other well-known self-taught artists, some not previously represented in the Museum's collection, including Lamont Alfred (Old Ironsides) Pry, Lonnie Holley, Vestie Davis, Jack Savitsky, Peter Minchell, and Sybil Gibson, as well as others who are beginning to be well represented here, such as William Traylor.

193. Forty-eight works on paper and one sculpture by twentieth-century folk and self-taught artists
Bequest of Derrel DePasse. 2002-53-1–48
See pages 124–25

A splendid group of forty-eight works by well-known self-taught artists collected by an important scholar in the field, Derrel DePasse, has been acquired by the Museum through her bequest. The highlight of the collection is the twenty-nine examples by Joseph Yoakum, whose work was of particular interest to DePasse. Among the other important artists represented are William Traylor, Eddie Arning, and Martín Ramírez. This significant acquisition adds enormously to our important and growing collections of works by self-taught artists and will interact interestingly with our contemporary and modern holdings.

194. Andrew Newell Wyeth (American, born 1917)
Five works on paper and one receipt, from a group of six objects (see also checklist no. 158)
Gift of Frank A. Elliott, Josiah Marvel, and Jonathan H. Marvel in memory of Gwladys Hopkins Elliott

Study for *Cooling Shed*
c. 1953. Graphite on wove paper, 13⁷⁄₈ x 10⁷⁄₈ inches (35.3 x 27.5 cm)
1998-180-2

Study for *Cooling Shed*
c. 1953. Graphite on wove paper, 21 x 14 inches (53.3 x 35.6 cm)
1998-180-3a,b

Study for *Cooling Shed*
c. 1953. Graphite on wove paper, 21¹⁄₄ x 13⁷⁄₈ inches (53.9 x 35.2 cm)
1998-180-4
See page 117

No. 195 Alexander Calder, *The Black Palm*

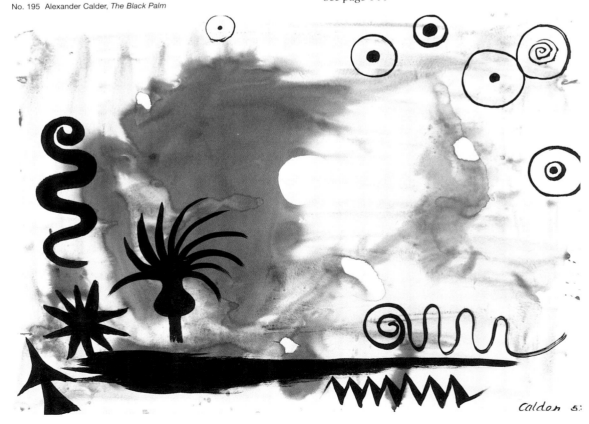

Study for *Cooling Shed*
c. 1953. Watercolor on wove paper, 17¹⁵⁄₁₆ x 11¹⁵⁄₁₆
inches (45.6 x 30.4 cm)
1998-180-5

Study for *Cooling Shed*
c. 1953. Watercolor on wove paper, 15⁷⁄₈ x 11⁷⁄₈
inches (40.2 x 30.1 cm)
1998-180-6

Receipt for *Cooling Shed*
1953. Graphite and ink on laid paper, 10½ x 7¼
inches (26.7 x 18.4 cm)
1998-180-7

*195. Alexander Calder (American, 1898–1976)
The Black Palm
1953. Ink, watercolor, and gouache on paper; 29½ x
41¼ inches (74.9 x 104.8 cm)
Promised gift of Dr. Luther W. Brady, Jr.

196. Georgia O'Keeffe (American, 1887–1986)
Drawing III
1959. Charcoal on paper, 18⅝ x 24¾ inches
(47.3 x 62.9 cm)
Purchased with funds contributed by the Arcadia
Foundation, and gift of The Georgia O'Keeffe
Foundation. 1997-42-1

197. Eva Hesse (American, born Germany,
1936–1970)
Untitled
1965. Gouache and ink on paper, 11½ x 16¼ inches
(29.2 x 41.3 cm)
Promised gift of Werner H. Kramarsky
See page 135

198. Sol LeWitt (American, born 1928)
Location of a Circle
1973. Pencil and crayon, dimensions vary
Gift of Henry S. McNeil, Jr. 2000-95-1

199. John Woodrow Wilson (American, born 1922)
Martin Luther King, Jr.
1981. Charcoal on paper, 38⅛ x 29⁷⁄₁₆ inches
(96.8 x 74.8 cm)
Purchased with funds contributed by the Young
Friends of the Philadelphia Museum of Art in honor
of the 125th Anniversary of the Museum and in
celebration of African American art. 2000-34-1
See page 146

Photographs

200. Robert Cornelius (American, 1809–1893)
Portrait of a Man
1840. Daguerreotype, quarter plate; image 3 x 2½
inches (7.6 x 6.4 cm)
Gift of Harvey S. Shipley Miller and J. Randall
Plummer. 2000-163-1

201. William Langenheim (American, born Germany,
1807–1874) and Frederick Langenheim (American,
born Germany, 1809–1879)
Merchants Exchange, Philadelphia
1849. Salt print from a paper negative, sheet 10¹³⁄₁₆ x 9⁷⁄₁₆
inches (27.4 x 23.9 cm)
Gift of The Miller-Plummer Foundation. 2000-164-1
See page 47

202. Ninety photographs
Purchased with the Lola Downin Peck Fund, the Alice
Newton Osborn Fund, and with funds contributed by
The Judith Rothschild Foundation in honor of the
125th Anniversary of the Museum. 2002-19-1–90
See page 82

*This group of ninety photographs by artists affiliated with
the Photo-Secession, including Frank Eugene, Gertrude
Käsebier, Edward Steichen, Clarence White, and
Philadelphia artists John G. Bullock and Robert Redfield,
was acquired from the collection of the scholar Dr.
William Innes Homer. Assembled to demonstrate the
scope and creative accomplishments of this important
chapter in the history of photography, this group of
images complements the Museum's select but modest
number of Photo-Secessionist works and directly ampli-
fies its core holding of work by Alfred Stieglitz by repre-
senting his early circle of associates.*

203. J. Mitchell Elliot (American, 1866–1952)
Quakeress
c. 1900–1920. Platinum print on tissue, sheet 9½ x
7⁷⁄₁₆ inches (24.1 x 18.9 cm)
Gift of Harvey Stokes Shipley Miller in memory of
Walter Penn Shipley. 2001-220-1
See page 71

204. Two photographs, from a gift of eleven works
on paper (see also checklist nos. 76, 167, 175)
Promised gift of Alice Saligman

 Man Ray (American, 1890–1976)

 Photograph of a lost Jean Crotti sculpture entitled
 *Portrait of Marcel Duchamp (Sculpture Made to
 Measure)*
 c. 1915–16. Gelatin silver print, sheet 9⁷⁄₁₆ x 7¹⁄₁₆
 inches (24 x 17.9 cm)
 See page 85

 Marcel Duchamp with Shaving Cream
 c. 1924. Gelatin silver print, sheet 3¼ x 2¼ inches
 (8.3 x 5.7 cm)
 See page 85

205. Alfred Stieglitz (American, 1864–1946)
Five photographs
Promised gift of The Georgia O'Keeffe Foundation

 Georgia O'Keeffe: A Portrait
 1918. Palladium print, sheet 9¹⁵⁄₁₆ x 7¹⁵⁄₁₆ inches
 (25.2 x 20.2 cm)

 Georgia O'Keeffe: A Portrait
 1918. Palladium print, sheet 9¾ x 7⅞ inches
 (24.8 x 20 cm)
 See page 87

 Georgia O'Keeffe: A Portrait
 1926. Gelatin silver print, sheet 4⅝ x 3⅝ inches
 (11.7 x 9.2 cm)

 Georgia O'Keeffe: A Portrait
 1932. Gelatin silver print, sheet 4⅜ x 9½ inches
 (11.1 x 24.1 cm)

 Georgia O'Keeffe: A Portrait
 1933. Gelatin silver print, sheet 3½ x 4½ inches
 (8.9 x 11.4 cm)

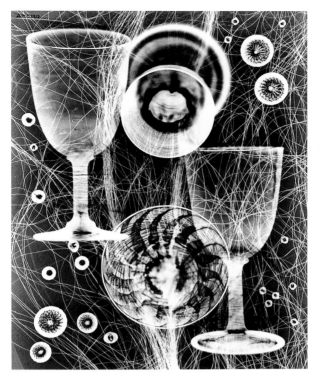

No. 211 Emilio Amero, *Glasses and Circles* (2001-62-40)

206. Alfred Stieglitz (American, 1864–1946)
Seven photographs
The Alfred Stieglitz Collection, purchased with the
gift (by exchange) of Dr. and Mrs. Paul Todd Makler,
the Lynne and Harold Honickman Fund for Photog-
raphy, the Alice Newton Osborn Fund, and the Lola
Downin Peck Fund, with funds contributed by Mr.
and Mrs. John J. F. Sherrerd, Lynne and Harold
Honickman, John J. Medveckis, and M. Todd Cooke,
and gift of The Georgia O'Keeffe Foundation

Georgia O'Keeffe: A Portrait
1919. Palladium print, sheet 9⅞ x 7⅞ inches
(25.1 x 20 cm)
1997-38-1

Georgia O'Keeffe: A Portrait
1920. Palladium print, solarized; sheet 9⅞ x 7¹⁵⁄₁₆
inches (25.1 x 20.2 cm)
1997-38-2

Georgia O'Keeffe: A Portrait
1921. Gelatin silver print, sheet 7⁹⁄₁₆ x 3⅝ inches
(19.2 x 9.2 cm)
1997-38-4

Georgia O'Keeffe: A Portrait
1923. Gelatin silver print, sheet 4½ x 3½ inches
(11.4 x 8.9 cm)
1997-38-6

Georgia O'Keeffe: A Portrait
1924. Gelatin silver print, sheet 4⅝ x 3⁹⁄₁₆ inches
(11.7 x 9 cm)
1997-38-5

Georgia O'Keeffe: A Portrait
1929. Gelatin silver print, sheet 3⅛ x 4⅝ inches
(7.9 x 11.7 cm)
1997-38-7

No. 216 László Moholy-Nagy, *Scandinavia*

Georgia O'Keeffe: A Portrait
1930. Gelatin silver print, sheet 6½ x 8⅝ inches
(16.5 x 21.9 cm)
1997-38-3

207. Two hundred twenty-five photographs
From the Collection of Dorothy Norman
1997-146-1–225
See page 99

The bequest, in 1997, of 225 photographs from Philadelphia-born photographer and author Dorothy Norman, brought the total number of works of art given by Mrs. Norman to the Museum to over eight hundred images, and concluded thirty years of generosity, which began in 1967 with the founding of the Alfred Stieglitz Center for photography. Mrs. Norman's extraordinary collection includes a superb range of Stieglitz's work as well as fine examples by such celebrated colleagues as Ansel Adams, Paul Strand, Edward Weston and Minor White. Her gift and commitment to photography as an art form and as a powerful means of human expression continue to inspire the Museum's mission.

208. George Hoyningen-Heune (American, born Russia, 1900–1968)
Untitled (Woman in Grecian Dress)
1920s. Gelatin silver print, sheet 11¾ x 9⅜ inches
(29.8 x 23.8 cm)
Gift of Harvey S. Shipley Miller and J. Randall Plummer. 2001-219-2

209. Edward Steichen (American, 1879–1973)
Untitled (Fashion Photograph)
1920s. Gelatin silver print, sheet 9¹⁵⁄₁₆ x 7¹⁵⁄₁₆ inches
(25.2 x 20.2 cm)
Gift of Harvey S. Shipley Miller and J. Randall Plummer. 2001-219-4

210. Man Ray (American, 1890–1976)
Untitled Rayograph
1923. Gelatin silver print, 11⁹⁄₁₆ x 8¹⁵⁄₁₆ inches
(29.4 x 22.7 cm)
Purchased with funds from the bequest of Dorothy Norman, the Alfred Stieglitz Center Revolving Fund, the Lola Downin Peck Fund and the Carl and Laura Zigrosser Collection (by exchange), the Lynne and Harold Honickman Fund for Photography, and with contributions from The Judith Rothschild Foundation, Marion Boulton Stroud, Harvey S. Shipley Miller and J. Randall Plummer, Ann and Donald W. McPhail, and Audrey and William H. Helfand in honor of the 125th Anniversary of the Museum. 1999-134-1
See page 106

*211. **Approximately 2,500 American and European photographs**
The Lynne and Harold Honickman Gift of the Julien Levy Collection. 2001-62-1–2447
See pages 90–91

The Julien Levy Collection of photographs is a trove of some 2,500 images amassed by one of the most influential and colorful proponents of modern art and photography in the United States during the 1930s and 1940s. More than 130 artists are represented in the collection, which bears witness to the Julien Levy Gallery's activities in New York from 1931 through 1948 and contains major and little known works by American and European photographers active between the world wars, including Eugène Atget, Anne Brigman, Imogen Cunningham, Charles Sheeler, Man Ray, László Moholy-Nagy, Paul Outerbridge, and Lee Miller. In the important group of European photographs are works by artists closely associated with Surrealism, among them Brassaï, Max Ernst, Dora Maar, Roger Parry, Maurice Tabard, and Umbo.

The Levy Collection, secured by a gift from the artist's widow and through the generosity of Lynne and Harold Honickman, quite literally transforms the Museum's holdings of photography, while paying tribute to Levy's principal mentors, Alfred Stieglitz and Marcel Duchamp who are also major areas of strengths of the Museum's existing collection.

212. Edward Weston (American, 1886–1958)
Nude, California
1927. Gelatin silver print, sheet 9⁵⁄₁₆ x 6⅞ inches
(23.7 x 17.5 cm)
Gift of Harvey S. Shipley Miller and J. Randall Plummer. 2000-163-5

213. Edwin Hale Lincoln (American, 1848–1938)
Studies of Cultivated Flowers
1929. Album of forty-six platinum prints, sheet 9½ x 7½ inches (24.1 x 19 cm) each
Gift of Beatrice B. Garvan. 2000-25-1–46
See page 83

214. Edwin Hale Lincoln (American, 1848–1938)
Trees of the Berkshire Hills
1929. Album of fifty-six platinum prints, sheet 7½ x 9½ inches (19 x 24.1 cm) each
Gift of Beatrice B. Garvan. 2001-50-1–56
See page 83

215. Edwin Hale Lincoln (American, 1848–1938)
The Berkshire Hills
1929. Album of fifty-one platinum prints, sheet 9½ x 7½ inches (24.1 x 19 cm) each
Gift of Beatrice B. Garvan. 2001-50-2(1–51)

*216. **László Moholy-Nagy** (American, born Hungary, 1895–1946)
Scandinavia
1930. Gelatin silver print, sheet 9¼ x 6⁵⁄₁₆ inches
(23.5 x 16 cm)
Gift of Harvey S. Shipley Miller and J. Randall Plummer. 2000-163-4

217. Walker Evans (American, 1903–1975)
The Breakfast Room, Belle Grove Plantation, White Castle, Louisiana
1935 (negative); 1966 (print). Gelatin silver print, sheet 8 x 10 inches (20.3 x 25.4 cm)
Gift of Harvey S. Shipley Miller and J. Randall Plummer. 2000-163-3

218. Walker Evans (American, 1903–1975)
Roadside Store between Tuscaloosa and Greensboro, Alabama
1936 (negative); 1960s (print). Gelatin silver print, sheet 8 x 9¹⁵⁄₁₆ inches (20.3 x 25.2 cm)
Gift of Harvey S. Shipley Miller and J. Randall Plummer. 2001-219-1

219. Man Ray (American, 1890–1976)
Underdrawing for *Le Beau Temps* (checklist no. 151)
1939. Gelatin silver print, 12½ x 11½ inches
(31.8 x 29.2 cm)
Promised gift of David and Naomi Savage

220. Paul Strand (American, 1890–1976)
Lobster Wharf, Corea, Maine
1946. Gelatin silver print, sheet 7⁹⁄₁₆ x 9⁹⁄₁₆ inches
(19.2 x 24.3 cm)
Gift of Brenda and Evan H. Turner in memory of Michael Hoffman

No. 223 Ralph Gibson, *Untitled, San Francisco*

221. Weegee (American, born Poland, 1899–1968)
Louis Armstrong
c. 1950. Gelatin silver print, sheet 9¹⁵⁄₁₆ x 8⅛ inches
(25.2 x 20.6 cm)
Gift of Harvey S. Shipley Miller and J. Randall
Plummer. 2002-56-1

222. Harry Callahan (American, 1912–1999)

Twenty-one photographs
Promised gift of Susan P. MacGill in memory of Harry
Callahan

One hundred photographs
Purchased with funds contributed by John J.
Medveckis. 1997-37-1–100
See page 142; for the publication, see page 191

*Harry Callahan is universally considered to be one of the
twentieth century's greatest photographers. Self-taught
but himself one of the most influential teachers, he pho-
tographed with a consistency of vision and distinction.
Among his recurrent themes were the landscapes repre-
sented in the 100 prints by the artist given by Museum
Trustee John J. Medveckis and the 21 donated by Susan
MacGill in Callahan's memory. Together they provide a
comprehensive survey of Callahan's work with landscape
and add to the Museum's already strong holdings of
American landscape photography.*

223. Ralph Gibson (American, born 1939)
Ten photographs
Promised gift of Mr. and Mrs. Jack M. Friedland in
memory of Michael Hoffman

 Untitled, San Francisco
 1961. Gelatin silver print, sheet 13¹⁵⁄₁₆ x 10¹⁵⁄₁₆
 inches (35.4 x 27.8 cm)

 * *Untitled, San Francisco*
 1961. Gelatin silver print, sheet 13⅞ x 10¹⁵⁄₁₆ inches
 (35.2 x 27.8 cm)

 Untitled, Hollywood
 1966. Gelatin silver print, sheet 13⅞ x 10¹⁵⁄₁₆
 inches (35.2 x 27.8 cm)

 Untitled
 1968. Gelatin silver print, sheet 13¹⁵⁄₁₆ x 10¹⁵⁄₁₆
 inches (35.4 x 27.8 cm)

 Untitled
 1968. Gelatin silver print, sheet 19¹³⁄₁₆ x 15¹⁵⁄₁₆
 inches (50.3 x 40.5 cm)

 Untitled
 1969. Gelatin silver print, sheet 13⅞ x 10¹⁵⁄₁₆ inches
 (35.2 x 27.8 cm)

 Untitled
 1974. Gelatin silver print, sheet 19⅞ x 15¹³⁄₁₆ inches
 (50.5 x 40.2 cm)

 Untitled
 1975. Gelatin silver print, sheet 19¹⁵⁄₁₆ x 15⅞ inches
 (50.6 x 40.3 cm)

 Untitled, France
 1986. Gelatin silver print, sheet 19¹³⁄₁₆ x 15¹⁵⁄₁₆
 inches (50.3 x 40.5 cm)

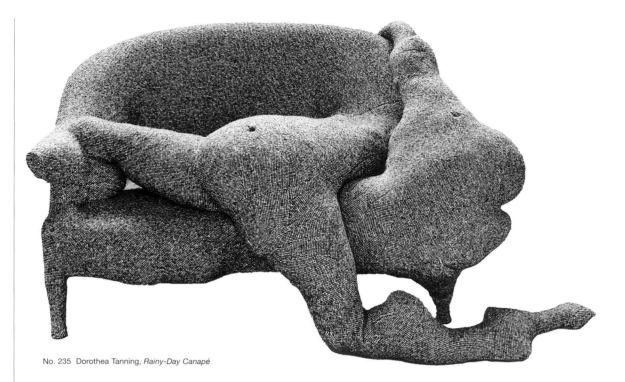

No. 235 Dorothea Tanning, *Rainy-Day Canapé*

 Untitled, France
 1989. Gelatin silver print, sheet 13⅞ x 10⅞ inches
 (35.2 x 27.6 cm)

224. William Eggleston (American, born 1939)
Five photographs
Gift of Walter Hopps and Caroline Huber

 Untitled (Wannalaw Plantation)
 1970 (negative); 1980 (print). Dye transfer print,
 sheet 14⅝ x 19¹⁵⁄₁₆ inches (37.1 x 50.6 cm)
 2001-216-1

 Untitled (Tricycle, Memphis)
 1972 (negative); 1980 (print). Dye transfer print,
 sheet 15⅞ x 19¹⁵⁄₁₆ inches (40.3 x 50.6 cm)
 2001-216-2
 See page 143

 Untitled (Red Ceiling, Greensboro)
 1972. Dye transfer print, sheet 15⅞ x 20¹⁄₁₆ inches
 (40.3 x 51 cm)
 2001-216-3

 Untitled (Christmas Candle)
 c. 1979 (negative); 1980 (print). Dye transfer print,
 sheet 15⅜ x 19¼ inches (39.1 x 48.9 cm)
 2001-216-5
 See page 143

 Untitled (Peaches!)
 c. 1979. Dye transfer print, sheet 15¹⁵⁄₁₆ x 20 inches
 (40.5 x 50.8 cm)
 2001-216-4

225. Minor White (American, 1908–1976)
Halibut Point, Massachusetts
1971 (print). Gelatin silver print, sheet 11 x 13⅞
inches (27.9 x 35.2 cm)
Gift of Harvey S. Shipley Miller and J. Randall
Plummer. 2001-219-5

Sculpture

226. Jacques Lipchitz (American, born Lithuania,
1891–1973)
Five sculptures
Gift of the Jacques and Yulla Lipchitz Foundation, Inc.

 Reader II
 1919. Plaster, height 30½ inches (77.5 cm)
 See page 141

 Barnes Foundation Relief: *Musical Instruments*
 1922–24. Plaster, height 33 inches (83.8 cm)
 See page 141

 Rescue of the Child
 1933. Terra cotta, height 10¾ inches (27.3 cm)

 Portrait of Yulla Lipchitz
 1956. Plaster, height 23½ inches (59.7 cm)

 Lesson of a Disaster
 1961. Plaster, height 27 inches (68.6 cm)

227. Edgar Alexander McKillop (American,
1879–1950)
Mountain Lion
Made in Balfour, North Carolina; c. 1935–38. Black
walnut and glass, height 14¼ inches (36.2 cm)
Gift of Melanie Gill in memory of her husband, Robert
Lee Gill, and in honor of Jack L. Lindsey. 2001-193-1
See page 110

228. William Edmondson (American, c. 1870–1951)
Untitled (Three Doves)
c. 1935–40. Limestone, height 7¼ inches (18.4 cm)
Partial and promised gift of Jill and Sheldon Bonovitz
See page 120

229. Rudolf Staffel (American, 1911–2002)
Head
1938. Glazed stoneware, height 8⅜ inches (21.3 cm)
Purchased with funds contributed by Daniel W.
Dietrich, Henry S. McNeil, Jr., Betty Gottlieb, Frances
and Bayard Storey, Robert Tooey and Vicente Lim,
June and Perry Ottenberg, and The Acorn Club, and
with the gift of Helen Williams Drutt English in honor
of the artist. 2001-109-1
See page 112

230. Joseph Cornell (American, 1903–1972)
Untitled (Woodpecker Habitat)
1946. Box construction, 13⅝ x 9⅛ x 3 inches (34.6 x
23.2 x 7.6 cm)
Partial gift of Mrs. Edwin A. Bergman, and purchased
with the gift (by exchange) of Anna Warren Ingersoll
2000-5-2
See page 118

231. Isamu Noguchi (American, 1904–1988)
Avatar
1948 (cast in bronze in 1982). Bronze, height 6 feet,
6 inches (1.9 m)
Gift of the Isamu Noguchi Foundation, Inc. 2001-45-1
See page 134

232. Elizabeth Catlett (American, born 1915)
Mother and Child
1954. Terra cotta, height 11½ inches (29.2 cm)
Purchased with funds contributed by Dr. Constance E.
Clayton and Mr. and Mrs. James B. Straw in honor of
the 125th Anniversary of the Museum and in celebra-
tion of African American art. 2000-36-1
See page 128

233. Joseph Cornell (American, 1903–1972)
Observatory American Gothic
c. 1954. Box construction, 17⁹⁄₁₆ x 11⁵⁄₁₆ x 2¹¹⁄₁₆ inches
(44.5 x 28.9 x 6.7 cm)
Partial gift of Mrs. Edwin A. Bergman, and purchased
with the gift (by exchange) of Anna Warren Ingersoll.
2000-5-1
See page 118

234. Barbara Chase-Riboud (American, born 1939)
Malcolm X, No. 3
1970. Bronze and silk, height 9 feet, 10 inches (2.9 m)
Purchased with funds contributed by Regina and
Ragan A. Henry, and with other funds being raised in
honor of the 125th Anniversary of the Museum and in
celebration of African American art. 2001-92-1
See page 133

*****235. Dorothea Tanning** (American, born 1910)
Rainy-Day Canapé
1970. Wood sofa, tweed upholstery, ping-pong balls,
and cardboard; height 43¼ inches (109.9 cm)
Anonymous gift

236. Sam Doyle (American, 1906–1985)
Turtle
c. 1970. Carved and painted wood, height 9 inches
(22.9 cm)
Promised gift of Ann and John Ollman

237. Sam Doyle (American, 1906–1985)
Large Fish
c. 1980. Carved and painted wood with nails, height
16 inches (40.6 cm)
Promised gift of Ann and John Ollman

238. John Chamberlain (American, born 1927)
Glossalia Adagio
1984. Painted and chrome-plated steel, height 6 feet,
8 inches (2 m)
Gift of Mr. and Mrs. David N. Pincus. 2000-96-1
See page 147

239. Michael Lucero (American, born 1953)
Rock Garden Dreamer
1984. Glazed earthenware, width 24 inches (61 cm)
Gift of Charles W. Nichols. 2001-199-1

240. Martin Puryear (American, born 1941)
Generation
1988. Red cedar and gourd, height 8 feet, 5 inches
(2.5 m)
Promised gift of Mr. and Mrs. Leonard I. Korman
See page 158

*****241. John McQueen** (American, born 1943)
In the Same Bind (#227)
1991. Spruce bark, elm, and string; width 48 inches
(121.9 cm)
Gift of Mr. and Mrs. Leonard I. Korman. 2001-97-1

242. Dan Graham (American, born 1942)
Heart Pavilion, Version II
1992–93. Two-way mirror, glass, and stainless steel;
8 feet x 12 feet, 9 inches x 16 feet, 4 inches
(2.4 x 3.8 x 4.9 m)
Promised gift of Eileen Rosenau
See pages 160–61

243. Sol LeWitt (American, born 1928)
Splotch (Philadelphia)
2002. Fiberglass, height 6 feet, 8 inches (2 m)
Gift of Henry S. McNeil, Jr.

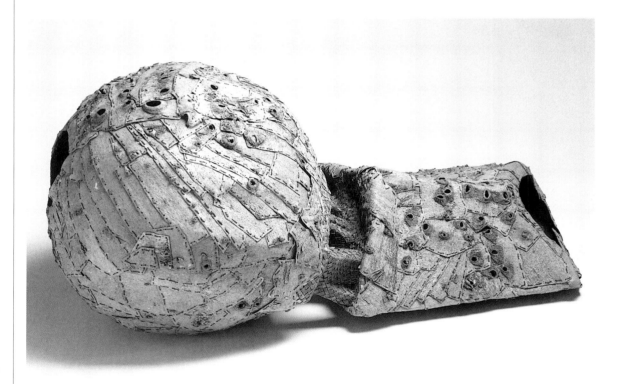

No. 241 John McQueen, *In the Same Bind (#227)*

FOR FURTHER READING

125th Anniversary Publications

Mason, Darielle, with contributions by B. N. Goswamy, Terence McInerney, John Seyller, and Ellen Smart. *Intimate Worlds: Indian Paintings from the Alvin O. Bellak Collection.* 2001.

Shoemaker, Innis Howe. *Jacques Villon and His Cubist Prints.* 2001.

Ware, Katherine. *Elemental Landscapes: Photographs by Harry Callahan.* 2001.

Watson, Wendy M. *Italian Renaissance Ceramics from the Howard I. and Janet H. Stein Collection and the Philadelphia Museum of Art.* 2001.

General

Blum, Dilys E. *The Fine Art of Textiles: The Collections of the Philadelphia Museum of Art.* 1997.

Brownlee, David. *Making a Modern Classic: The Architecture of the Philadelphia Museum of Art.* 1997.

Dorment, Richard. *British Painting in the Philadelphia Museum of Art: From the Seventeenth through the Nineteenth Century.* 1986.

Ellis, Charles Grant. *Oriental Carpets in the Philadelphia Museum of Art.* 1988.

Garvan, Beatrice B. *The Pennsylvania German Collection.* Handbooks in American Art, No. 2. 1982. Reprint, 1999.

Paintings from Europe and the Americas in the Philadelphia Museum of Art. 1994.

Philadelphia Museum of Art: Handbook of the Collections. 1995.

Ramljak, Suzanne. *Crafting a Legacy: Contemporary Crafts in the Philadelphia Museum of Art.* 2002.

Schaap, Ella, et al. *Dutch Tiles in the Philadelphia Museum of Art.* 1984.

Sutton, Peter C. *Northern European Paintings in the Philadelphia Museum of Art: From the Sixteenth through the Nineteenth Century.* 1990.

Temkin, Ann, Susan Rosenberg, and Michael Taylor, with contributions by Rachael Arauz. *Twentieth Century Painting and Sculpture in the Philadelphia Museum of Art.* 2000.

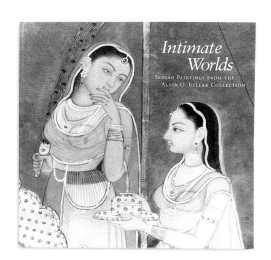

INDEX OF DONORS

INDEX OF ARTISTS AND MAKERS